MARTIN DAVIES

Rogier van der Weyden

Frontispiece:
Detail from
The Adoration of the Kings
(Plate 61).
Munich, Alte Pinakothek
(Cat. Rogier, Munich 1)

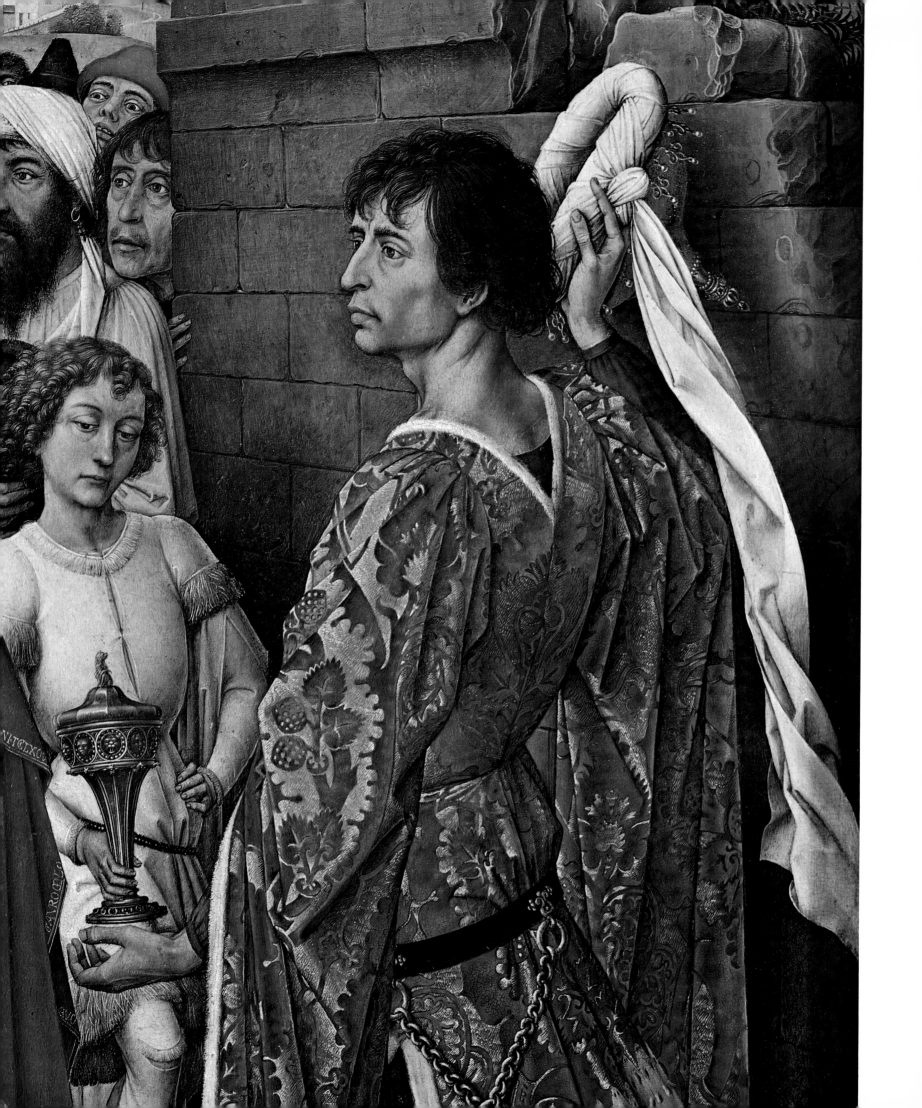

MARTIN DAVIES

Rogier van der Weyden

AN ESSAY, WITH A CRITICAL CATALOGUE OF PAINTINGS
ASSIGNED TO HIM AND TO ROBERT CAMPIN

PHAIDON

PHAIDON PRESS LIMITED · 5 CROMWELL PLACE · LONDON SW7

PUBLISHED IN THE UNITED STATES OF AMERICA BY PHAIDON PUBLISHERS, INC.
AND DISTRIBUTED BY PRAEGER PUBLISHERS, INC.
III FOURTH AVENUE · NEW YORK · N.Y. 10003

FIRST PUBLISHED 1972
© 1972 BY PHAIDON PRESS LIMITED
ALL RIGHTS RESERVED

ISBN 0 7148 1516 0
LIBRARY OF CONGRESS CATALOG CARD NUMBER: 79-173437

TEXT PRINTED IN GREAT BRITAIN BY WESTERN PRINTING SERVICES LTD · BRISTOL
PLATES PRINTED BY FANTONIGRAFICA · VENICE

CONTENTS

PREFACE

THIS BOOK has been prepared as an introduction to the paintings of Rogier van der Weyden. Also, secondarily, to those of Robert Campin, often referred to as the Master of Flémalle or the Master of Merode; these are by some critics attributed to Rogier, but for me are by a distinct painter.

High quality in the pictures has been the prime consideration. Inferior works that may be more or less closely associated with one or other of the two painters are here mostly recorded slightly, or omitted. I hope that doing this will present more clearly some Masterpieces of European painting, which are assigned to Rogier and to Campin.

At the beginning of the book is an Essay on aspects of Rogier.

Paucity of documentation and of dates for the known pictures adds to other difficulties in arranging the rest of the material.

For arranging the plates, some attention has been paid to dates and dating. Plates of the group of works associated with Rogier are in this order: the two best documented pictures; altarpieces; smaller compositions; half-length Madonnas; then (with some imprecision) diptychs, followed by portraits; lastly, a small unclassified group. After the plates for Rogier come those for Campin, beginning with the pictures at Frankfurt and the Merode triptych. Jacques Daret's four certified paintings are placed last. The names of Rogier and Campin appearing in the captions do not have attributional status; they form references to the catalogue. Various pictures, a few of which are meritorious, are not reproduced.

The catalogue is divided into two groups, for Rogier and for Campin; entries are arranged by location. Some compositions are known in several versions, no one of which need dominate; these are classed under V (Various Collections). Reference to a reproduction elsewhere is given if the subject of the entry is not here reproduced. Some cross-references and indexes will, I hope, make the entries findable.

The book also includes lists of records concerning Rogier, Campin and Daret, and a list of bibliographical abbreviations.

The treatment is not full. Catalogue entries for Campin are slighter than for Rogier.

I have received much help. I wish here particularly to thank Dr. I. Grafe, Mr. Keith Roberts and Miss Patricia Wood of the Phaidon Press for varied assistance; Professor E. Holzinger of the Staedelsches Kunst-institut at Frankfurt for giving me permission to reproduce the recently cleaned reverse of Campin's *Thief*; Dr. F. Klauner of the Kunsthistorisches Museum in Vienna, and Drs. E. Herzog and F. Lahusen of the Staatliche Kunstsammlungen at Cassel for allowing me to study pictures in their charge not at the time on public view.

January 1972 M.D.

I

EXPLANATIONS

In the pages that follow, my present opinions on Rogier and Campin, whether for use of either painter's name or for autograph execution, are sometimes stated. Absence of a personal comment may mean that I do not dispute the current view; that I am incurious about the grading; etc. Not all the pictures recorded have been seen, or seen recently; the importance of this for some pictures could be exaggerated.

In the catalogue entries, supports of paintings are not specified if believed to be of wood, presumed oak; sizes are taken from a respectable source. References are given to some published scientific photographs. Inscriptions are given if thought to be important, these records being slighter for derivatives. Comment on subject does not extend to patterns of tiles etc., found in some of the pictures. Versions, etc., are recorded selectively: some that are in one way or another of interest, in some detail; derivatives chiefly if they are not in all ways irrelevant to the original. Provenance is given summarily if not of much importance and easy to check on.

Errors may be silently corrected.

References to the opinions of writers are few; it is not my intention to run here a polling-station for attributions or datings. References are given, if they exist, to the volumes of the *Corpus* series; to Friedländer; to Panofsky. Much bibliography can be found there.

Speculations by writers may be silently passed over.

ESSAY

THE DELIGHT of seeing superior pictures is very strong. But 'seeing' is partial unless it includes seeing the originals: which usually means travel. And yet, despite that labour (and then perhaps seeing the originals under poor conditions!) the best pictures do have a most strongly attractive power.

A painter of the right class for this is Rogier van der Weyden.

The present book is primarily a collection of plates; and photographs may very greatly help for liking and for seeking to understand such pictures. Yet it is to be stressed that photographs do not tell everything; in particular, they tend to pass over the more delicate distinctions of aesthetic quality, and may be misleading for stylistic analysis. So one comes back, soon, to the need of seeing originals; and if the plates here encourage people to do this, the book is working as it should.

Nobody has yet been clear and persuasive about what pictures are for; yet their being seen and enjoyed must enter in—the many, who are not creative artists, should cling to that. Nevertheless, merely looking at pictures does not usually get one as far as is desirable. Working at them almost always brings more enjoyment —even if that result is not evident immediately. And for some old painters a good deal of work may be called for.

A good deal is with Rogier van der Weyden.

We must begin by painfully defining what we are talking about. Certainly; he was a celebrated painter of the fifteenth century, mentioned by contemporaries with very high praise. Such fame makes it incredible that not one of his pictures should have survived; but which are they? Our first task is to enquire into this; and the enquiry is not simple.

No existing picture is known to be authentically signed by him, or to be in a strict sense documented as his. Concerning his life, certainly, facts are established. Born at Tournai in 1399 or 1400, maintaining some contact with that place, he settled in Brussels, where he was living by 1435, and he died there in 1464.

In seeking to identify the pictures he painted, we find the best authenticated one in a magnificent *Deposition*, belonging to the Escorial and now deposited at the Prado Museum in Madrid. It is firmly identified as a Plates 1–9 picture recorded with detail in an inventory of the Escorial in 1574; the attribution there is to 'Maestre Rogier'. But this, constituting our best record, is from more than a century after his death—as if the basis for recognizing any work of Delacroix were something being written now! The reliability of the attribution, nevertheless, is good; this inventory of the King of Spain's gifts to the Escorial is highly to be esteemed, as being of useful authority. Also, the record is confirmed to some extent from other sources. This *Deposition* was certainly of very great repute where until not long before it had been, at Louvain; and not many years after its removal, the historian of Louvain, Molanus, wrote of a picture, identifiably this one, as by Rogier (his miscalling the painter Rogier of Louvain will be referred to presently). Further, there is an engraving by Cornelis Cort,

3

dated 1565, of this composition, with background differing and a few other variations; the engraving includes the inscription *M. Rogerij Belgiae inuentum*. Although Cort's engraving is earlier than the Escorial inventory, yet it has (given the unknown circumstances of its origin, and the distance of time from the painting itself) less value as evidence.

One of the other pictures ascribed to Rogier in the Escorial inventory in 1574—this one as by 'Masse Rugier'—is despite less detail in the record to be identified surely as the large and noble *Christ on the Cross* *with the Virgin and St. John*, still in the Escorial. There is some further support for the attribution in that the picture is there recorded to come from the Charterhouse of Brussels, *i.e.* Scheut, a house with which Rogier is known to have had associations.

These two inventory mentions do not provide ideally good documentation for the attribution of pictures already old; and incidents such as fire may cause confusion or wrong identification. Yet it is to be accepted that the two great pictures now in the Prado and in the Escorial have firmly attached to them a tradition recorded in 1574 of being by Rogier, and that this is evidence acceptable as good that they are by him.

No existing picture is better documented as Rogier's than these two. There is, nevertheless, some documentation that is quite useful for a triptych showing scenes of the Virgin Mary, presumed to be the version now at Berlin (Dahlem). True, it is from Ponz, a writer of the later eighteenth century, that our information comes: that what could hardly be disputed as being a triptych of this composition was given to the Charterhouse of Miraflores by King John II of Castile in 1445—who indeed had founded that monastery in 1442; the attribution being to *magistro Rogel, magno et famoso Flandresco*. But it is to be accepted that Ponz did copy this record from the cartulary of Miraflores (the date at which the record had been written is not made clear by him). Regrettably, Ponz at the same time prints a tradition that the picture had been given to King John by Pope Martin V, who died in 1431. It is desirable to mention at this stage that so early a date seems impossible; and most critics agree to say no, or at least attach little importance, to the tradition of Martin V's ownership, as distinct from the quoted document that records the gift of the picture to the monastery in 1445. Also to be mentioned at this stage is that it is not of the first importance in establishing a basis for Rogier's style of painting whether or not the Berlin triptych was executed by Rogier's own hand.

Although less useful for identification than the old references to these three pictures, records of interest in two further cases should not be neglected.

What is acceptably an existing altarpiece, dated 1443, in S. Pierre at Louvain, is recorded as is the *Deposition* by Molanus and with attribution to Rogier (here too he says Roger of Louvain). This picture is now considered far too weak to be by Rogier; but the central part of it does repeat the *Deposition* without much variation. The record by Molanus concerning the picture still at Louvain, and known as the Edelheer altarpiece, adds little to the basis for attribution to Rogier.

A differing record, by its date better than the Escorial inventory of 1574, but less precise in its application, concerns a portrait of Duke Charles the Bold, mentioned as by Rogier in the inventories of Margaret of Austria in 1516 and again in 1524. The portrait she owned showed him bareheaded, in black, wearing the emblem of the Order of the Golden Fleece on a chain, and holding in his right hand a roll of paper. A portrait recognizably of this sitter, and at least reflecting something very good, is at Berlin (Dahlem). This picture is not identical with the one that belonged to Margaret of Austria, since the sitter at Berlin has no roll of paper,

Plates 10–12

Fig. 4
Plates 13–15

Plate 123

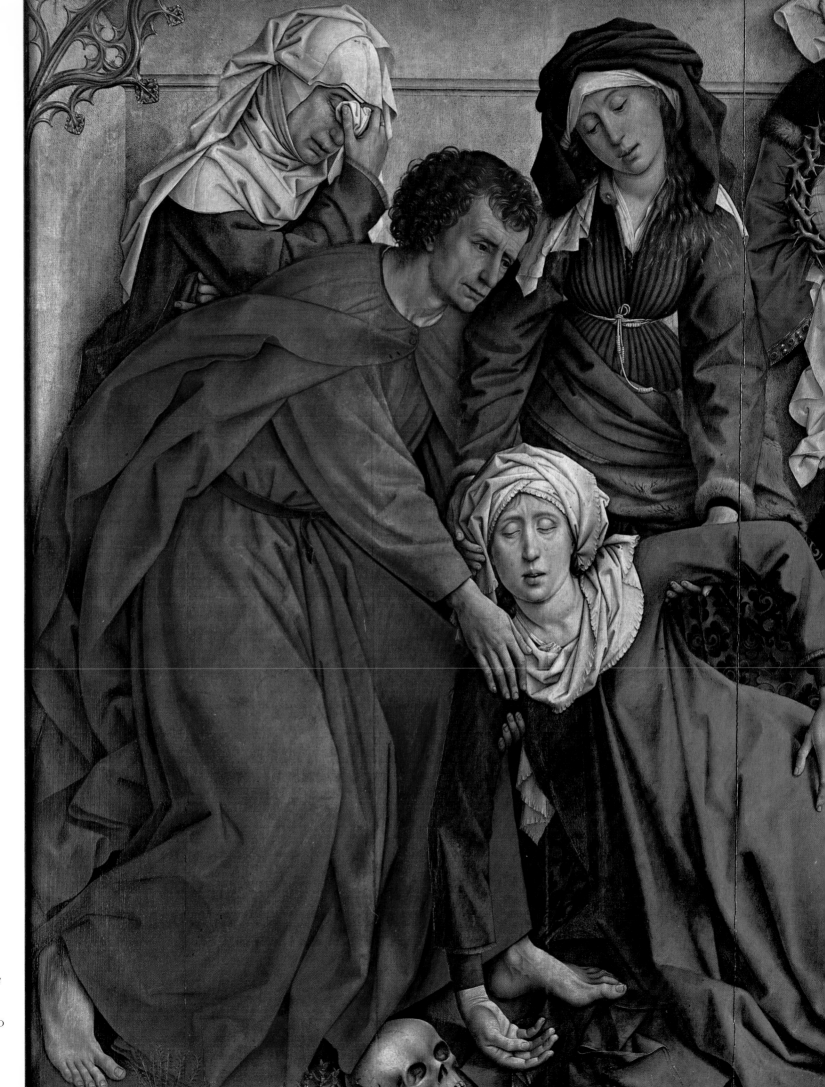

Detail from
*The Deposition
from the Cross*
(Plate 1).
Madrid, Prado
(Cat. Rogier,
Madrid 1)

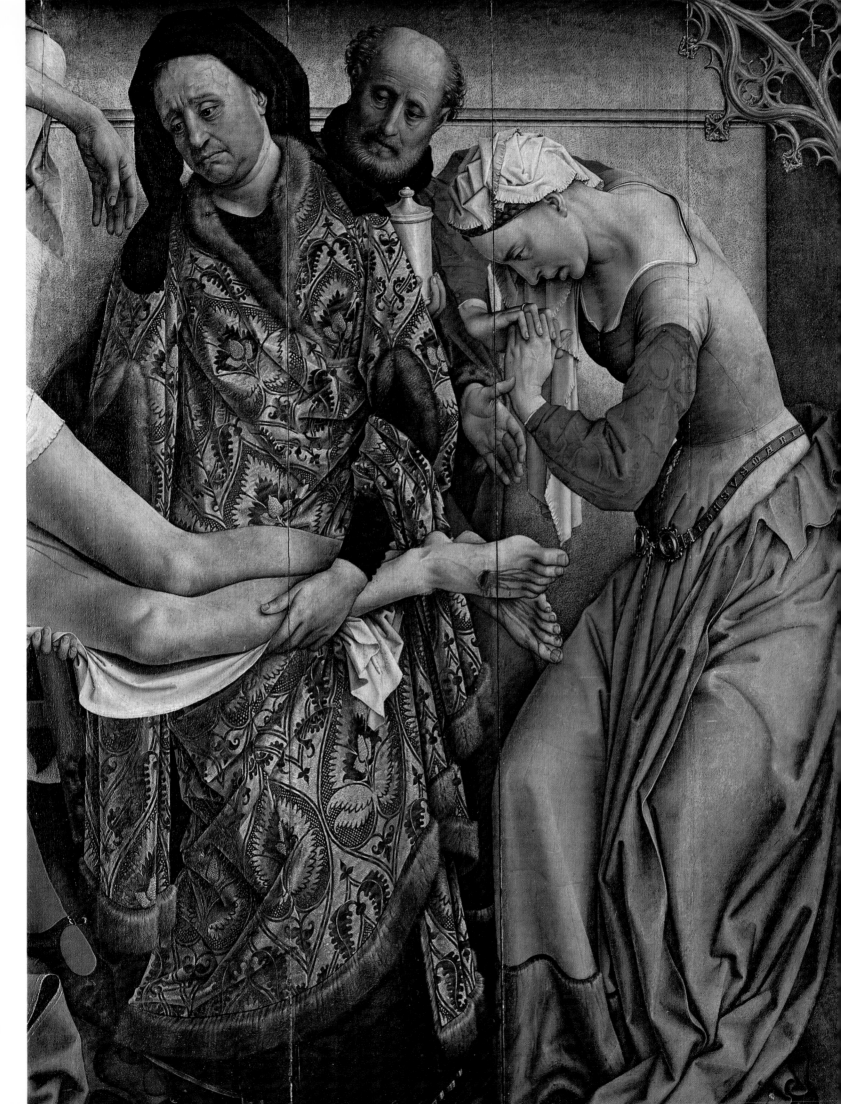

Detail from
*The Deposition
from the Cross*
(Plate 1).
Madrid, Prado
(Cat. Rogier,
Madrid 1)

but holds in his left hand the hilt of a sword or dagger, his right hand resting on a parapet; yet otherwise the description tallies. It is thus legitimate to believe that the Berlin portrait is a variant of Margaret's. Her picture —the composition of which (in spite of what has sometimes been said) appears not now to be known in any more precise derivation—from being a portrait of her grandfather, and mentioned in her inventories as by Rogier, is indeed certified to a considerable degree.

There are known yet other early records with Rogier's name, but not associable, or else too imprecisely, with existing pictures, and so not suitable for inclusion on this page: except that a claim on behalf of the Sforza triptych at Brussels (not acceptable as by Rogier) for identification with a picture recorded at Pesaro under Rogier's name cannot be neglected silently.

Other, later references are to be considered of slight account for establishing a basis of attribution to Rogier. Yet it should be mentioned, among the records of missing works, that his murals in the town hall at Brussels, certainly his (two of them inscribed with his name, one of them dated 1439), survived until late in the seventeenth century, and were admired by some people in that century; so late notices of pictures as being his may sometimes have been made for pictures at least not grossly different in style.

These statements on the existing pictures that are basic for attribution to Rogier may seem pitifully slight for a painter of his fame. More could be desired also for clarity in our studies now; yet there is enough for many attributions—a good many of which are not more disputed than attributions to other fifteenth-century painters with surer basic works surviving. But further troubles in studying Rogier must now be admitted; let us begin with minor trouble.

As has been indicated, the records do not necessarily mean that the pictures thus identified are by Rogier himself. To be sure, mentions in the King of Spain's inventory are less likely to refer to poor pictures than a local record, for which quality may not even have been thought of. Also, the pictures themselves can testify; the two in the Prado and the Escorial are patently good enough to be works of a leading fifteenth-century Netherlandish painter. The triptych at Berlin, seemingly more precisely documented, must be accepted as Fig. 4 Rogieresque; but its quality is a little down, and since a clearly better version of it is known (now divided Plates 13–15 between Granada and New York) most critics do not think it is by Rogier's own hand. Even so, the Berlin triptych is a good guide to what his style was. These words can be said, more faintly, of the Edelheer altarpiece, which is mostly derived from the Prado picture; here the quality is much down. The portrait of Charles the Bold has already been enough commented on.

It was useful to stress variations of quality in these pictures, in my opinion the ones that form the basis of attribution to Rogier. It should also be stressed that any variations of style in them seem by no means so great as to make difficult their association—whether as autograph originals, as works of collaboration, as studio pieces, or else as school pieces or copies—with the gross product of one painter.

One painter: the next hurdle is whether there *was* more than one prominent painter Rogier in Flanders in the fifteenth century. There indeed existed, as I have noted, Rogier of Tournai, who lived much at Brussels. Molanus, we have seen, refers to Roger of Louvain. Carel van Mander, the historian of earlier Flemish and Dutch painters, gives in his book published in 1604 two separate biographies for Roger of Bruges and for

Rogier van der Weyden of Brussels. In Italy, by 1449 or soon after Ciriaco d'Ancona refers to Roger of Bruges who worked at Brussels. More recent historians, struggling to bring order into their account of fifteenth-century Netherlandish painting, not surprisingly went to and fro for decades. Still: it is not difficult to suppose that traditions had become confused, confusion no doubt being aided by the existence of pictures in different towns, even by commissions that may have been given to Rogier when on a visit to these towns, or payments made there; by feebleness in many of Rogier's followers; by the strong movement in taste away from fifteenth-century style. In Italian tradition, 'Roger of Bruges' might merely have followed on from Jan van Eyck of Bruges. It is indeed true that a great-grandson of Rogier van der Weyden bore the same names; but there is no reason to think him a famous painter, or a painter of fifteenth-century style. The evidence for more than one famous Rogier must be considered very weak; indeed, some contemporary or very old references indicate or imply that the writers felt no need to specify the Rogier they were referring to. Most critics accept the great Rogier's uniqueness, and I do not care to squander words; in the present book too, Rogier is presumed unique.

A more complicated problem comes next.

Plates 124–32 Some pictures at Frankfurt (*The Virgin and Child, St. Veronica, The Trinity*) became labelled as by the Master of Flémalle (they were wrongly supposed to come from an abbey at Flémalle). A small triptych in the Cloisters
Plates 141–3 at New York was in the collection of the Comtesse de Merode; so, by the Master of Merode. They were grouped together; so it was considered equivalent, for these and for other pictures stylistically associated, to say *Master of Flémalle* or *Master of Merode*. The associations are of course purely stylistic. Some particular pictures may seem to me not to fit in, or may suggest a collaboration, but that does not mean that I think the group a mis-birth; merely that a constituent of it may have been wrongly attached, or that its place in the group deserves a restricting definition.

There have been great struggles in the nineteenth and twentieth centuries—struggles already touched on—to bring sense into the history of early Netherlandish painting. Before, it had been much neglected by connoisseurs; documentation for it, despite much diligent search, still remains scanty. So it is not surprising that an error of judgement had a long life: stylistic connections between the Master of Flémalle/Merode and Rogier (not so satisfactorily defined now—then less so, with fewer pictures known, with more variation of opinion current) led critics to imagine the anonymous painter as a pupil of the painter they tended to refer to as the elder Rogier. But in time the works assigned to the anonymous painter were recognized stylistically as being early in the School; and this caused a proposal that he was Rogier's master. An alternative proposal has also been made, that these works are youthful works by Rogier himself.

Either of the two proposals might accord with an acceptable dating: although there may be some reason for wishing to place certain pictures of the group rather too early in time for Rogier's authorship to be credible. I shall come further on to stylistic comment on some of these works, following after comment on some of those I accept as Rogier's; but I here record my stubborn reluctance to believe that most of the group Flémalle/Merode can be by Rogier, painter of the Prado and Escorial pictures and a good many others stylistically associable with them. I think that on this view there would have been a psychological upheaval in Rogier. No attempt at analysis of that just yet; but it may be repeated (with added strength) that certain of the pictures

assigned to one or to the other are close to each other in style, and that this is one reason, often *the* reason, for expressed wishes to amalgamate Flémalle/Merode and Rogier.

But fifteenth-century Netherlandish painters did sometimes paint closely in one style. And this is likely to occur particularly for master and pupil.

Certain pictures, assigned reasonably or not to one group or to the other, do indeed form stylistic links between the two groups. But one should have this in mind: the power for a trained and talented individual to make attributions of pictures on stylistic grounds is very great—much greater than the power to attribute, on stylistic grounds alone, poetry to its author. Yet the power thus embodied, so great for pictures, is not unlimited; it goes far, but it cannot always be relied on, even for good pictures, even for bare attribution without refinements of dating or extent of studio intervention. One may wonder whether certain disputed matters concerning works of eminent merit (e.g. Masaccio–Masolino, Giorgione–Titian) have been resolved through the close attention given to them over a long time by talented critics.

In this very problem of ours, the *Deposition* now in the Prado and a picture at Frankfurt not yet mentioned, Plates 1–9 a fragment showing the Bad Thief on his cross, are paintings of the top class in the Netherlandish or any other Plates 135–8 school of painting. Further on, I shall make some detailed comments on them. It is for the general consideration being given now that I record:—Friedländer, first of writers on this School, in later life tended to believe in amalgamating Flémalle/Merode with Rogier. Then he wrote that if the two pictures had been on view in the same place, instead of one at Frankfurt and one far away in Spain, it would not have been possible to construct the personality of Flémalle/Merode, or at least not in the way it was done; the stylistic agreement between the two pictures, he wrote, is so great that we must assume not only identity of authorship, but approximately the same date. Panofsky, second of writers on this School, some years later wrote that comparison of the two pictures proves the non-identity of the two painters, adding some penetrating comments in support of his view.

The above remarks were needed before I introduced the historical evidence of who Rogier's master was. But the idea that Rogier had Flémalle/Merode as his master is not just that Rogier must have had a master. Some facts are known. Alas, these too are troublesome.

I state that *the* master of Rogier (though possibly not his first master) was Robert Campin of Tournai. This painter was born probably ca. 1375–9. He was prominent at Tournai. He had a partly stormy life, in stormy times. He died in 1444. No documentation is known that associates with him any pictures in the grouping Flémalle/Merode.

Campin's relationship (in life) to Rogier is confusingly recorded, and must be considered at some length.

The earliest known register of the painters' guild at Tournai, a document starting from 1423–4 although demonstrably written (no doubt with the use of contemporary records) about 1482 or soon after, includes the following entries here summarized:

(a) Rogelet de la Pasture (which is a French form of van der Weyden), of Tournai, began his apprenticeship on 5 March 1427 (1426 old style). His master was master Robert Campin, painter. Rogelet duly completed his apprenticeship with his master.

(b) Master Rogier de le Pasture, of Tournai, was received into the painters' guild on 1 August 1432.

Some general remarks concerning these two entries may be made straightaway. No case has been made for disputing the dates. According to the best authority (Paul Rolland), it is not a difficulty that the famous Rogier, born in 1399 or 1400, would have been in his early manhood on becoming an apprentice in 1427; nor does the appellation 'little Rogier' have any significance other than his being an apprentice; nor is it odd that he remained an apprentice for longer than the statutory four years—this happened quite often. The guild system at Tournai meant that apprenticeship was the way to acquire the right to work individually. An apprentice could well start with knowledge of how to paint, already taught or largely taught to him. His painting during his apprenticeship might or might not be in collaboration with his master or with other apprentices; in any case such work would have been sold from the shop as work of the master. Only after being received as a master himself (which involved the production of a work for the purpose) would the ex-apprentice be free to accept commissions in his own name.

Such apprenticeship is indeed different from attending an art school now. Yet the above comments would hardly have let doubts on the applicability of the two documents remain among people with knowledge of social history at the time and place; at least would not have led serious critics to radical disputation; if a third document, also of Tournai but from another source, had not made some people think that the Rogier who was apprentice in 1427 and master in 1432 could not be identical with the famous painter to whom eminent pictures are now attributed.

This denial of identity is indeed difficult to sustain. The famous Rogier's membership of the guild of St. Luke at Tournai is clearly indicated by the guild's associating itself with a memorial service for him after his death in 1464. But if he was a member of the guild at Tournai, why think he became so, not according to the records of apprenticeship and mastership in 1427 and 1432, but at some other, presumably earlier, unrecorded time?

After which, I come to the document from another source that has given rise to dispute. On 17 November 1426, the town of Tournai made a present of wine, as was done from time to time to people deemed suitable, to *maistre Rogier de le Pasture*. How, it is asked, could such an official recognition have been given to a man who in the following year entered Campin's studio as an apprentice? Perhaps it couldn't. Some efforts have been made to show it might have, but they seem tinged with special pleading. The most reasonable explanation of the facts known is that this present of wine from the town was to a Rogier van der Weyden other than the famous painter; the recipient is not described as a painter. If this explanation is accepted, the famous painter Rogier's apprenticeship with Campin from 1427 to 1432 becomes for me unworthy of any doubt.

These words towards interpretation of puzzling records were desirable before I brought in different evidence, which strongly confirms that the famous painter Rogier was apprenticed to Campin. It further suggests that some existing pictures are by Campin; for it is also evidence that Campin did paint like, or at least somewhat like, Rogier.

Jean du Clercq, abbot of Saint-Vaast at Arras, commissioned an altarpiece for the chapel of Our Lady there. The paintings on it were by Jacques Daret, and included the shutters; this is known from an account-book of various works commissioned over many years by the abbot for the abbey. Another document establishes that in 1435 the altarpiece had been set up recently. A commentary on the latter document, published in 1651, includes a description of this altarpiece, with description of the painted shutters. This is detailed enough to

establish without any doubt the identity of these painted shutters with four existing pictures, *The Visitation* (including the kneeling abbot, identifiable from his coat of arms) and *The Adoration of the Kings* at Berlin (Dahlem), *The Nativity* in the Schloss Rohoncz Collection at Lugano and *The Presentation in the Temple* in the Petit Palais at Paris. Plates 166–9

It would stretch credulity too far to suppose that the Jacques Daret who painted these pictures is other than a Jacques Daret who is recorded at Tournai, apparently as a pupil of Robert Campin from 1418, and who was apprenticed to him from 1428 until 1432. It should be noticed that Daret—who was born, it seems, in 1400 or soon after—would seem to have studied painting under Campin only.

The value of these four pictures for our purpose is that they manifestly show stylistic and compositional similarities to those assigned to Flémalle/Merode, and (a little less) to those assigned to Rogier. Let the reader turn over the plates here, at this stage merely noting that associations with Campin and Rogier are in the captions; and particularly look at the reproductions of Daret's *Nativity* and the *Nativity* at Dijon assigned to Campin, at Daret's *Visitation* and the two pictures of that subject at Leipzig and Turin assigned to Rogier. Plates 167, 155, 166, 20, 70

The date of completion of Daret's pictures, 1435, is rather near the time of Daret's apprenticeship to Campin, and of the apprenticeship of 'Rogier de la Pasture'. It is, further, an early date in the history of the early Netherlandish School of painting as normally considered. The naturalistic style apparent in Daret's pictures was still a new thing in 1435: which links them even more closely to Flémalle/Merode and to Rogier, since one may suppose that this attitude to Nature had not yet overwhelmingly spread. The pedestrian quality of Daret's pictures strengthens further the clear impression that, to paint them thus, he was in close contact with a milieu that was creative of the new style.

Daret does seem to have been just a little younger than Rogier, which may have deepened in him respect for a brilliant co-apprentice. One may fancy that Rogier, when working in Campin's studio, was to some degree running the studio. Yet I do not think it worth while labouring to cut out Campin, or seeking to interpret what we know or have, otherwise than in the natural way: that Daret took what he could for his style of painting from his master Campin (and from his co-apprentice).

I should not care to avoid the conclusion that Campin was a painter of this style.

There is, further, no reason to suppose that Campin painted badly. The contrary is likely; what records we have indicate a prominent (though as it happened stormy) career.

It should here be stressed that, for the early Netherlandish School, contemporary or near contemporary remarks about a painter or his pictures, or suggesting his or their importance, are rare and haphazard. Such remarks for some painters are indeed known; for Campin himself rather little, for his pictures none. I refuse to deduce that Campin's paintings were insignificant.

Unsatisfactory though (or because) the state of knowledge is, it was essential to enquire at some length into the above questions of definition, which indeed concern a major section of European painting. True, the first-class pictures—most of which have not yet even been mentioned, none yet stopped over—are the aim and justification; yet consideration of the pictures, with hopeful attribution or dating, must not be indulged in previously to the basic definitions.

This may be taken as an objection to relying on simple vision alone of the pictures, which leads me to a different objection to doing that.

This time it is at least directly concerned with what is seen in a picture credited to Rogier: but in reference to that picture's content. Painters at different times have been told to do, and/or have done many things. The subject, and their treatment of it imposed or chosen, should be attended to for our appreciation. So let us

Plates 26-33 consider from that point of view the Bladelin altarpiece at Berlin, which I call (without now seeking at all to justify the statement) a mature work by Rogier.

It shows itself immediately as a fine thing. Some enquiry into what Rogier was there representing is our present interest; that indeed does not form an enquiry into Rogier's pictorial merits, yet something connected with these may come in.

It is perhaps not evident that the central panel, showing *The Nativity*, needs interpreting much. The anachronism of introducing a donor into the scene is, indeed, so frequent as not to need excusing. Yet why is St. Joseph holding a lighted candle? At one time it was thought that this indicated symbolically that the event takes place at night; maybe there is some truth in that. Yet the Nativity had earlier been depicted as a scene at night; and if one limited oneself to this explanation, one might need to claim that realistic painters of the Netherlands objected to painting a darkness that hides the material details they wanted to record, and so resorted to a symbol meant to carry the spectator from what he does see to what he should imagine. The main explanation of St. Joseph's candle here is not acceptable as being this, and is to be found in a widely known writing, the *Visions of St. Bridget*. St. Bridget indeed in her text introduces St. Joseph's candle with a meaning that is not apparent in this picture. According to her, St. Joseph at the time had brought a lighted candle, but the material light was as nothing as soon as Christ was born, the celestial radiance from Him being overpowering. Yet Rogier's not telling in his picture what St. Bridget tells does not exclude that St. Bridget is the source of his candle, since painters (or their advisers) often cut things down, and other pictures of the time do exist more explicitly following St. Bridget.

Plate 31 Then what of the prominent column here supporting the ruined stable? Shed it more humbly should be. Granted there is here some strong stone construction in it; but that does not explain the prominence given to the column. One can easily believe that this is derived from a book perhaps even more popular than the *Visions of St. Bridget*, the *Meditations* wrongly ascribed to St. Bonaventura. It is stated in that work that the Virgin when about to give birth at Bethlehem leant faintly against a column that was there. So, a column is shown very frequently in the Nativities of early Netherlandish painting; e.g. in one of its triumphs, by van der Goes, in the Uffizi at Florence.

Romanesque (instead of Gothic) architectural elements in the rest of the 'shed' are believed partly to indicate the Old Law, destined to be replaced at the Birth of Christ; the Romanesque style, remote from current building, was also used to suggest oriental location of a scene.

Two holes in the ground, one grated, either or both seen in many early Netherlandish Nativities, may be there to suggest that below is the cave in which according to tradition the Birth took place at Bethlehem.

The ox and the ass at the scene might seem self-explanatory; yet they are not recorded in the Gospels. True, they entered into the education of Christians very soon; and their presence at the Nativity was justified in particular by a prophecy of Isaiah, i, 3, *The ox knoweth his owner, and the ass his master's crib*. Some distinction is there made between the two animals, favouring the ox. So the inferior ass came to be associated with recalcitrant Jewry; and is sometimes shown in works of art, presumably in reflection of current opinion, as un-

worthy of its privilege of being there. Here this is hardly touched on; and yet it is clear from the representation that the ass is behind the ox in importance—two long ears, a muzzle, a line of back and one hoof are all the ass gets.

The right wing of the Bladelin triptych is easily seen to show the three Kings about to set out on their Plates 28, 30 journey to Bethlehem. One of them is negroid, according to tradition (the three Kings became considered as representatives of the three continents, Europe, Asia, Africa); but the tradition of precisely a Negro king was not very old at the time of this triptych.

Then why is the star they are to follow shown in the form of a Child? I daresay this could be thought done to make clear the story; and yet Rogier did not invent it. *The Golden Legend* was one of the very most popular books of the time; it is stated in a chapter on the Nativity there that the Kings saw the star in the form of a beautiful Infant.

The left wing shows the vision of Augustus, Emperor of Rome, on the Capitol. This is to humanity from Plates 27, 29 the West a manifestation of the Birth of Christ—what is shown in the central panel here—additional to the homage of the Kings from the East. Augustus was to be worshipped as a god. One of the Sibyls directed him to a vision of a most beautiful Virgin holding a Child. Here, the Sibyl explained, was the true God. Here was the altar of heaven, *ara caeli*; and on the spot of this vision now stands in Rome the church of S. Maria in Araceli. The story, precisely linked to the Birth of Christ, is recorded in many books, including again *The Golden Legend*; it is perhaps only there that Augustus is stated to have offered incense to the Virgin and the Child he saw, as he does in Rogier's painting.

It may be Rogier's own invention (we shall see he was an inventor) that, for his illustration of the story, the Virgin with the Child is depicted upon a visible altar in the sky.

I do not attempt in this book to comment in full detail upon the iconography of Rogier's pictures, which is partly carried on from earlier tradition; for one thing, explanations may elude us now. Yet the remarks just made show that some enquiry into what a painter chose to paint or was set to paint is of use to us for our understanding, for our appreciation, supplementary to our merely looking at the pictures. We shall see that the subject of a *Lamentation* at Florence is relevant to its dating.

These comments on the Bladelin altarpiece, as I suggested, concern the literary basis of the triptych rather than its artistic merit. Everything that has been mentioned could appear in a bad picture. All the same, consideration of things that may seem or ought to seem odd to us is good; for any method of seriously directing the attention to works of art is to be esteemed.

It may be added that a chapter of Panofsky's book on Early Netherlandish Painting is entitled 'Reality and Symbol'; symbol or references with some symbolical content were considered, one may think, increasingly important as the taste for realism was developing, lest religion should be too much lost from a picture. It may well be that Jan van Eyck at this time was the prince of symbolism more or less hidden; but Rogier and others were much involved with it.

It is here to be remarked that the tangles and oddities I have been touching on did not assist recognition of Rogier's status, which is that of leader in the fifteenth century in the north. Recognition of his *best* quality (and Rogier must have run an extensive studio, apart more loosely from his followers) was impeded by the difficulty of finding bases to start from, valuable information concerning which was discovered bit by bit; and even

difficulties in understanding the iconography may have made the best quality less apparent. One should be grateful to many scholars who over many decades have helped the return to light of Rogier; more light may remain to be thrown, and views may thereby be changed.

Even in a simple introduction to Rogier such as this, it was desirable to outline some matters concerning him that anyone seeking enjoyment seriously ought to take into account. At last it is time to pay attention more to the pictures themselves. The main service this book can give for them is, as I said, from the plates, which include a number of details taken expressly for it. There are no photographs taken under infra-red light, nor are there X-radiographs, both of which may reveal much of interest that the human eye cannot by itself see, but are outside the scope of this book. The plates here are photographs taken under ordinary light; so used, the camera records (with variations of emphasis) what the human eye can by and large see. These plates should encourage people to go and see the originals, the *best* of the originals, again, or for the first time.

It is also true that photographic reproductions have shortcomings. In particular, it may be claimed that even a large collection of details of a picture does not add up to the picture; the matter is only partly rectified by a reproduction of the whole also. Yet it is fair to comment that the painter himself, although having in mind more clearly than we can the picture he was aiming for, worked at any particular time on a detail; the detailed photograph is normally no clue to how the picture grew, yet it can be said to correspond partly with what the painter himself at some moment of his work was seeing and working on.

The photographs might have been left to say for themselves what they can say. But some commentary on Rogier's achievements, here and there supported from the photographs, will be written out. Some pictures only will be touched on in this commentary; a good many authentic ones, some excellent, will not. Nor will the comments be aimed, by any means, at all that the pictures are thought to contain.

After what I have been writing on Campin, readers should not be surprised that consideration of pictures usually assigned to him is postponed. My comment on Rogier's achievements can properly begin, not with those works although they are admitted to be for the most part early in time, but with the group of works that is generally accepted as Rogier's. True, this leaves undefined how far Rogier was original by painting in a style other than that prevalent when he was beginning to grow up. The question is of some importance; it may partly answer itself when pictures assigned to Campin come to be considered. Now, I point out that invention of a style of painting is no direct indication of a painter's achievements in that style. It might sound fine to say that Rogier led the way, or took a principal part in leading the way, for Netherlandish painting to go against the international Gothic trend, adopting the realism we look on as characteristic of the fifteenth-century painters there. But this would affect our estimate of Rogier's place in the history of art-trends; it should not much affect our estimate of what he did well in his pictures—although indeed doing well implies in some degree being influential, and that also is for the history of art-trends!

There will be references soon to Rogier as an innovator, in particular to his inventing certain motifs in pictures; but that is invention of a kind other than breaking through to a new concept of what pictures should do.

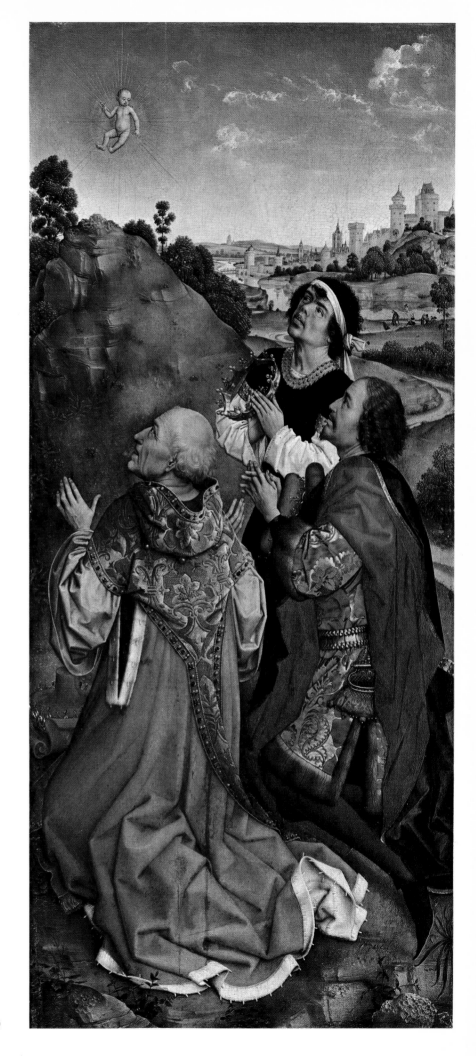

The Star of Bethlehem appearing to the Magi.
Right wing of the Altarpiece of Pierre Bladelin.
Berlin-Dahlem, Staatliche Museen (Cat. Rogier, Berlin 4)

So, let us respectfully try to approach some works not normally disputed as being Rogier's. For this—now—we may keep well back within our minds the difficulty of making any attribution to him. It is further fortunate that, for our approach to his pictures, we just go to see them in whatever place they are, as best we can. The touristic charm of Bruges slanted appreciation of Memlinc in the nineteenth century, making appraisal of his work less easy; but Rogier's pictures, for the most part, are not much aided or impeded in that way by their location.

Also fortunately, it is licit to begin with the picture that is first as a basis for attribution: the Escorial *Deposi-* Plates 1–9
tion now shown at the Prado in Madrid. Fortunately: for this is not only for eminent quality, but also rather early—as has been noted, the Edelheer altarpiece clearly derived from it is dated 1443.

One short attempt at defining is needed first. Variations from this picture, or parts of it, occur during the fifteenth century and the following century. Rogier may have made several designs, of which this *Deposition* would be one, not necessarily the earliest. Yet there can well accrete from a painter, from his pupils, or from others, variations of a key design; one need not fight against the impression seriously conveyed, that Rogier's complete statement on the theme is the picture at Madrid. And *it* was famous in the sixteenth century (there is paucity of written information from the fifteenth century!); leaving an altar at Louvain to please the Regent of the Netherlands, Mary of Hungary, and then going to her nephew, King Philip II of Spain; arriving famous and staying so for decades. I treat it without more ado as *the* picture; and itself not later than 1443.

It is fairly large, the figures approximately of life size. This may be the first thing to strike some people; so many fifteenth-century Netherlandish pictures they may be familiar with are small. No large one is in the National Gallery in London, remarkable as that collection is.

The subject is Christ being let down from the Cross, one incident of Christ's story: incident, since in Christian belief it is the Resurrection that is important, and before that Christ's death upon the Cross. Yet this is not the sole altarpiece of the fifteenth century with the *Deposition* as main subject (Fra Angelico's picture in Florence may come at once to mind); there was at that time a pervasive bent to pathos, in which this subject is steeped, nor is the ensuing stress here on tragedy at all against firm faith in the painter or anyone concerned. That Rogier was a pious Christian we have some historical evidence to show; and it could be deduced surely from this picture, although Rogier here has concentrated on human grief.

Christ is (temporarily) a corpse, sagging between supporting hands across the picture. His Mother faints.

Her attitude echoes that of Christ. This may stem partly from rigour in pictorial pattern; observe (as an example) the two descending folds of her dress across her body, running similarly left of her at the edge of St. John's dress over his left leg, right of her at the uprights of the ladder.

But, considered emotionally or intellectually, her attitude has been claimed to indicate her special relation to the redemption of man by Christ's death on the Cross. Yes; even so, her parallel Passion (to use a phrase of Emile Mâle) stems first from her special relation in being His Mother.

Heart-rending at the event is undergone also by the others present, most of whose faces are bedewed with Plate 2
tears; their attitudes, woven into the elaborate composition, have been seized on, might one say photographically caught, at the moment when these are significant for the emotion of themselves and of the scene.

Grief is intense, yet the representation is marked by restraint. The fifteenth-century Flemings are indeed

rather rarely violent or brutal, compared say with the North-Netherlanders or the Germans; in Geertgen's *Deposition* at Vienna the bad thief of Calvary is sludged into a hole.

The tragedy here is recorded by Rogier as a group of sculptures. The setting is a niche of gold, as if of mosaic, almost entirely plain; the retreating sides are flat, the tops rounded: with just a little tracery painted in front of it in the top corners, to decorate no doubt, yet especially to stress that we look into a space behind it. The fifteenth-century Flemings are well known for placing their scenes in a natural setting, often with much detail. Here, the one concession to this taste is soil with grass and plants and rocks; an earth upon which the Event does take place. That earth is shown joining at the back and right in wavy lines to the lower edge of the golden niche—artefact within which the sculptures are encased behind and above. Treatment comparable with this can be found in other pictures, but here the rigorous clarity with which Rogier carries it out strikes.

What here is most boldly not conceded to naturalism is the Cross itself. Its arms are truncated; such parts as remain of them wedge against the gold walls of the niche. Surely: the Cross did not have arms so short for Christ to be crucified on it. But now that He has been let down from it, a fragment fulfils the picture's purpose. Plate 9 The material of the Cross is indeed painted realistically, as everything else that has a place in the drama; yet the Cross because of its truncation can be called here a symbol rather than the Cross itself.

There is a wealth of observed detail, though not excessive, in the figures; controlled to show them as more real, participating in the solemn event.

Yet sculptural indeed is their arrangement, a brightly and harmoniously polychromed group. Sculptures were very often at the time coloured with painting; we have records of such work by Rogier himself. Primary intention of the design is to fit the figures in planes, at varying distances behind the picture surface, until we reach a rigid plane formed by the gold niche at the back; this is emphasized by its only decoration, a strong horizontal moulding crossing the picture at the height of several of the heads.

This basic idea is supported by the chief movement suggested in the picture. Christ's body is being carried towards the right, the Virgin has fallen towards the left; one might say that slowly, and parallel to the surface, the group is being pulled apart.

The treatment of spatial layers in front of a not very deep niche leads the painter, despite much vigorously third-dimensional modelling, to show the forms somewhat reduced in thickness. Indeed, seen near to, an extreme hardness of certain contours makes the depth appear even to be shallow.

These aims of solidity on the one hand and restriction of depth on the other have, I grant, not been worked on so that everything throughout is in place. For instance, the Virgin's left foot is back nearly at the Cross, behind which is a ladder; and this hardly accords with the position of the man holding a pot on the right, part of whose dress is in front of this ladder, part behind. Yet one has to cavil a good deal at this composition to find things in it that fail to convince; the whole hangs together, from an effort of pictorial construction and from concentration of thought, as well as from the concentration of feeling the scene brings.

A picture clearly based mostly on it, where the whole does not hang together, and which may penetratingly Fig. 5 make Rogier's achievement clear, is the *Deposition* in the Louvre by the Master of St. Bartholomew. This painter of Cologne (perhaps born *c.* 1440–50, perhaps died *c.* 1510–20) is far from despicable: a dominating characteristic of his being an acute, even contorted sensibility. The *Deposition* in the Louvre is a principal and impressive picture by him. He has ruined Rogier's.

Although Rogier's composition is made up of lines that are often sharply broken, the painter's interest in establishing his picture from their flow is unmistakable. One may claim that in this Rogier shows himself as expressing rather a Gothic spirit than the realistic mode as followed in Flanders in the fifteenth century. Using realistic forms, he controls them to make a pattern beautiful in itself, and apt for expressing the emotion the subject demands. Think of Jan van Eyck, how different; to that painter interest starts with the air around us, and its effects on what we see. An altarpiece of 1436 by him—not 'far from despicable', but masterly; all the same, a blown-up miniature, if one wants to be unkind—is at Bruges. It is an exquisite record of goldsmith's Fig. 6 work; also, the treatment of flesh there is just natural. Yet the parts are not successfully arranged for building up a whole design—should I say rather for transmitting a message; the structure of the picture, which is perfectly rendered in play of light, is of incoherent richness. As for the proper display of emotion, one may tend rather to find oneself repelled, particularly by the faces of the Virgin and of St. George; in that matter Rogier's rigorous rightness is away and beyond van Eyck, sharply inferior as Rogier may be to him in other ways.

The use of colours in Rogier's picture does not appear as that of a colourist, for whom colour helps to direct and may dominate the picture. Here we have a brightly polychromed group, statues with colours applied; the effect, to be sure, is harmoniously rich.

Several times I have written 'statues', but stress that use of the word is not to suggest exaggerated coldness. Friedländer says that more of the blood of life is felt to be flowing here than in other pictures assigned to Rogier. This may be so, and as we shall see, Rogier's nature tended over the years with increasing rigour towards the abstract. But compare him again with van Eyck. The outside of the shutters to the altarpiece in S. Bavo at Ghent includes figures of St. John the Baptist and St. John the Evangelist. These are representations of uncoloured sculpture. Part of the figure of St. John the Evangelist is reproduced here; it is apparent that Fig. 7 this statue is more atmospheric, even more like a figure of flesh than those Rogier painted in his *Deposition*, although those are not formally statues—and are coloured. But, as Friedländer remarked, Rogier never did paint flesh to look like flesh.

His great powers of draughtsmanship are used in this picture with the aim of beauty of line and areas created by lines, as detailed plates in this book largely make clear. He amuses himself with his mastery, here and there. One example is the fluttering ends of the servant's headpiece by the ladder. Not here, in this grave picture only Plate 9 symbolically in the open air, is Christ's loincloth loosely fluttering from the body— although, as we shall see, Rogier did this in Crucifixions conceived as in the open air or the wind, and was maybe the first to do it just so; but here in a subsidiary figure he gave his high fancy play. Yet in this picture most lines, beautiful as indeed they are, closely depend on recording or interpreting the subject. See, for instance, the pattern formed in blood from Christ's Wounds at Hands and Feet. Blood flowed thence when Christ was erect on the Cross; some Plate 8 blood still flows, the Nails having been taken even now from the flesh, now that His limbs are otherwise, and its marks run right-angled to the first streams. Hardly so from the Wound in His side; the flow of blood (and water) is less there. Nor from the less deep marks of the Crown of Thorns.

This picture makes it easy to credit that Rogier was the dominating painter of the north in the fifteenth century. A sentiment of pity, so much then in people's minds; clear presentation of forms easily recognized; strong and sincere piety; spirituality without strangeness; technical mastery.

In the middle of the sixteenth century a courtier's reference to it is unrivalled for naturalness and devoutness.

One should stress particularly Rogier's sensitivity in creating beautiful shapes or lines (this is not to claim perfect proportions in the architecture he represents!). For clarification by contrast, consider the work of Memlinc, a very good painter, who painted much in Rogier's style. It is patent that Memlinc's feeling for forms lacks Rogier's intelligence, delicacy and distinction. There is in the Prado an excellent Memlinc of *The* Fig. 8 *Adoration of the Kings* (clearly derived indeed from an altarpiece by Rogier at Munich); it hangs very near Rogier's *Deposition*. Memlinc's picture, I do think, shows feeling for serene space, expressed by a man of high skill. But, for beautiful shapes or lines made out of the constituents of a picture, Memlinc shows himself insensitive, indifferent, null. Let him be examined in another picture, in a detail simple enough for him to grope towards showing some interest; a detail of costume where enrichment was desired. In Rogier's *Deposi-* Fig. 18 *tion*, the servant supporting Christ's body from above has at his shoulder some decorative tags. In Memlinc's *Deposition* in the Royal Chapel at Granada (one of his best works, in my view) there is a corresponding figure, Fig. 19 with similar decoration at the shoulder; one may even fancy that Memlinc was imitating Rogier's picture. Certainly, disposition of the tags is no occasion for subtle effects, shapes made by the intervals of draperies or limbs, as one finds again and again in Rogier, and as some detail plates in this book illustrate; there is just a direct wish to make a detail agreeably. Memlinc has done quite well. Yet comparison with Rogier shows how pedestrian is Memlinc's work.

Comparison on another level may be made with another painter of the time; greater than Memlinc. I began by referring to the large scale of the *Deposition*, saying that many fifteenth-century Netherlandish pictures are small; but Hugo van der Goes painted some large, famous pictures. These powerful works (one at Florence has already been referred to) rightly excite enthusiasm. They too are works of high imagination; yet, compared with Rogier's *Deposition* they seem to me to have a lower aim, of illustrational character.

No picture by Rogier is more fitting than the *Deposition* for opening comment on his emotional, intellectual, religious achievements.

Plate 75 Closely to be associated with it for quality, though clearly later in date, is the *S. Ivo* (?), recently discovered and acquired by the National Gallery. This picture also is one of those by Rogier to be prized by people sensitive to his penetrating concepts and his skill. It most probably does represent S. Ivo, the Poor Man's lawyer, charitably intent on a petition addressed to him. Rogier was gifted in imaginative understanding; not for him an anecdotal treatment, with the picturesque poor besieging a figure merely deduced to be saintly. His treatment is so simply natural that it may surprise. Great artists do or should surprise: though often we are so familiar with their creations that we do not see any more at all, unless with diligent effort.

Writing of some significant pictures by Rogier, I pass on to two triptychs, each showing three scenes of the same size framed in arches. One has been divided up. Two of the panels, truncated, showing the *Nativity* and Plates 13-15 the *Lamentation*, are in the Royal Chapel at Granada; the third, complete, showing *Christ appearing to His* Fig. 4 *Mother*, is in the Metropolitan Museum at New York. The already mentioned Miraflores altarpiece at Berlin (Dahlem) is a very close version of this triptych; a little inferior in quality, yet occasionally also ascribed to Plates 58-60 Rogier himself in part. The second of the triptychs shows scenes from the life of St. John the Baptist; it also is at Berlin (Dahlem).

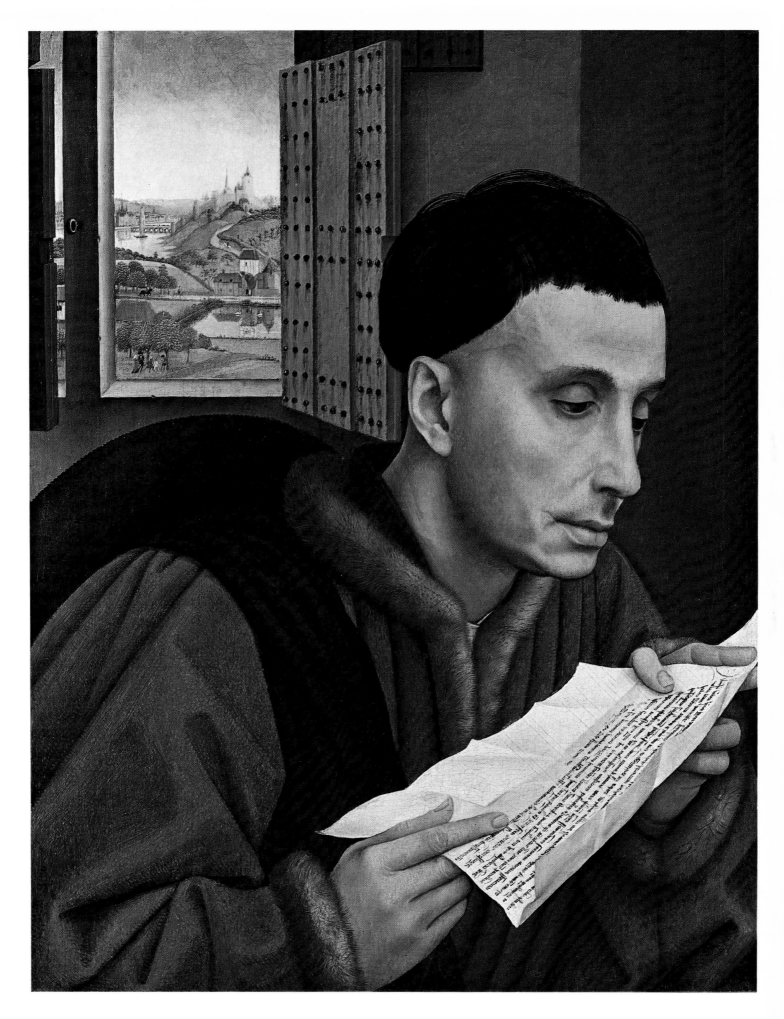

St. Ivo (?). London, National Gallery (Cat. Rogier, London 5)

Although dates for Rogier's pictures are distressingly few and vague, it is possible that both these triptychs are later than the Prado *Deposition*, with which my comments on Rogier's formed or nearly formed style began. That, it will be recalled, is not later than 1443. It will further be recalled that a date of not later than 1445 does attach to the triptych of the Virgin; in that year King John II of Castile gave a version of it (presumed to be the version now at Berlin) to the monastery of Miraflores.

Whatever its date, Panofsky has made it clear from his analysis of the pictures that the triptych of St. John succeeded it. His demonstration need not be gone over in detail. It is sufficient to remark that the scenes of the triptych of the Virgin are set under round arches, those of the St. John triptych under pointed arches; there seems no symbolical usage here, so this is one argument for dating the triptych of St. John later, to which can be added other matters brought out by Panofsky—though perhaps with too precise a claim for the date itself.

What strikes one first about these two pictures is the use of the arches for separating and giving space to the scenes without disrupting unity. Certainly arches had been used before by other Netherlandish painters, but nothing just like this is known to have preceded. So here probably is a case where Rogier was an innovator.

The arches (round or pointed), being produced at a time when a developed Gothic taste was prevalent, are ornamented with sculptures of small scenes. These are related to the subjects of the main pictures below, and this allows the painter to concentrate on main aspects of the principal scenes; more markedly indeed in the triptych of the Virgin—in the other he amused himself with complications. Approximations to this use of small sculptured scenes are found elsewhere in pictures assigned to Rogier (apparently earlier), to Campin and others; yet here it seems for the first time there is subordination of display.

The arches also help the painter in indicating recession. The third dimension, as could be expected from the painter of the *Deposition* in the Prado, is given by linear more than by aerial perspective.

In the triptych of the Virgin the main actors are given positions across the picture, similar on the whole to what we saw in the *Deposition*: though the depth, stretching some way behind them, in two of the sections far back, is a naturalistic setting diverse from the golden niche there.

The central panel of this triptych (the *Pietà*), the most important for its position and for its subject, is varied from the others in that the group there comes further forward in front of the framing arch. Plate 14

The treatment of the scenes in the triptych of St. John would by itself show that that picture is more Plates 58–60
mature. The figures are now, some of them, well forward of their arches; the painter is enjoying his skill in treating these arches, not simply as doors through which the scenes are observed, but for more elaborately constructing the recession. The architecture suggests a wall parallel to the picture surface, in front of which the main actors gain relief and prominence from being in front, and behind which the subjects or some elaborations of them continue, stretching backwards in their place. In the other triptych, the arches seem primarily to be there for the simplification and clarity of the stories told; but here the painter embroiders on the earlier concept, without losing its benefit. Panofsky published ground plans of the quite complicated interiors shown in the two side panels; quite complicated, yet Rogier convinces us with his high skill in perspective aided by controlled lighting that all is neatly in order.

The comments so far on these two triptychs have been somewhat different from those on the *Deposition* in the Prado. There one might be blinded to almost anything except sorrow, expressed with a taste and strength that do not falter; with beauty in every gesture, every line, every shape. It is well therefore to add that the

triptychs, in a less heroic way, manifest the same powers of properly expressing sentiment with formal beauty. I mention here the Christ in the *Baptism*, hardly more than a boy; the beauty of His youthful curls does not (as with lesser painters it could) interfere with our intense feeling that an important event is taking place. There is a good, old version of this triptych at Frankfurt; all sentiment has gone from that.

Plates 22–5 In trying to suggest Rogier's great talents, I reach a picture at Vienna representing the Crucifixion. It may well be rather earlier than the triptych of St. John. It also is a triptych, but of more usual form; not three panels of the same size, but a central panel with narrower side panels; which usually, but perhaps not in this example, could be folded over the central one. These folding triptychs were indeed employed for illustrating more than one subject, though I think less happily than Rogier's arrangement in his triptychs of the Virgin and of St. John; in the picture at Vienna there is only one subject. Christ crucified is depicted on the middle panel; on the wings the Magdalen and St. Veronica are present. Mourning angels in all three sections and a continuing landscape serve the unity of the scene. Such unification may seem to us now usual enough; yet here Rogier, even if he did not invent, at least perfected.

Unity in the single subject is stressed; but it is remarked that, as in the triptychs previously recorded, the three parts were conceived as seen within framing. Here it is not architectural framework, it is gold surrounds applied flat but with modelling represented, to show as frames in front; only a little is preserved for the central compartment. The single scene was thus visible as if through three windows: windows on a world where Christian mysteries take place. The way this is done seems to be at least unusual.

Grief is less passionate than in the *Deposition*. It is most in the figure of the Virgin Mary: a lady; not young; her face pulled with grief, but not distorted to ugliness.

In the central panel there are further things to record; though two of these also did not remain or become a tradition in painting. One is placing the donors (who are on the same scale as the other figures) immediately under the Cross, separated from it only by a cleft in the ground, and not (as became usual in Netherlandish painting) showing them respectfully on the wings, respectfully presented by their patron saints. The close association of the donors with the Event was, I think, for its piety much to Rogier's taste. I repeat that the event is the *Crucifixion*, since a donor praying directly to the Virgin and Child (there to be prayed to) is a different thing.

A second matter, also of strong religious sentiment, and perhaps invented by Rogier, is that the sorrowing Virgin kneels embracing the Cross. This place and action is usually for the Magdalen; traditionally in pictures the Virgin falls fainting, or is supported from falling by St. John. True, the motif of the Vienna picture occurs in a *Crucifixion* at Berlin, ascribed to Campin; but I do not think that picture earlier.

It is some evidence that Rogier was an inventor if he used motifs that were not followed. It would, nevertheless, be sad for us if we confined ourselves mostly to matters of technical skill, however brilliant, or of iconography, however interesting. So it is well to call attention to the loincloth of Christ here, loose and beautifully fluttering here as we noticed it did not in the *Deposition* at Madrid, one reason there being that the concept is of statuary not so directly subject to the breezes of the open air as here. The painter in this motif again demonstrates his command of a feeling for beauty. He may, also, have invented or at least developed it as it is shown here; it was destined to popularity.

Returning to the donors, I remark that Rogier placed them in his pictures with a liberty not often taken by succeeding painters. This freedom is exemplified also in a composition of the *Pietà*, known in various versions: seemingly based with variations on the composition in the Granada-Berlin triptychs, it was perhaps (unlike the triptych at Vienna, one may think) a design held in stock for commissions. Changes could be made to the taste of the clients wanting pictures. In two examples of one variant, at Berlin (Dahlem) and in the Prado, the donor is indeed associated with the great subject, yet is separated from the principal Actors by the lie of the ground. In a variant in London, which I consider to have been executed by Rogier himself, this position Plate 72 is taken by a Dominican saint; and the donor, introduced by his patron St. Jerome, is placed to be directly associated with the Christian theme.

The Last Judgement in the Hôtel-Dieu at Beaune is a very large picture (total width, 550 cm.): but not large Plates 34–48 for its destined chapel. The hospital was founded by Nicolas Rolin, whose portrait appears on what was the exterior of a shutter, in 1443; the picture was presumably painted for it fairly soon after. It should be mentioned that the chapel there was consecrated in 1451; and the dedication of the hospital was changed from St. Anthony to St. John the Baptist in 1452, it being St. Anthony who appears seemingly as a patron on this altarpiece.

The main picture, even though divided into nine compartments (presumably for convenience of transport, in particular), is remarkable in its coherent structure; such coherence was a notable achievement in very large Netherlandish painting at the time. Once again, van Eyck comes up for comparison. Whatever circumstances may have caused the painting of the altarpiece in Ghent—there may have been Jan's brother Hubert involved; possibly it was adapted from some previous, distinct commission—its general effect, both the inside with Fig. 10 shutters open and the outside with shutters closed, is confused. Rogier, whose clear and rigid mind we have already been attending to, controls the scene of the Last Judgement, spread out on a grand scale. Fig. 11

It may in particular be noticed that the figures are not all of a size; this hierarchical concept is found elsewhere at the time. It contrasts with the naturalistic way in which the figures individually are painted.

It is not a violent scene; rather a rite, conducted by the priestly figure of St. Michael, who stands. No devils are seen to help torture many damned. Paradise (for the moment) is empty of resurrecting elect.

One may notice as characteristic of Rogier, not a colourist, that the flames of hell do not tinge the flesh of the damned.

Rogier went to Rome in the Holy Year, 1450. This is recorded by the Italian Fazio, writing in 1456, and should be believed. Fazio writes as if he knew Rogier personally, and some of his pictures; he records that Rogier greatly admired frescoes by Gentile da Fabriano in the Lateran at Rome. These have been destroyed, and hints about them that have been picked up by art-historians give no clue to what Rogier found to admire.

But we do know something of Gentile da Fabriano's style. He is believed to have been born about 1370; he died in 1427, and the Lateran frescoes were very late work. Nearly as late, from 1423, is a celebrated picture of *The Adoration of the Kings* in the Uffizi at Florence. The style of that picture is mainly Gothic, even Venetian Gothic. True, perspective is used in the predella in a way suggestive of the progressive Italians of the fifteenth century, who were just beginning to operate; yet the style of the picture is soft Gothic in its forms—as Rogier's (admittedly later) pictures are not—even though in spirit he can be strikingly Gothic.

It may be of significance in defining Rogier's work that Gentile da Fabriano is the painter mentioned as having been admired by him; not other painters (whether or not he did admire them, but Fazio did not know or did not care to say), who are much more significant in the development of the Renaissance in Italy. Rogier recorded with eminent skill the surrounding world seen by the new vision of the north: in form indeed rather than in lighting or atmosphere. But his tendency is to make these subserve the emotion arising from the subject—a character rather of International Gothic than of the developing Netherlandish naturalism. Masaccio's abrupt reaction to what he saw, tempered as it was with a sense of the Antique latent among Italians, could hardly touch on Rogier's aims. And Rogier was surely strong enough to resist what he may have seen of Italian art if he did not care for it, if he thought it useless for his own art.

It is noticeable that at about this time for some decades (and aside from painters who transferred their domicile) there seems to have been more influence from Flanders to Italy than the other way about on the taste of collectors and on the artists. Something of this is due, as has been repeated so often and from so early a date, to the oil technique of the north: to the feeling that, whatever else of estimable a picture may contain, this technique and its visual effects are precious. Yet it does also seem that in the fifteenth century Netherlandish painters found little for their own art in the triumphant, partly pagan progress of the Renaissance in Italian painting. They did nicely undisturbed. The sixteenth-century northern painters knew this less well (the patrons' taste too was altering), and yielded to the lure of the Renaissance and so of the Antique; their responses on the whole are classable as unfortunate, revealing an ill-digested acceptance of non-Netherlandish forms—hardly an assimilation of new life-matter.

What has been said above can be illustrated in Rogier's own case, with high probability that it applies, by an existing picture. We do not know how for the jubilee of 1450 Rogier travelled to and from Rome. We do not know how long he stayed (hardly very long). We do not know if he made other journeys to Italy; but commissions he is known to have received from the Ferrarese court need not imply that he visited Ferrara, and he is unlikely to have been dragged corporeally from court to court like Rubens, for instance. In any case, it is not extravagant to suppose that on his way to or from Rome for the jubilee of 1450 he went through Florence. And at present in the Uffizi Gallery there, possibly in Florentine ownership since the fifteenth century, is Rogier's

Plates 77–82 picture of a Lamentation; the body of Christ, with five grieving figures in attendance, is shown before His tomb.

One's visual impression is that there is very little of Italian art in this picture; what elements here are there that Rogier, a few of whose works we have already been attending to, could not have evolved free of direct Italian influence? And yet one influence is difficult to dispute. The *subject* does not appear to be one represented in Netherlandish art at the time. The Deposition from the Cross, yes; the Entombment, yes; but a Lamentation before the Tomb, apparently no. It does occur sometimes in Italy. In particular, it is found in a small panel by

Fig. 12 Fra Angelico now at Munich, reasonably believed to be part of the predella of the high-altarpiece of S. Marco at Florence. Whatever its date, one should not think that this picture is later than 1450, even though Fra Angelico did go on living until 1455; the date is probably about 1440. If Rogier went to Florence, surely he could have seen Fra Angelico's picture. Greatly different in many aspects as Rogier's treatment is, the compositions are somewhat related (as well as the subject): enough so for one to believe Rogier did see it.

Here then is a highly probable case of Rogier's imitating a contemporary Italian picture (the particular Italian artist mentioned is to be noted), perhaps encouraged by the strangeness for him of the subject. And this

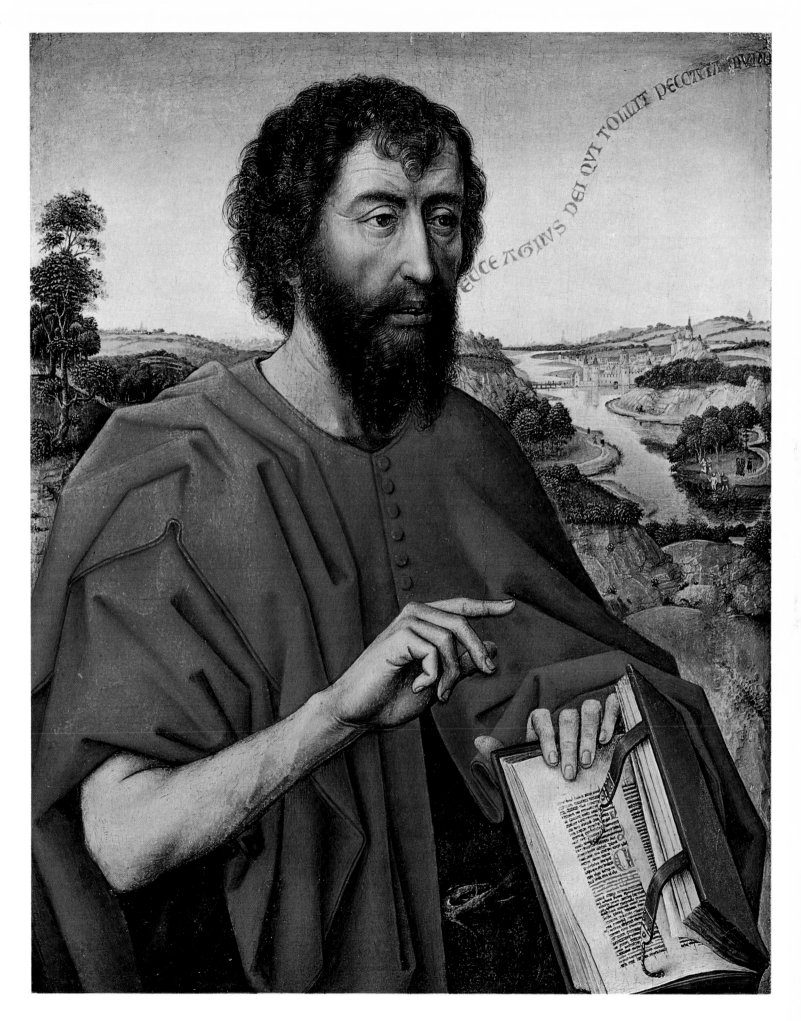

St. John the Baptist. Left wing of the Braque Triptych (Plate 49). Paris, Louvre (Cat. Rogier, Paris 1)

would illustrate how little moved by Italian *art* he was, how precisely he continued on his own way. It suggests also that claims made for other Italian influences in some other pictures by him, with consequential dating, are likely to be shaky.

Rogier's picture at Florence does not derive its merits from any Italian contribution to it. Some of its great character is to be seen in detail photographs here, of actual size or twice that: further examples (though a little reduced in quality) of what we have been seeing in the *Deposition* in the Prado. The billowing mantle of St. John, drawn to be beautiful, but here a little emptied of naturalism, more rigidly schematic, is from the mind of the man who with his St. John there was making beautiful shapes. And here again, the intervals of forms are beautiful. Between the boot on St. Nicodemus' left foot and the shroud is an area of grass echoing the shape of the boot; Memlinc (for instance) would not have conceived nor chanced on this. To the left of Christ's feet, Rogier sets the Magdalen's right hand with the thumb rightly placed for limiting an area of the tombstone to a shape agreeable in itself. Plates 78–82

There are some records that Rogier's pictures were sought after by Italian collectors. There is paucity of evidence that Rogier got much for his art from his Italian journey on the jubilee of 1450. Even a superficial motif such as a swag with putti that Memlinc used is not found in Rogier's pictures.

A triptych of Christ and other figures in the Louvre includes the now mostly effaced names *Bracque et Brabant*, indicating the donors, who were of Tournai. Jehan Braque married Catherine de Brabant in 1451 or just a little before (she was nineteen in 1451), and died on 25 June 1452; the date is thus plausibly considered to be not long after Rogier's return from Italy. The absence of portraits and the presence of a skull on the outside of one wing suggest that the picture was commissioned by his widow, as a memorial presumably soon after Jehan Braque's death. Friedländer considered this picture to be the painter's most complete expression. 'No other shows him so far removed from other masters. Here he has prevailed—his spirit permeates the whole conception.' Plates 49–53

The hieratic monumentality, although the picture is only 34 cm. high, is marked; fairly large figures at half-length are well to the front, against landscape with hardly any middle-ground. Yet how persuade oneself of much influence from Italian painting, monumental or otherwise? It seems irrelevant that some Italians from early times, and here and there continuing in the middle of the fifteenth century, painted single half-length saints on either side of a half-length Madonna or a half-length Christ; why should Rogier have needed to see some of those works? Was he not merely exercising his talents for originality in choosing to paint half-length saints? What he indeed did use in this triptych is his own *Last Judgement* at Beaune; the connections of several figures being reasonably interpreted as derivatives here.

Rogier's grave picture is little suggestive either of the Renaissance or of Italian Gothic; rather of Rogierian Gothic. Attention is concentrated on the figures, with distant landscape employed to mark the unity. This naturalistic setting does not preclude the painter from elaborating a glory round Christ's head; and he puts informative inscriptions across the sky, curling them to serve the overall pattern. The subject is timeless; it is as emblems that the Baptist and the Magdalen maintain actions from their lives—he speaks, she weeps. Very clearly, a humanistic taste is remote from what Rogier set out to express. The picture is indeed full of detail, yet the painter is an abstract man.

Plates 26–33 Maybe of about the same date is the Bladelin altarpiece at Berlin, the main subjects in which have been already commented on. It comes from Middelburg near Bruges, a small town founded by Pierre Bladelin in or about 1444; the picture may well be somewhat later, but it is difficult convincingly to attach a precise date to it. Here I refer to the colours. The Virgin in the central panel wears a deep mauve underdress, a dress of bluish white and a blue mantle. The three cloths are seen side by side where they lie on the ground behind her. The colours are harmonious, bright; their use may closely be compared with what is found in the Prado *Deposition*. But this is not the work of a colourist; for colours that sing, think of Lochner's *Presentation* of 1447 at Darmstadt. In the picture at Madrid it was colour applied to statuary—here perhaps the picture may be defined (yet with no discredit) as a coloured drawing. As usual Rogier's picture is in the plain light of day, which may at times be (most delicately) filtered; not normally for him were atmospheric effects, such as Bouts was to try and Bellini, hardly later, recorded. Scenic lighting seems aside from his normal style.

Plates 61–9 Perhaps a little later is a larger triptych (height, 138 cm.) at Munich, once in St. Columba's at Cologne and probably commissioned for Cologne. Part of the background of the central panel corresponds, though varied, with part of the background of the Bladelin altarpiece; this suggests, though it does not prove, that the two may be not far apart in date. In carrying out commissions for separate places Rogier could well risk repeating himself; and he might conveniently have done so if the two commissions were roughly contemporaneous. Some writers, it is true, find Bladelin's own castle at Middelburg in the two backgrounds; this is barely possible.

Objection used to be made to the picture at Munich on grounds of poor preservation, but it is not badly damaged.

An obviously important commission, it gives us Rogier's mature expression for some problems of painting, including the representation of figures in action proper to the scene, and the coherent management of many figures.

Plate 62 For the former, it is well to refer to Panofsky's comments. Of the angel Gabriel in the Annunciation here he writes: an ineffable being, who glides into the room like a white cloud. Other St. Gabriels by or associated with Rogier may be seen on plates 21 and 114; comparison immediately manifests the perfection of the figure at Munich. Or rather think of Fra Angelico, who has been mentioned. Maybe Fra Angelico's very

Fig. 13 finest *Annunciation* is the one in the Prado. St. Gabriel there is surely an ethereal being, partly from the colour of his robe, and largely enveloped in rays. Respect pervades his attitude. Yet it is not the pose itself that contributes effectively to the character of heavenly vision. Although Fra Angelico is more and more esteemed as a serious picture-maker; although his life indicates in him ability in the affairs of life; yet one may fancy that his St. Gabriel is (among much else) monkish. Rogier's is (among much else) supremely civilized.

As for the management of many figures, Rogier in the central panel uses recession in his grouping more freely than in the Prado *Deposition* (where indeed parallelism to the picture surface is deliberately and strongly marked), or in the *Last Judgement* at Beaune, where the drama being enacted is spread out for us as on a relief plan. In the picture at Munich Rogier shows himself supremely competent to arrange in depth a group of complicated elements, with clarity, and carrying richly from across the room.

Plate 61 Execution is what it should be. Concept, too. The eldest king, for instance, gently supports with one hand the Child's feet, and with the other raises the Child's left arm for His left hand to be kissed; the king's face

expresses the pleasure of an old man, whose wearisome journey is being proved worth while. Tenderness is not absent from Rogier's work.

Here again I refer to Memlinc, whose style clearly was much influenced by Rogier's; and one may well believe that in particular the Columba altarpiece was a significant influence on Memlinc. Take once again one of Memlinc's best works, the triptych in the Prado at Madrid. It is quite closely comparable, and the central panel shows the Adoration of the Kings and the right wing the Presentation in the Temple, as in Rogier's Fig. 8 triptych. One may think that Memlinc's display is serene. Yet Memlinc's realization of picture space, estimable as indeed it is, and expressed in classic calm, succeeds partly by impoverishment of what Rogier had provided. Memlinc does very well. Yet Rogier's rhythms have been lost, rather have not been sought for; Rogier in the Columba altarpiece is the mature master of complicated arrangements, and is in control. Memlinc presumably realized that he could not perform so complicatedly, remaining in control; he aims lower, with good success.

Yet there is more to be said against Memlinc. Rogier, and perhaps especially the mature Rogier records his individuals with strong and original personalities, proper to the subjects, with their gestures proper. At Munich, the dark King standing on the right is a noble figure; his stance if you like displays panache, yet with no trace of falsity. And the cloth falling from his turban-crown takes the beautiful and noble forms we have learnt to expect from Rogier. Memlinc's corresponding figure—even derived—is a poor wight; Memlinc's insensibility to beautiful shapes has previously been mentioned.

These harsh words on Memlinc are for indicating by contrast Rogier's quality. Memlinc is *not* a painter to be dismissed. The esteem in which he was held during most of the nineteenth century and the earlier part of this century is *not* due merely to the accessibility of some of his best works, *or* to less attributional difficulty than for Rogier, *or* to rather less iconographical trouble, *or* even to the mediaeval charm of Bruges. Memlinc was a good painter, who made various developments beyond Rogier's legacy; but here I concentrate on his short-comings in so far as they may help to indicate Rogier's supremacy, Rogier's place among the greatest European artists. In the series *Corpus des Primitifs Flamands*, volumes for Poland and Granada, there are some detail photographs of good Memlincs; they should be compared with the photographs in this book of the Columba altarpiece.

For these notes upon some aspects of some significant subject pictures by Rogier, probably latest in time is the extraordinary *Christ on the Cross between the Virgin and St. John* in the Escorial. It is large, about 320 cm. Plates 10–12 high; and people may wonder at having a fifteenth-century Netherlandish picture on the scale of Rubens. Readers will remember that it is one of the two pictures that are best as basis for attribution to Rogier, being identifiable in the Escorial inventory of 1574. There it is recorded to come from the Charterhouse of Scheut near Brussels.

It is displayed now in the Museum of the Escorial, which—unlike many parts of that building—an individual may wander around as he may care; you are probably unlucky if there are packed crowds in the room.

One may believe that the picture was painted for Scheut, which was founded in 1454. Rogier's known connections with that house might suggest it is his legacy, in the form of a picture expressing his matured feeling for last things, just as Titian's moving *Pietà* at Venice would appear to be for Titian. It is much damaged; yet nobly striking. As in the *Deposition* with which we began, but more austerely, the scene is reduced as far as may be to what the actors can contribute to it. A red background gives the sole strong colour. This is no scene

of the Crucifixion in a landscape, an event in time. It is an Event for all time that Christ died on the Cross. There with Him are only the persons most closely associated with Him, His mother huddled in grief and yet resigned, St. John in wondering grief. Grief, as in the *Deposition*. A serious view of life was Rogier's, tinged with sadness. His Nativity in the Bladelin altarpiece, a joyful theme, is not a scene of gaiety; whatever splendid qualities may be attributed to Rogier, one should not go to him for illustration of what fun it is to be alive.

It is to be expected that Rogier, marvellously skilful, accepting the new mode of northern painting and using it for sentiment and piety as people then wanted, should have been favoured by the rich and powerful; so he would have painted many portraits, which are still to be considered.

From what has gone before, one might imagine him more at home in painting types (however subtle) than individuals with their vagaries. But let us seek to see.

As so often, his slightly older contemporary Jan van Eyck is to be compared. It chances that we have portraits of the same man by each painter. These are indeed not separate portraits, but parts of pictures; yet a pious mood proper to donors need not greatly deindividualize.

Nicolas Rolin, already mentioned, was born in 1380 or a few years before at Autun; was Chancellor to Duke Philip the Good from 1422; and died at Autun in 1462. He had the reputation of being grasping.

He kneels, nearly in profile, before the Virgin and Child in a picture in the Louvre, which is accepted as Fig. 1 being the work of Jan van Eyck (d. 1441). Head, about 8 cm. high. It is not right to question the sitter's identity; for this there is a tradition recorded already in the eighteenth century and obviously reliable, as well as other reasons. The date of the picture is not established; it is usually believed to be from the middle 1430's. Plate 76 One can deduce from Rogier's *St. Luke* (at Boston) that Rogier knew at least the composition of van Eyck's picture.

Fig. 2 Rolin is also shown kneeling, less nearly in profile but facing the same way, on the now detached outside of a Plate 36 shutter of Rogier's *Last Judgement* at Beaune. Head, about 15 cm. high. As has been noted, that picture dates from not before 1443, perhaps from not very long after.

Jan van Eyck's picture is small (66 cm. high). Rogier's whole altarpiece is large, a principal object in the hospital Nicolas Rolin founded.

As anyone familiar with Jan van Eyck's painting expects, his description of Rolin's features involves attention to the play of light on the skin, and to the blood beneath the skin. Rolin's head is also a solid object. He is associated with the Virgin and Child, to whom he prays across a narrow interval of distance; a hard and unattractive personality is displayed in his face, although at this moment it is wreathed in pious respect. We admire not only van Eyck's skill in painting, but also his acuteness.

Rogier's portrait is of the man older and not face to face with Christ and His mother. I think that the same character does emerge. The language of the two painters, nevertheless, differs much. Rogier for recording the facts depends more on contours; for instance at the root of the sitter's nose, where puckers are shown by van Eyck as differences of lighting on surfaces and are by Rogier recorded with precise lines.

I call attention to evidence we chance to have of how Jan van Eyck used his visual impressions for a portrait. There exists a drawing of Cardinal Albergati(?), with colour notes for the painting to follow; also a picture, obviously done from this drawing. One may indeed think that the painted picture of Albergati(?) has

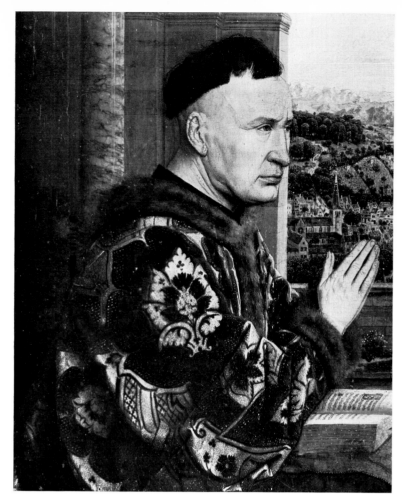

Fig. 1. Jan van Eyck: Nicolas Rolin. Detail from the *Virgin and Child with Nicolas Rolin*. Paris, Louvre

Fig. 2. Rogier: Nicolas Rolin. Detail from Plate 36

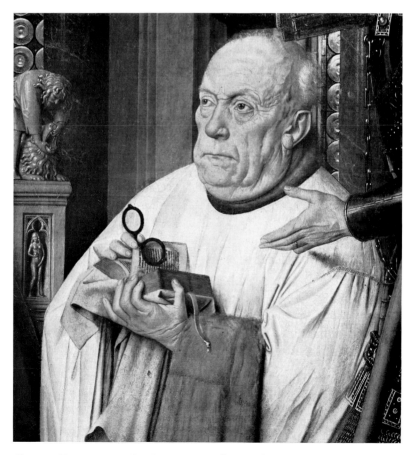

Fig. 3. Jan van Eyck: Canon van der Paele. Detail from Fig. 6

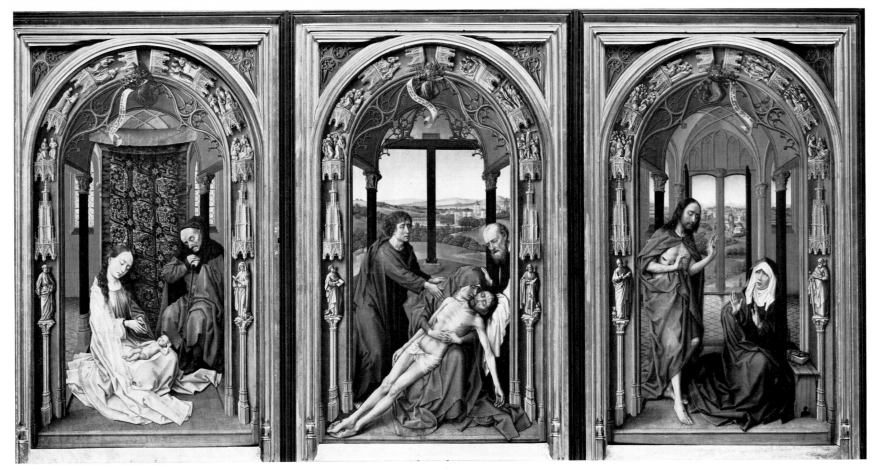

Fig. 4. After Rogier van der Weyden: *Triptych: The Holy Family; Pietà; Christ Appearing to His Mother after the Resurrection* (The "Miraflores Altarpiece"). Berlin-Dahlem, Staatliche Museen (cf. Plates 13-15)

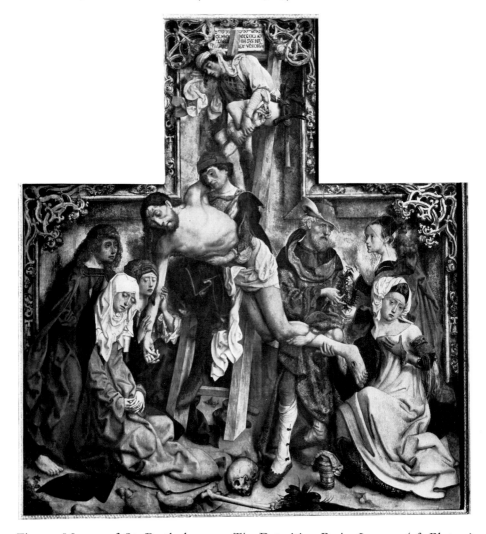

Fig. 5. Master of St. Bartholomew: *The Deposition*. Paris, Louvre (cf. Plate 1)

Fig. 6. Jan van Eyck: *The Virgin and Child with SS. Donatian and George and Canon van der Paele.*
Bruges, Musée Communal des Beaux-Arts

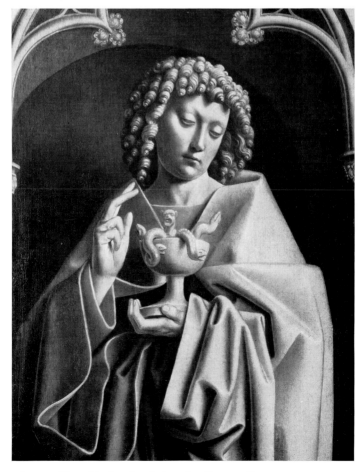

Fig. 7. Van Eyck: St. John the Evangelist.
Detail from the Ghent Altarpiece. Ghent, St. Bavo

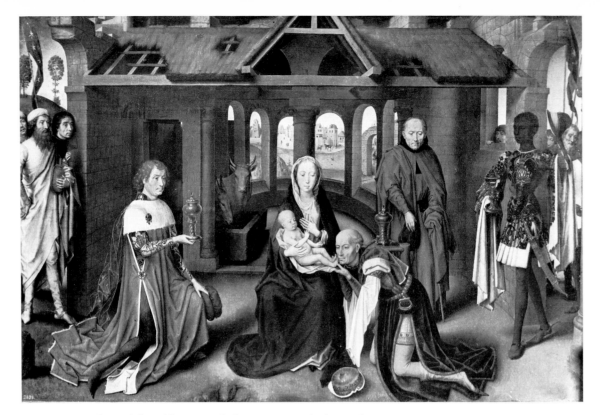

Fig. 8. Memlinc: *The Adoration of the Kings*. Madrid, Prado

Fig. 9. Memlinc: *Bathsheba at the Bath*.
Stuttgart, Staatsgalerie

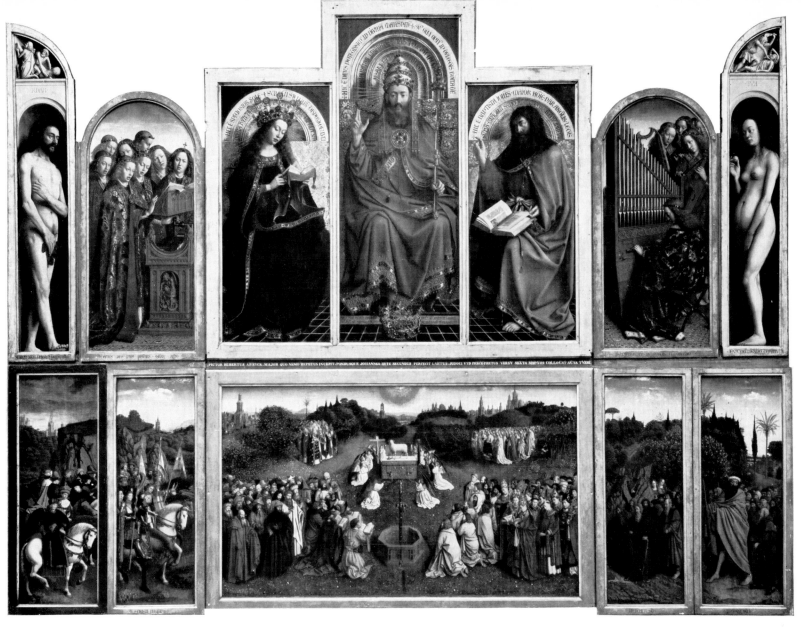

Fig. 10. Van Eyck: Inside of the Ghent Altarpiece. Ghent, St. Bavo

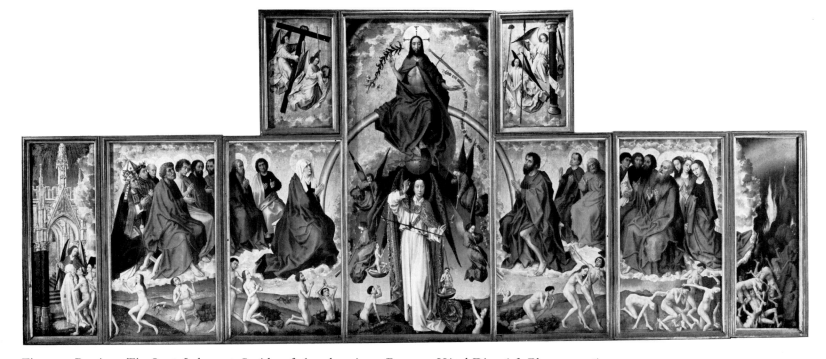

Fig. 11. Rogier: *The Last Judgement*. Inside of the altarpiece. Beaune, Hôtel-Dieu (cf. Plates 34-48)

Fig. 12. Fra Angelico: *The Lamentation for Christ at His Entombment*. Munich, Alte Pinakothek

Fig. 13. Fra Angelico: *The Annunciation*. Madrid, Prado

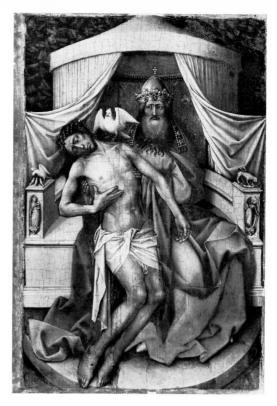

Figs. 14-15. Campin: *The Virgin with the Child by a Fireplace; The Trinity*. Diptych. Leningrad, Hermitage

Figs. 16-17. After Rogier (?): *The Trinity; the Virgin and St. John the Evangelist*. Grisailles on the outside of the "Edelheer Altarpiece". Louvain, S. Pierre

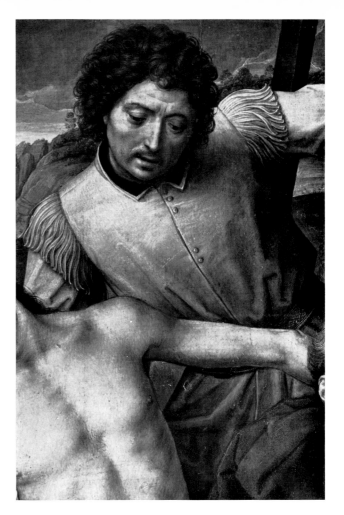

Fig. 18. Rogier: Detail from the *Deposition* (Plate 1)

Fig. 19. Memlinc: Detail from the *Deposition*. Granada, Capilla Real

Fig. 20. Jan van Eyck: Detail from the *Marriage of Arnolfini*. London, National Gallery

moved farther away from life. But we may think also that van Eyck's painted Rolin is nearer life than Rogier's painted Rolin.

Let us bring in for comparison another of Jan van Eyck's portraits, the head of Canon Georges van der Fig. 3
Paele, which is the best part of his already mentioned, distinguished altarpiece of 1436 at Bruges. The head clearly is recorded so as to be accurate; it is this, not arrangement of its constituent parts, that makes it convincing. The numerous puckers of the skin are again recorded hardly as lines, rather as shadows on the exquisitely rendered skin. It is when we consider the shapes or contours for themselves that a lack appears; for instance, the wavy line of the sitter's cheek seen against the pillar is not itself expressive, it lacks style—it lacks Rogier.

Rogier makes of Rolin's face a contour map, convincingly accurate; features are recorded in outlines with clarity, and the painter's intelligence keeps his work under control. The sitter's character does not, indeed, become lost. Yet Rogier's skilful record may leave one wondering if there is much animal life in the face; van Eyck is sensitive to that, as well as to the light and air of the surroundings, for achieving his portrait.

Van Eyck's paintings have a richly visual basis that Rogier's more abstract nature does not touch. Nevertheless, Rogier is a portraitist to reckon with in European painting. He could produce a portrait, not just excellently executed but estimable as an interpretation of character. This although the 'blood of life', found by Friedländer most clearly in the Prado *Deposition*, is not one of the greatest qualities of that great picture: and one might imagine that for a portrait painter warmth is desirable. Yes; remember Titian. Yet what could be called a cool look by painter at sitter may do very well indeed. And very happily, I daresay, when the talented painter has to make portraits of the powerful.

I pass by an exceptional portrait of a lady at Berlin, to which I shall come later in connection with Campin, and write just a few words more on a portrait in the Metropolitan Museum at New York. It represents a bastard of the Ferrarese House of Este, Francesco. Comment used to be made on it with a wrong identification Plate 112
of the sitter, and wrongly based deductions were made about Rogier's connections with Italy. Francesco d'Este, born *c*. 1430 (?), lived in Flanders fairly constantly from 1444; he died not earlier than 1475. He was within the court circle there. For this sitter, surely, the highly civilized Rogier had sophistication to deal with; using his clear sight, he painted what he registered of the sitter's character. The little picture, I think, has a fine place in European portraiture. Even so, painting the great themes of Christianity is where Rogier challenges all competitors.

It is time for some miscellaneous remarks. A pictorial form that had much popularity for a century or so from about 1450 is the diptych, with the Virgin and Child at half length on one leaf, and the donor at half length on the other. This arrangement, well suited to a donor who did not want anything elaborate or large but did want his personal association, was probably invented by Rogier. No diptychs of his, it is true, have reached us with the two leaves attached; but three have survived, with leaves certainly or probably associable. They are to Plates 91–6
be dated rather late among Rogier's works. The donors are treated as plain portraits, except for being shown in devotion. Varying the grouping for the Virgin and Child, in such diptychs and also in other types of picture, was an exercise Rogier did not tire of. Perhaps we do, rather. Rogier liked action; or, if you think the

poses frozen, a suggestion of action with implied drama. In trying to give life (and create patterns), Rogier may make his Infant Christs seemingly trivial in action.

It is fortunate that despite many losses a good deal of the highest quality, acceptably by Rogier, survives. It would seem unnecessary, in order to appreciate his great contemporary reputation and his great contribution, to spend much time in shakily interpreting studio-pieces and copies. Yet it must not go unmentioned that some recorded and presumably significant kinds of his work are not now to be seen, or not well enough for appreciation. His murals of scenes of Justice in the town hall at Brussels are destroyed, with only faint records known. A woman in a bath, claimed as his, was in Genoa in his life-time; could he have felt sincere enthusiasm Fig. 9 for a scene where the restricted theme, with whatever conventions treated, is lust? Perhaps Memlinc's *Bathsheba* at Stuttgart suggests to us what we might think were the shortcomings of Rogier's achievement or attempt.

It was sense to direct attention towards appreciating outstanding pictures for evaluation of Rogier. Whatever attractions (or repulsions) the fifteenth-century Flemish style of painting may arouse in one or in another person, the quality of Rogier's good pictures raises them above being curiosities. I have not been concealing their limitations—no air, no flesh, not a colourist, no joy of living: narrow. Yet high intellectual art is 'narrow'; *and* some of his pictures are achievements in European production. Also, it is the great artists who withstand restrictive definitions—for whom indeed doing this is interesting.

Rogieresque pictures, with Rogier himself diminished or lacking in them, are woefully not thus. Constrain yourself to look at the large triptych in the Prado, once fancifully identified as one that Rogier contracted in 1455 to paint and delivered at Cambrai in 1459. So its reputation accrued. But reaction now must not make us blind: this is a large and elaborate work, clearly no ordinary commission. Nor can we be blind to its overloaded character; it is far from us, an old-fashioned thing. Many Rogierian pictures exist that are like this one, often worse, with Rogier himself not participating enough to instil life and sentiment and taste and beauty. There exist also pictures, unlike those, acceptably Rogier's—some only quite good or not very good—which I have been passing over in this essay; these may not tell us much new about Rogier's great personality, may merely repeat less well what is well found elsewhere. And confusion rather than clarity, boredom rather than enthusiasm ensue from trying to bring in every available thing.

There now follow some pages on a large problem connected with Rogier. The historical evidence concerning Campin has been stated earlier. Without that, it would not have been good to begin considering Rogier's contribution to painting with the *Deposition* in the Prado, produced when Rogier was maybe as much as forty years old. If there were evidence that certain greatly important existing pictures ought to be thought earlier works by him they should have been discussed first. But the historical evidence, in my opinion, links these pictures with Rogier's being apprentice in Campin's studio at Tournai from the age of about 27 years to about 32: I do not believe that he was at that or an earlier age independently painting these great works.

Almost all that has been said hitherto on existing pictures, datable or presumed early, that are not by or not Plates 166–9 usually accepted as by Rogier, was on Daret's four panels completed by 1435; it was enough even for them to refer slightly. They are, I repeat, from their documentation of authorship and date, most relevant to any judgement of what other records mean.

Now that some consideration has been given to Rogier's works, with adumbrations of his talents: now that some notion of what to expect in Rogier's pictures has been sought for: now, it is proper to return to the problem of Campin, and this time the pictures.

The known pictures are mostly of high quality, one characteristic they share with Rogier's. They have to be considered here particularly for their attribution by style.

Two matters intermingle in the consideration of them. One is what we think on looking at them—with some opinions on Rogier formed. Anyone will find many close similarities and marked dissimilarities. Are the latter explainable on the view that they are Rogier's works, but immature? Or are the dissimilarities too radical for the pictures to be supposed creations of the same painter? The other matter stems from the presumption that the great painter Rogier was apprenticed to Campin (so far as can be judged, himself a prominent painter) from 1427 until 1432; are these pictures works by Campin? For this second question, recorded history laces problems of authorship with problems of possible collaboration. If Rogier worked as apprentice of Campin, we should suppose his influence within the studio considerable; though we should not reject the opinion of historians that during that time he had not the right to sell a picture from the studio as his. This seems to imply that, whatever he contributed to making a picture then (perhaps a lot), he would not often have been free either to conceive it or to realize it just as he would choose. The stylistic problem would thus be to identify Rogier helping Campin in the studio; accepted successes at this would be in favour of Campin's work of painting being significant, if it is the impression that some pictures are in concept uncharacteristic of Rogier.

So history offers a peculiarity in the study of this problem. Yet the problem does remain one of what eye can see and brain therefrom deduce.

I think a main impression concerning Rogier is that he was a rigid man. In pictures acceptably later than the *Deposition* in the Prado, there is a refining, an abstracting of what I see in that picture; yet nothing very important needs changing in it to make it illustrative of Rogier's mature or late style. So when he was about 40 years old, perhaps even a little less, the road he followed was already mapped; one *can* say this, even though dating of his pictures suffers from shortage of evidence. But this does not prove that some years earlier his nature was already fully set: though I think it likely, even if then his strength were less.

So let us look (rather slowly: as they deserve) at some pictures often assigned to Robert Campin. Only some; indeed, fewer than for Rogier. And it is pointed out that comment on these is primarily concerned with attribution (to or not to Rogier), only secondarily with estimating Campin's contribution to painting.

I have not seen the Merode *Annunciation* in the original (this book from its title is not a book on Campin). I Plates 141–3 choose, to begin with, the *Marriage of the Virgin* in the Prado. This also is acceptably characteristic, although occasionally doubted; by no means Gothic in style, but clearly somewhat primitive, even crude. A further advantage for enquirers is that it hangs in a room next to the *Deposition*, key-piece of the fairly young Rogier.

The story is illustrated in two scenes: on the left St. Joseph with flowering rod is being forced back into the Plate 148 temple in order that he may accept having won the test for the Virgin's hand; on the right his marriage with the Virgin is shown. As one expects in a painting patently early, symbol plays a large part. The subject signifies the approaching end of the Old Law and beginning of Christianity. Christianity is symbolized by the style of architecture current in the fifteenth century, Gothic; the Old Law by architecture already of the past, which (*pace* architectural specialists) I call Romanesque. The New Law is being created; so the Gothic edifice is not

yet complete. But this new building is destined to replace the old one, and some beginnings of it are shown in the left half of the picture for the scene of St. Joseph trying to escape from the temple, an event preceding the marriage on the right. In particular, the recalcitrant St. Joseph stands on a step of the new building already laid.

It should be noted that the abrupt stylistic change to fifteenth-century realism was not accompanied by an abrupt break in iconography, where the changes for some while are rather evolutions. In a double picture at Vienna by the Master of Heiligenkreuz (believed active ca. 1410), the Annunciate Virgin is seated in what may be called a Gothic shrine, under construction. A statue of Moses with the Tables of the Law is, indeed, already in place. Other parts of the building are being worked on, by angels. True, in Campin's picture there is no sign of angel-masons for the new Building; indeed, no work is at the moment going on. Yet such pretty fancies had not lapsed—witness angels bending the date-palm at the Rest on the Flight into Egypt, to put the refreshing fruit within reach, in a print by Schongauer and thereafter frequently (even repeated by Correggio!).

Such symbolism was indeed used by Rogier. Look for instance at the architecture, mostly on the right wing, of the Columba altarpiece at Munich; a mature work. The scene there is the Presentation in the Temple, a ceremony of the Old Law, but taking place for Christ, Founder of the New Law. Despite some early Gothic detail, the building within which this ceremony takes place is Romanesque. Yet the ancient structure, shown so for the ancient ceremony, has on its outside Gothic additions, with flying buttresses to support and a Gothic portal, here suggesting that the New Law is built upon the Old Law.

Plates 61, 63

It was desirable to refer briefly to the use of symbol in the *Marriage of the Virgin*, since this *partly* accounts for what a person looking at the picture might find chaotic in it. The struggles, at what might be this early picture's date, of an oncoming style of painting are also relevant to that impression. Yet this is not enough to make acceptable to me a view that we have here a creation—immature maybe, though not a mere student's exercise—of Rogier's. The picture, all excuses or explanations made, is garrulous. There exist, for brutal contrast, pictures acceptable as by the mature Rogier that show many people or crowds, e.g. the Columba altarpiece at Munich. I do not find in the picture at Madrid trace of Rogier's sense of clarity and beauty. Consider the nearby *Deposition*, at very latest of 1443. Could the same painter not many years before have had so different a conception of what a picture should be? Could he, even in malleable youth, have evolved from what may be called the anecdotal, and dedicated his talents to strict order as the means for conveying the emotion proper to a subject?

Plate 1

There is no firm dating for the *Marriage of the Virgin*. Nor for it shall I indulge in a search after Rogier in Campin's studio. The picture is brought forward as somewhat early, of striking quality, and un-Rogieresque.

Before we proceed to other, even more distinguished pictures, some closer to Rogier, it is well to make a short detour; which we may believe to be backwards in time. What indeed about Campin's pictures before Rogier joined his studio and (one may suppose) gave him a leg up? Whatever date we may attribute to the *Marriage of the Virgin*, it is possible to believe that some still earlier pictures of Campin survive, best conceived as from before contact with Rogier in 1427–32: stylistically associable with what we have been looking at in the *Marriage of the Virgin*, but in some cases less good. At Berlin, for instance, there are two such. One is the head of a man in a turban. Inserted with less effort into this early period of Campin, I think, is the *Virgin and Child in a Garden*. Not brilliantly attractive, the forms here seem closely Campinesque, i.e. such as the painter

Plate 161
Plate 159

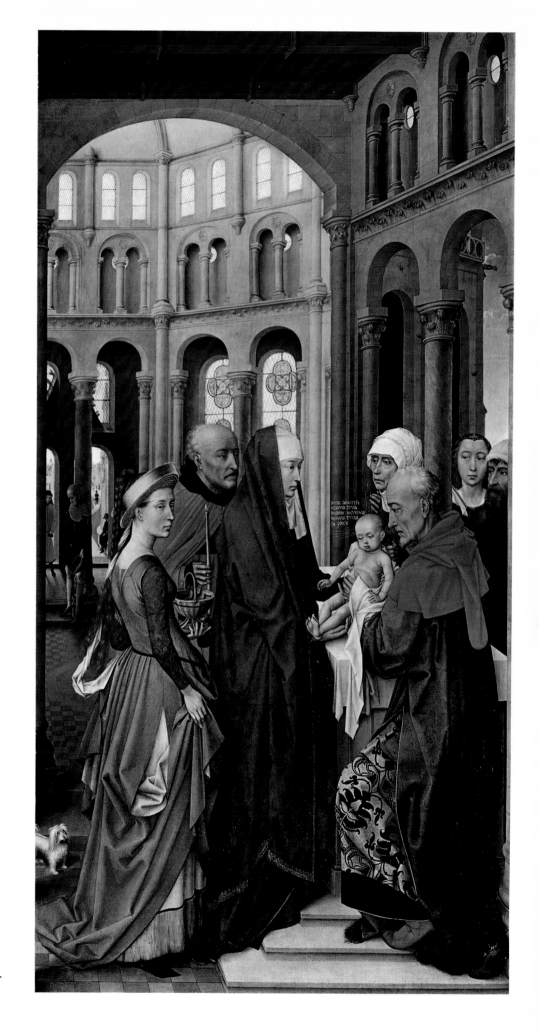

The Presentation. Right wing of the 'Columba Altarpiece'.
Munich, Alte Pinakothek (Cat. Rogier, Munich 1)

of the *Marriage of the Virgin* might have painted; and I incline to think it passes as an original. There is a powerful sweep of the Virgin's drapery in this quite small picture, worthy of a fine painter, and not dissimilar to what can be found in the *Marriage*. In that picture we noted a confused presentation; in the picture at Berlin this perhaps reveals itself as insensitivity to beauty of arrangement—but that beauty is what I find characteristic of Rogier, and lacking in pictures assigned to Campin.

It is time to visit and linger in the Städel Institute at Frankfurt. There are there three pictures already referred to some pages back, with figures nearly of life size, *The Virgin Standing holding the Child* (with a painting of later style on the reverse), *St. Veronica Standing*, and a grisaille of *The Trinity*, reasonably presumed once to ⟶ Plates 124–32 have been on the reverse of the *St. Veronica*. These are what is known to survive of an altarpiece (two separate altarpieces would seem fanciful), reputed to come from an abbey of Flémalle; which provided the name *Master of Flémalle* for a group of pictures also classed as by the Master of Merode, or else Campin.

In the picture Gallery at Frankfurt there is also the fragment with life-size figures, stylistically close to the preceding, showing a Thief on the cross and two spectators; the one in armour is presumably the centurion ⟶ Plates 135–8 who believed. No tradition of provenance attaches to this. It might have come from Bruges; for what seems to be a copy little varied of the whole picture, now at Liverpool, is claimed to be from St.-Julien at Bruges, and a ⟶ Plate 133 picture of later style, but partly related, is still at Bruges, in St.-Sauveur. The original picture was a triptych; if one trusts the accuracy of the copy at Liverpool, the central panel showed Christ being let down from the Cross, each wing a thief still on his cross. A large picture, therefore, and clearly one of the very most important of the early Netherlandish School.

Readers will remember Friedländer's comment on the Frankfurt *Thief*: if Rogier's *Deposition* now in the Prado had been of easier access, the Master of Flémalle would not have taken form in art history, or at least not as he did. Let us try to see. I look on the other pictures at Frankfurt, allegedly from Flémalle, as closely enough related to the *Thief* for them to be associated in discussion.

As often, there are no firm dates. A statement sometimes made that the *Thief* is from before 1430 is a deduction from yet another (partial) derivation, a miniature in what is best known as the D'Arenberg Book of Hours, now in the Pierpont Morgan Library at New York. But that miniature is not dated, is not acceptably of 1430, and is now usually supposed to be datable towards 1440. True, some stylistic elements in the pictures at Frankfurt (e.g. gold background instead of sky for the *Thief*) suggest that all four are early works of the Netherlandish School.

Before I labour on some analysis of style, it is well to insist that the four pictures at Frankfurt are of a quality fit to be discussed when Rogier's *Deposition* is being discussed.

It may also be well to introduce them on a point of iconography. The *Thief* at Frankfurt, clearly at Christ's ⟶ Plate 135 left and turning away from Him, must be the bad thief of Golgotha; some writers have pleaded for his being the good thief. A great artist's treatment of good and evil may embrace much; also (a different and more simple thing) the writers may have been misled by an engraving that is partly derived from the whole composition. Engravings normally invert right and left. The good thief, that is the one shown on Christ's right in the ⟶ Plate 134 painted copy at Liverpool, is thus on His left in the engraving, and is there labelled the bad thief. The engraving ⟶ Plate 133 supplies on Christ's right a new good thief, whose figure is maybe a makeshift adaptation from the other. So,

the good thief of the Liverpool picture is the bad one of the print; therefore the bad one of the Liverpool picture, not in the print—repeating the fragmentary original at Frankfurt—can be deduced to be the good one. But wrongly; bad he surely is.

It is apparent that this painting of the *Bad Thief* at Frankfurt displays much similarity of style to the *Deposition* in the Prado. Yet the differences seem to me too great for one man to have been the creator of both pictures. Too great, even allowing that the painting at Frankfurt should be the earlier by some years, and so could be argued for as an immature work of Rogier's. I see in the Frankfurt picture the expression of a feeling for strong decoration—in what remains of the patterned gold background, in the ornaments of the soldier-spectator. But this is distinct from the decorative sense I find in the Prado picture; there the elements needed in the composition, in flow of drapery for instance, are made to contribute to the emotion the subject should bring, and with feeling for refined beauty.

Plate 28 Rogier's mature taste in this—with decorative elements not introduced independently of their being kept under control—may be seen in the Bladelin altarpiece at Berlin; there are there the three Kings, in costumes indeed worthy of the riches of the Orient. If anyone claims that the manner of enriching the Frankfurt picture, with the ornaments not properly subordinated, reflects a stage in Rogier's development towards his masterly usage and his taste, I can only say I find the difference unbridgeable.

Plates 135–8 Let us leave aside certain details in the Frankfurt picture that might be attributed to the awkwardness of an artist's immaturity, his dubiously successful effort to get the hands to scale, the poorly drawn second toe of the thief's right foot or thumb of the civilian spectator's right hand, or the silly chance that his left hand is so placed that it seems to be dragging at his companion's headband. And when we speak of control for emotion, it is right to admit that this corner of a picture is not in itself a subject so apt as the *Deposition* in the Prado. What indeed should one think is the meaning of this fragment, with the unrepentant thief maimed and dead or dying, and a civilian and a soldier, both (especially the soldier) Jewish in appearance, looking wonderingly up? The civilian perhaps merely pities an unrepentant criminal executed; the soldier may rather be looking towards the Redeemer on the missing central panel. And yet, granted this, I do not recognize Rogier here. The painter is hardly interested in order; he is interested in force (the tight-strung rope bites into the thief's flesh) and in audacious realism for this dramatic scene,—a vigorous chap he is. Think of the beautiful shapes made by the intervals of the forms in the Prado *Deposition*. I do not find these in the Frankfurt picture, not even in the folds of what seems to be the thief's shirt or tunic serving as a loincloth. These are here the forms maybe most fit for expressing such a taste; yet the shirt's lowest part, granted that its conception has been thought out, is confusing rather to the eye—and confusion is against such beauty. Nevertheless, the firm vigour with which this drapery is twisted over the rope is striking. Even more, the vigour with which higher up it is pulled round the hip at the right, suggesting the solid form (Christ's loincloth in the Prado picture is weaker). As for the two spectators, so boldly and so naturally recorded, they might prepare the way for the painting of van der Goes, whose illustrational character I have touched on earlier; it is not clear to me that Rogier followed much along this line. It is noticeable that in pictures assigned to Campin there are often heavy outlines; Rogier's outlines are thinner, and more elastic.

If force is the quality that strikes one most in the Frankfurt picture, one should also recognize some expression of the anecdotic character of the *Marriage of the Virgin*. Maybe an uncontrolled use of decoration, referred

to above, is allied to this. More closely, the heads and necks of the two spectators are, one may say, very care- Plate 137
fully described; too carefully perhaps—or at least too carefully to be by Rogier! Rogier's taste, I consider, was
for selecting, omitting. The right hand of the soldier-spectator is in this respect to the point. It is mapped out
as a wrinkled hand; but somewhat incoherently wrinkled, with wrinkles accumulated as if added over the
surface. This enthusiasm for uncontrolled detail is seen also in the wrinkles of the thief's feet, especially his
right foot. More clearly still (and a minor detail sometimes is revealing because done more carelessly) in the
rings of the wood at the end of the cross on the right; I do not think that Rogier would have painted this
detail so superficially, as something stuck over the wood itself—nor so uglily.

Compare the stubble on the chins of the thief and the civilian spectator with the arranged stubble on the
chin of St. Nicodemus in the Prado picture. At Frankfurt, blood flows down from the wounds of the thief's
legs; but this does not form a pattern beautifully as do the blood marks in the Prado picture. We keep returning Plate 8
at Frankfurt to the absence of Rogier's sense of beauty, which strongly suggests a different artist.

One might fancy it useful to bring in the poorly painted copy at Liverpool for comparison of the central Plate 133
picture as seen there and the Prado *Deposition*; the subjects are practically the same. Yet the temptation is to be
resisted. Who knows whether what we might find non-Rogierian in the Liverpool picture is not due to the poor
copyist? Indeed: it is sound, and interesting also, to analyse pictures such as the *Thief* at Frankfurt and the
Deposition in the Prado, because these are of high quality. It is from works of high quality that characteristics
significant for the temperament of painters can properly be deduced.

Campin the Master of Flémalle, and Rogier his apprentice; yes. And the Frankfurt *Thief* itself is evidence
that these statements are right, if as I strongly feel it cannot be Rogier's creation. With the statements true, the
young Rogier would of course have known pictures such as this. And I mention that some compositions
associated with Campin recur with variations in pictures associated with Rogier or Rogier's studio.

But especially it is great paintings such as the Frankfurt *Thief* that I consider formative for Rogier: although
somewhat aside from his own character. I think that in the Prado *Deposition* Rogier was still profiting much
therefrom, but was breaking loose and already displaying a temperament distinct.

I refer again to Rogier in Campin's studio. We should believe that a picture at that time was sold from the
studio as a Campin; and within the studio, I do suppose, Rogier would not often have had a free hand. For
the large picture of which the Frankfurt *Thief* is a fragment, it seems obvious that Campin (no evidence to be
taken seriously that his painting was bad) would have evolved, directed, done much himself. It cannot be
excluded that Rogier executed some parts of the *Thief*, but I will not speculate here, though presently I shall
with the other pictures at Frankfurt. Here, I find it more worth saying that some details—e.g. the rings of the
wood on the cross, selected for adverse comment above—may have been executed neither by Campin, nor by
Rogier, but by some other member of the studio (we know that there were other hands available for Campin
to employ). One should nevertheless be hesitant in pursuing this speculation; painters capable of participating
at all, even under supervision, in such a painting without disgracing it are perhaps not plentiful at one time.

I go on to two of the other pictures at Frankfurt, the *Virgin and Child* and the *St. Veronica*. As it has turned Plates 124-5
out, they form the core of the group here labelled Campin; and maybe they serve well for this.

They are very like the *Thief*, and also powerful pictures; as hung in 1971, the *Virgin and Child* can be seen
from several rooms away—it carries.

The particular feeling for decoration is even more marked here. The textile backdrops, in effect foldless, are painted with great skill and with evident joy in the patterns. These also seem to me to reflect a different taste from Rogier's in the Prado *Deposition*, where the more formal background is rigorously kept back, and is used to define the space.

The shirt draped over the Thief's body was vigorously pulled over his hip; St. Veronica's handkerchief, Plate 130 diaphanously frail as it is, is sharply tugged by her left hand. The realistic, almost animal character of the Plate 129 Child's head in the other picture can be related to those of the spectators, almost crudely realistic, in the *Thief*.

Plate 126 Turning to the grisaille of *The Trinity* from the back of the *St. Veronica*, I think I find a difference. One must have in mind that this is a representation of unpolychromed sculpture; it is meant to look three-dimensional, even to project forward in front of the picture-surface, so the figures cast strong, hard shadows.

One must also have in mind that this picture is rather badly damaged.

If Rogier was a leading, an exceptional workman in Campin's studio, one may fancy that within the studio he might have been given more liberty than usual for the outside of a shutter (Rogier himself seems to have been willing to leave the painting of outsides to assistants). And it is this picture of the four at Frankfurt that brings to my mind some suggestions of the painter whose work we were looking at in the Prado *Deposition*. In this picture hair is curled into flowing lines, more than in the other three (the nearest, I think, being the carefully arranged curls of the *Thief*). Take two examples that might seem comparable, the curls by the temple Plates 132, 128 of God the Father in *The Trinity* and the curls by the Virgin's temple in the *Virgin and Child*. They are similar, yet I find those of God the Father more flowing, more Rogieresque. This is clearer still in the beard of God Plate 131 the Father, in the hair of Christ (not forgetting the structure of the Crown of Thorns itself), and His beard. In the right foot of Christ, the painting of the wrinkles suggests to me Rogier's taste; not incoherently plastered on (as I find characteristic of Campin), but more incorporated into the foot and at the same time worked out, not confusing the form, in patterns displaying a sense of beauty. I can look on them as an immature expression of Rogier's taste; for a mature example, see what is indeed not one of his successes, the wrinkles on the head of the ox in the Bladelin altarpiece at Berlin.

We must not forget that this representation of sculpture invited less detail, less richness than the other three pictures at Frankfurt. Such a picture was to be executed rather more coarsely. Yet, although coarser, I find the drawing more accurate; compare Christ's right foot with the left foot of the *Thief*. One may go further. Despite the evident desire to give solidity to this sculpture, Christ's loincloth seems more similar to that in the Prado *Deposition* than to the Thief's drapery, which although roughly arranged is more vigorous. The thumb of Christ's left hand seems suggestive of Rogier; it is not merely realistic. And here at last we find a shape made between forms, of comparable taste to those (more elaborate, more perfect) that hold us in the Prado picture; the shape formed on Christ's body by this left thumb, the left arm and the fingers of God the Father's left hand.

I could not have made the above suggestion for *The Trinity* from photographs alone. It may be wrong; also, alas, impressions can too easily be dictated by preconceptions. Yet I incline to think at present that there may be some truth in it. According to this view, the Prado *Deposition* would show Rogier freeing himself from what did not suit his nature in the magnificent products of Campin. *The Trinity* at Frankfurt, supposed earlier

and indeed acceptably so, would show Rogier in Campin's studio, hardly as yet consciously freeing himself from Campin, yet with his own personality already breaking through and altering the character of the product from what Campin would have made.

This of course is indissolubly linked with the idea that Rogier is not by himself responsible for the Flémalle group. And, if something of Rogier's taste can be detected in *The Trinity*, why should there seem to be less in the more important parts of the altarpiece, *The Virgin and Child* and *St. Veronica*? Unless the Director-General here was another man?

Relevant also is one's idea of what Rogier painted as soon as he was on his own. It might seem fine to imagine that participation by him in the Frankfurt *Trinity* was directly followed by the *Deposition* in the Prado; but I doubt if this will do. Little pictures, a diptych at Vienna, a *Virgin and Child* in the Schloss Rohoncz Col- Plates 85–8 lection and a *St. George* at Washington might well come between, if they are Rogier's. It is not merely owing to their small scale that I accuse these exquisitely pretty pictures of timidity when compared with the forceful, large pictures at Frankfurt and Madrid. Is it too harsh to say that the landscape in the wing with St. Catherine at Vienna, perfectly done, is suggestive of a colour postcard? What then should one fancy? I incline to think that, if Rogier in Campin's studio gave Campin a leg up, Campin then may have done the same to Rogier. But Rogier might have let a little time go by before competing on his own with Campin's triumphant works. This suggestion is made as possibly true; since there are hardly any facts to tie the critic's fancy, other suggestions possibly true are for the making.

Some readers may wonder if it is worth while torturing oneself and the material at such length, in order to define what (in any product from one studio) was obviously intended to look as evenly the same as possible. But the problem is intriguing, being in relation with the start of one of the most important schools of European painting—its emergence as realism, its dominance under Rogier's dominance, although in his hands becoming different. Further, our concern with it not only touches the question whether Rogier was a principal in starting the movement, or merely the leader in making use of it: the time we have been spending on great pictures, even if the comments made are wrong, even though these have been introduced primarily in respect of attribution, has not been wasted if in the process we have got at all closer to the great pictures.

I shall not linger over all the works usually associated with Campin; not even over all the original ones; not even over the Merode Triptych, most important as that picture is, since *The Marriage of the Virgin* has sufficed. Plates 141–3

I shall, however, before coming to another attributional twist of mine, comment on Campin's *Portrait of a Lady* in London and Rogier's *Portrait of a Lady* in Berlin. Plates 164, 106

Consideration of the latter was held over from the paragraphs concerning Rogier's portraits. On its arrival at Berlin, Friedländer confesses to incoherence from emotion felt when he saw this till then unknown picture; yet, rightly I feel sure, he opted for Rogier (rather early work). The portrait in London is usually believed to be by Campin; also rightly, I consider.

There are indeed many similarities between the two; to start with, neither sitter would seem to be a great lady. The homely character of the sitter at Berlin would accord with a suggestion that she is the painter's wife; and she turns her eyes towards the spectator—or should one say the painter, rather?—as Jan van Eyck's wife does in her portrait by him at Bruges. This is not so in the portrait in London; the portrait of a man who is obviously her husband is also in the National Gallery there. Plate 163

Two portraits of sitters of a similar type, in a presentation also similar. Yet the differences, even in photographs, and much more so in the originals, are extreme.

I can't myself attribute the pictures to the same hand, even assuming some difference of date (as usual, there is no firm date for either). The National Gallery portrait (a masterpiece) is strongly solid, without marked refinement on the painter's part. The portrait at Berlin (a superior masterpiece) could with exaggeration be accused of being—to recall a phrase—a coloured drawing. There, distinction in the execution is the characteristic most strongly marked, bourgeoise as the sitter may have been; the painter's sensibility there in doing everything just right is apparent. Not so in the portrait in London, where it is the power to realize the third dimension that makes the picture.

Plate 164
Plate 106

I find these apparently similar portraits of great value for estimating the characters of Rogier and of Campin. I do not think that a man painting the National Gallery portrait in his youth could have painted the Berlin portrait soon after, or at any time; I refer again to Rogier's character, which I have tried to show as a stable one, even though I think it continued to harden as the years passed.

To say that the Berlin portrait may suggest a coloured drawing is not to say that it lacks modelling. On the contrary, there is much tender yet firmly controlled modelling by shadow, which in the more prominent hand or the top part of the headdress achieves a softly flowing exquisiteness. First-rate modelling of this type is indeed to be found in the figure of the Thief at Frankfurt; yet it is coarser there, and not only I think because the Thief is a rough man in agony. There is nothing there closely comparable with the modulations in the top part of the headdress at Berlin; so, a somewhat similar style of painting, but at Berlin a refinement that I think can hardly be within the development of one artist.

In the portrait at Berlin we find what we have learnt to expect from Rogier: rigour of construction, delicacy of contour (the sitter's left eye should be examined), feeling for beauty in the arrangement of the parts. With regard to the last, the shape made across the sitter's body by the hanging parts of her headdress and what is tied under her chin is for me clearly in the same taste as the (sometimes more broken) shapes similarly formed that pervade the *Deposition* at Madrid. And the blood of life Friedländer finds markedly in that picture is surely in the Berlin portrait much the same, granted that this shows a woman in calm; much else as one could say in praise of this portrait, the painter has here caught in a high degree the quality of a living creature.

The portrait at the National Gallery is greatly different. There, force; as we expect from Campin. And I call attention to the sitter's hand, a network of wrinkles as also we expect from that painter, irreconcilable in my view with the refined form and abstract treatment of the hand at Berlin.

In the group usually assigned to Campin, there may be several changes of attribution worth proposing. I will discuss one case only.

Plates 150–3

The two altarpiece wings in the Prado, one showing Heinrich von Werl and St. John the Baptist, the other St. Barbara, are the only pictures of high quality assigned to Campin or Rogier that are firmly dated; the year 1438 is included in the inscription running along the base of the donor's panel.

This gives them much importance for students. Indeed, I find them of cardinal importance in considering the question whether some or all of the pictures grouped for stylistic reasons as by Campin are by a painter distinct from Rogier or are works, mostly youthful, by Rogier himself.

Most writers who admit duality seem to have had not much difficulty in separating these pictures from Rogier, although recognizing the many and close similarities to what is accepted as his work. But the date should be observed. It is 1438. In 1432 Rogier (and as I have explained I take this to be the great painter, not some other painter whose works remain unidentified) left Campin's studio; at latest by 1435 Rogier (the great painter, without possible restriction) was established at Brussels. Although he kept up contact with Tournai, I find it very hard to suppose that after 1432 or so he kept up close artistic contact with what was being done there; nor does there seem to be any documentary evidence that Campin remained in close artistic contact with Rogier.

Admittedly the dates of other existing pictures before about 1440 are speculative, only to a slight degree supported by historical evidence. Yet the basis of any concept that some of the pictures we know are early or fairly early works by Rogier and that others are works by Campin is largely this: that the similarities listable in such works are to be explained by Rogier's period of apprenticeship with Campin from 1427 until 1432.

Nobody knows what happened to Campin's style of painting after 1432 until his death in 1444. It is not too much to say, notwithstanding the laborious restrictions made earlier in this essay concerning the attribution of any pictures to Rogier, that we do know something of what happened to Rogier's style after 1432 until his death in 1464. Continuing to express his personal character, which I do find absent from some pictures assigned to Campin, he moved further and further towards an abstract form of expression—though continuing to include in his picture a wealth of detail from the visible world.

What then should one say about the two wings of 1438 in the Prado? Plates 150–3

First, that our interpretation of them is impeded by the absence of the central part. One should believe that this showed an interior, possibly with a continuation of the ceiling shown in the *St. Barbara*, and maybe with some upright post of undefined kind or height in the foreground at the right (a shadow in the left foreground of the *St. Barbara* seems hard to explain otherwise). Apart from this, we know nothing precise of it, not even its subject; *à la rigueur*, we do not know that it was a painting.

But secondly, and bearing much in mind this difficulty concerning the central part, one is bound to say that these two wings are very like Rogier's work of an early-middle period. In my opinion they are more precisely like Rogier's work than any other pictures assigned to Campin. But why should that be in 1438, six years after Rogier and Campin had ended their precise association?

Should one try to water down the difficulty? The date of 1438 may be the date of completion of a work commissioned and at least designed earlier. Yet the rather small size of the pictures reduces the probability of much delay in execution, and even on general stylistic grounds it would be unwelcome to set the pictures back much before 1438.

So the Rogieresque quality of the Werl wings, dated 1438, remains a stumbling-block to me for the attribution of them to Campin. What then do we find written by Friedländer, who indeed never entirely allayed his discomfort in separating the Master of Flémalle from Rogier, long before he came to denying the duality? I think his chief comment in favour of an attribution away from Rogier derives from the treatment of light in the pictures at Madrid; and with good justification he brings in the influence of Jan van Eyck.

Granted that the double shadows seen in the Werl wings are often to be found similarly in other pictures assigned to Campin. Rogier, indeed, would not have been ignorant of this treatment, and presumably found it

Plate 97 not to his taste; yet something similar occurs in the grisaille painting on the back of the portrait of Laurent
Fig. 16–17 Froimont at Brussels, also on the outsides of the wings of the Edelheer altarpiece at Louvain (a picture clearly
not executed by Rogier himself). But I think it is more rewarding to consider the influence of Jan van Eyck in
Plate 152 the Prado pictures. One may certainly suppose this for the mirror in the panel showing Heinrich von Werl and
St. John the Baptist. It reflects the room, St. John, and two figures in front of the picture-surface entering the
Fig. 20 room; and this is closely similar to the use of the mirror in Jan van Eyck's Arnolfini portrait in London. Here
I think one may say that the painter bases himself on the taste and inventive skill of Jan van Eyck, he is copying
from Jan van Eyck. Rogier indeed is generally admitted to have picked up ideas from that painter, in his
formative or at least early period. A clear case is the *St. Luke Painting the Virgin*, of which we should not
Plate 76 doubt that we do have various versions—in the picture at Boston (according to the opinion of myself and
many others) the original; there, as has often been pointed out, the structure of the picture, with certain details
pinpointing the comparison, is influenced by Jan van Eyck's *Virgin and Child with Chancellor Rolin* in the
Louvre.

I do not find it hard to suppose that a painter, picking up this and that from van Eyck, may have exercised
himself in painting approximatively in van Eyck's taste; and so we come to the treatment of light in these
Plate 153 pictures at Madrid, particularly the panel of *St. Barbara*. It is indeed more elaborate than we would expect from
Rogier: though we should recognize at once that we have here ingenuity rather than Jan van Eyck's use of
light as the basis of the picture. There is here much attention paid—in places with partial rather than complete
success—to different sources of light and their curious effects. Most strikingly this applies to the light from the
fire; reproductions do not show clearly, but the effects of this light, touching the edges of the furniture, stretch
to the far side of the bench, the tip of the shutter, even the wall behind.

I cannot say anything more precise than that Jan van Eyck might have been interested in this play—which
he might have managed better. Perhaps one can cite his *Virgin in the Church* at Berlin, where a source of light
not clearly indicated touches here and there, according to the variation of the folds, the gold edging of the
Virgin's mantle. And I daresay that Campin did play with light like this, though I do not recall a close parallel.
Fig. 14 Perhaps the nearest is in the *Virgin and Child* at Leningrad; there, I am informed, the light from the fire is
painted to touch the edges of some objects close to it.

What I can say about this is that the attribution to Rogier of the picture at Madrid is not ruled out, even if
influence either from van Eyck or from Campin is left aside. Rogier in a mature picture did do something that
Plate 31 deserves to be compared; in the Bladelin altarpiece at Berlin (noticeably unatmospheric as that is) the light from
St. Joseph's candle illuminates the column nearby, just touching the edge, for a short length.

There does not seem to me to be much of any kind in either of the pictures at Madrid to separate them from
Plate 152 Rogier. Yet I must not avoid comment on the gesture of the Baptist's upraised right hand. This has rightly
Plate 15 been compared with the right hand of Christ in *Christ appearing to His Mother*, one panel of the 'Miraflores'
composition, and a deduction for the dating of that has been made. This gesture can signify various things,
and in showing Christ's wound is proper in the Miraflores composition. It is not proper to the patron saint of a
donor; patron saints of donors may, for instance, protectively put their hands on them. Nor is it easy to sup-
pose that the strangeness here, with the gesture so to speak bypassing the donor, would have been clear as a
connection of the Baptist with what was shown on the missing central panel of the altarpiece. It remains

unexplained, and one is indeed tempted to think of it as a distorted repetition of Christ's hand in the *Christ appearing to His Mother*. But what deduction ought to be made from that? The usual one, to put it crudely, is that Campin liked the shape of the gesture he saw depicted in Rogier's picture, did not understand its meaning and reproduced it approximately in an unsuitable subject.

It would be a pity to end this essay with attributional arguing. Yet the reader will not find here pages on the Gothic style, against which it was, I believe, Campin who reacted significantly, and previously to Rogier; I think that Rogier built on what Campin (and Jan van Eyck) had founded. But this book is not a history of painting as it occurred in the north before and after the year 1400. Nor is it concerned with situating Rogier in the social conditions.

So I end just with him. *Maximus pictor*, he is for various reasons difficult to get to know, still, and in spite of much work of elucidation by many writers. I have not been belittling difficulties. I warned that cognizance should be taken of these. Yet the plates here are the justification of the book. They should encourage people to look for the pictures, and then at the pictures; especially the best and most significant of the pictures.

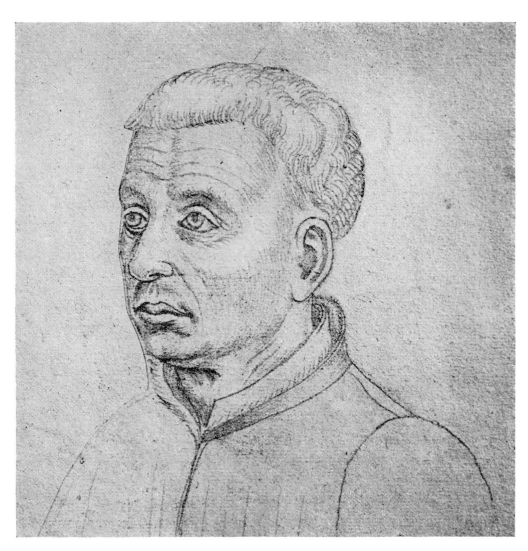

Portrait of Rogier van der Weyden. Detail of a sixteenth-century drawing
in the 'Recueil d'Arras'. Arras, Bibliothèque Municipale

PLATES

ROGIER VAN DER WEYDEN

DOCUMENTED PAINTINGS
Plates 1-12

ALTARPIECES
Plates 13-69

SMALLER COMPOSITIONS
Plates 70-82

HALF-LENGTH MADONNAS
Plates 83-84

DIPTYCHS
Plates 85-100

PORTRAITS
Plates 101-113

SOME FURTHER ASSOCIATED WORKS
Plates 114-123

ROBERT CAMPIN
Plates 124-165

JACQUES DARET
Plates 166-169

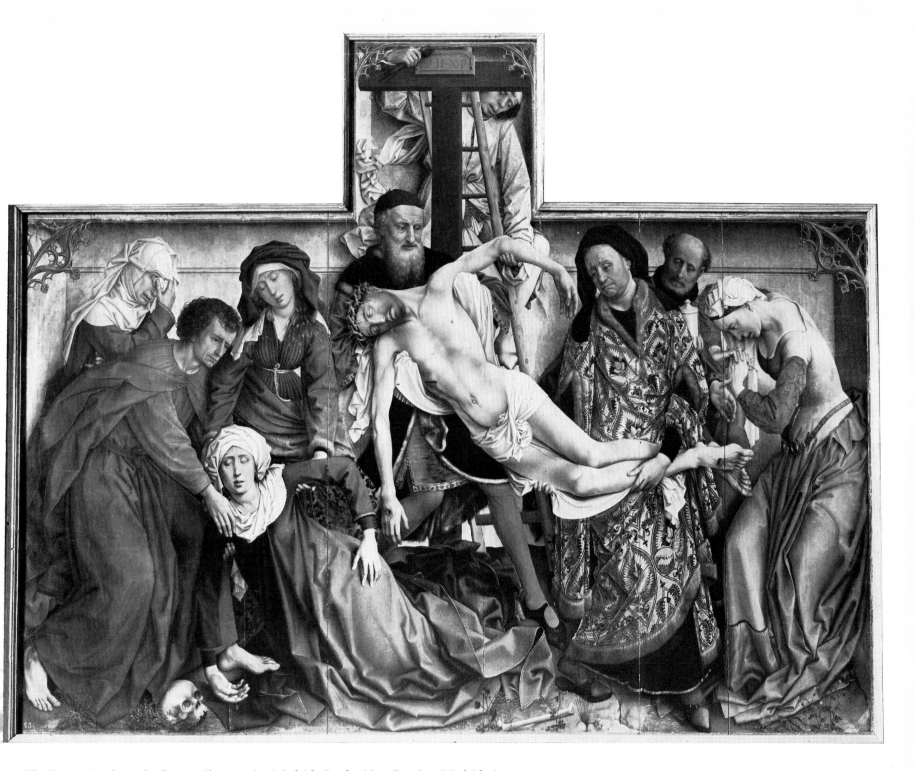

1. *The Deposition from the Cross.* 86½ × 103 in. Madrid, Prado (Cat. Rogier, Madrid 1)

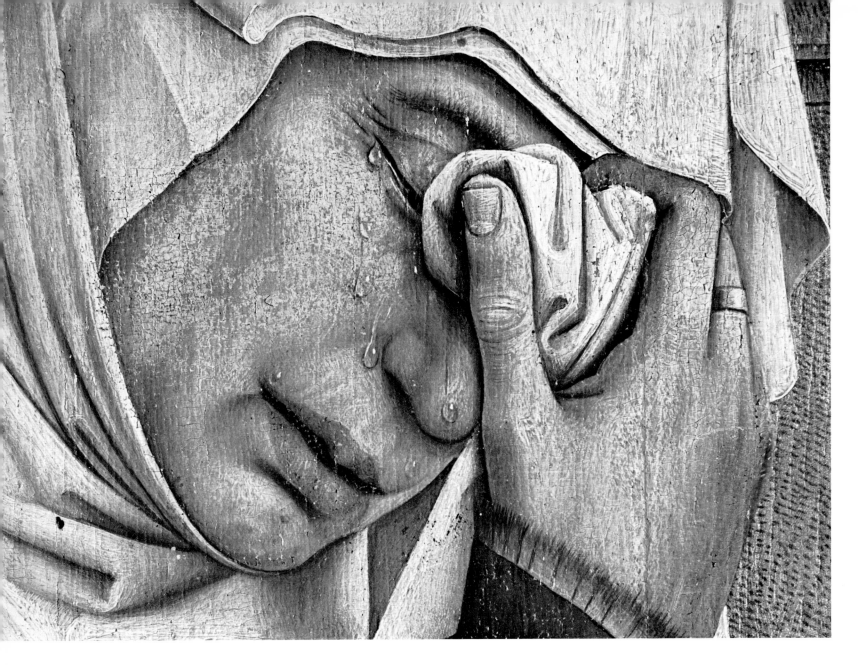

2. Head of one of the Maries. Detail from Plate 1 (enlarged)

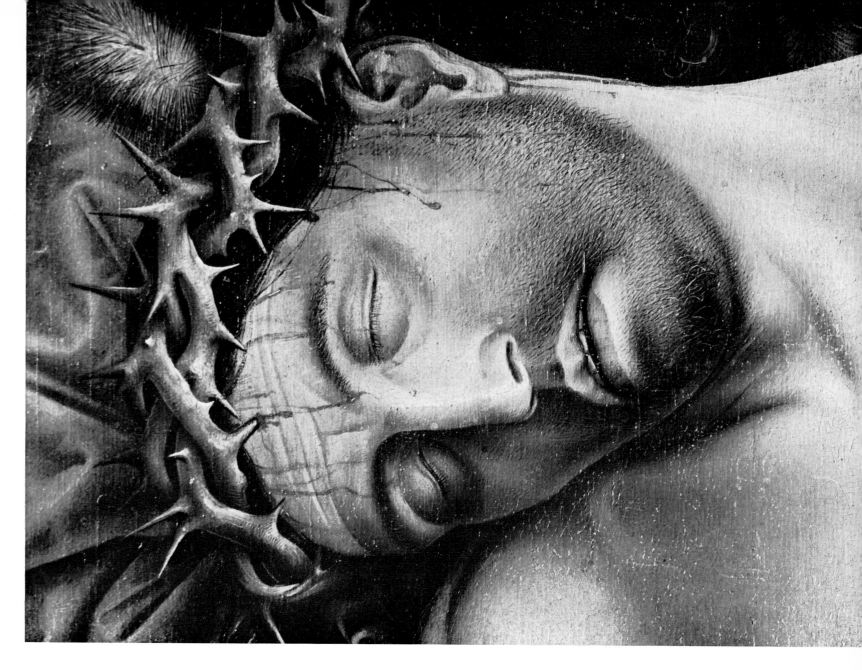

3. Head of Christ. Detail from Plate 1 (in original size)

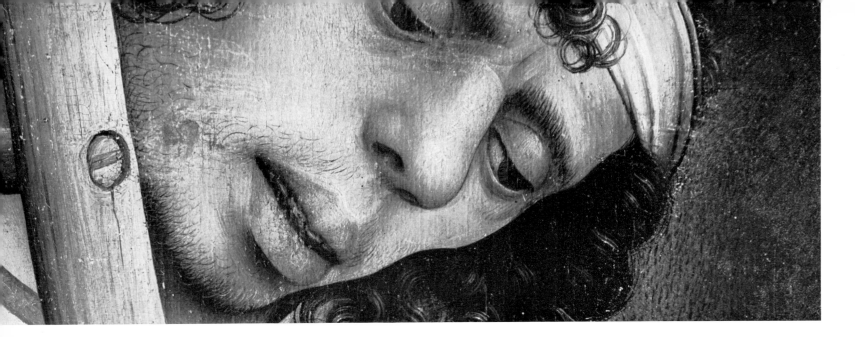

4. Head of the Servant. Detail from Plate 1 (in original size)

5. The Servant's Hand holding Nails. Detail from Plate 1 (in original size)

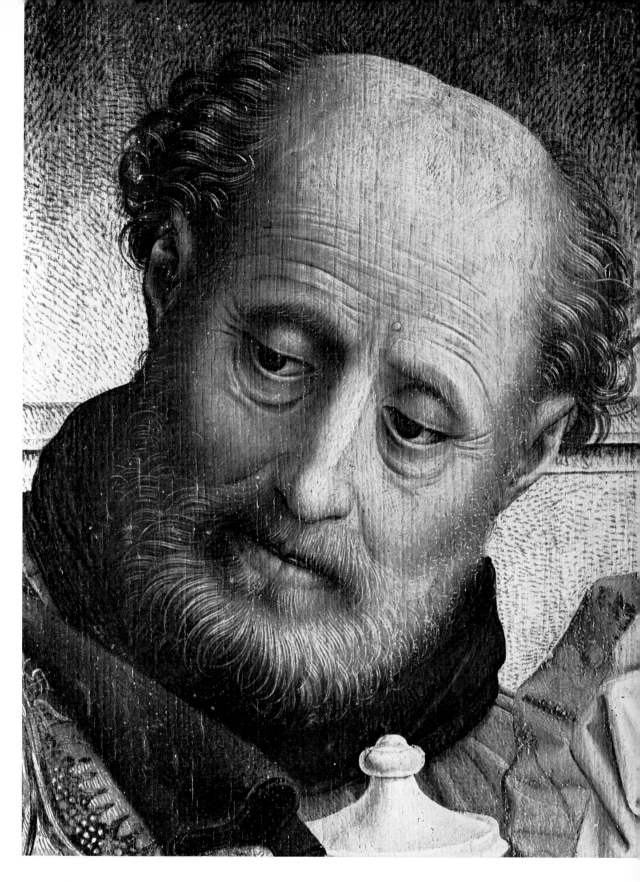

6. Head of Man. Detail from Plate 1 (in original size)

7. Hand and Foot. Detail from Plate 1 (in original size)

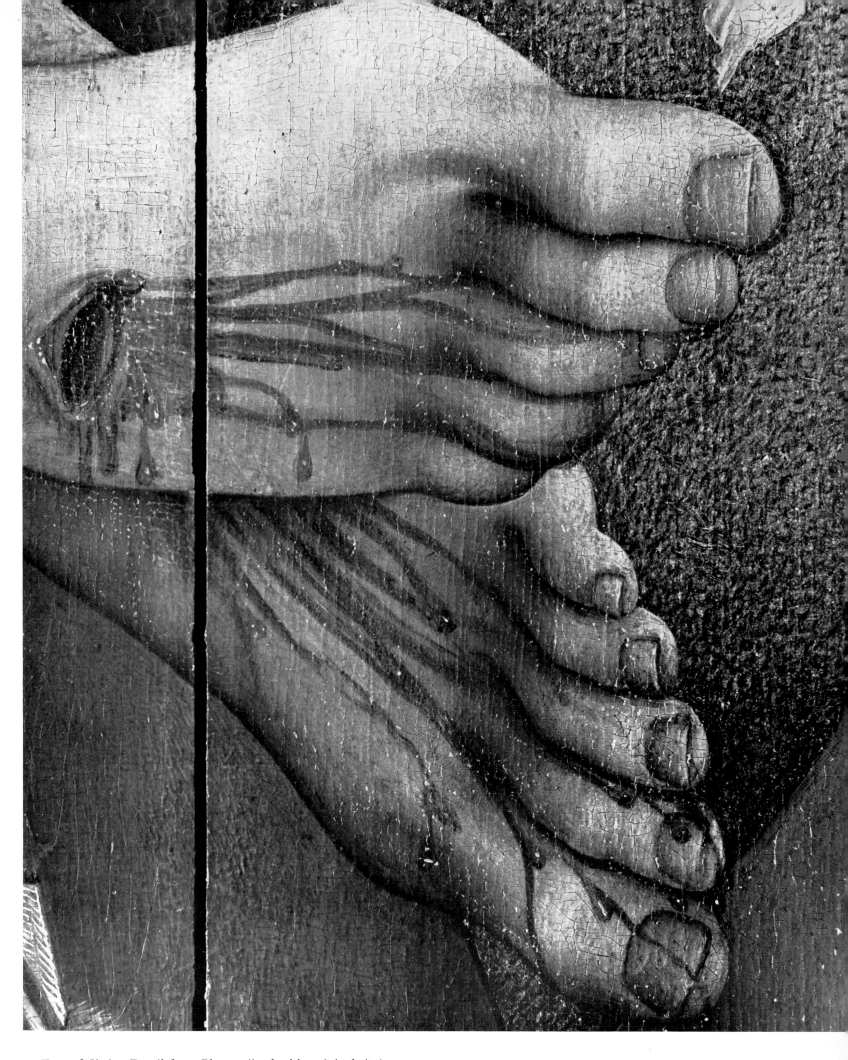

8. Feet of Christ. Detail from Plate 1 (in double original size)

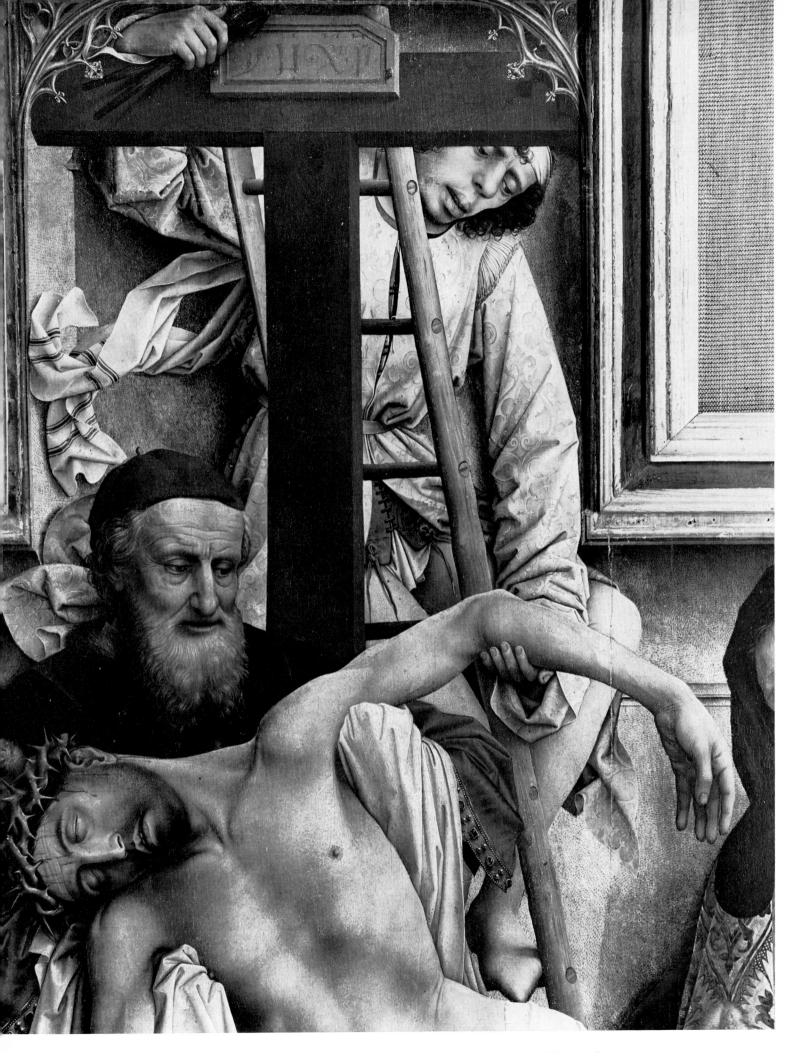

9. The Body of Christ supported by St. Joseph of Arimathaea and the Servant. Detail from Plate 1

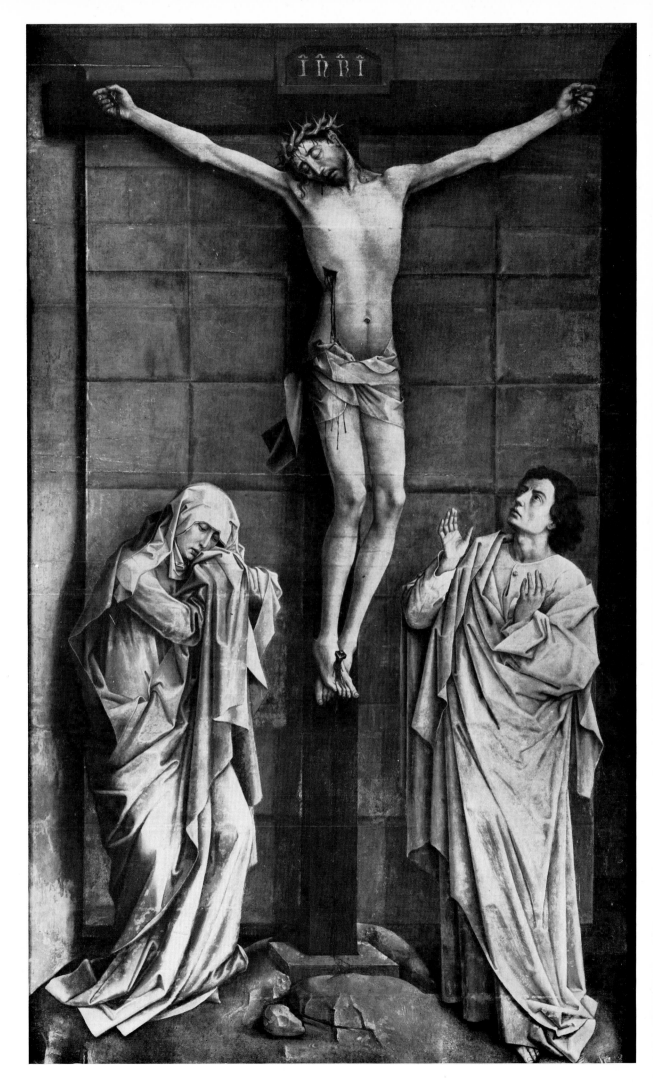

10. *Christ on the Cross
with the Virgin and St. John.* 128 × 75½ in.
Monastery of the Escorial,
Nuevos Museos (Cat. Rogier, Escorial)

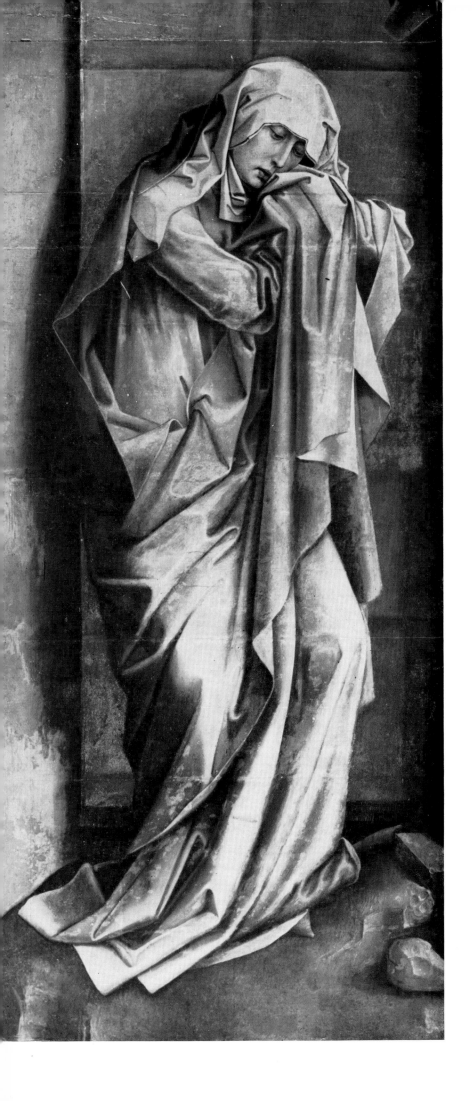

11. The Virgin. Detail from Plate 10

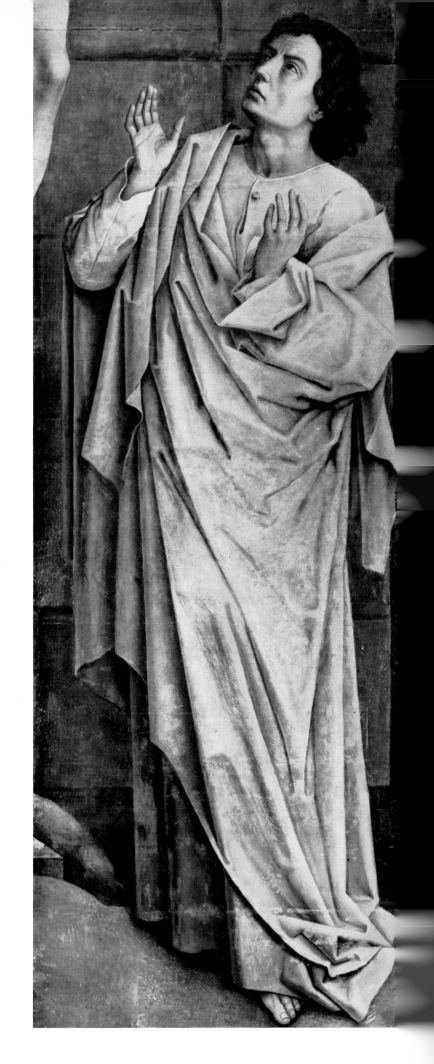

12. St. John. Detail from Plate 10

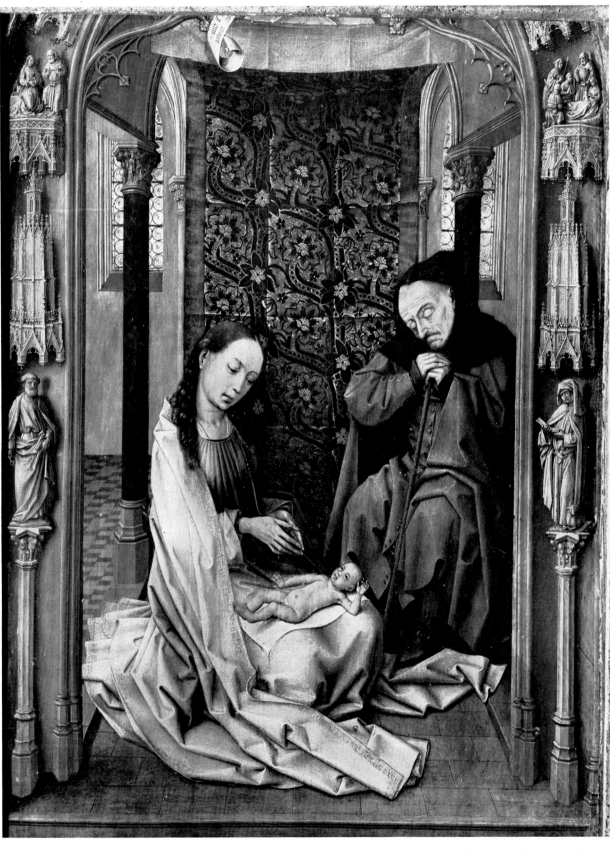

13. *The Holy Family*. 19¾ × 14½ in. (cut at the top). Left wing of the Triptych of the Virgin. Granada, Capilla Real (Cat. Rogier, Granada)

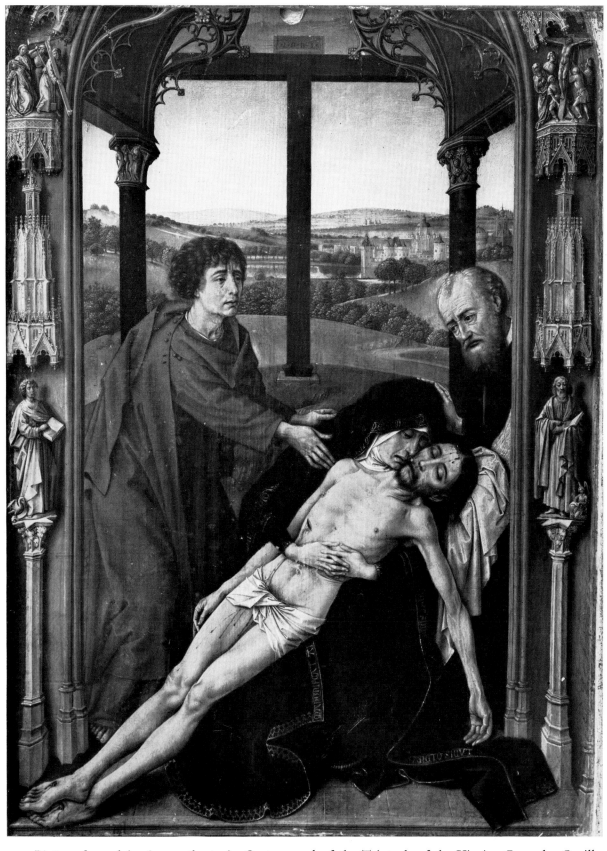

14. *Pietà*. 19¾ × 14½ in. (cut at the top). Centre panel of the Triptych of the Virgin. Granada, Capilla Real (Cat. Rogier, Granada)

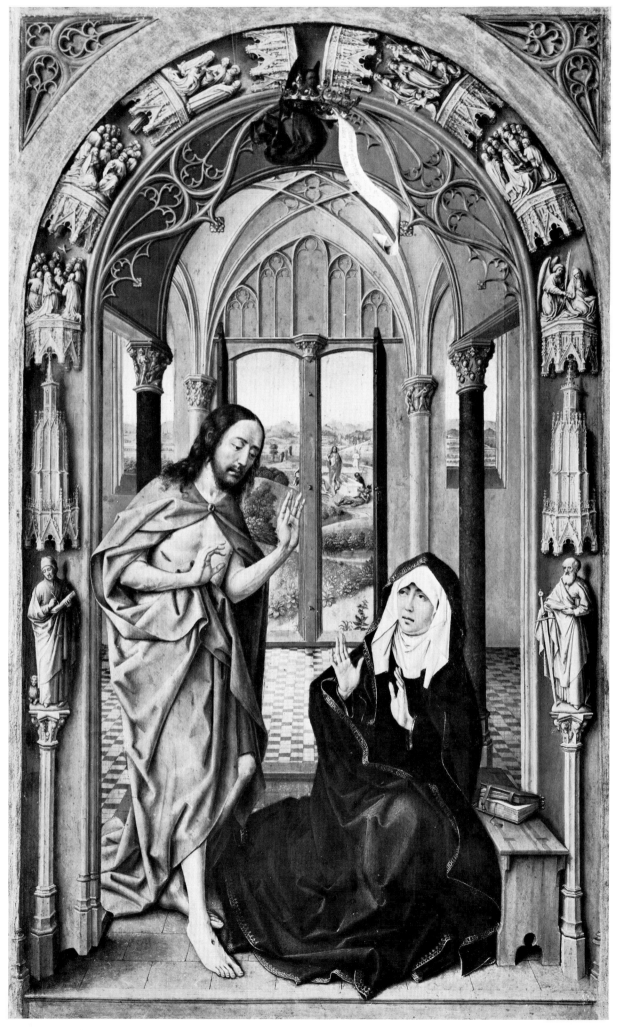

15. *Christ appearing to His Mother after the Resurrection.* 25 × 15 in. Right wing of the Triptych of the Virgin. New York, Metropolitan Museum of Art (see Cat. Rogier, Granada)

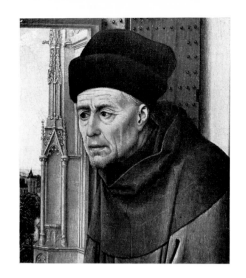

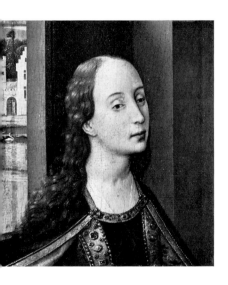

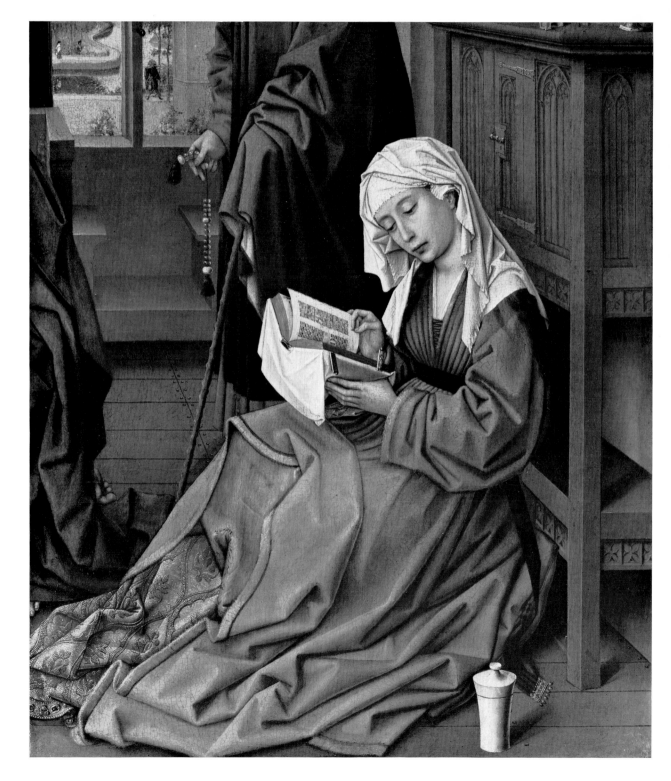

16-18. Fragments of an Altarpiece:
Heads of St. Joseph and St. Catherine (?).
Each 8½ × 7 in. Lisbon,
Calouste Gulbenkian Foundation.
The Magdalen reading. 24¼ × 21½ in.
London, National Gallery
(Cat. Rogier, London 1)

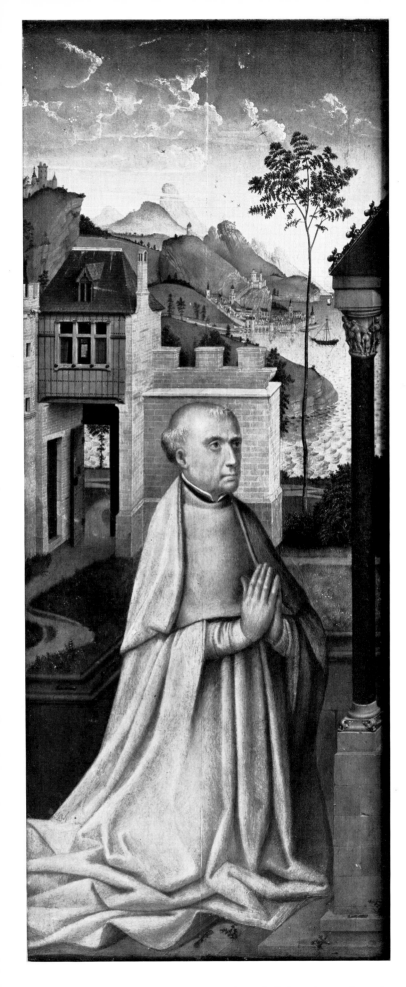 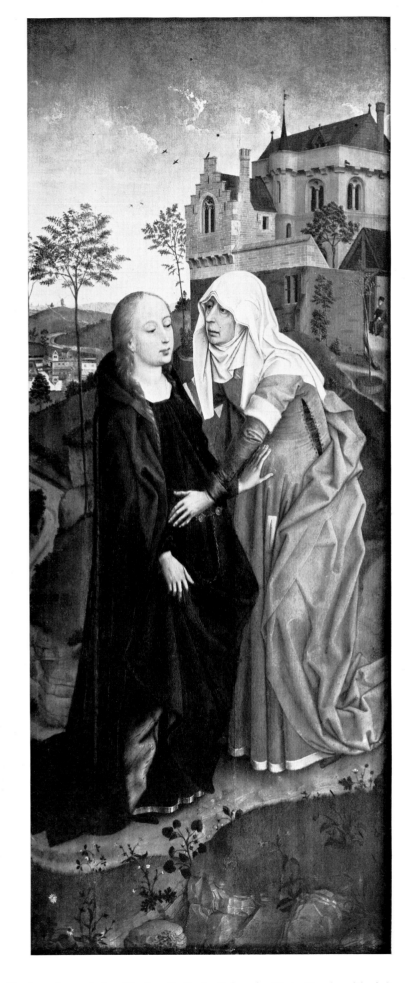

19-20. *A Donor; The Visitation*. Left and right wings of a triptych. Each $34\frac{1}{2} \times 14\frac{1}{2}$ in. Turin, Galleria Sabauda (Cat. Rogier, Turin)

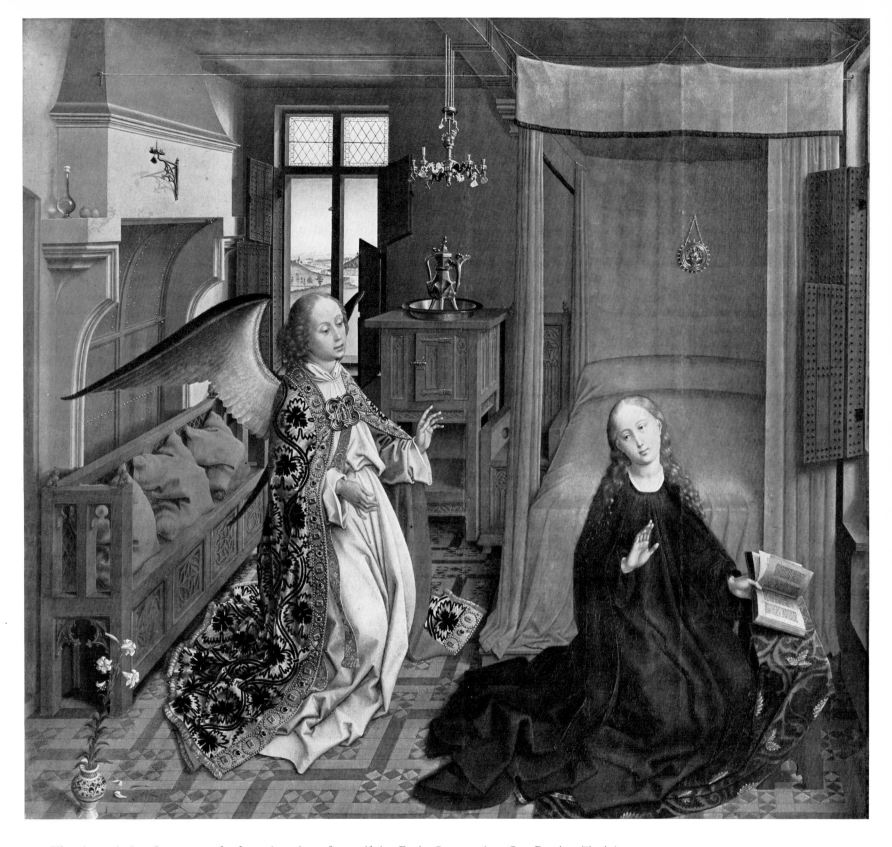

21. *The Annunciation*. Centre panel of a triptych. 33¾ × 36¼ in. Paris, Louvre (see Cat. Rogier, Turin)

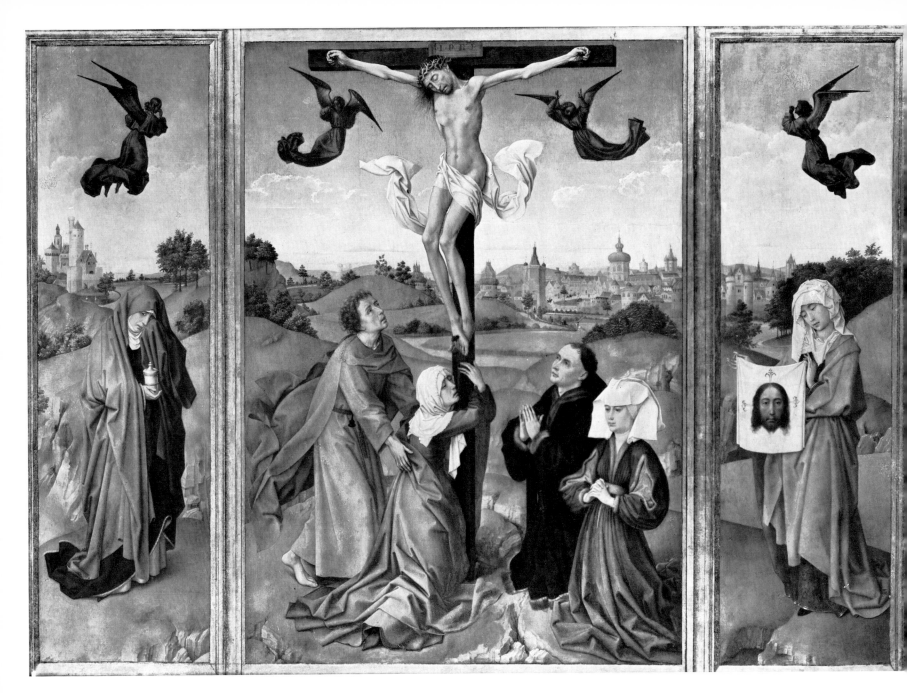

22. *Triptych: Christ on the Cross; the Virgin, St. John, The Magdalen, St. Veronica; two Donors.* Centre, $37\frac{3}{4} \times 27\frac{1}{4}$ in., each wing, $37\frac{3}{4} \times 10\frac{5}{8}$ in.
Vienna, Kunsthistorisches Museum (Cat. Rogier, Vienna 2)

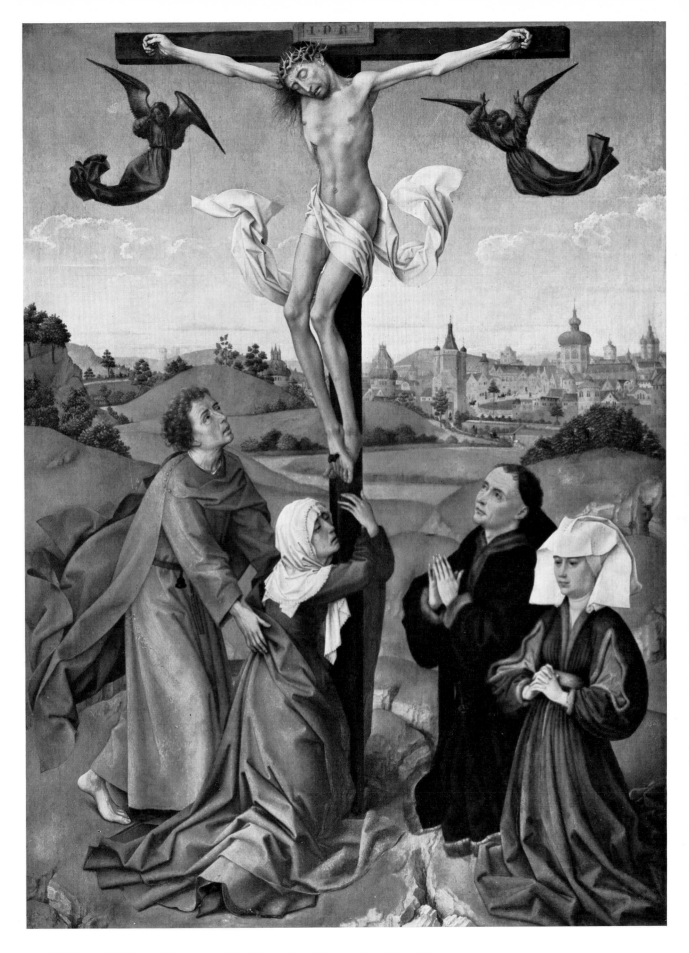

23. *Christ on the Cross*. Centre panel of the triptych reproduced on Plate 22

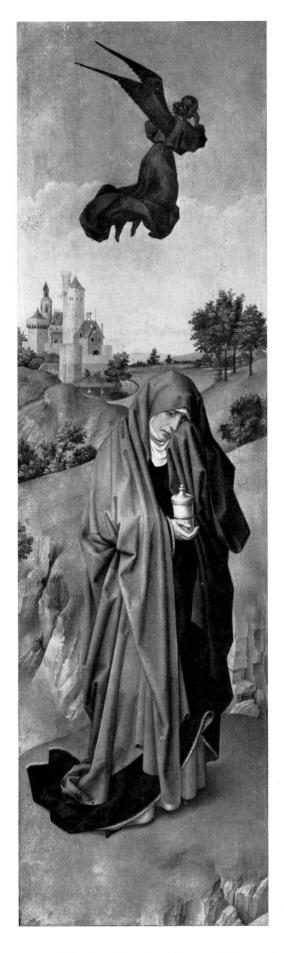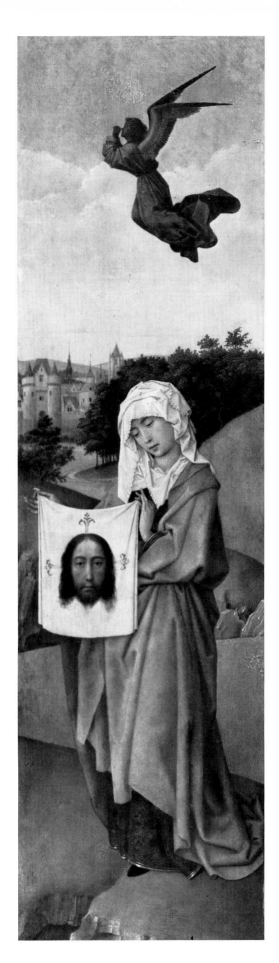

24-25. *The Magdalen, St. Veronica*. Wings of the triptych reproduced on Plate 22

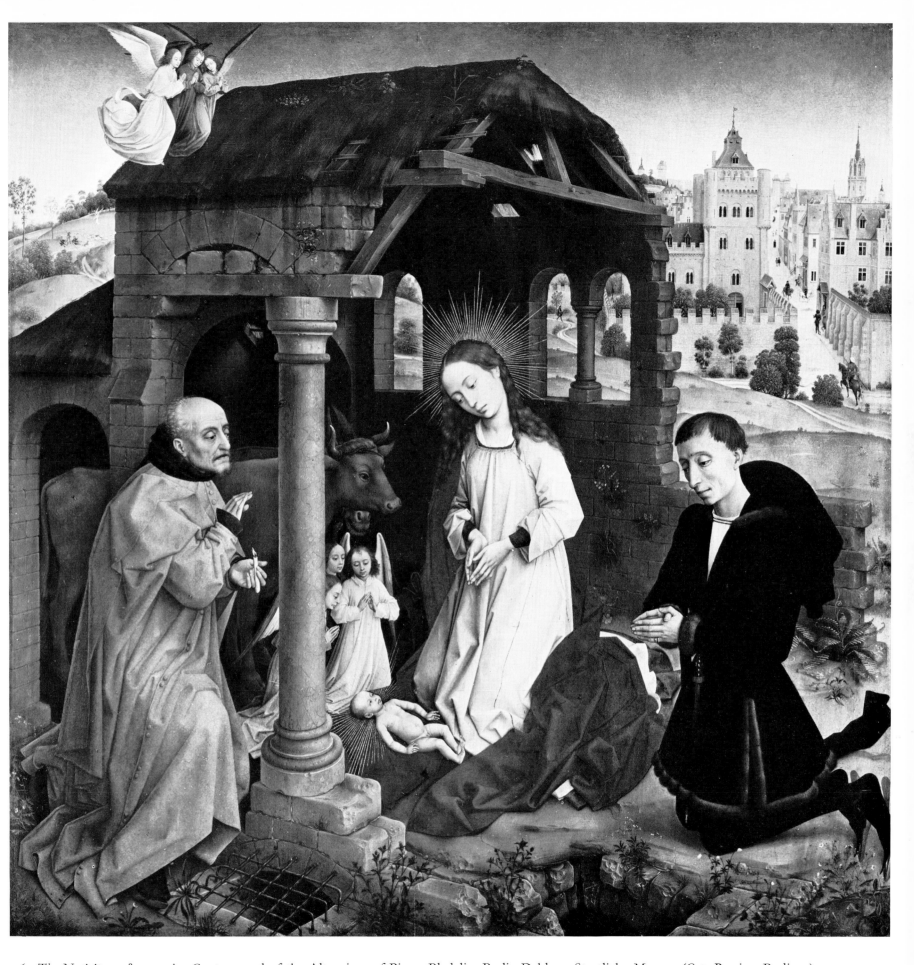

26. *The Nativity.* 35¾ × 35 in. Centre panel of the Altarpiece of Pierre Bladelin. Berlin-Dahlem, Staatliche Museen (Cat. Rogier, Berlin 4)

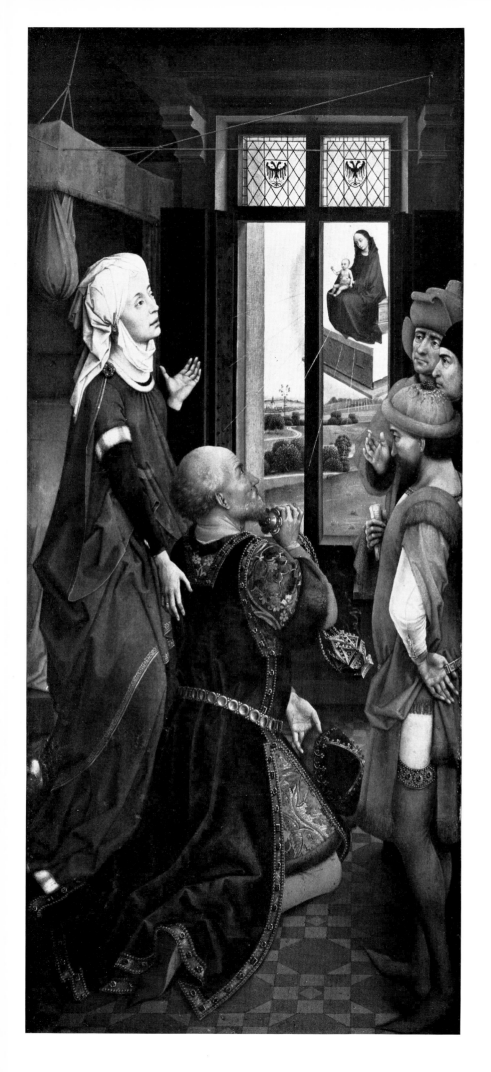

27. *Augustus and the Sibyl.* $35\frac{3}{4} \times 15\frac{3}{4}$ in.
Left wing of the Altarpiece of Pierre Bladelin.
Berlin-Dahlem, Staatliche Museen (Cat. Rogier, Berlin 4)

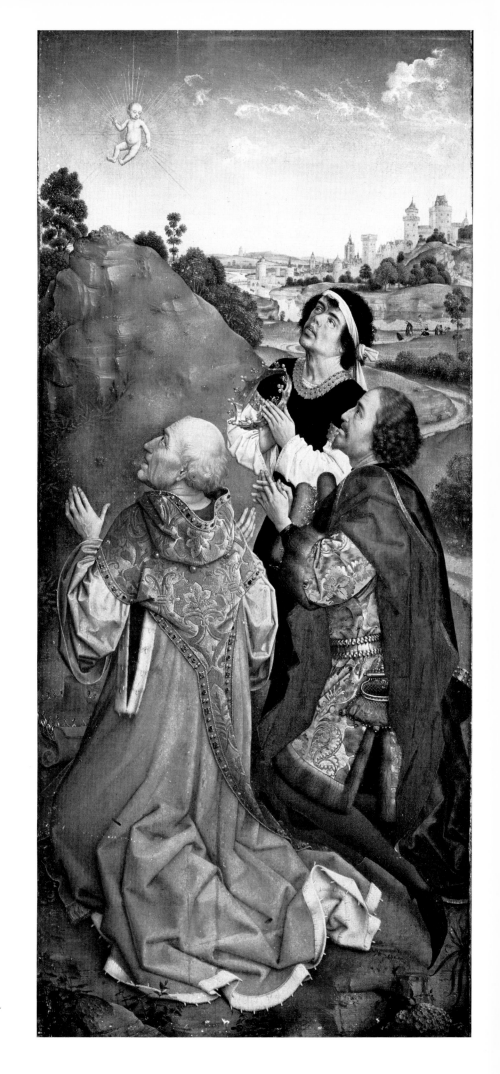

28. *The Star of Bethlehem appearing to the Magi.* 35¾ × 15¾ in.
Right wing of the Altarpiece of Pierre Bladelin.
Berlin-Dahlem, Staatliche Museen (Cat. Rogier, Berlin 4)

29. The Vision of Augustus and the Sibyl. Detail from Plate 27

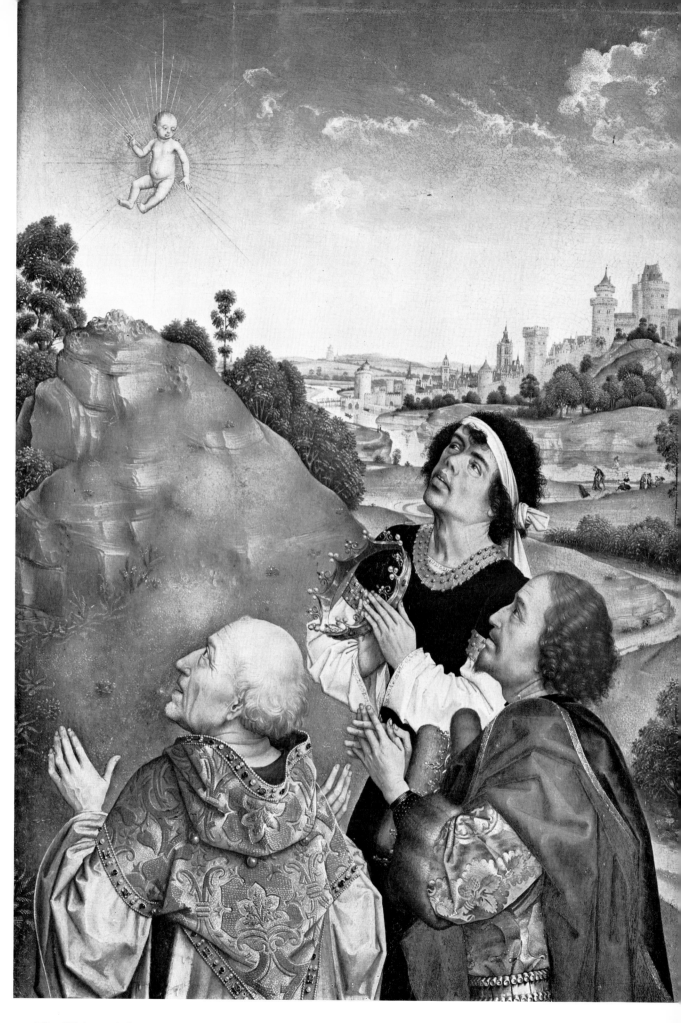

30. The Vision of the Magi. Detail from Plate 28

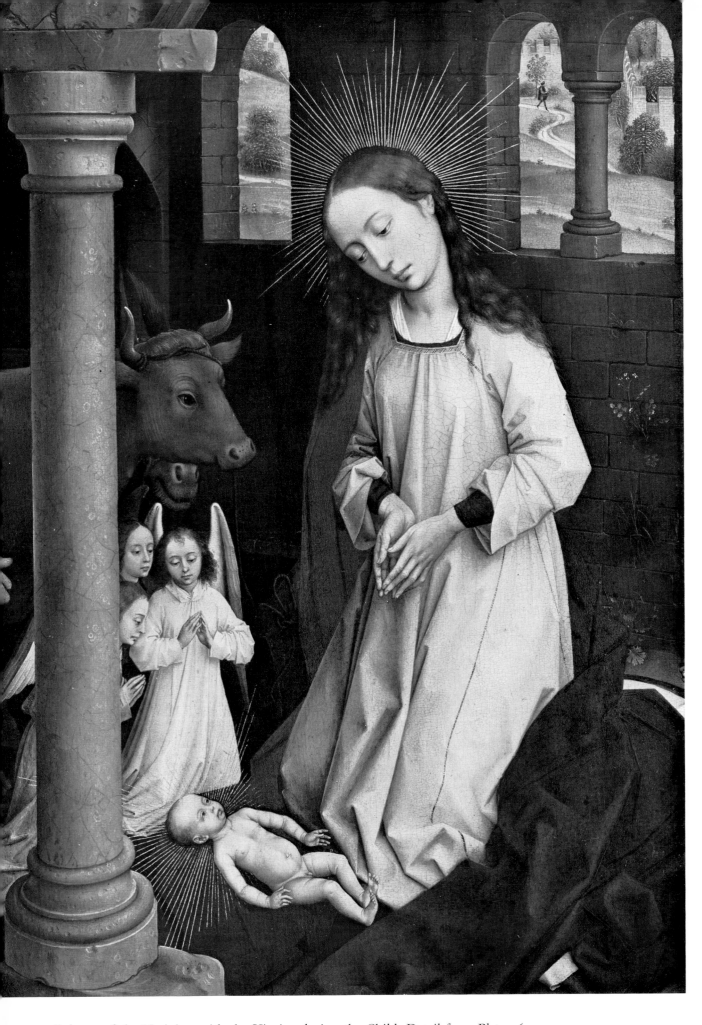

31. Column of the Nativity, with the Virgin adoring the Child. Detail from Plate 26

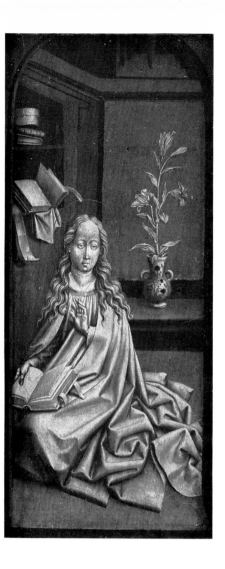
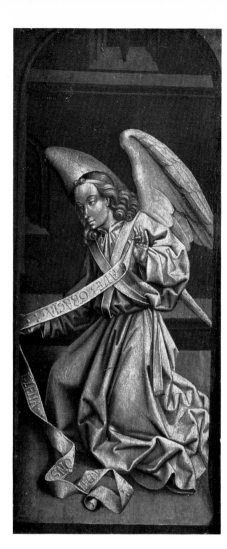

32-33. *The Annunciation.* Each panel $35\frac{3}{4} \times 15\frac{3}{4}$ in.
Grisaille on the outside of the wings of the Altarpiece of Pierre Bladelin.
Berlin-Dahlem, Staatliche Museen (Cat. Rogier, Berlin 4)

34-35. *The Annunciation.* Each panel ca. $29\frac{1}{4} \times 18\frac{1}{4}$ in.
Grisaille on the outside of the wings of the
Triptych of the Last Judgement. Beaune, Hôtel-Dieu
(Cat. Rogier, Beaune)

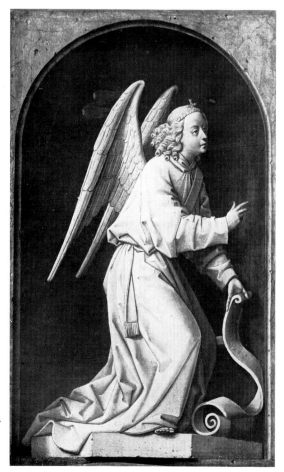
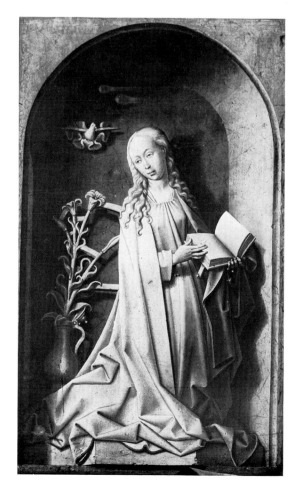

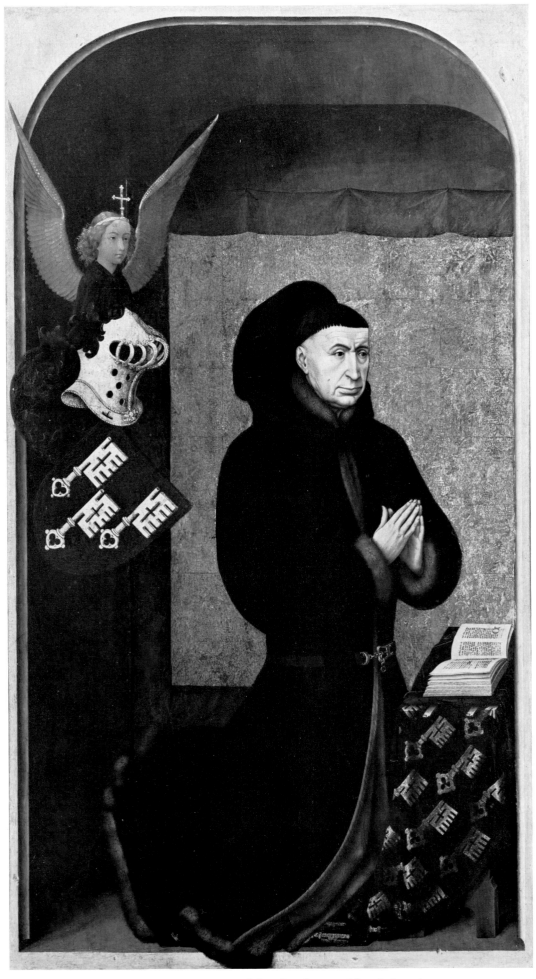

36. *The Donor, Nicolas Rolin*. ca. 54 × 32½ in. On the outside of the wings
of the *Triptych of the Last Judgement*. Beaune, Hôtel-Dieu (Cat. Rogier, Beaune)

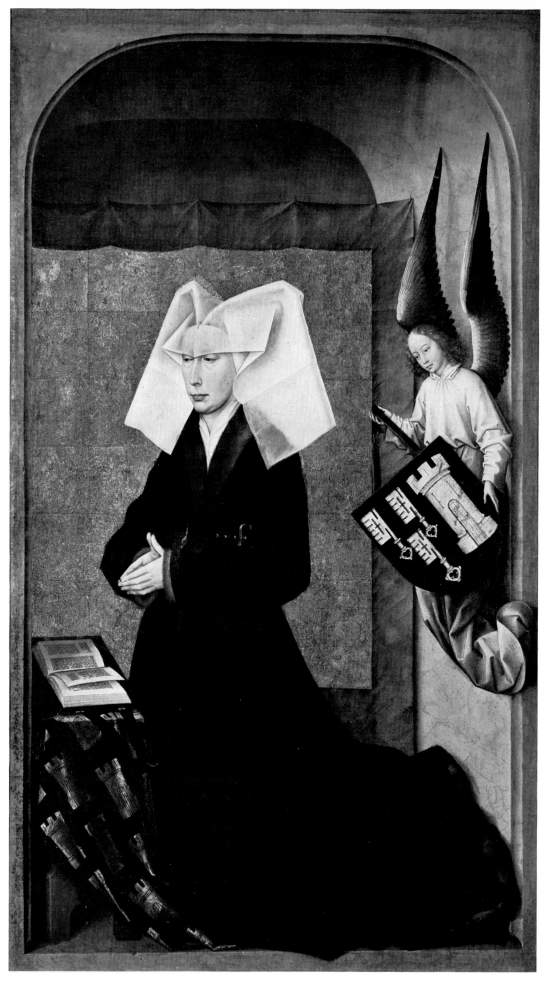

37. *Guigone de Salins, wife of Nicolas Rolin*. ca. 54 × 32½ in. On the outside of the wings
of the *Triptych of the Last Judgement*. Beaune, Hôtel-Dieu (Cat. Rogier, Beaune)

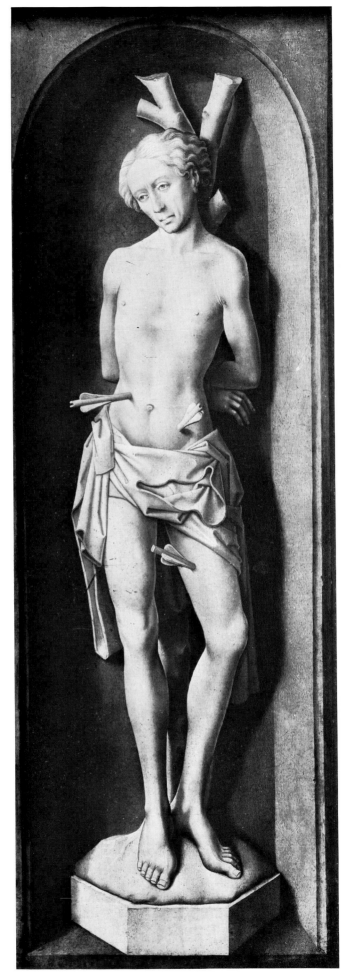
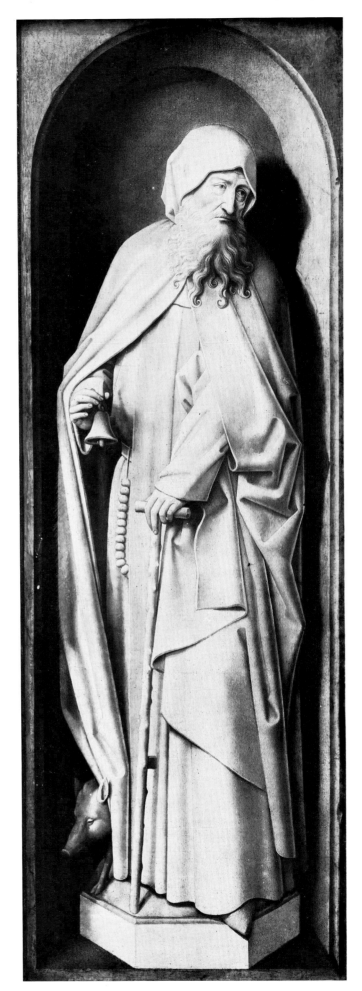

38-39. *St. Sebastian*, *St. Anthony*. Each panel ca. 54 × 21½ in. Grisailles on the outside of the wings of the *Triptych of the Last Judgement*. Beaune, Hôtel-Dieu (Cat. Rogier, Beaune)

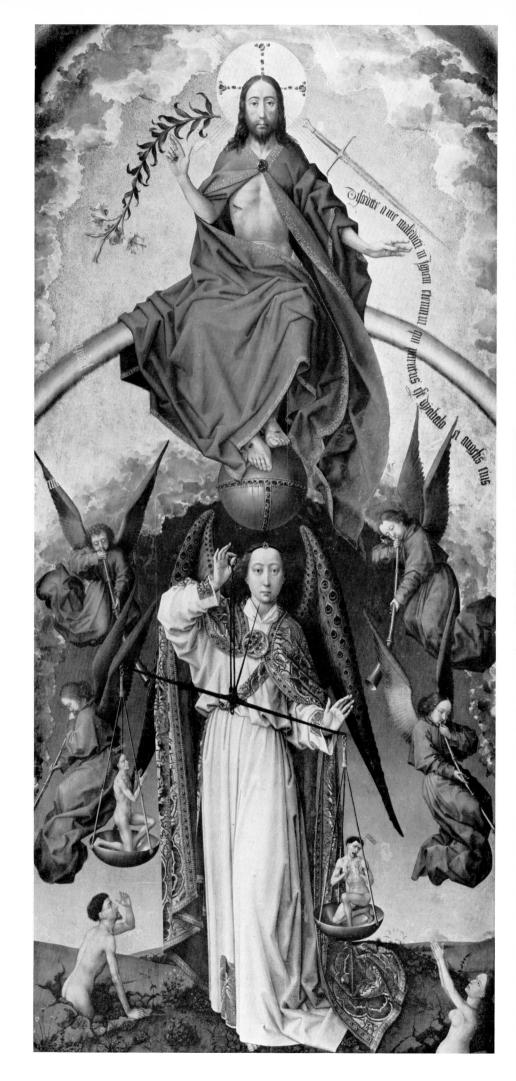

40. *Christ in Judgement*. ca. 86½ × 43 in.
Centre panel of the *Triptych of the Last Judgement*.
Beaune, Hôtel-Dieu (Cat. Rogier, Beaune)

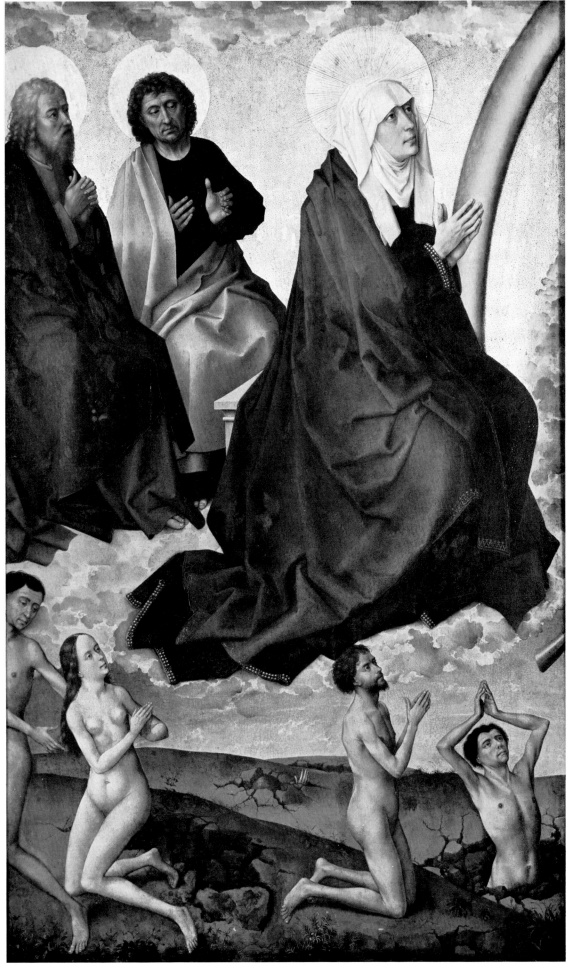

41. *The Virgin and two Apostles*. ca. 54 × 32½ in. Lateral panel of the
Triptych of the Last Judgement. Beaune, Hôtel-Dieu (Cat. Rogier, Beaune)

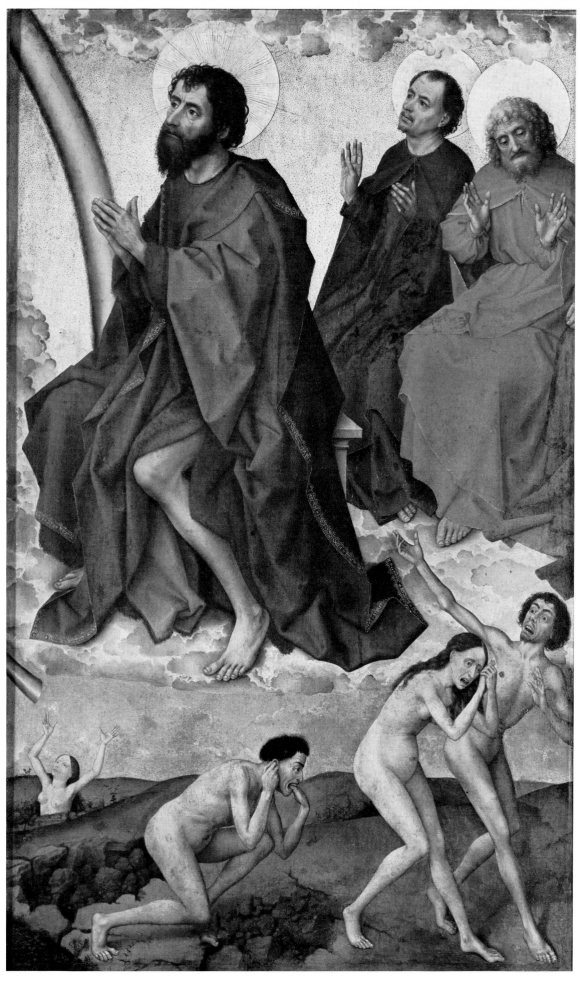

42. *St. John the Baptist and two Apostles*. ca. 54 × 32½ in. Lateral panel of the
Triptych of the Last Judgement. Beaune, Hôtel-Dieu (Cat. Rogier, Beaune)

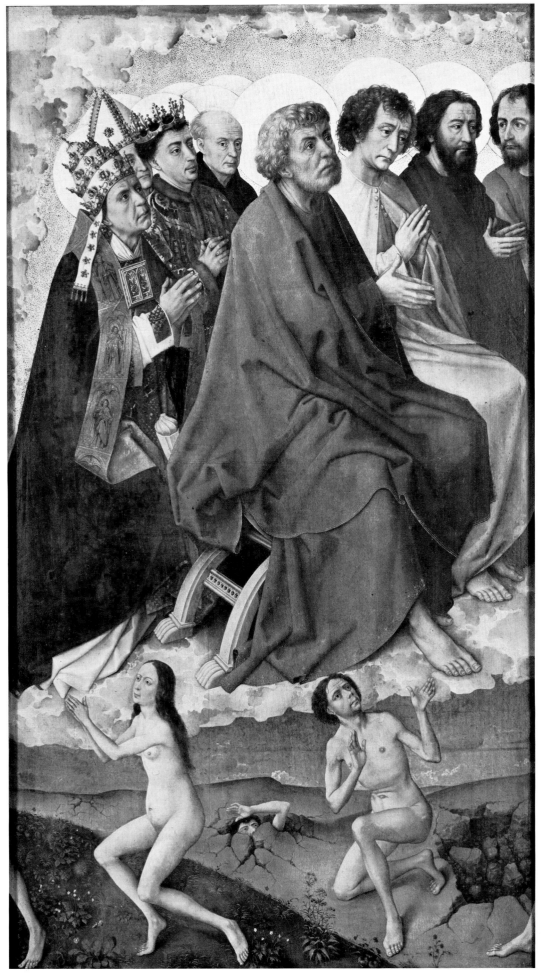

43. *St. Peter, three other Apostles, and four Saints.* ca. 54 × 32½ in. Lateral panel of the *Triptych of the Last Judgement*. Beaune, Hôtel-Dieu (Cat. Rogier, Beaune)

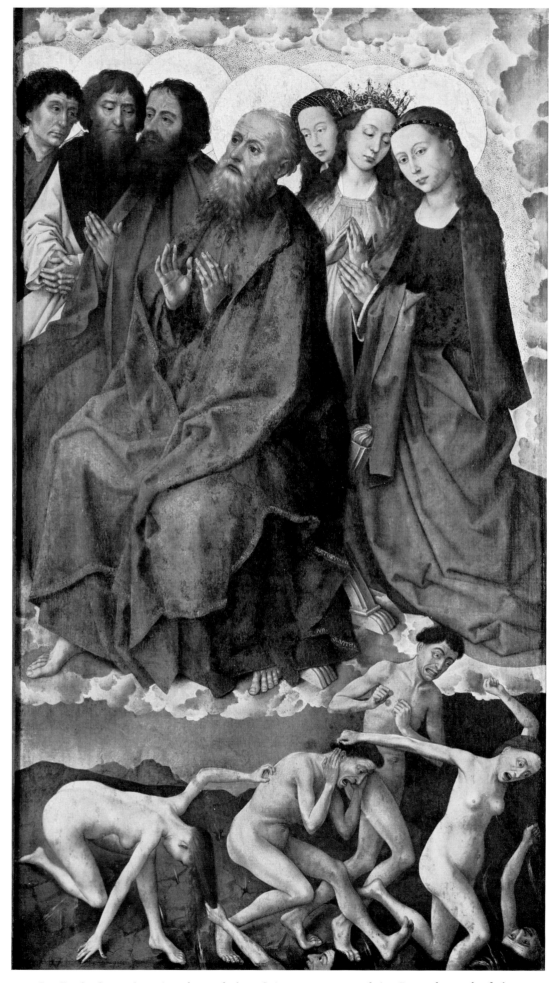

44. *St. Paul, three other Apostles, and three Saints.* ca. 54 × 32½ in. Lateral panel of the *Triptych of the Last Judgement.* Beaune, Hôtel-Dieu (Cat. Rogier, Beaune)

45-46. *The Entrance to Paradise.* ca. 54 × 21½ in.
Angels with Instruments of the Passion. ca. 29¼ × 18¼ in.
Lateral panels of the *Triptych of the Last Judgement.* Beaune, Hôtel-Dieu
(Cat. Rogier, Beaune)

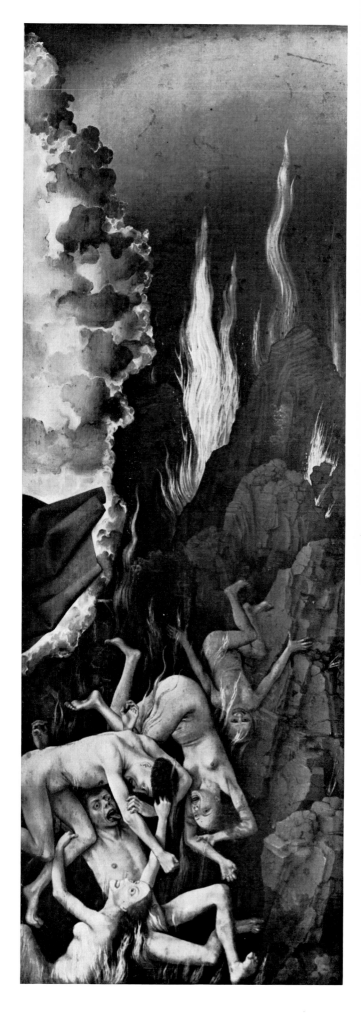

47-48. *Angels with Instruments of the Passion*. ca. 29¼ × 18¼ in.
Hell. ca. 54 × 21½ in.
Lateral panels of the *Triptych of the Last Judgement*. Beaune, Hôtel-Dieu
(Cat. Rogier, Beaune)

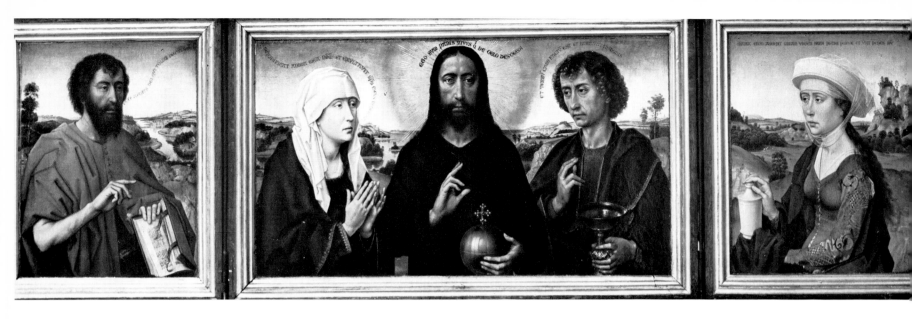

49. *The 'Braque' Triptych: Christ, the Virgin and Saints at Half-Length.* Centre panel 16¼ × 26¾ in., each wing 16¼ × 13⅝ in, including the original framing Paris, Louvre. (Cat. Rogier, Paris 1)

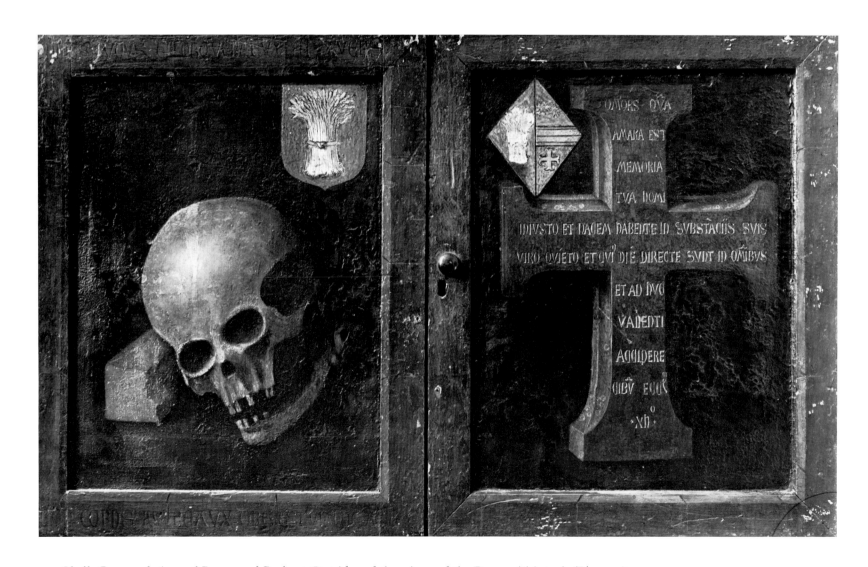

50. *Skull, Cross, and Arms of Braque and Brabant.* Outsides of the wings of the Braque Triptych (Plate 49)

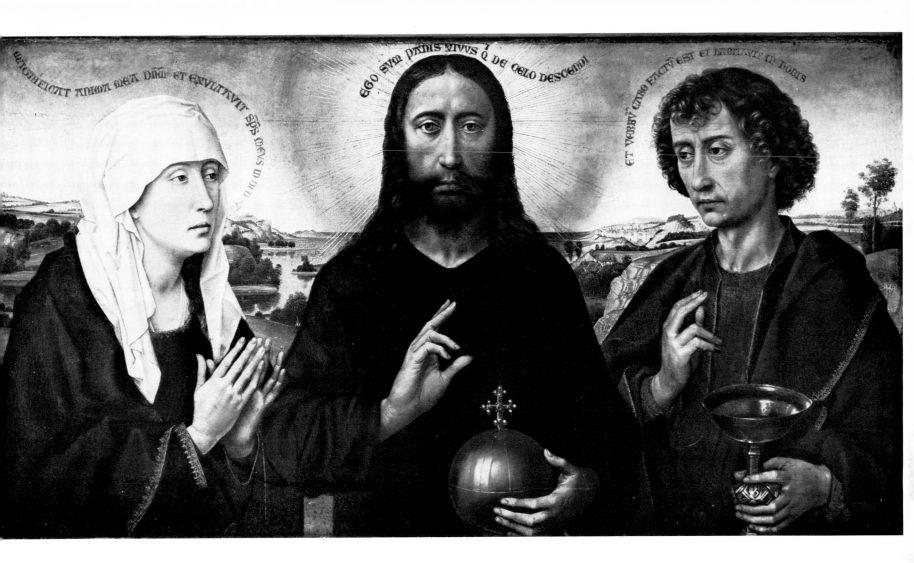

5 1. *Christ between the Virgin and St. John the Evangelist*. Centre panel of the Braque Triptych (Plate 49)

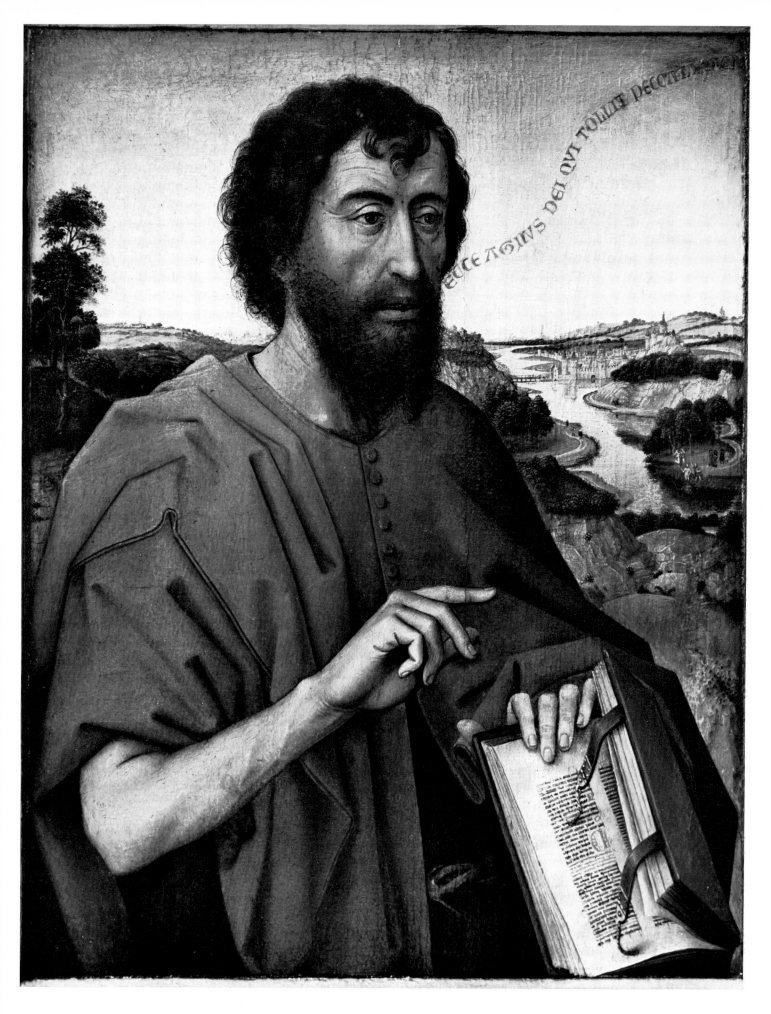

52. *St. John the Baptist.* Left wing of the Braque Triptych (Plate 49)

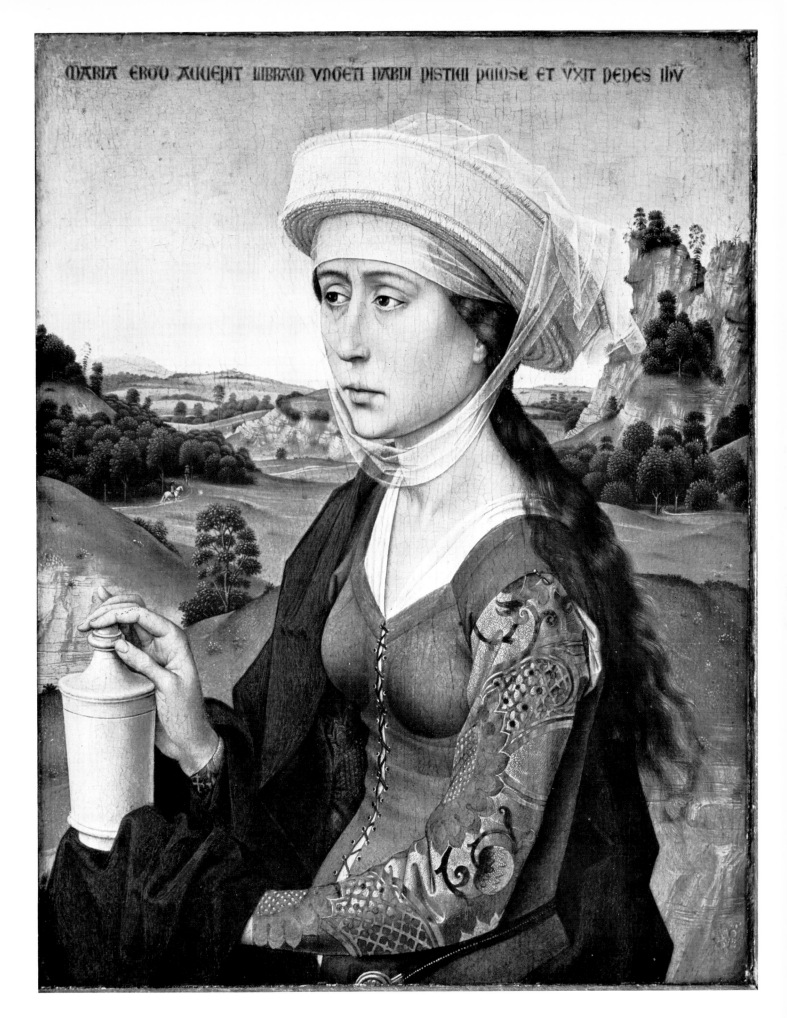

MARIA ERGO ACCEPIT LIBRAM VNGETI NARDI PISTICI PCIOSE ET VNXIT PEDES IHV

53. *The Magdalen*. Right wing of the Braque Triptych (Plate 49)

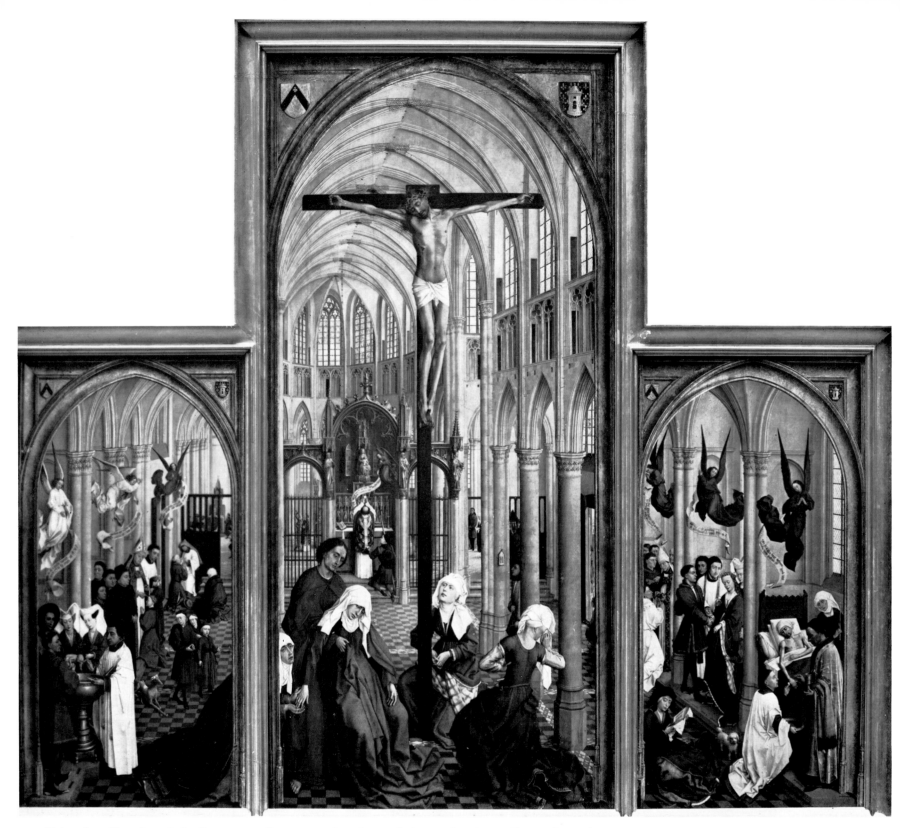

54. *Triptych: Altarpiece of the Sacraments.* Centre panel $78\frac{1}{2} \times 38\frac{1}{4}$ in., each wing $46\frac{3}{4} \times 24\frac{3}{4}$ in. Antwerp, Koninklijk Museum (Cat. Rogier, Antwerp 2)

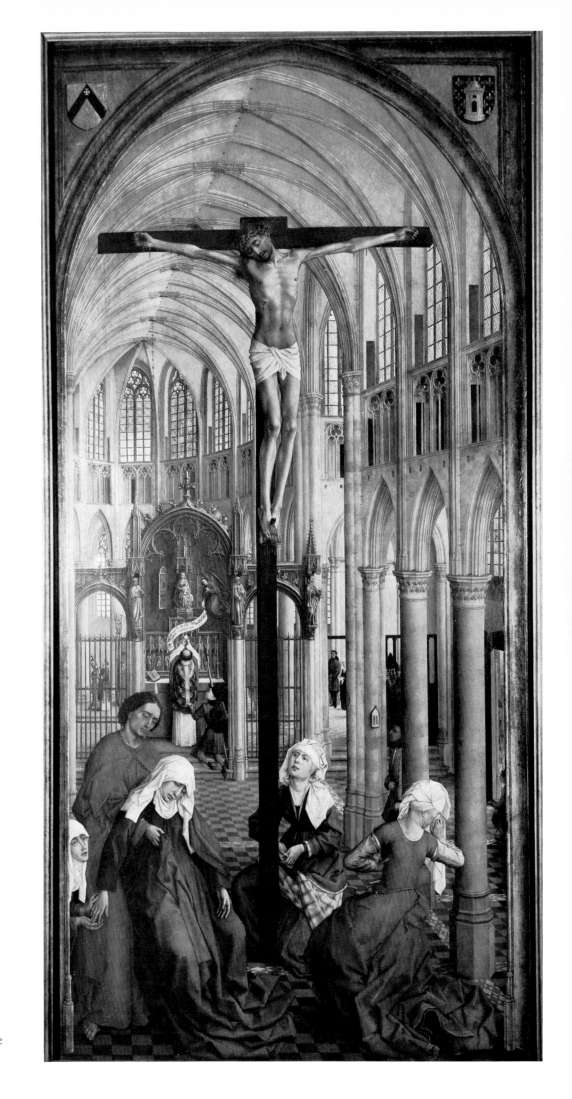

55. *The Eucharist, with Christ on the Cross, the Virgin,
St. John and the three Maries.* Centre panel of the Altarpiece
of the Sacraments (Plate 54)

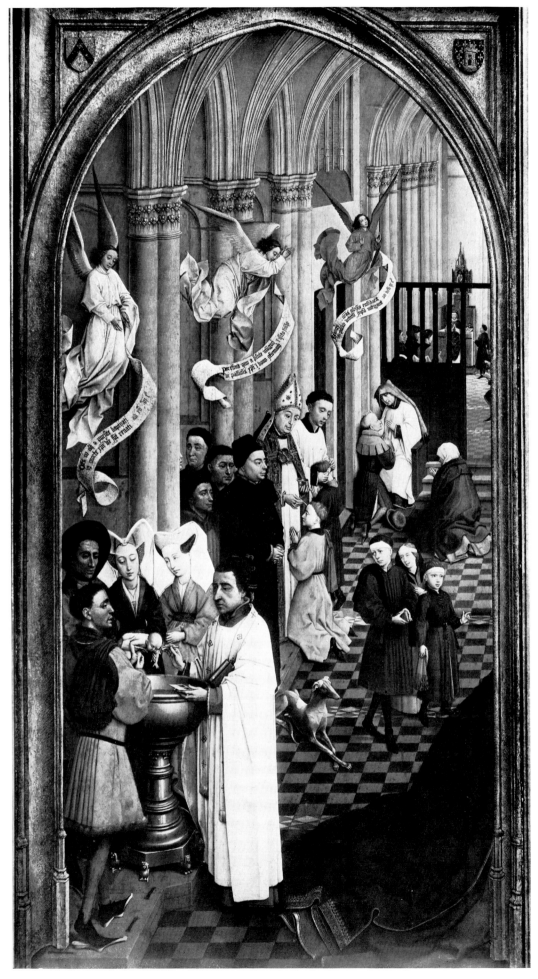

56. *Baptism*, *Confirmation*, *Penance*. Left wing of the Altarpiece of the Sacraments
(Plate 54)

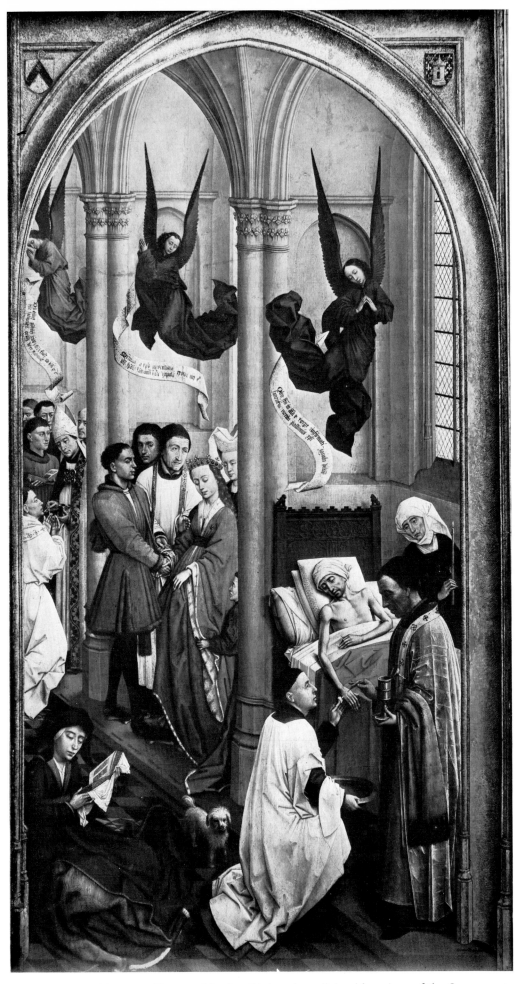

57. *Ordination*, *Marriage*, *Extreme Unction*. Right wing of the Altarpiece of the Sacraments
(Plate 54)

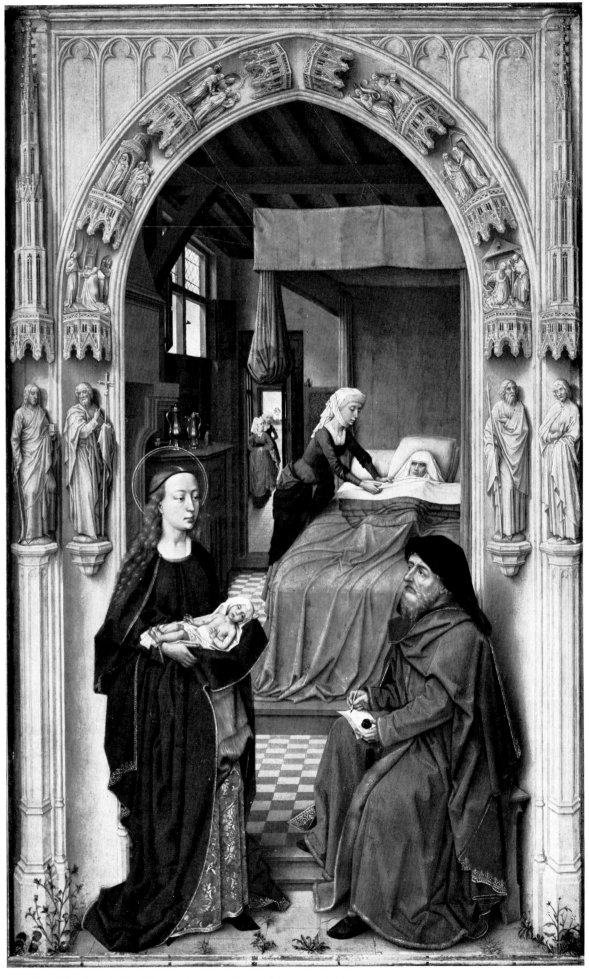

58. *The Naming of St. John.* 30¼ × 19 in. Left wing of the Triptych of St. John the Baptist.
Berlin-Dahlem, Staatliche Museen (Cat. Rogier, Berlin 1)

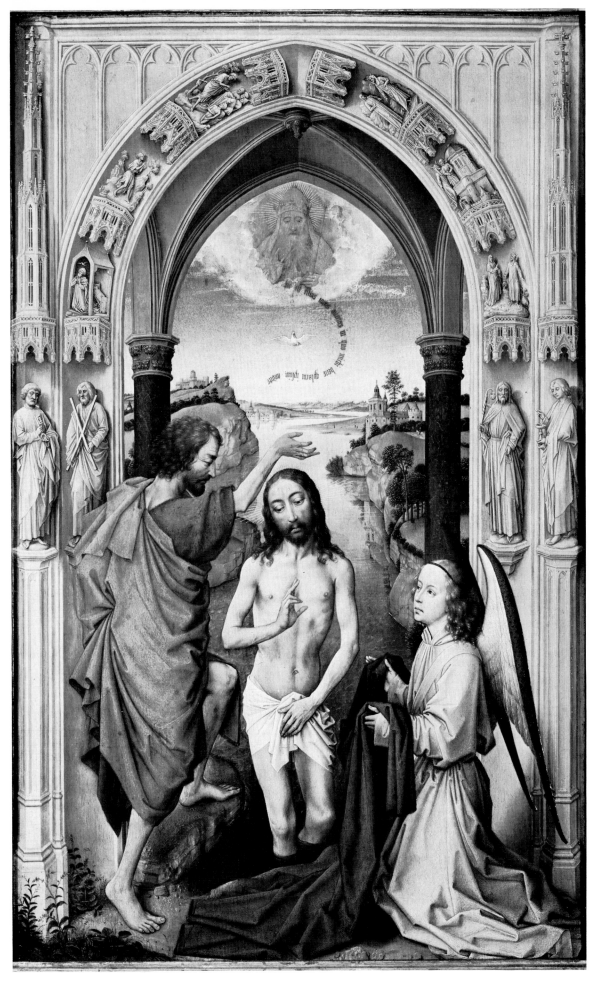

59. *The Baptism of Christ.* 30¼ × 19 in. Centre panel of the Triptych of St. John the Baptist. Berlin-Dahlem, Staatliche Museen (Cat. Rogier, Berlin 1)

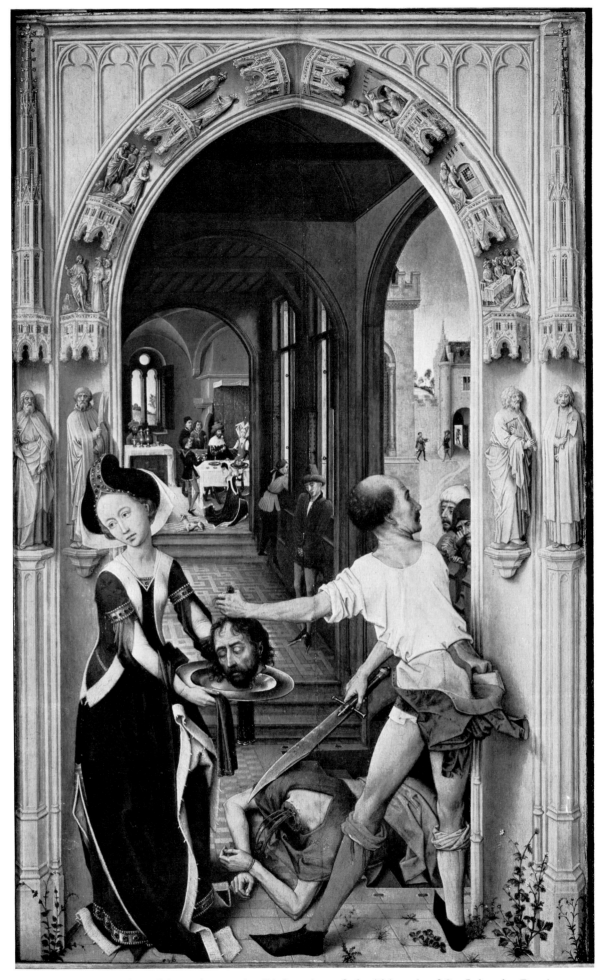

60. *The Beheading of St. John.* 30¼ × 19 in. Right wing of the Triptych of St. John the Baptist.
Berlin-Dahlem, Staatliche Museen (Cat. Rogier, Berlin 1)

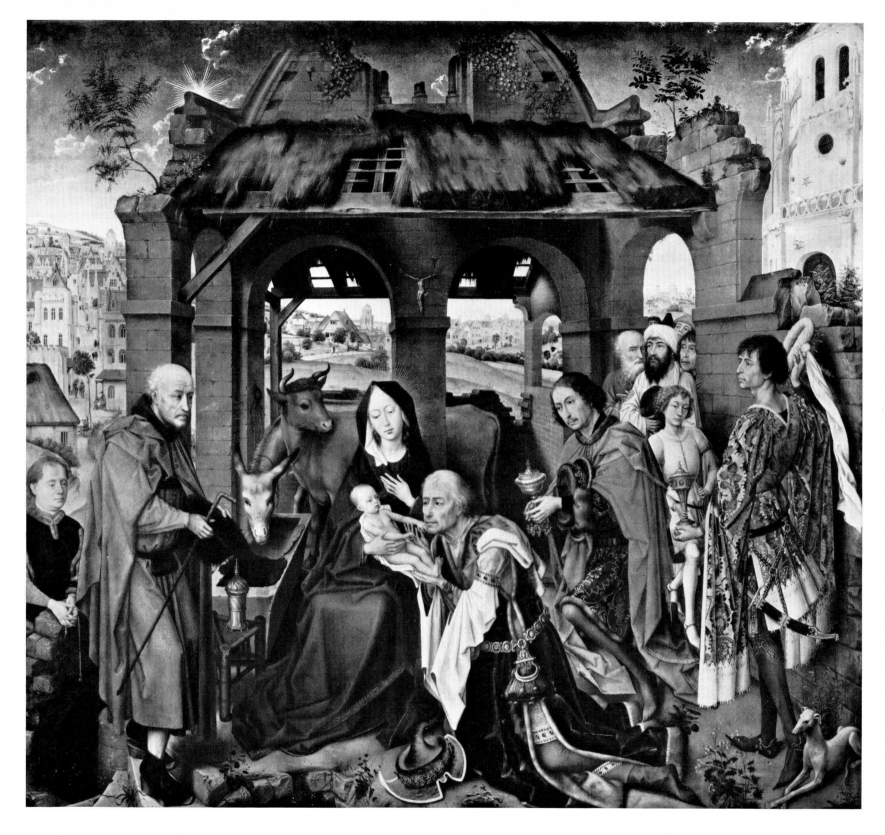

61. *The Adoration of the Kings*. 54¼ × 60¼ in. Centre panel of the 'Columba Altarpiece'. Munich, Alte Pinakothek (Cat. Rogier, Munich 1)

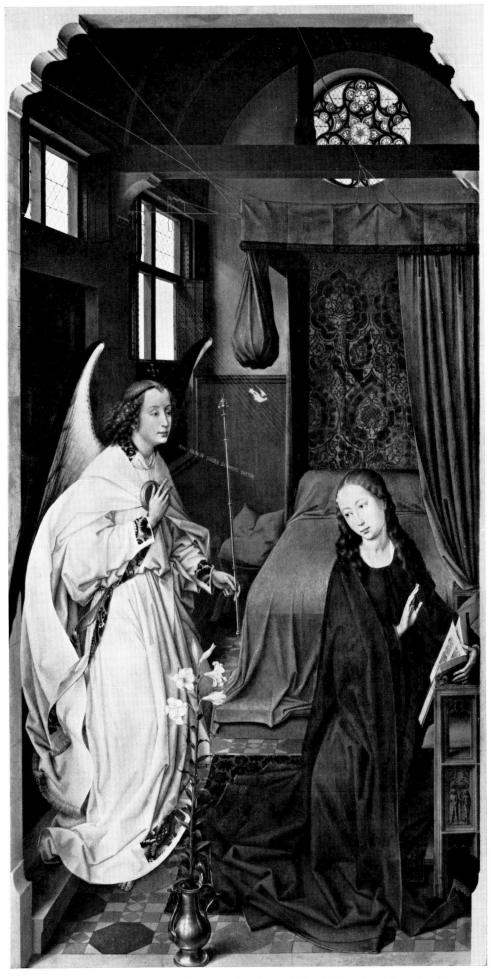

62. *The Annunciation*. $54\frac{1}{4} \times 27\frac{1}{2}$ in. Left wing of the 'Columba Altarpiece'.
Munich, Alte Pinakothek (Cat. Rogier, Munich 1)

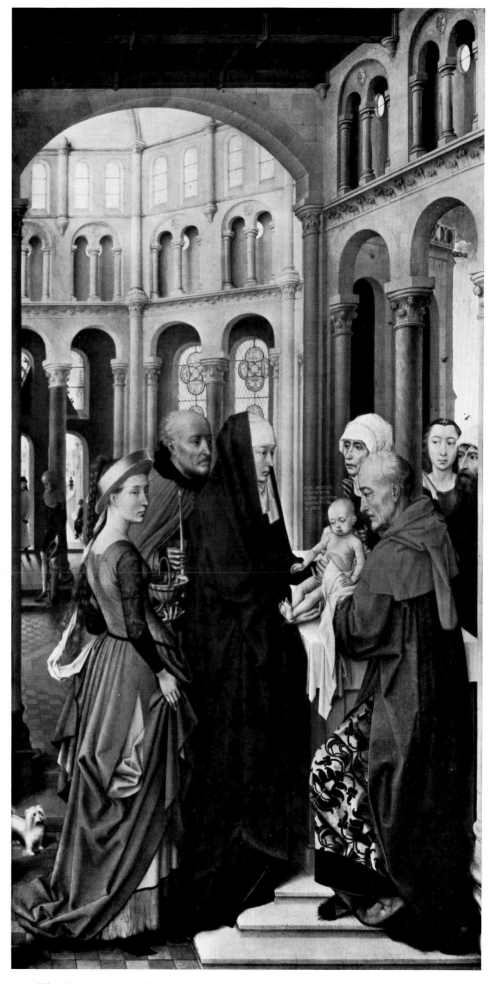

63. *The Presentation.* 54¼ × 27½ in. Right wing of the 'Columba Altarpiece'.
Munich, Alte Pinakothek (Cat. Rogier, Munich 1)

64. The Gift of the Second King. Detail from Plate 61 (in original size)

65. The Gift of the Third King. Detail from Plate 61 (in original size)

66. Greyhound and Plants. Detail from Plate 61 (in original size)

67. Distant Landscape. Detail from Plate 61 (in original size)

68. The Archangel's Robe. Detail from Plate 62

69. Head of Anna the Prophetess. Detail from Plate 63 (in double original size)

70. *The Visitation.* $22\frac{1}{2} \times 14\frac{1}{4}$ in. Leipzig, Museum (Cat. Rogier, Leipzig)

71. *The Virgin and Child in a Niche*. 39¼ × 20½ in. Madrid, Prado
(Cat. Rogier, Madrid 2)

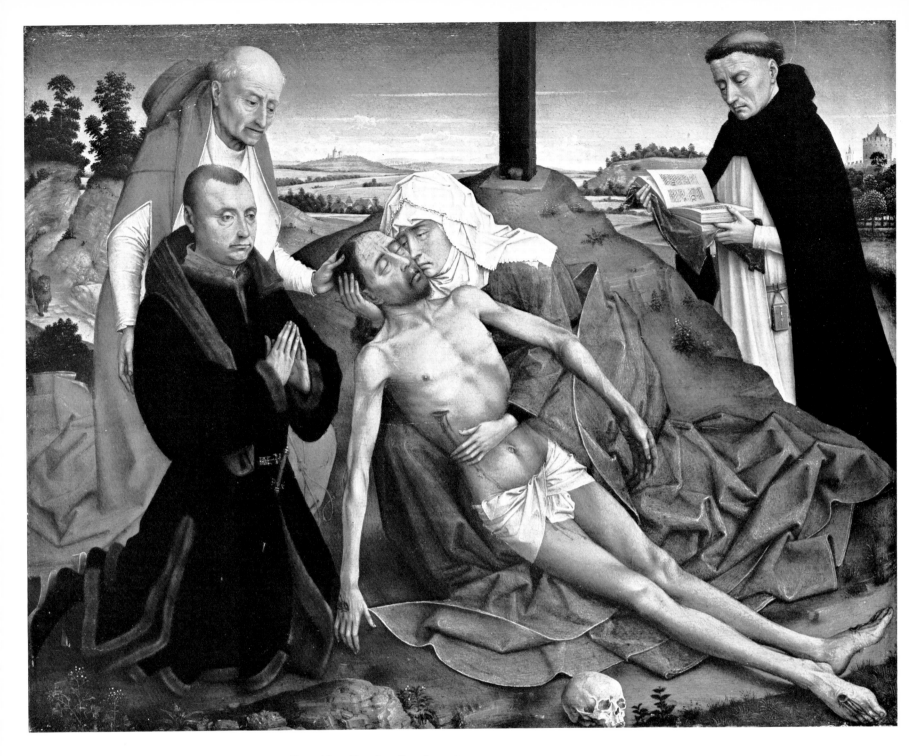

72. *Pietà*. 14 × 17¾ in. London, National Gallery (Cat. Rogier, London 3)

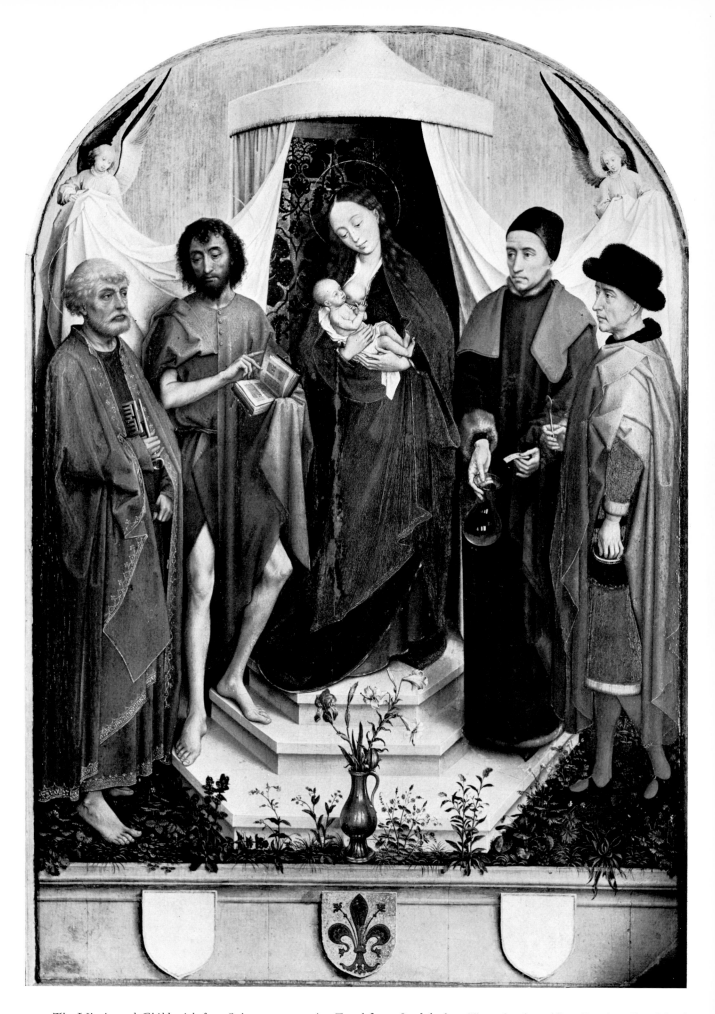

73. *The Virgin and Child with four Saints.* 21 × 15 in. Frankfurt, Städelsches Kunstinstitut (Cat. Rogier, Frankfurt)

74. *Jean Wauquelin Presents a Book to Philip the Good*. Miniature in a manuscript, from a page 17¼ × 12¼ in. Brussels, Bibliothèque Royale (Cat. Rogier, Brussels, Bibliothèque Royale)

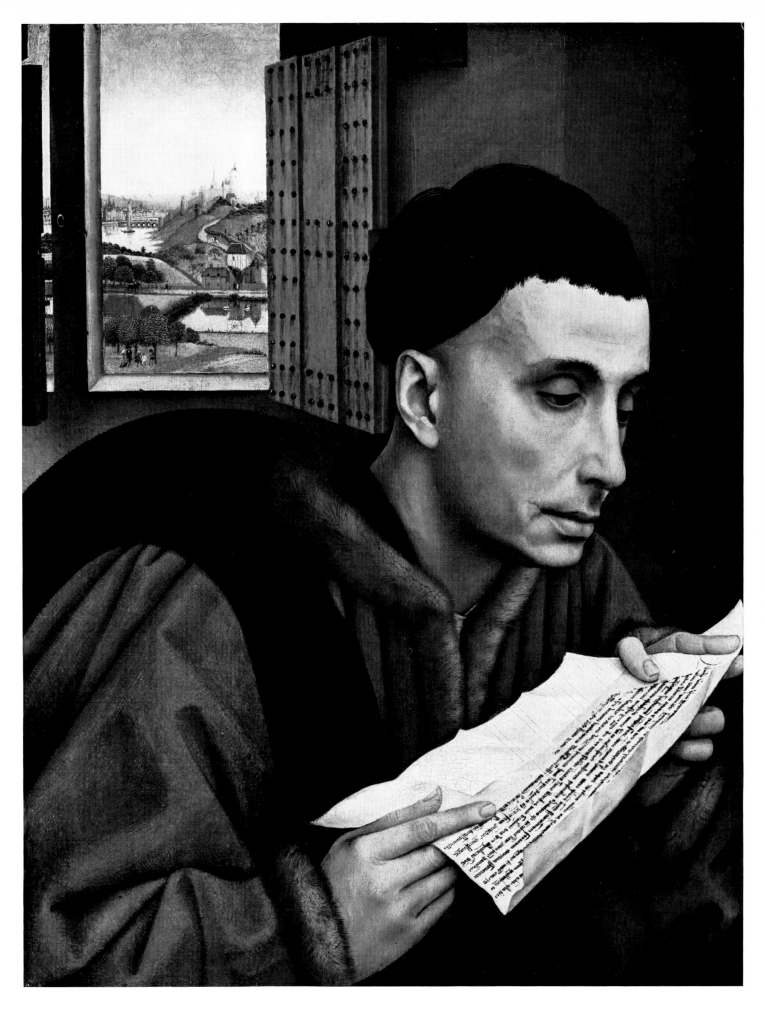

75. *St. Ivo* (?). 17¾ × 13¾ in. London, National Gallery (Cat. Rogier, London 5)

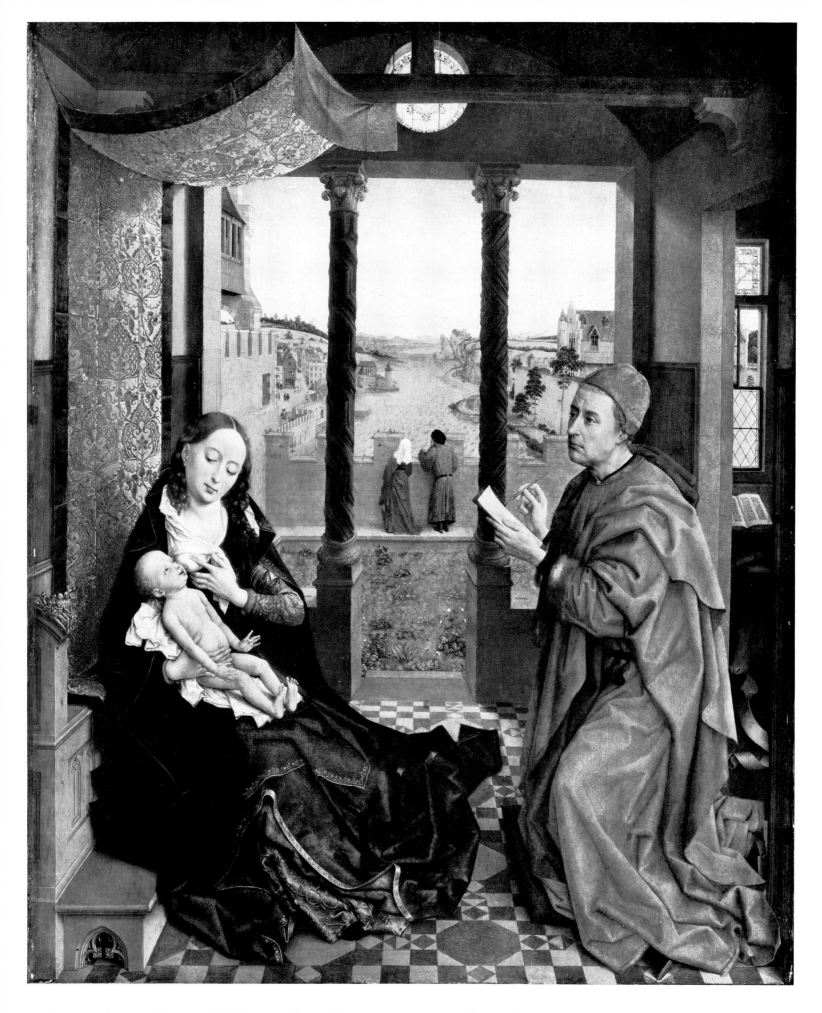

76. *St. Luke drawing a Portrait of the Virgin.* 53¼ × 42¾ in. Boston, Museum of Fine Arts (Cat. Rogier, Boston)

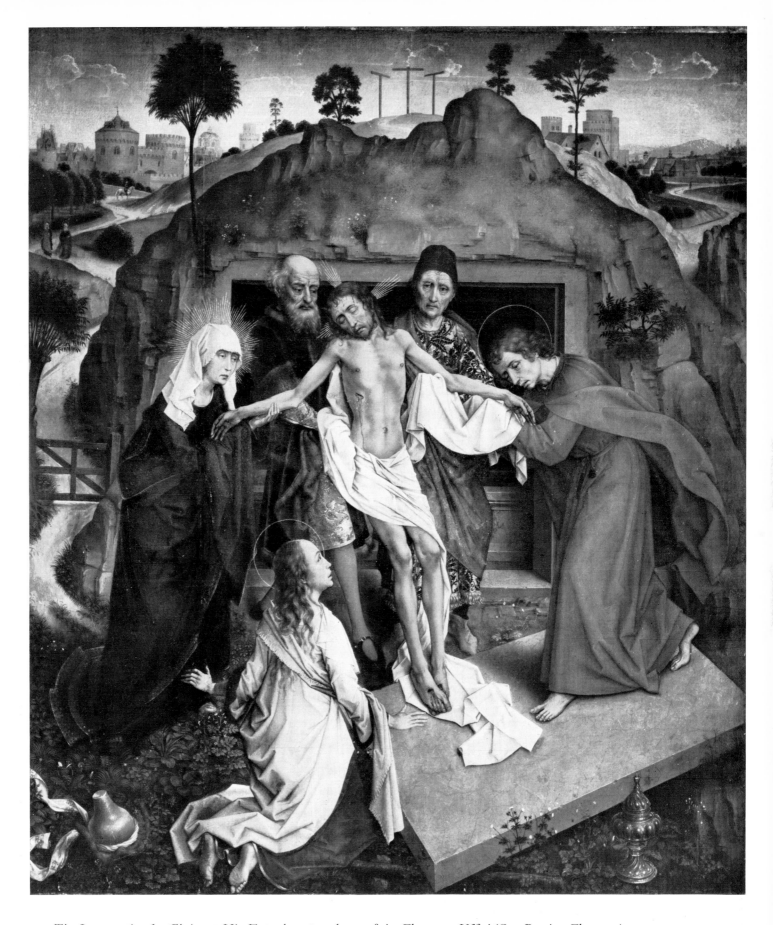

77. *The Lamentation for Christ at His Entombment.* $43\frac{1}{4} \times 37\frac{3}{4}$ in. Florence, Uffizi (Cat. Rogier, Florence)

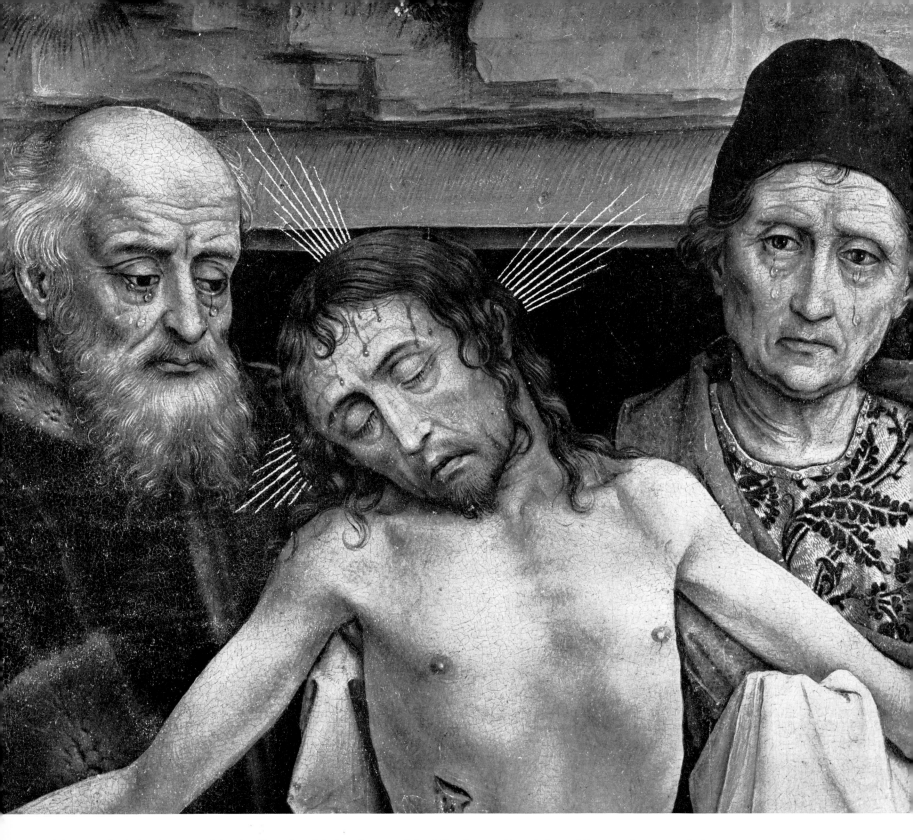

78. The Dead Christ Supported by St. Joseph of Arimathaea and St. Nicodemus. Detail from Plate 77 (in original size)

79. St. John the Evangelist. Detail from Plate 77 (in double original size)

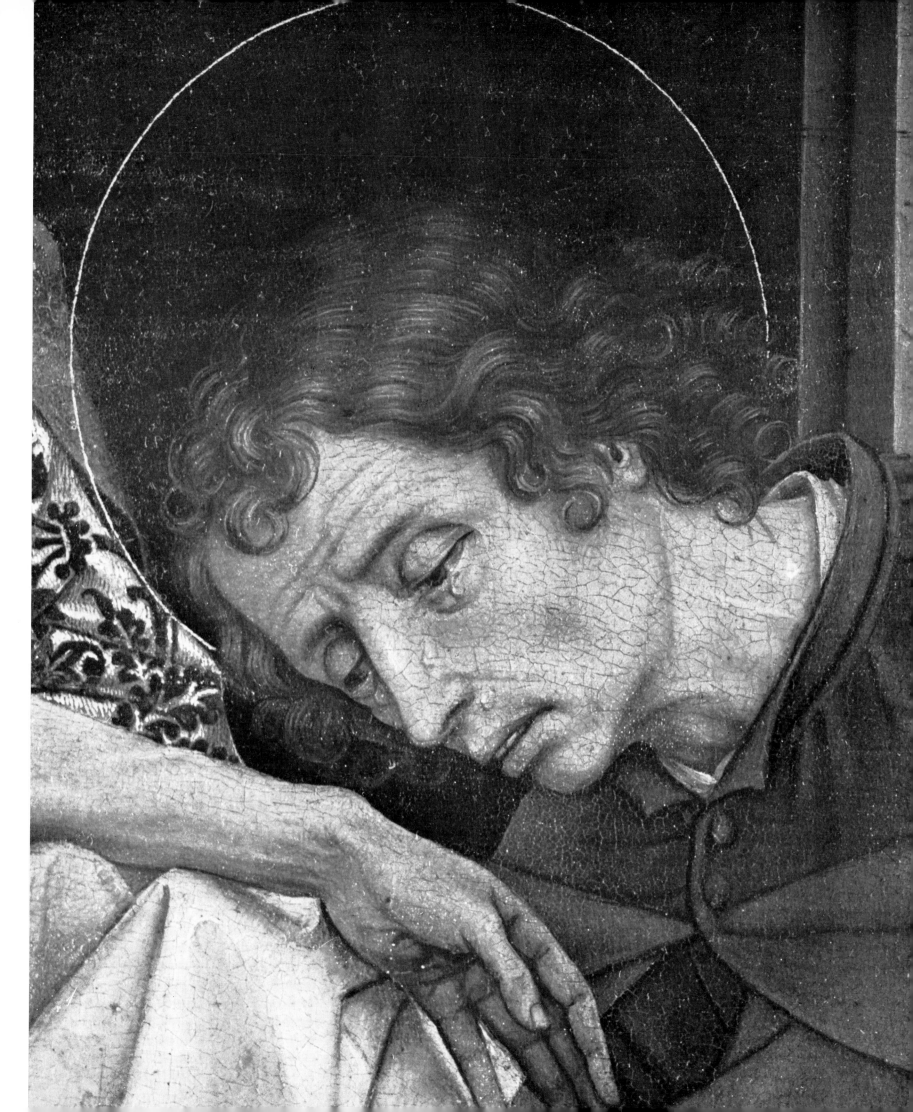

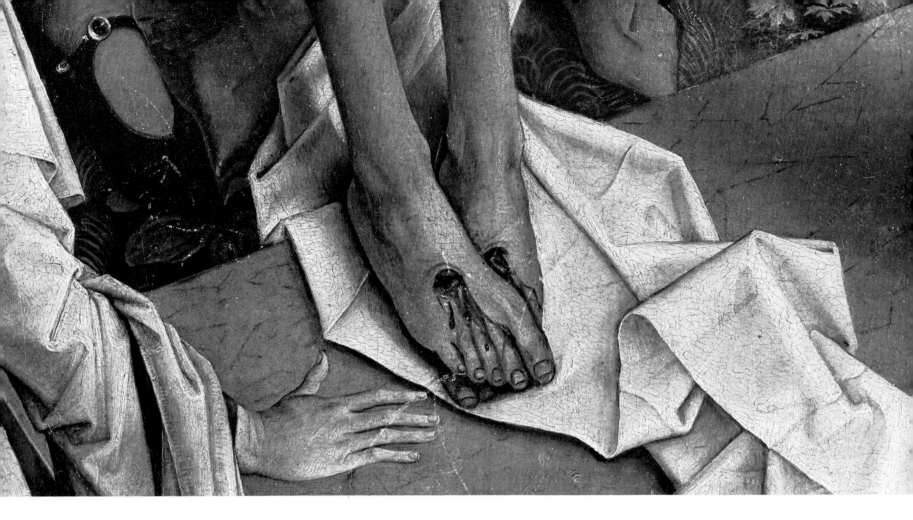

80. The Feet of Christ. Detail from Plate 77 (in original size)

81. Headgear and Plants.
Detail from Plate 77 (in original size)

82. Distant Landscape. Detail from Plate 77 (in original size)

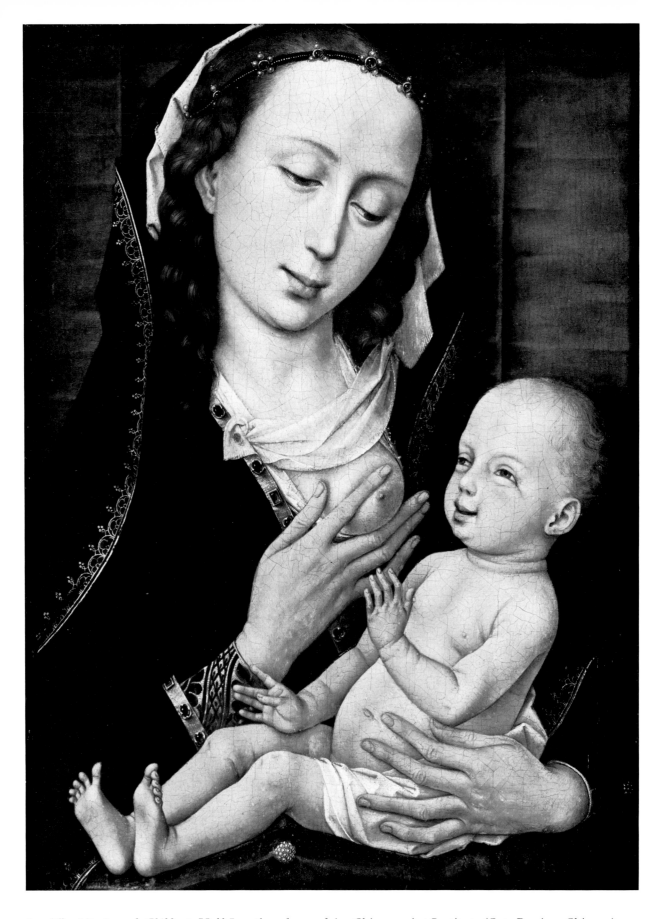

83. *The Virgin and Child at Half-Length.* $15\frac{1}{8} \times 11\frac{1}{8}$ in. Chicago, Art Institute (Cat. Rogier, Chicago)

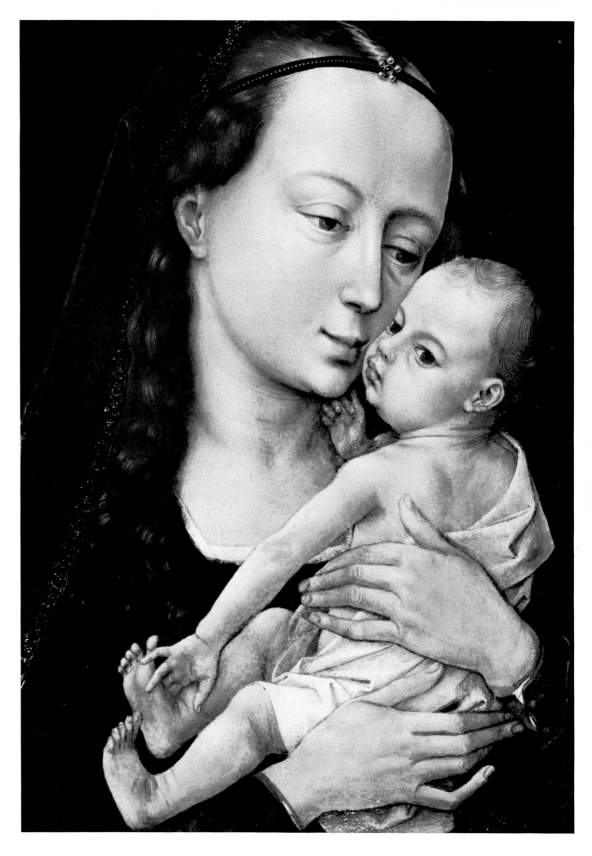

84. *The Virgin and Child at Half-Length*. $12\frac{3}{8} \times 8\frac{7}{8}$ in. Houston, Texas, Museum of Fine Arts (Cat. Rogier, Houston)

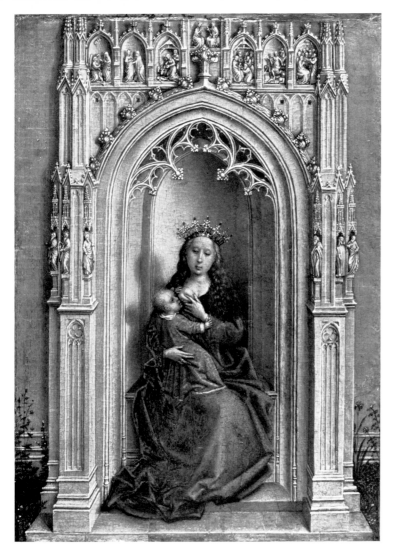

85-86. *Diptych* (?): *The Virgin and Child.* $5\frac{1}{2} \times 4\frac{1}{8}$ in. Lugano, Thyssen-Bornemisza Collection. *St. George and the Dragon.* $5\frac{5}{8} \times 4\frac{1}{8}$ in. Washington, National Gallery of Art (Cat. Rogier, Lugano 1)

 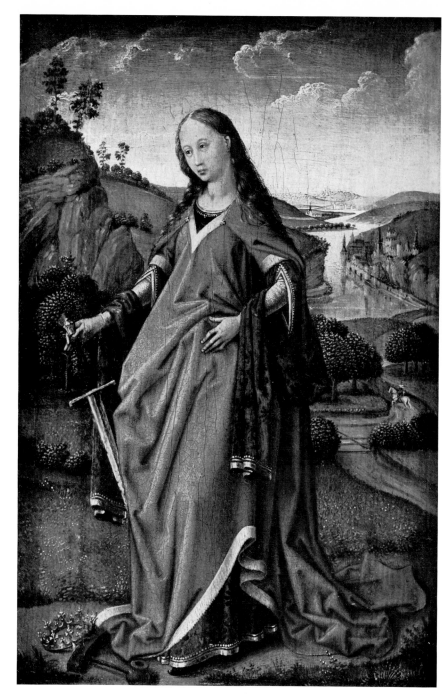

87-88. *Diptych* (?): *The Virgin standing in a Niche, holding the Child; St. Catherine in a Landscape, standing.* Each, $7\frac{1}{4} \times 4\frac{3}{4}$ in. Vienna, Kunsthistorisches Museum (Cat. Rogier, Vienna 1)

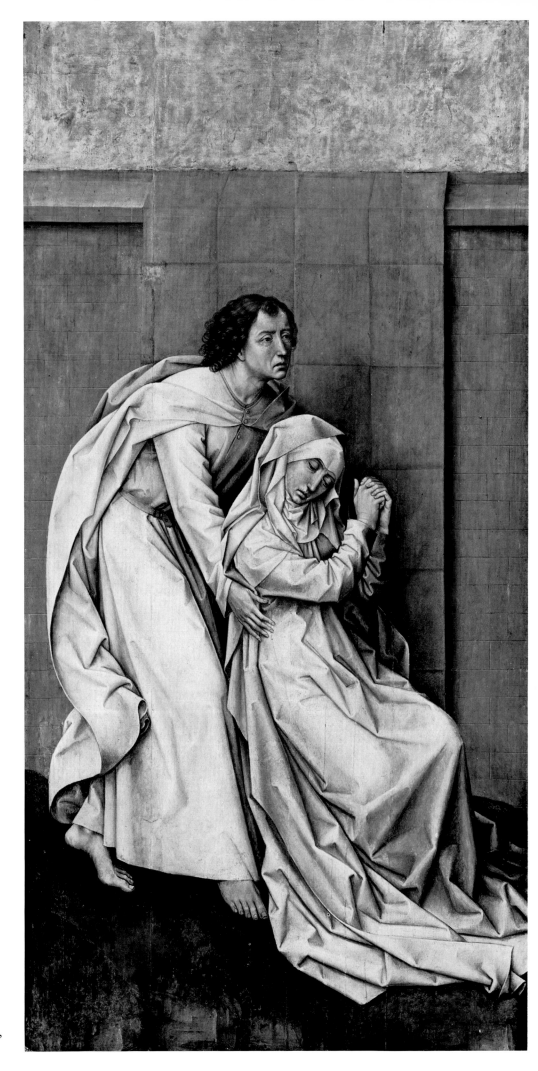

89. *The Virgin supported by St. John.* 70 × 36¼ in. Philadelphia, John G. Johnson Collection (Cat. Rogier, Philadelphia)

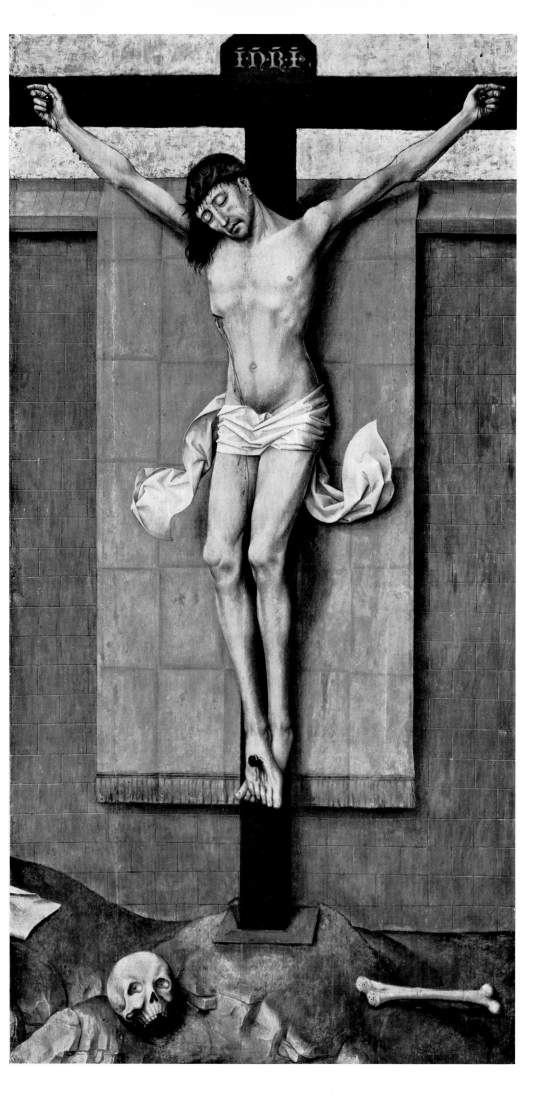

90. *Christ on the Cross*. 70 × 36¼ in. Philadelphia,
John G. Johnson Collection (Cat. Rogier, Philadelphia)

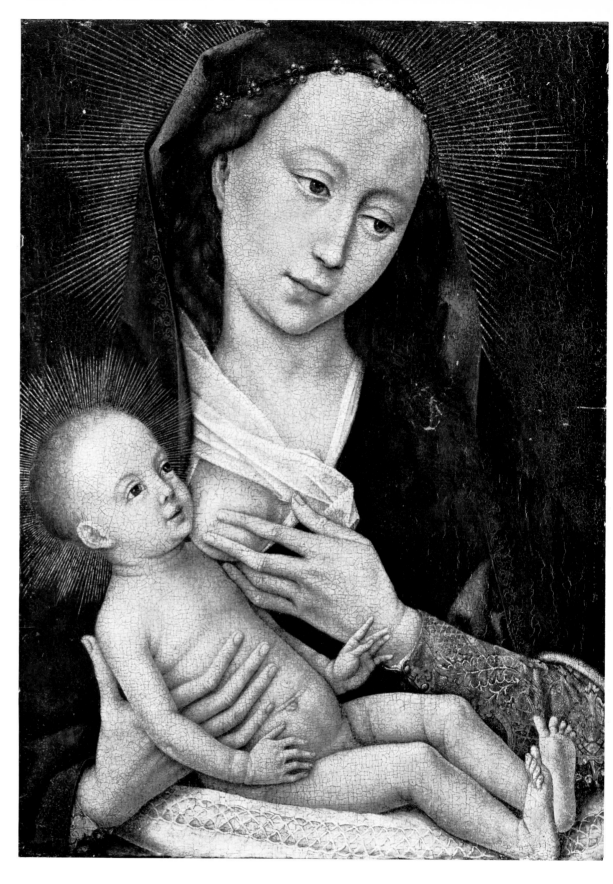

91. *The Virgin and Child*. 15¼ × 11¼ in. Left leaf of a diptych. Tournai, Musée des Beaux-Arts
(Cat. Rogier, Tournai)

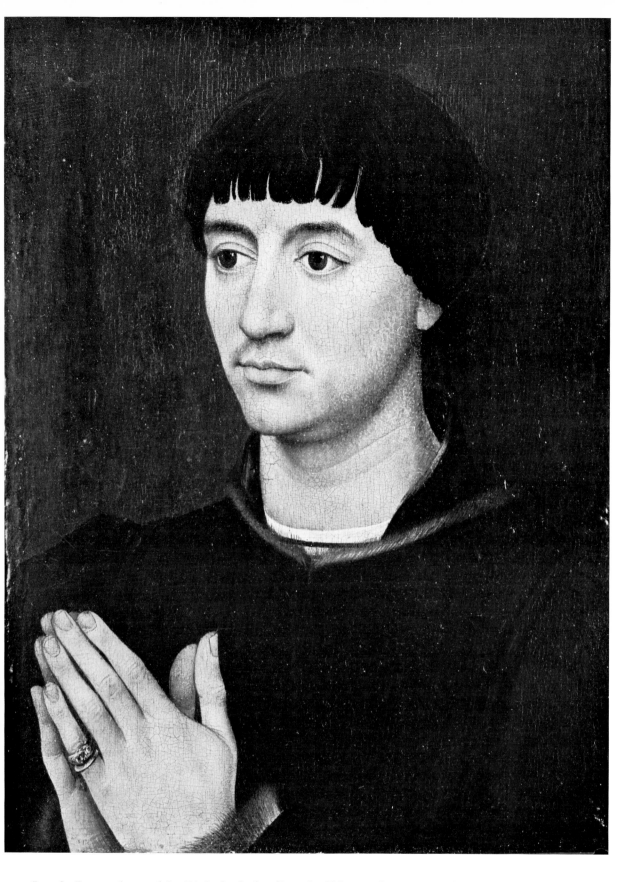

92. *Jean de Gros.* 15¼ × 11¼ in. Right leaf of a diptych. Chicago, Art Institute (see Cat. Rogier, Tournai)

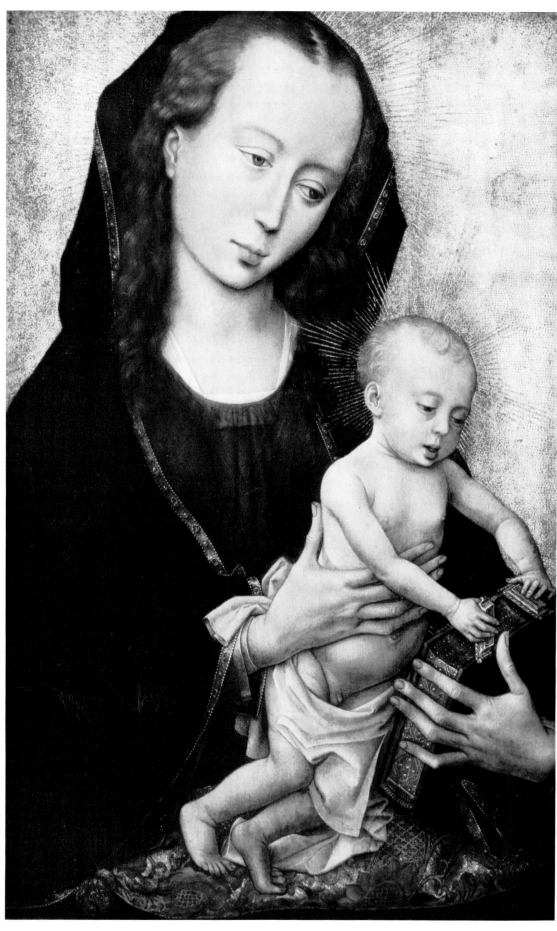

93. *The Virgin and Child.* 19¼ × 12¼ in. Left leaf of a diptych. San Marino (Cal.), Huntington Library and Art Gallery (Cat. Rogier, San Marino)

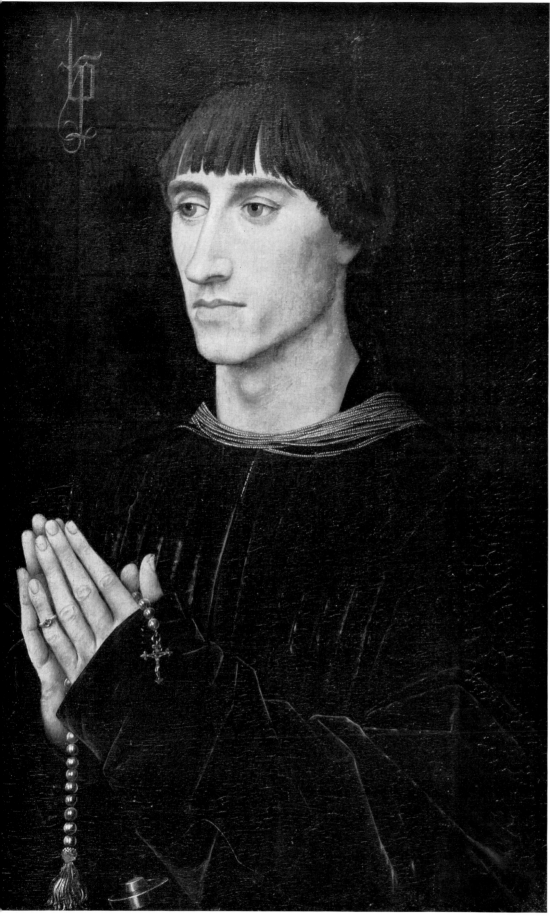

94. *Philippe de Croy, Seigneur de Sempy.* 19¼ × 11⅞ in. Right leaf of a diptych. Antwerp, Koninklijk Museum (see Cat. Rogier, San Marino)

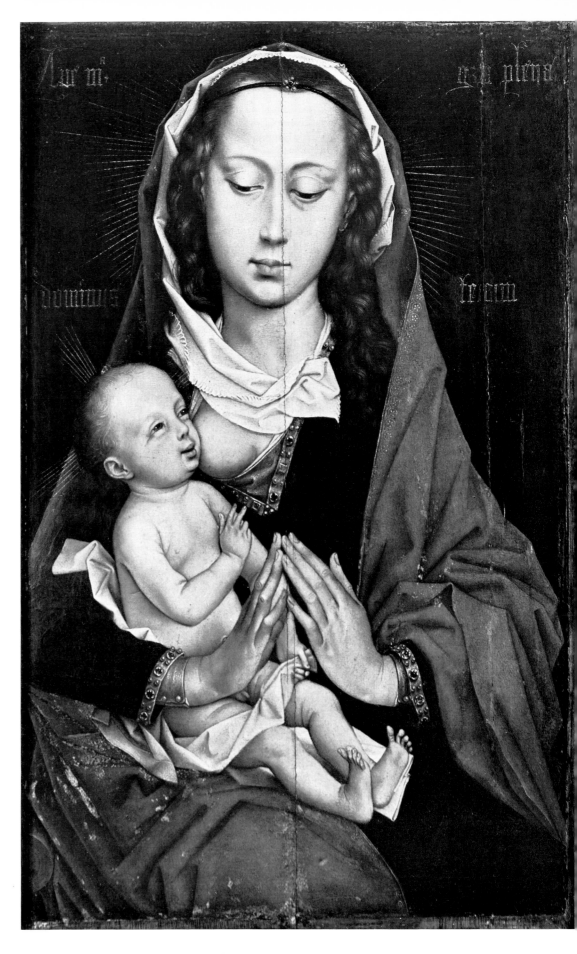

95. *The Virgin and Child.* 19½ × 12¼ in. Left leaf of a diptych. Caen, Musée (Cat. Rogier, Caen)

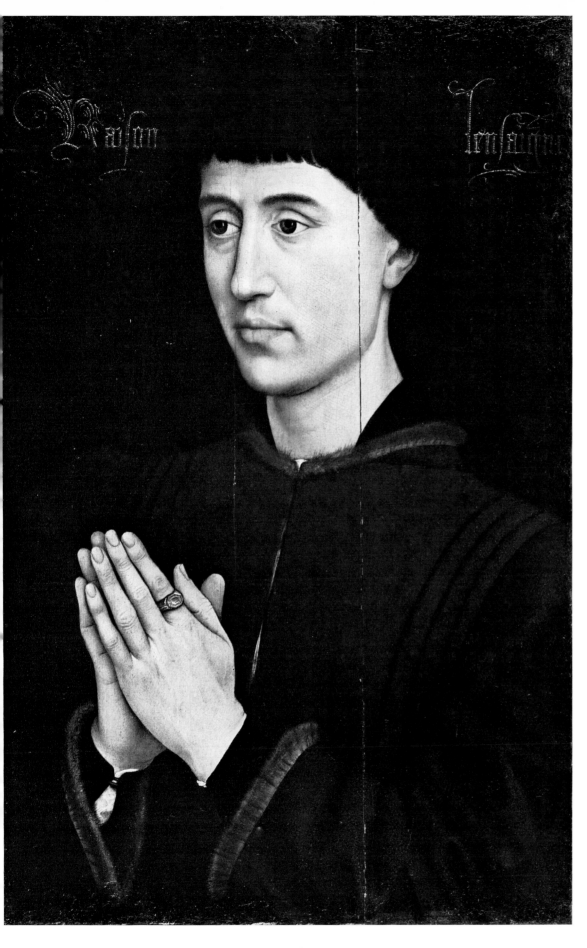

96. *Laurent Froimont* (?). 19⅛ × 12⅜ in. Right leaf of a diptych. Brussels, Musées Royaux des Beaux-Arts (see Cat. Rogier, Caen)

97. *St. Lawrence.* $19\frac{1}{8} \times 12\frac{3}{8}$ in. Grisaille on the reverse of *Laurent Froimont* (Plate 96)

98. *A Lady*. 18½ × 15 in. New York, Estate of the late Mrs. John D. Rockefeller, Jr. (Cat. Rogier, New York, Rockefeller)

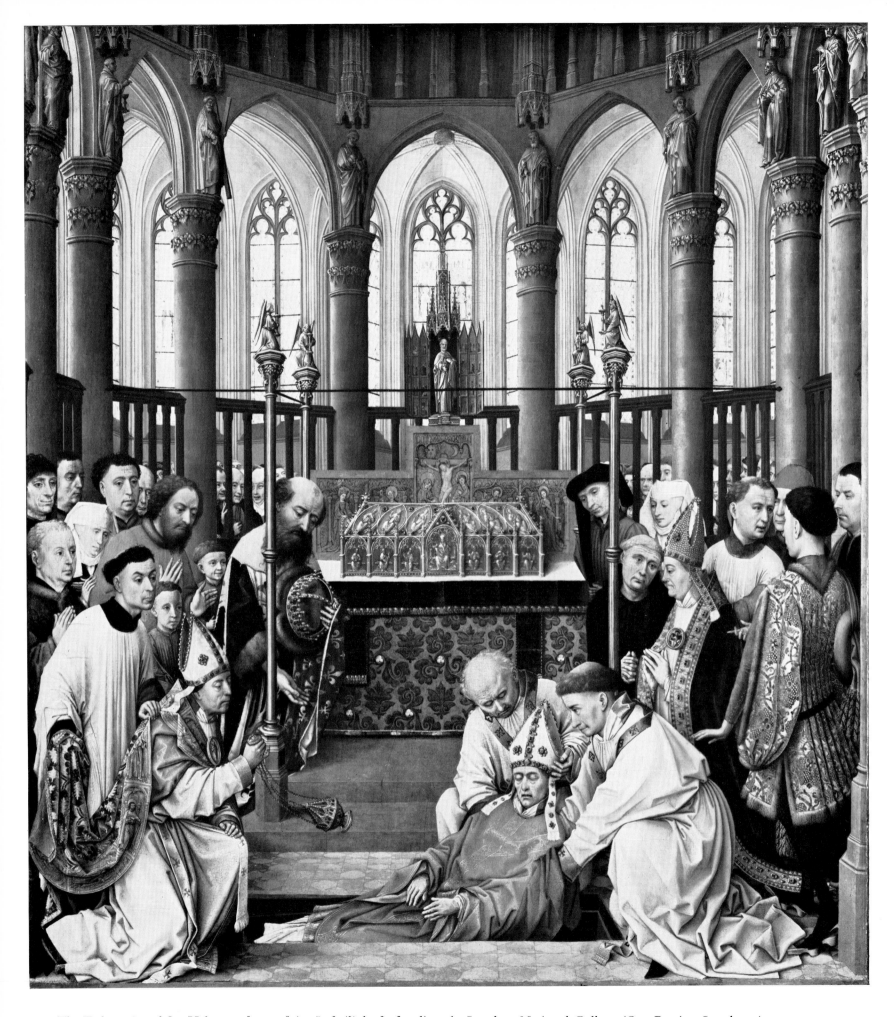

99. *The Exhumation of St. Hubert.* 34⅝ × 31¾ in. Left (?) leaf of a diptych. London, National Gallery (Cat. Rogier, London 2)

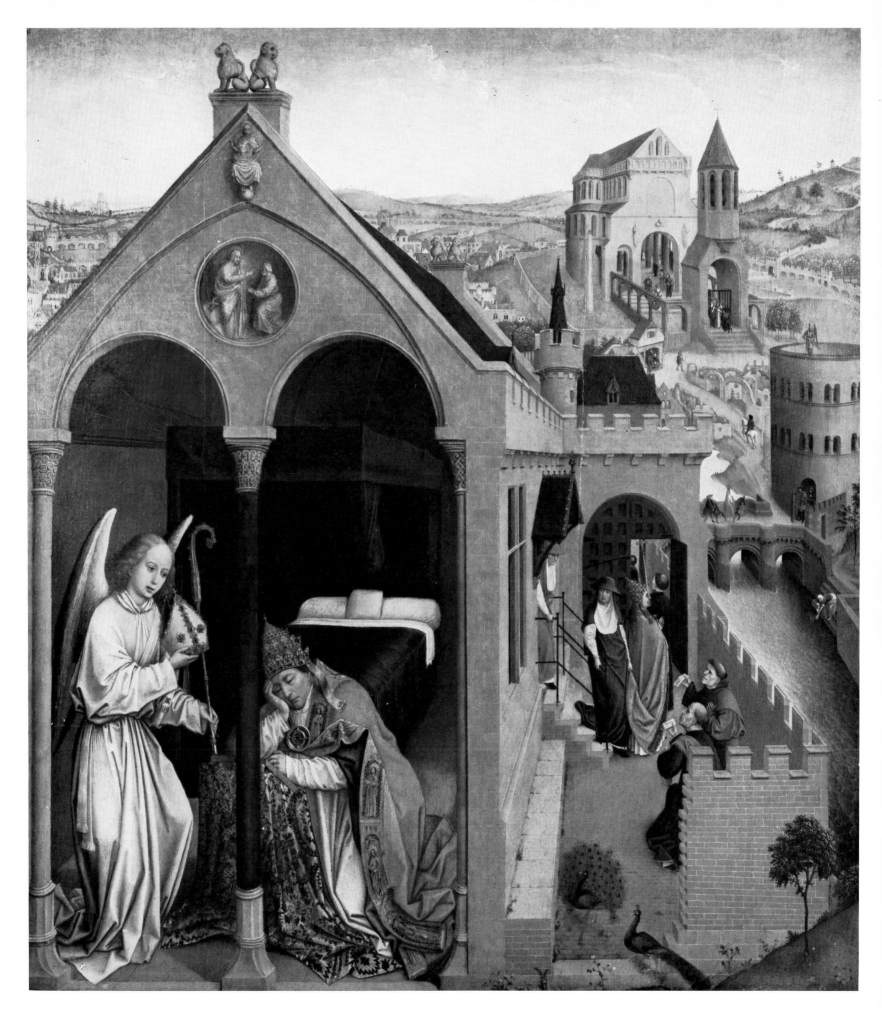

100. *The Consecration of St. Hubert (The Dream of Pope Sergius)*. 34½ × 31½ in. Right (?) leaf of a diptych. Brazil and New York, von Pannwitz Collection (see Cat. Rogier, London 2)

101. *Coat of arms.* Reverse of the portrait reproduced on Plate 102

102. *Portrait of a Man.* 13 × 8½ in. New York, Wildenstein (Cat. Rogier, New York, Wildenstein)

103. *Branch of Holly*. Reverse of the portrait reproduced on Plate 104

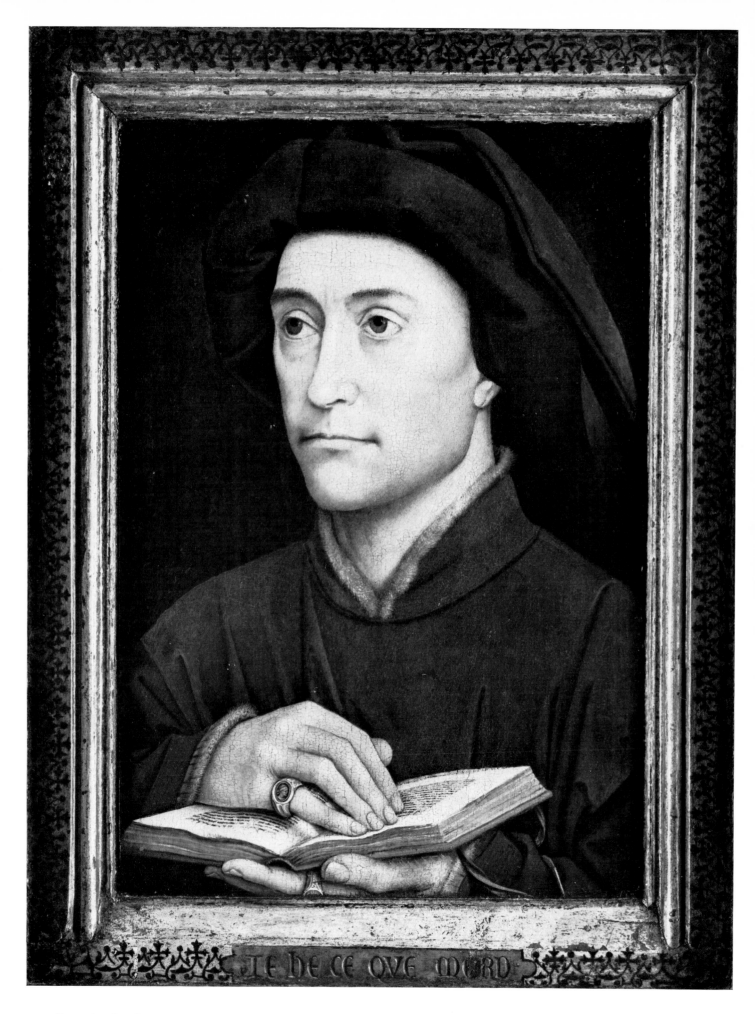

104. *Portrait of a Man holding an open Book.* $13\frac{3}{8} \times 9\frac{1}{2}$ in. (without the frame). Maidenhead Thicket, Collection of the late Sir Thomas Merton (Cat. Rogier, Maidenhead)

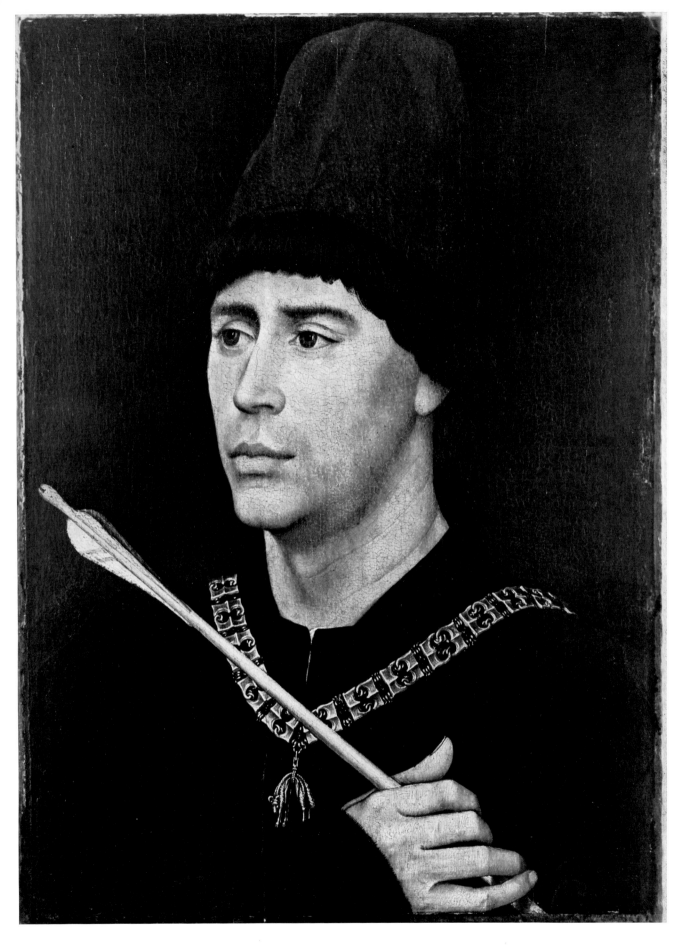

105. *A Knight of the Golden Fleece holding an Arrow.* $15\frac{1}{4} \times 11\frac{1}{4}$ in. Brussels, Musées Royaux des Beaux-Arts (Cat. Rogier, Brussels 2)

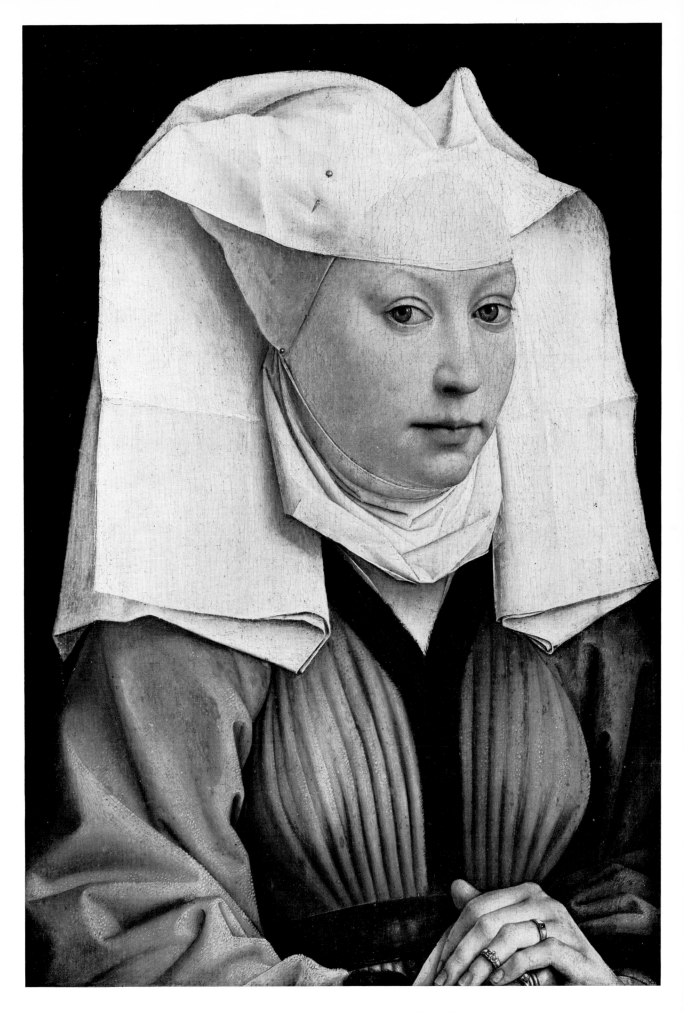

106. *Portrait of a Woman.* 18½ × 12⅝ in. Berlin, Staatliche Museen (Cat. Rogier, Berlin 2)

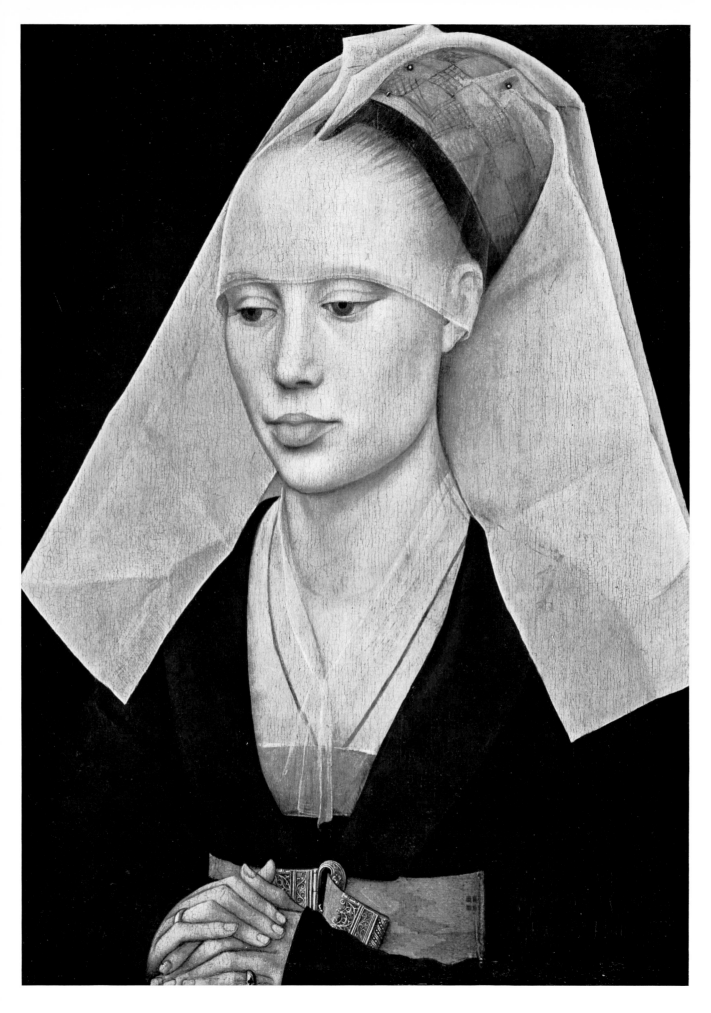

107. *Portrait of a Lady.* $14\frac{1}{2} \times 10\frac{3}{4}$ in. Washington, National Gallery of Art (Mellon Collection) (Cat. Rogier, Washington)

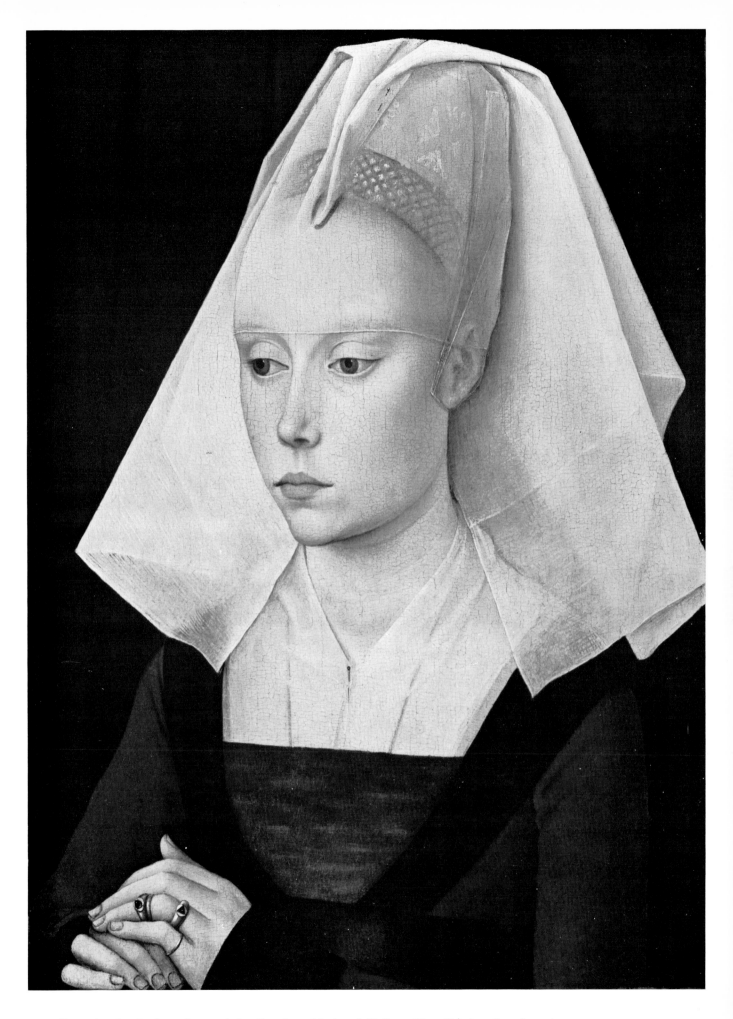

108. *Portrait of a Lady.* 14¼ × 10½ in. London, National Gallery (Cat. Rogier, London 4)

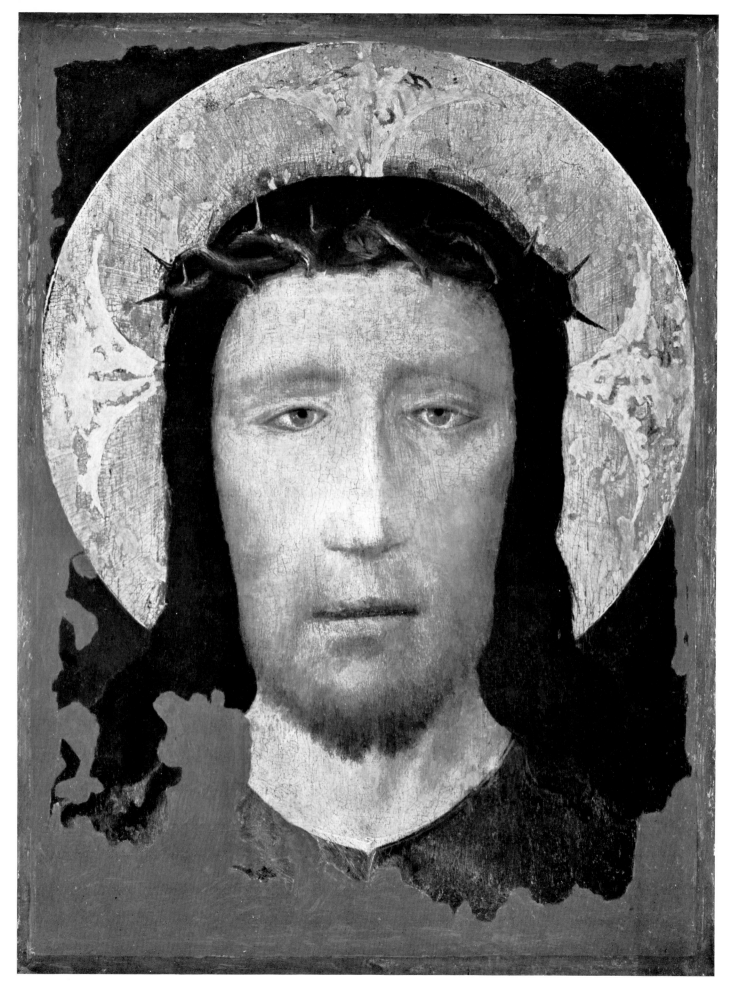

109. *Christ crowned with Thorns*. Reverse of the portrait reproduced on Plate 108

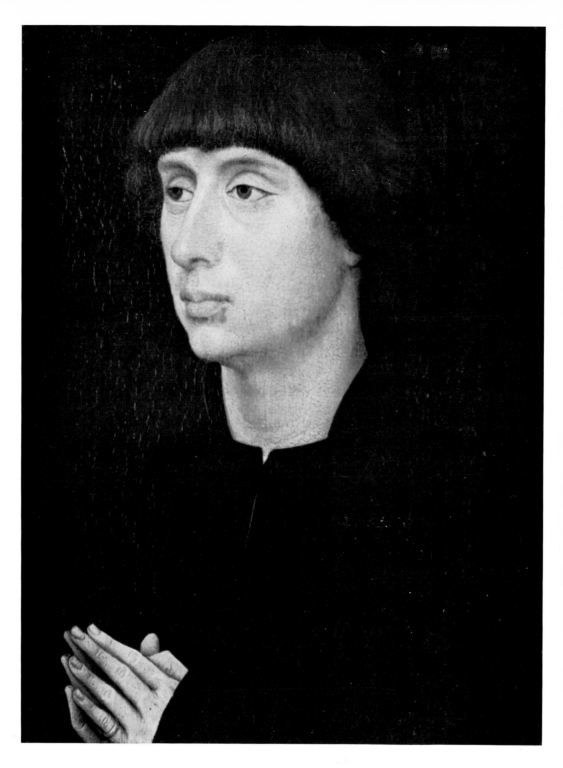

110. *Portrait of a Man.* $7\frac{1}{2} \times 5\frac{3}{4}$ in. Upton House, National Trust, Bearsted Collection (Cat. Rogier, Upton)

111. *The Este Arms, and Inscriptions.* Reverse of *Francesco d'Este* (Plate 112)

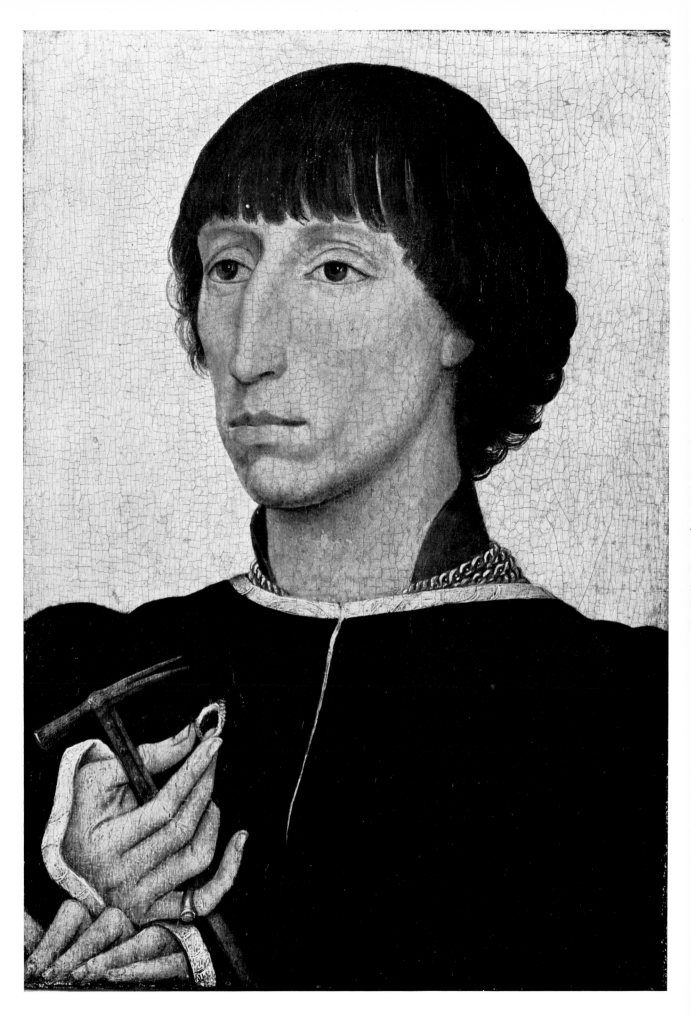

112. *Francesco d'Este*. $11\frac{3}{4} \times 8$ in. New York, Metropolitan Museum of Art (Cat. Rogier, New York 1)

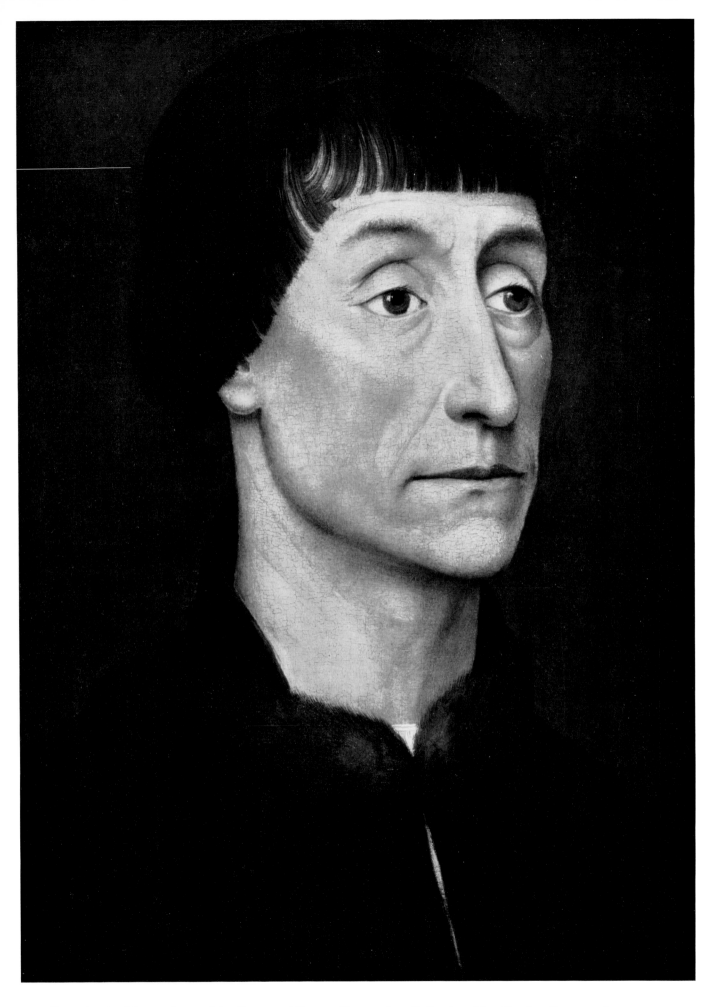

113. *Portrait of a Man.* 12½ × 10¼ in. Lugano, Thyssen-Bornemisza Collection (Cat. Rogier, Lugano 2)

SOME FURTHER ASSOCIATED WORKS

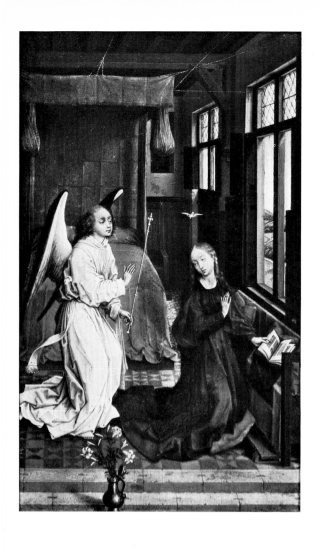

114. *The Annunciation*. 8 × 4¾ in.
Antwerp, Koninklijk Museum
(Cat. Rogier, Antwerp 1)

115. *The Virgin and Child*.
Drawing, 8½ × 5¼ in. Rotterdam,
Boymans-van Beuningen Museum
(Cat. Rogier, Rotterdam)

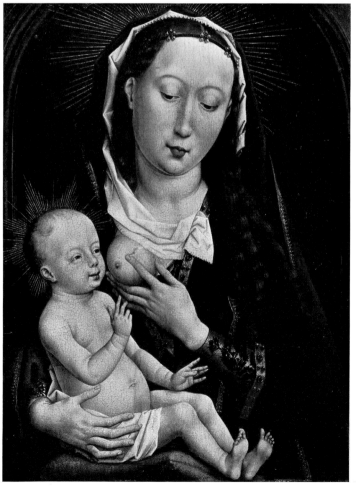

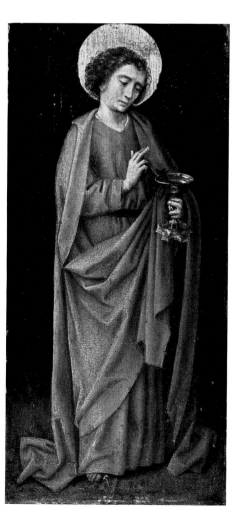

116. *The Virgin and Child at
Half-Length*. 16½ × 12¼ in.
Berlin-Dahlem, Staatliche Museen
(Cat. Rogier, Berlin 6)

117. *St. John the Evangelist*. 8⅝ × 4 in.
Berlin-Dahlem, Staatliche Museen
(Cat. Rogier, Berlin 7)

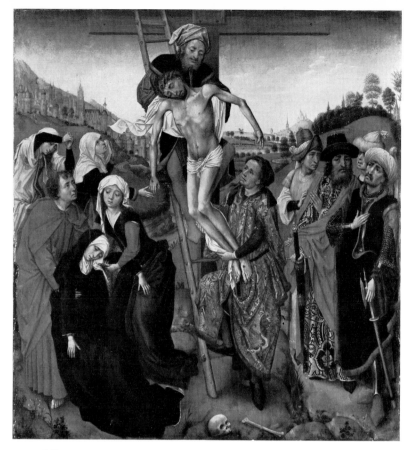

118. *The Deposition.* 22½ × 20½ in. Munich, Alte Pinakothek
(Cat. Rogier, Munich 2)

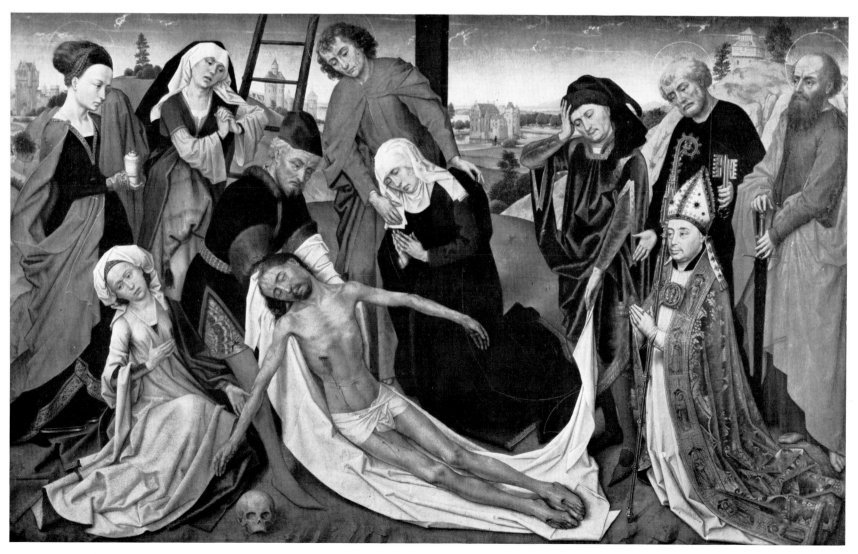

119. *The Lamentation after Christ's Deposition.* 31¾ × 51¼ in. The Hague, Mauritshuis (Cat. Rogier, The Hague)

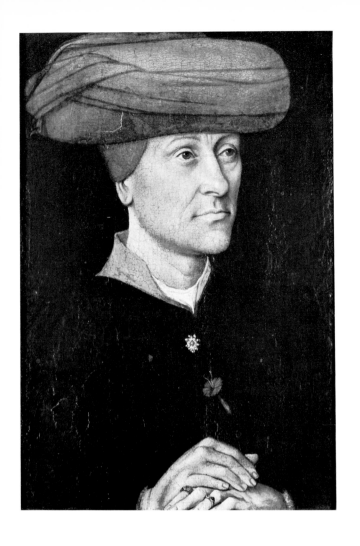

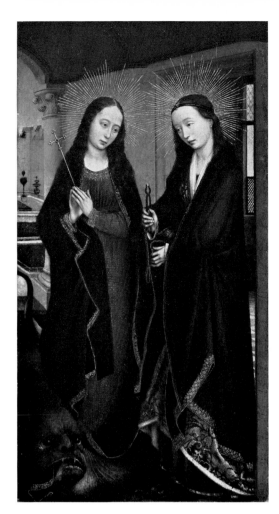

120. *A Man in a Turban, with a Pink*. 11 × 8
New York, Metropolitan Museum of Art
(Cat. Rogier, New York 4)

121. *SS. Margaret and Apollonia*.
Right wing of a triptych, 20¼ × 11 in.
Berlin-Dahlem, Staatliche Museen
(Cat. Rogier, Berlin 3)

122. *Philip the Good, Duke of Burgun*
14 × 9 in. Version at Windsor Cast
Royal Collection (Cat. Rogier,
Various Collections 5)

123. *Charles the Bold*. 19¼ × 12⅝ in.
Berlin-Dahlem, Staatliche Museen
(Cat. Rogier, Berlin 5)

ROBERT CAMPIN

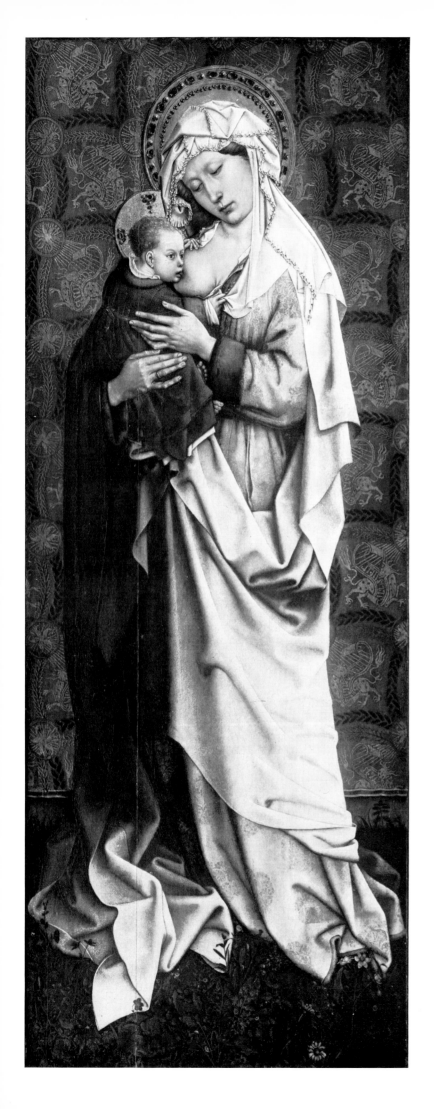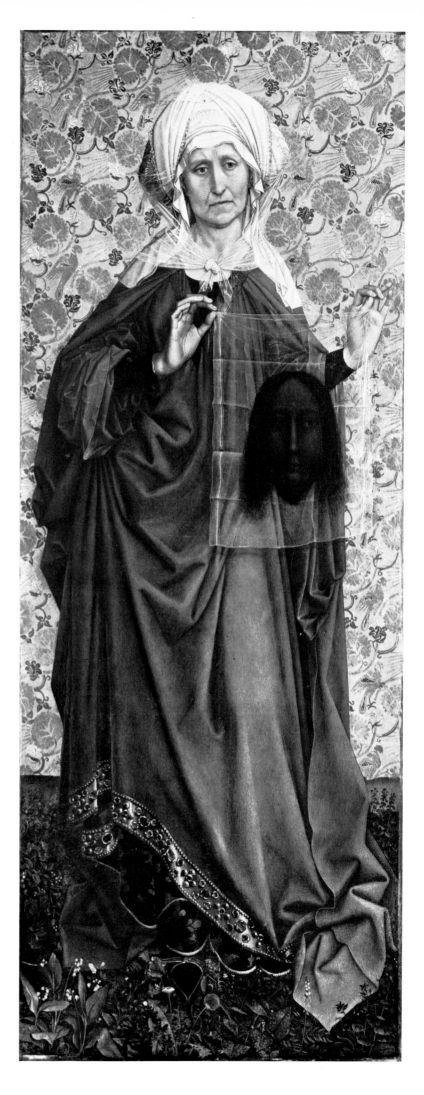

124. *The Virgin and Child.* 63 × 26¾ in.
Frankfurt, Städelsches Kunstinstitut
(Cat. Campin, Frankfurt 2)

125. *St. Veronica.* 59½ × 24 in.
Frankfurt, Städelsches Kunstinstitut
(Cat. Campin, Frankfurt 2)

126. *The Trinity.* 58¾ × 24 in. Grisaille,
formerly on the reverse of *St. Veronica* (Plate 125).
Frankfurt, Städelsches Kunstinstitut
(Cat. Campin, Frankfurt 2)

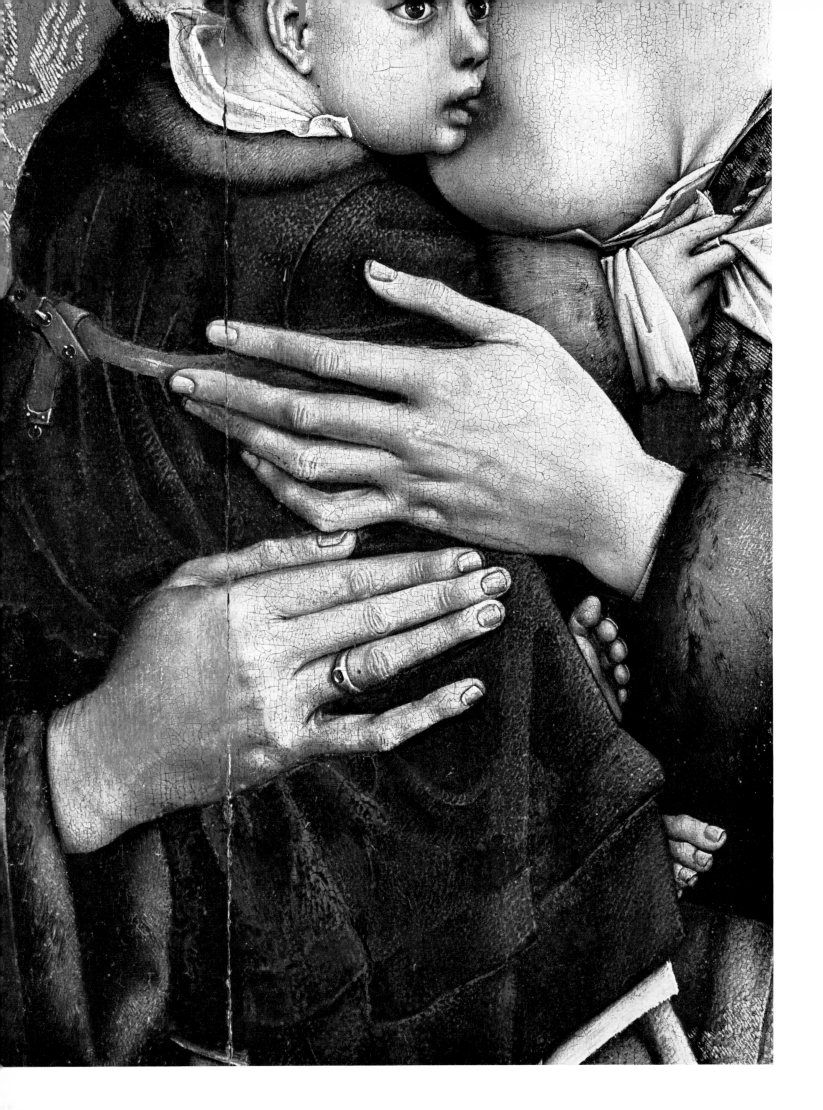

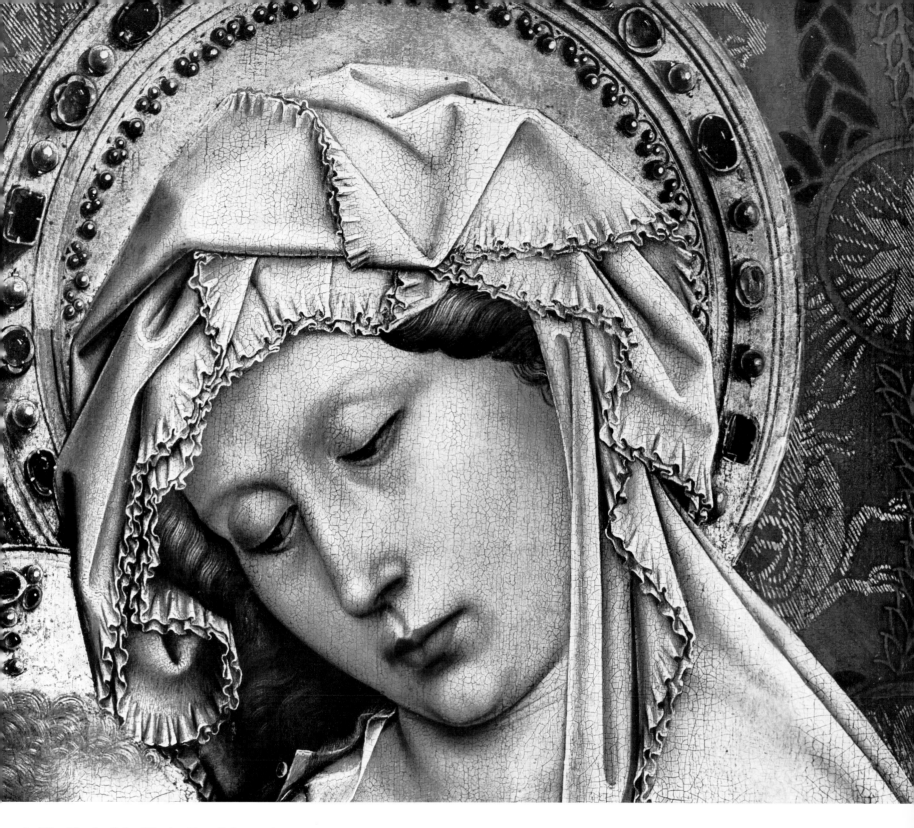

128. The Head of the Virgin. Detail from Plate 124 (in original size)

127. The Hands of the Virgin.
Detail from Plate 124 (in original size)

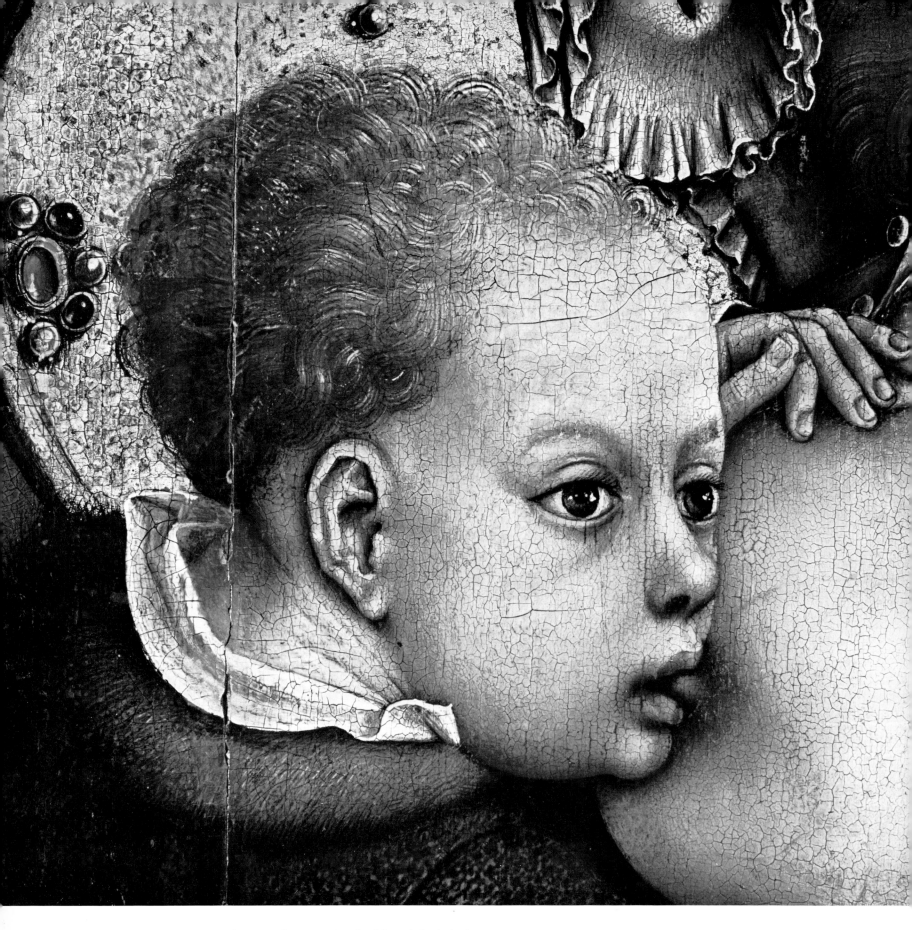

129. The Head of the Child. Detail from Plate 124 (in double original size)

130. The Hand of St. Veronica. Detail from Plate 125
(in double original size)

131. Christ and the Dove of the Holy Ghost. Detail from Plate 126 (in original size)

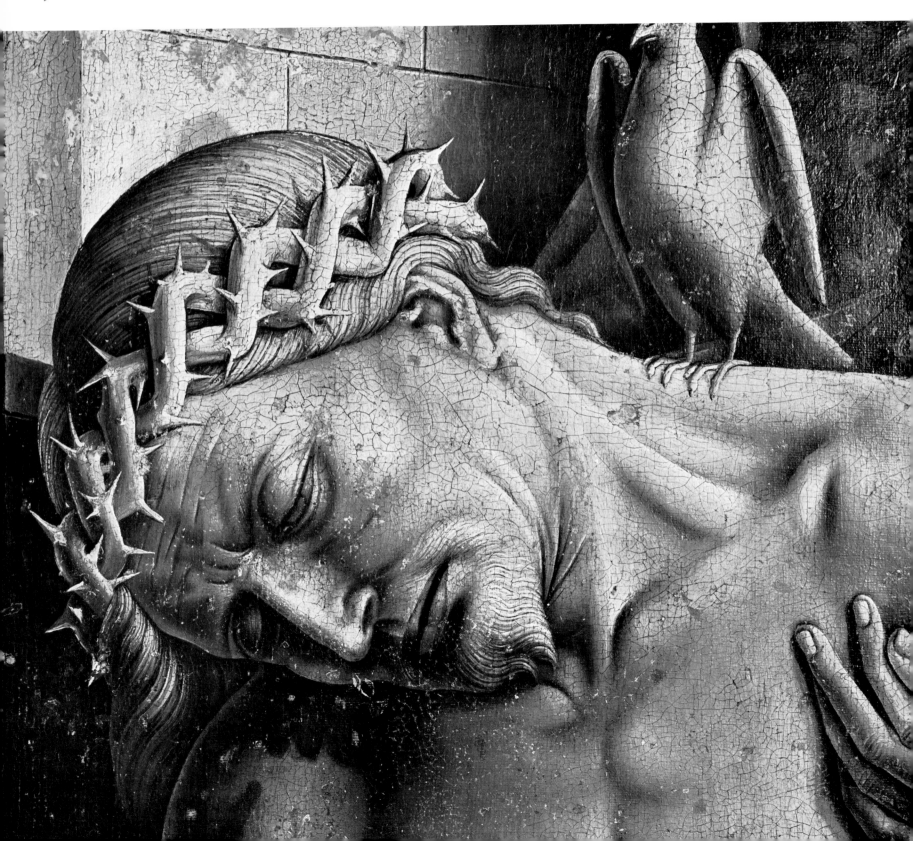

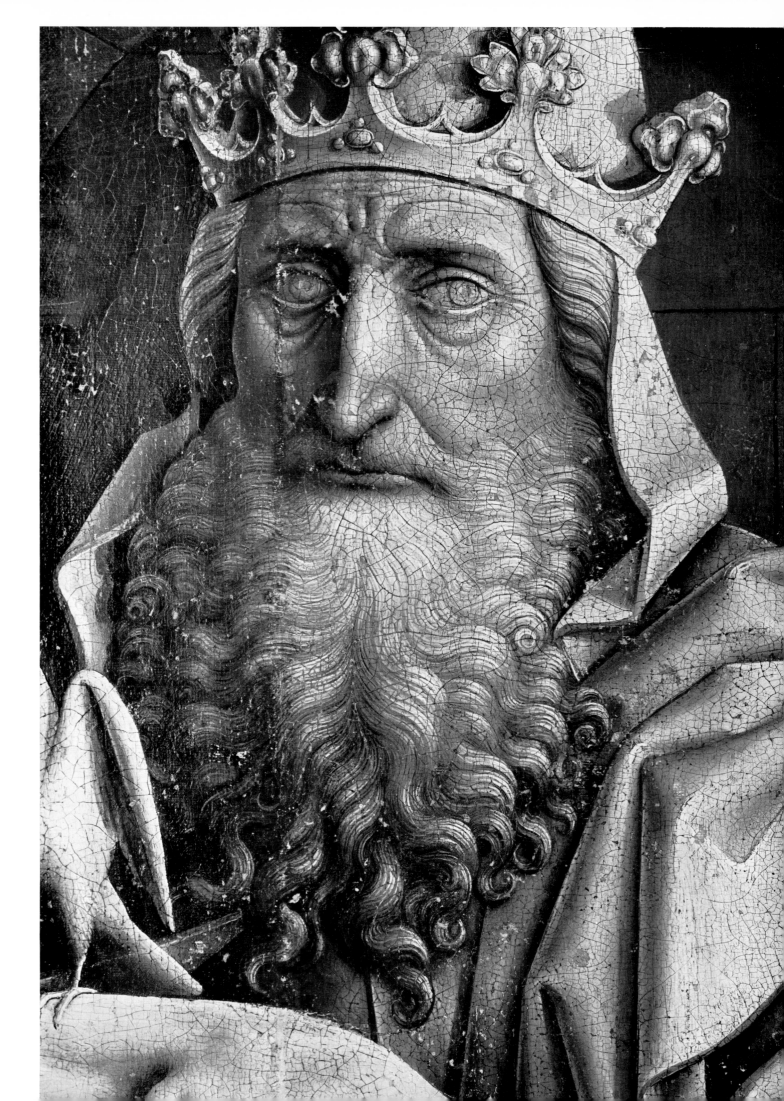

132. God the Father.
Detail from Plate 126
(in original size)

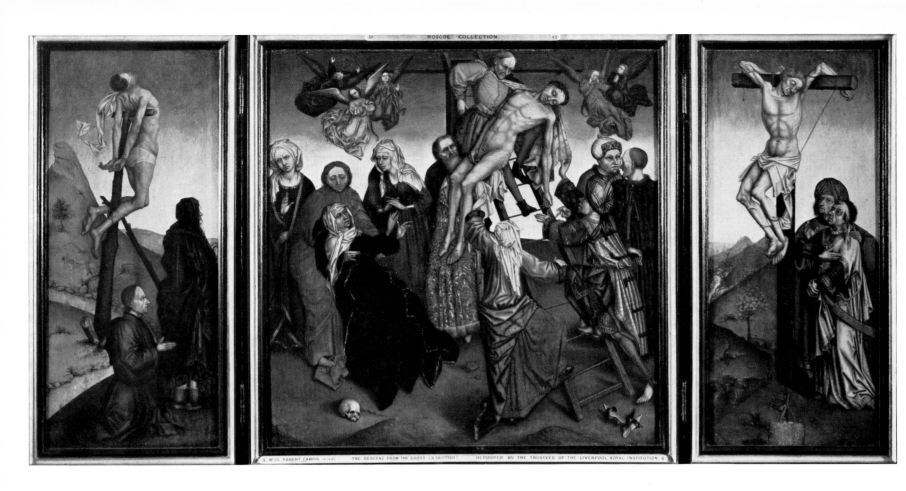

133. *Triptych of the Deposition*. Liverpool, Walker Art Gallery (see Cat. Campin, Frankfurt 1)

134. *The Deposition*.
Engraving assigned to the Master of the Banderoles
(see Cat. Campin, Frankfurt 1, also Cat. Rogier, Madrid 1)

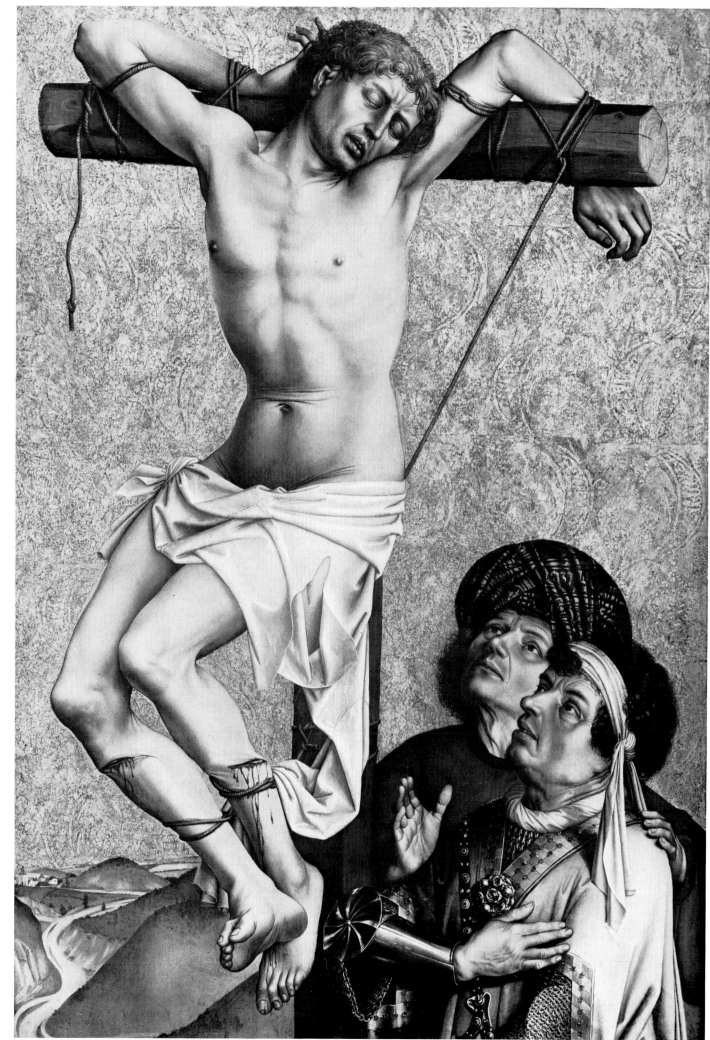

5. *The Bad Thief of Calvary*
his Cross, with two Spectators.
$\frac{1}{4} \times 36\frac{1}{2}$ in.
ragment from the right
ing of a triptych. Frankfurt,
ädelsches Kunstinstitut
at. Campin, Frankfurt 1)

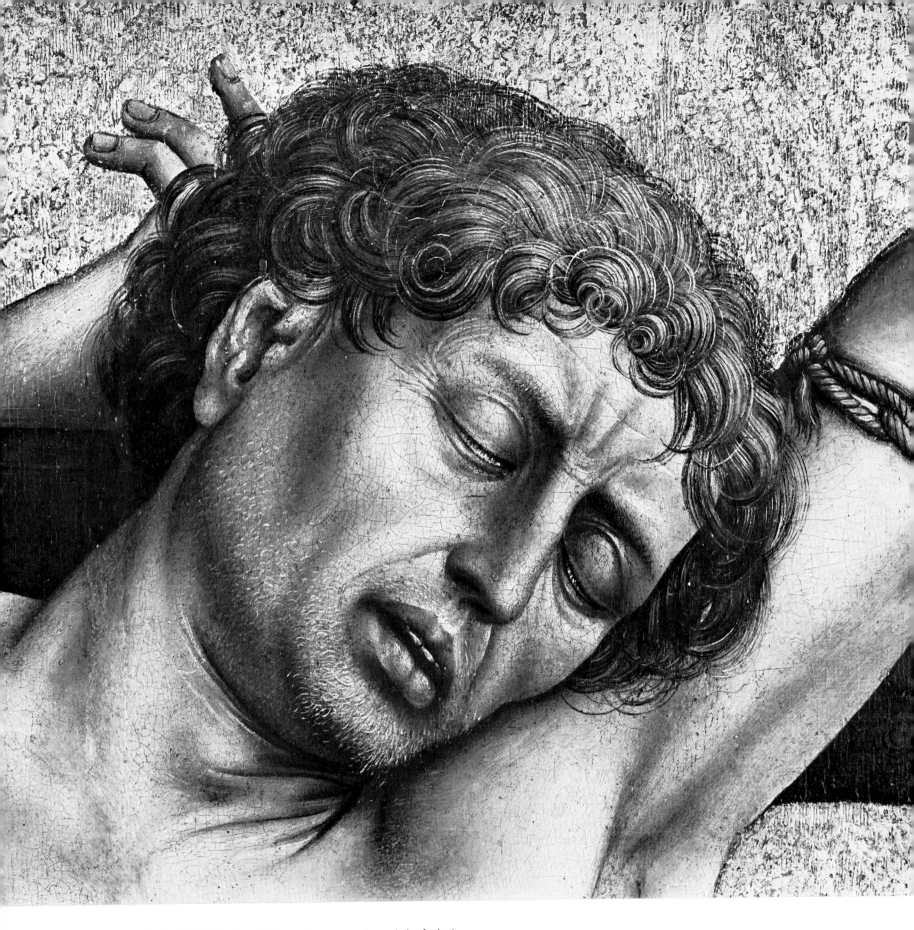

136. The Head of the Bad Thief. Detail from Plate 135 (in original size)

137. The two Spectators. Detail from Plate 135 (in original size)

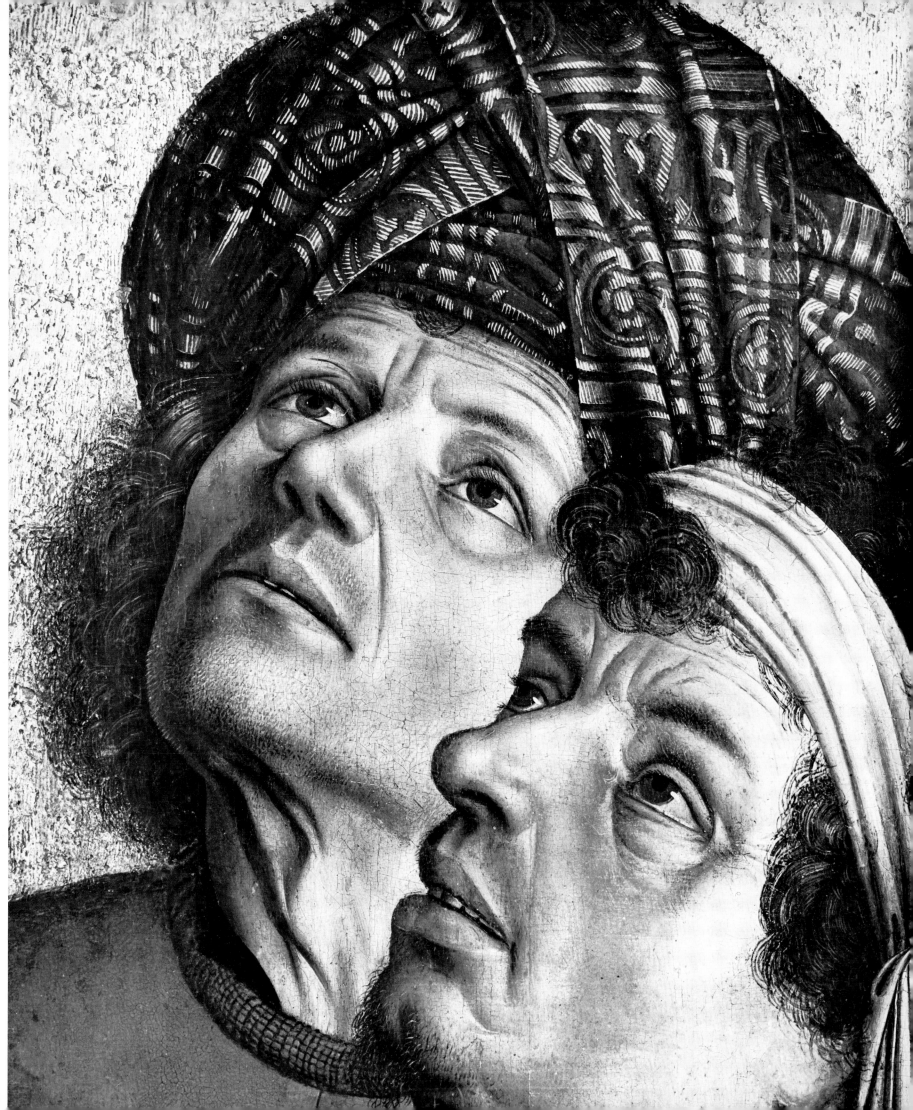

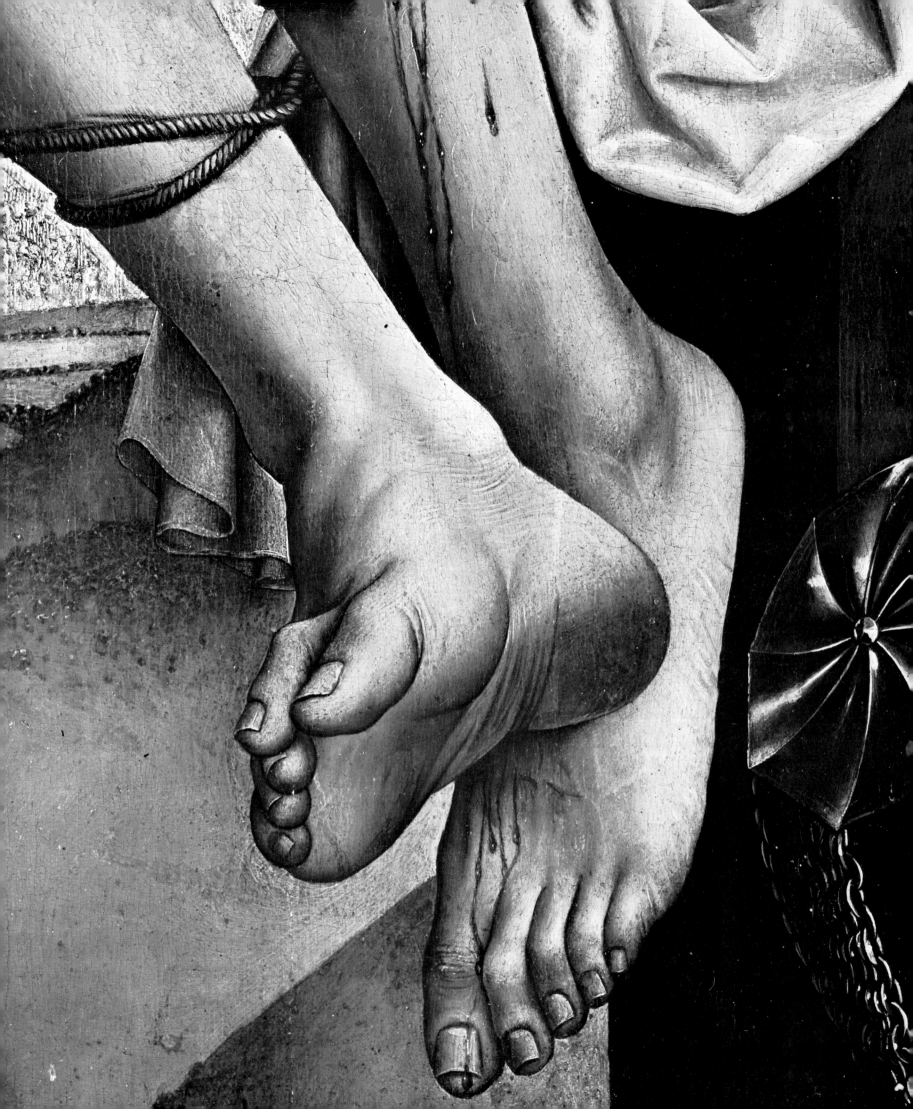

139. Grisaille on the reverse of *The Bad Thief* (Plate 135)

The Feet of the Bad Thief.
ail from Plate 135 (in original size)

140. *The Annunciation*. 24 × 24¾ in. Variant of Plate 141. Brussels, Musées Royaux des Beaux-Arts (see Cat. Campin, New York)

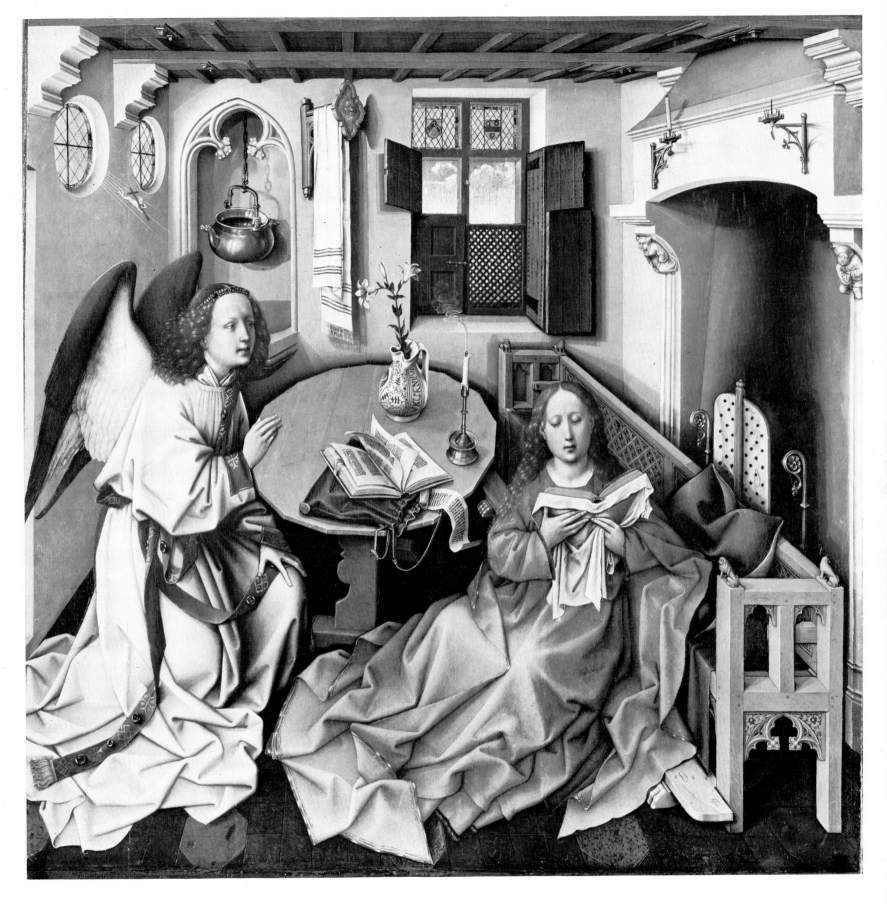

141. *The Annunciation*. 25⅛ × 24¾ in. Centre panel of the Merode Triptych. New York, Metropolitan Museum of Art, The Cloisters (Cat. Campin, New York)

142. *Donor and Donatrix.* 25⅛ × 10¾ in. Left wing of the Merode Triptych.
New York, Metropolitan Museum of Art, The Cloisters
(Cat. Campin, New York)

143. *St. Joseph at Work in his Carpenter's Shop.* $25\frac{1}{8} \times 10\frac{3}{4}$ in.
Right wing of the Merode Triptych.
New York, Metropolitan Museum of Art, The Cloisters
(Cat. Campin, New York)

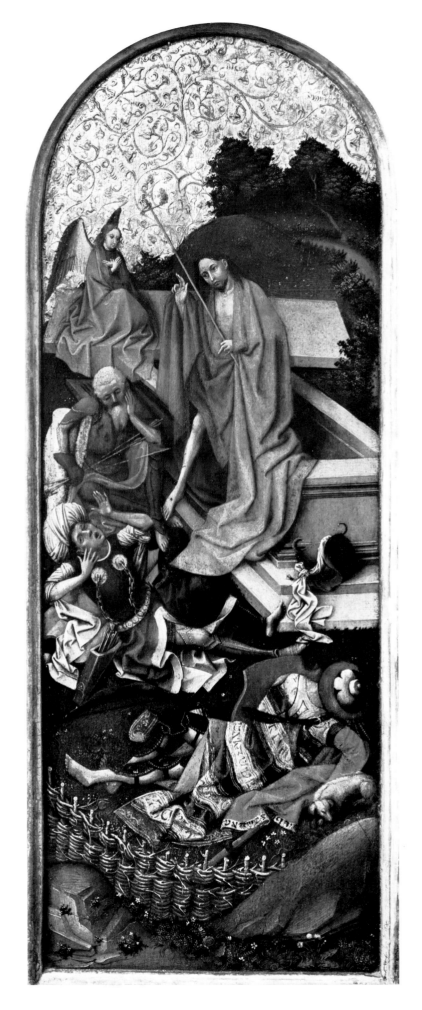

144-145. *The Thieves on their Crosses with a Donor; the Resurrection.* Each 23¾ × 8⅞ in. Wings of a triptych. London, Count Antoine Seilern (Cat. Campin, London, Seilern)

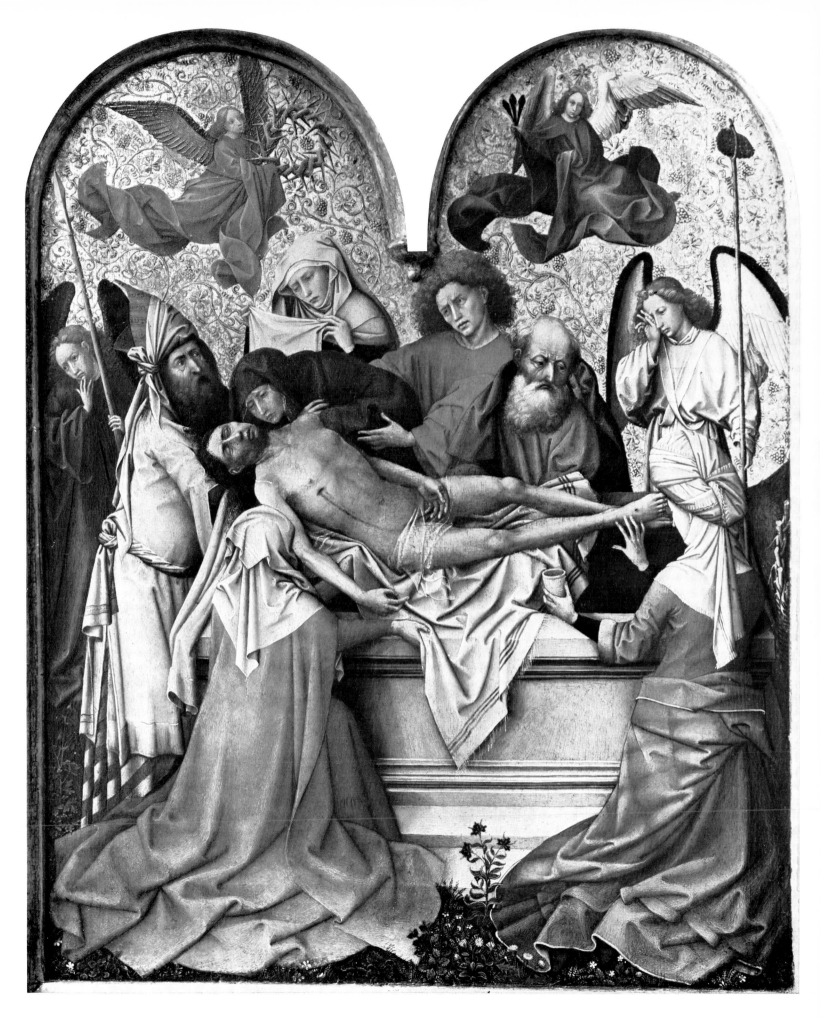

146. *The Entombment*. 23¾ × 19¼ in. Centre panel of a triptych. London, Count Antoine Seilern (Cat. Campin, London, Seilern)

147. *The Annunciation.* $30\frac{1}{8} \times 27\frac{1}{2}$ in. Madrid, Prado (Cat. Campin, Madrid 1)

148. *The Marriage of the Virgin.* 30⅛ × 34½ in. Madrid, Prado (Cat. Campin, Madrid 1)

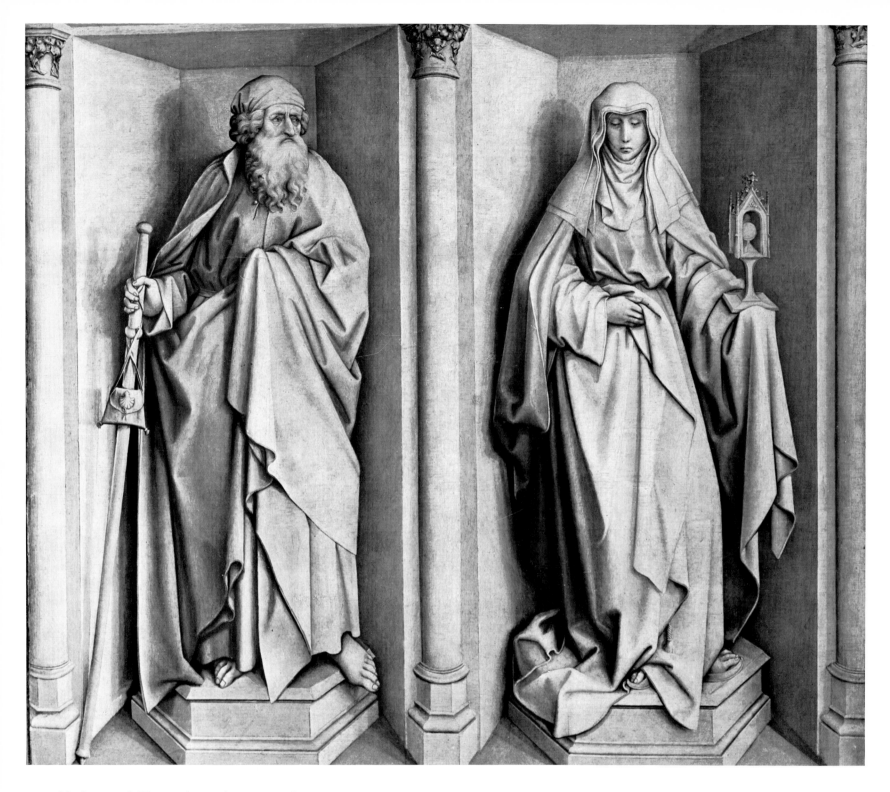

149. *SS. James and Clare*. 30⅛ × 34½ in. Grisaille on the reverse of the *Marriage of the Virgin* (Plate 148)

150-151. Sculpture of the Virgin and Child; Sculpture of the Trinity. Details from Plates 152-3

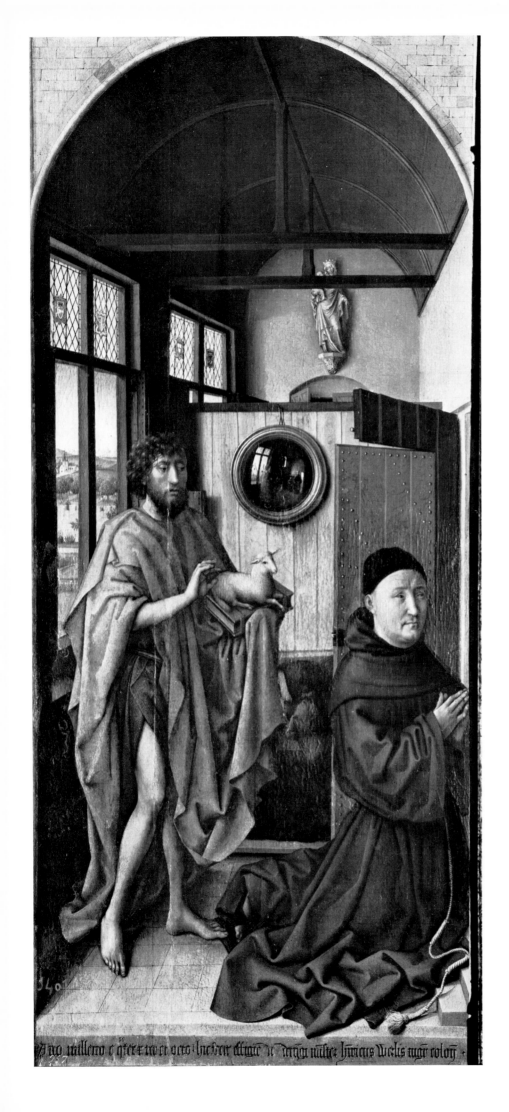

152. *St. John the Baptist introducing Heinrich von Werl.* $39\frac{3}{4} \times 18\frac{1}{2}$ in.
Left wing of a triptych. Madrid, Prado (Cat. Campin, Madrid 2)

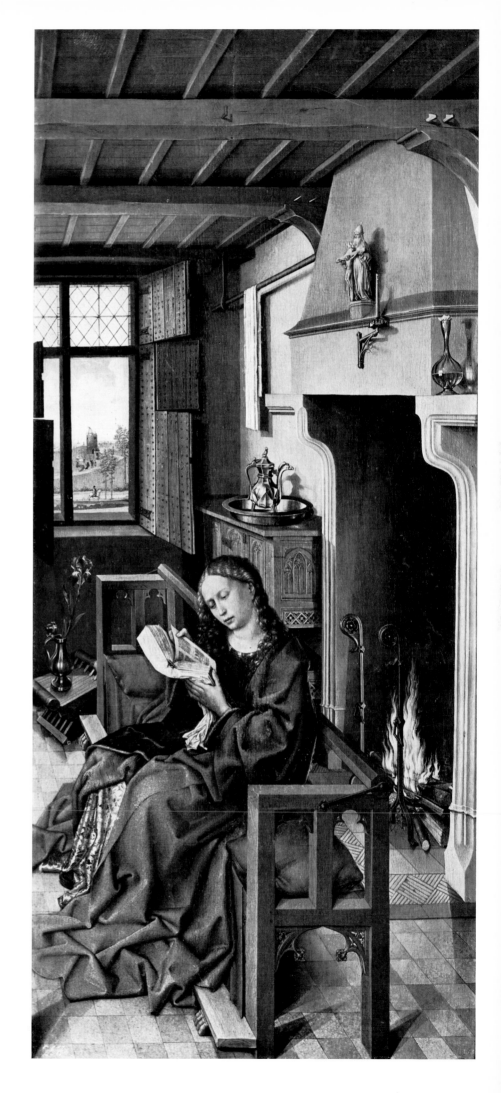

153. *St. Barbara.* 39¾ × 18½ in. Right wing of a triptych.
Madrid, Prado (Cat. Campin, Madrid 2)

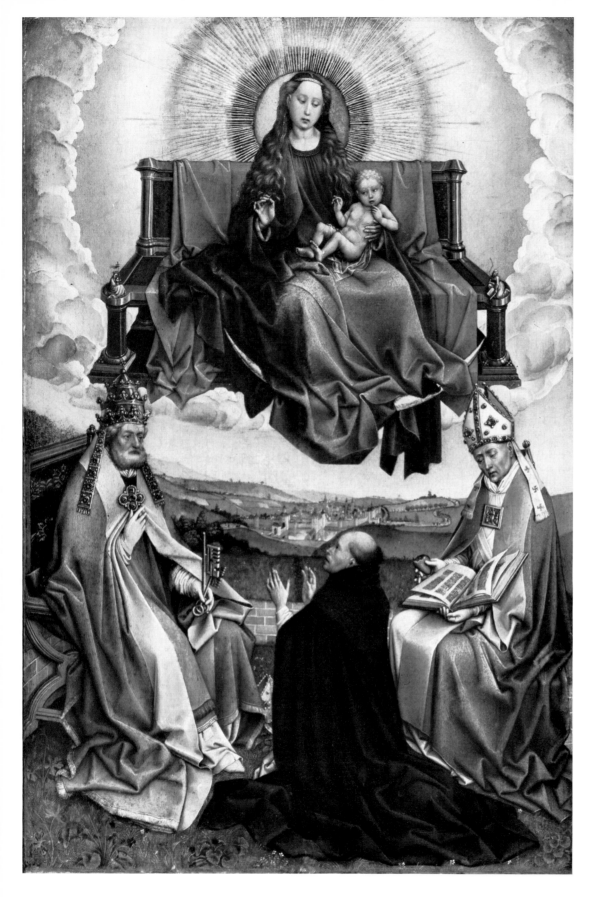

154. *The Virgin and Child, SS. Peter and Augustine, and a Donor.* 19 × 12½ in.
Aix-en-Provence, Musée Granet (Cat. Campin, Aix)

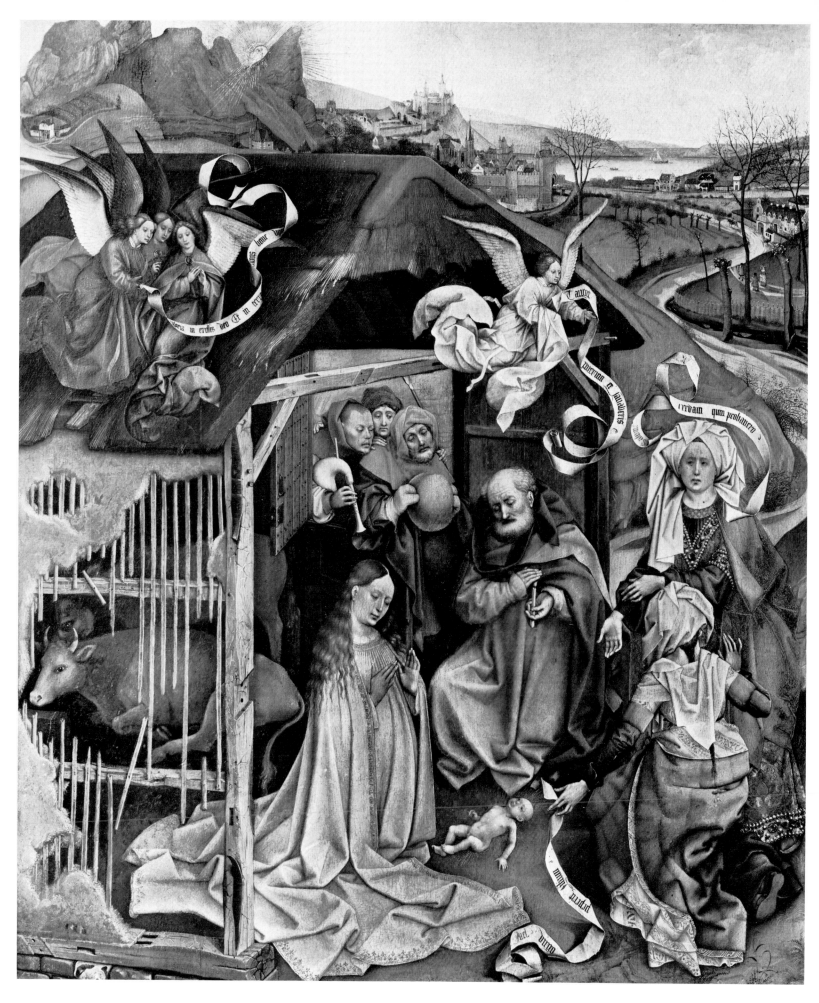

155. *The Nativity.* 34¼ × 28¾ in. Dijon, Musée des Beaux-Arts (Cat. Campin, Dijon)

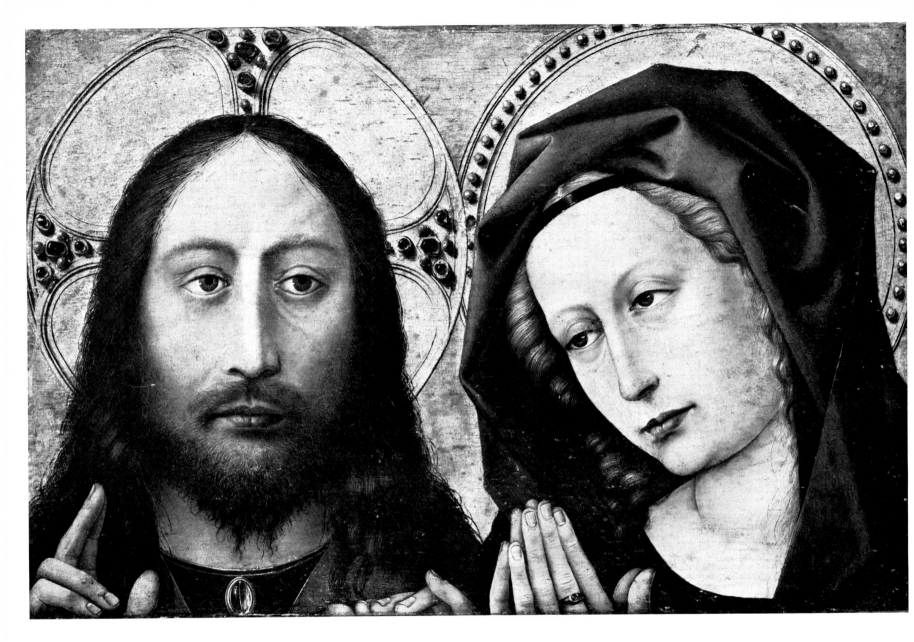

156. *Christ blessing, with the Virgin in Prayer.* 11¼ × 17¾ in. Philadelphia, John G. Johnson Collection (Cat. Campin, Philadelphia)

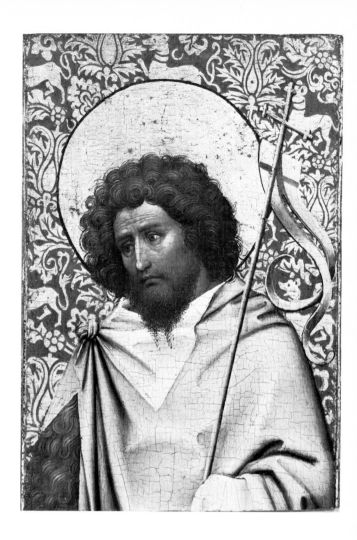

157. *St. John the Baptist.* Fragment, 6¾ × 5 in.
Cleveland, Museum of Art (Cat. Campin, Cleveland)

158. *The Virgin and Child with Saints and
Donors in an Interior.* Drawing, 7 × 9¼ in.
Paris, Louvre, Cabinet des Dessins
(Cat. Campin, Paris)

159. *The Virgin and Child in a Flowery Setting*. $14\frac{5}{8} \times 10$ in. Berlin-Dahlem, Staatliche Museen
(Cat. Campin, Berlin 1)

160. *The Virgin and Child before a Fire-Screen*. $25 \times 19\frac{1}{4}$ in.
London, National Gallery (Cat. Campin, London 2)

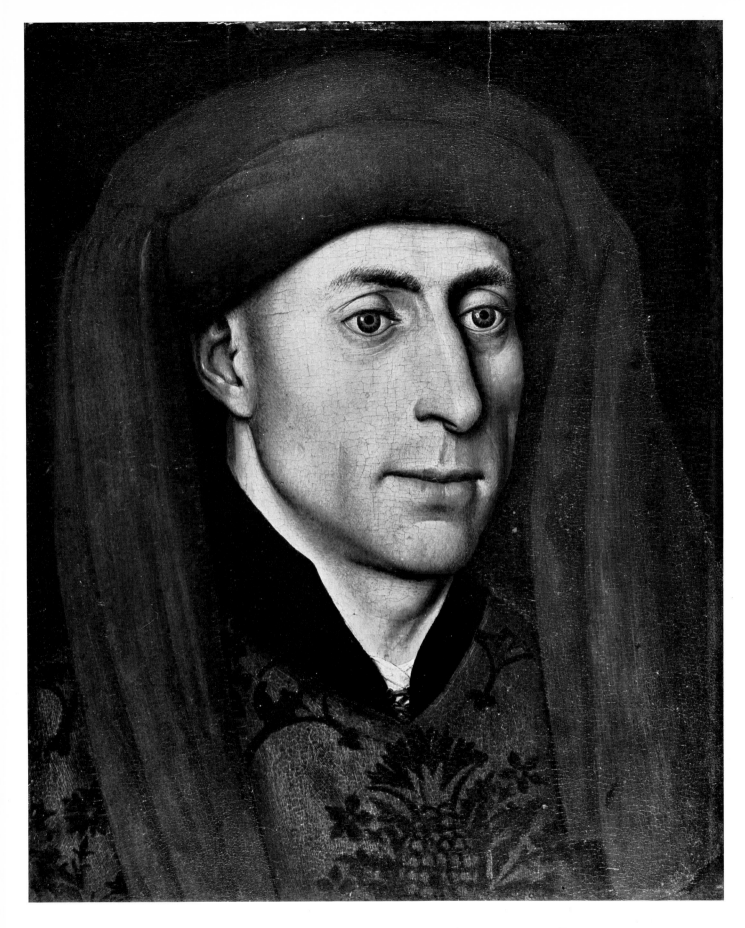

161. *Portrait of a Man.* 14⅝ × 11⅞ in. Berlin-Dahlem, Staatliche Museen (Cat. Campin, Berlin 3)

62. *Bust Portrait of a Fat Man.* $11\frac{1}{4} \times 7$ in.
Berlin-Dahlem, Staatliche Museen
(Cat. Campin, Berlin 2)

163. *A Man*. 16 × 11 in. London, National Gallery (Cat. Campin, London 1)

164. *A Woman*. 16 × 11 in. London, National Gallery (Cat. Campin, London 1)

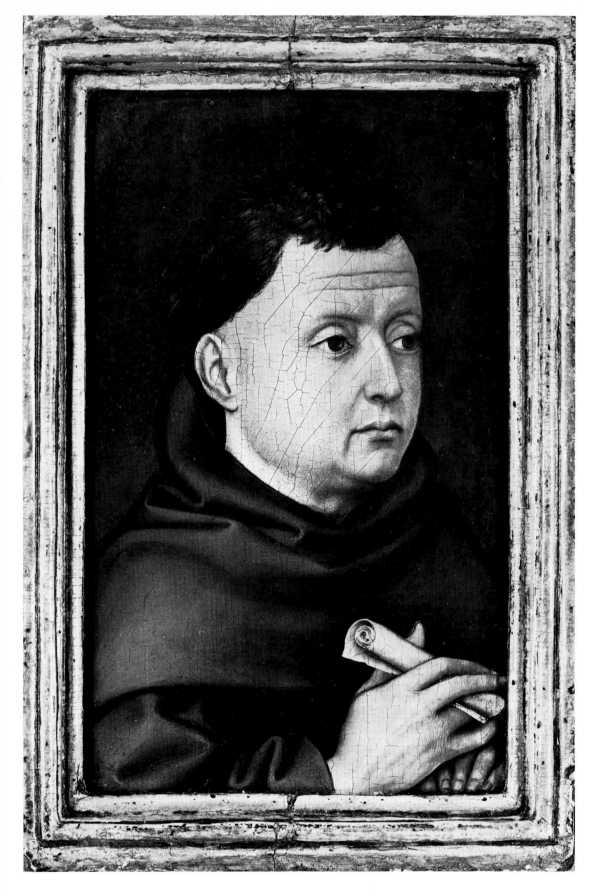

165. *Portrait of a Man.* 9 × 6 in. (including the original frame). London, National Gallery
(Cat. Campin, London 5)

JACQUES DARET

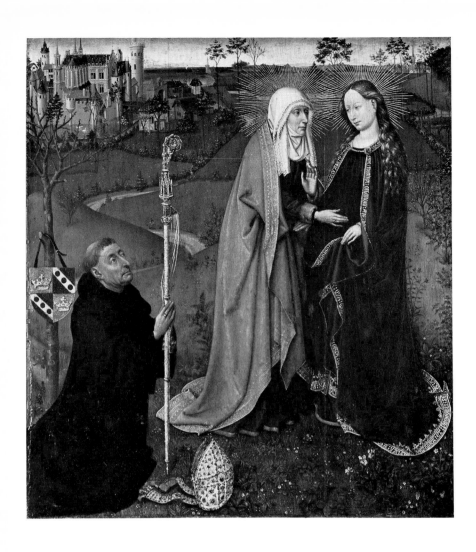

166. *The Visitation.* $22\frac{1}{2} \times 20\frac{1}{2}$ in.
Berlin-Dahlem, Staatliche Museen

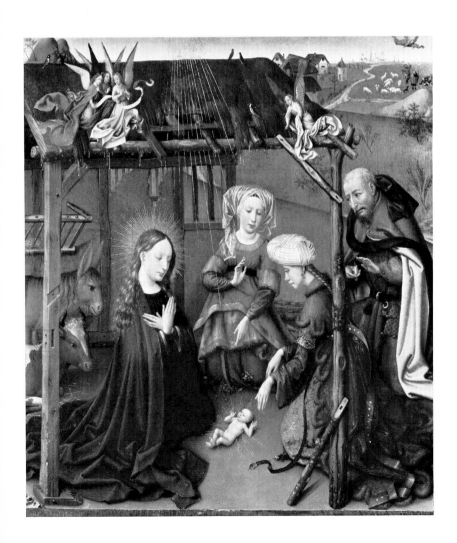

167. *The Nativity.* $22\frac{1}{2} \times 20\frac{1}{2}$ in.
Lugano, Thyssen-Bornemisza Collection

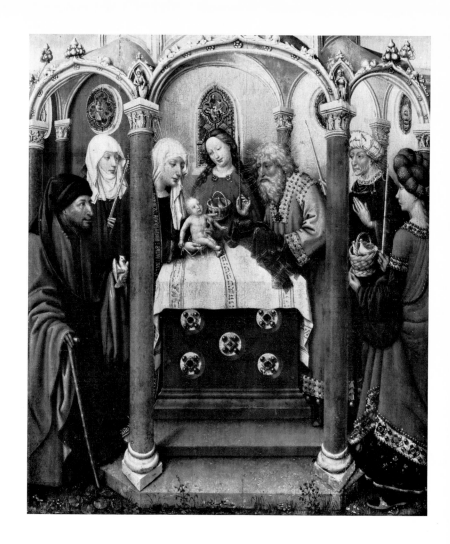

168. *The Presentation.* $22\frac{1}{2} \times 20\frac{1}{2}$ in.
Paris, Musée du Petit Palais

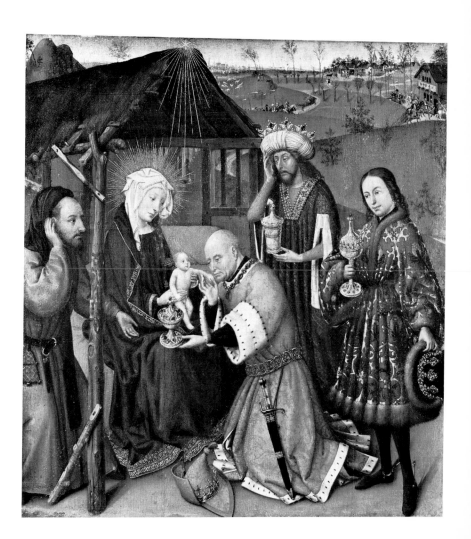

169. *The Adoration of the Magi.* $22\frac{1}{2} \times 20\frac{1}{2}$ in.
Berlin-Dahlem, Staatliche Museen

BIBLIOGRAPHICAL ABBREVIATIONS

BIOGRAPHICAL DATA AND RECORDS OF WORKS: A SELECTION

CATALOGUE

ROGIER VAN DER WEYDEN

ROBERT CAMPIN

BIBLIOGRAPHICAL ABBREVIATIONS

Beenken, 1951 — H. Beenken, *Rogier van der Weyden*, 1951

Corpus — *Les Primitifs Flamands. I. Corpus de la Peinture des Anciens Pays-Bas Méridionaux au Quinzième Siècle*. (In progress.) Cited as follows:

Corpus, Bruges, 1959 — A. Janssens de Bisthoven, *Musée Communal des Beaux-Arts (Musée Groeninge) Bruges*, 2nd edition in French, 1959

Corpus, Granada, 1963 — R. van Schoute, *La Chapelle Royale de Grenade*, 1963

Corpus, Leningrad, 1965 — V. Loewinson-Lessing and N. Nicouline, *Le Musée de l'Ermitage, Leningrad*, 1965

Corpus, London, 1953, 1954, 1970 — M. Davies, *The National Gallery, London*; Vol. I, 1953; Vol. II, 1954; Vol. III, 1970

Corpus, New England Museums, 1961 — C. Eisler, *New England Museums*, 1961

Corpus, Paris, 1962 — H. Adhémar, *Le Musée National du Louvre*, Vol. I, 1962

Corpus, Poland (or Pologne), 1966 — J. Bialostocki, *Les Musées de Pologne*, 1966

Corpus, Turin, 1952 — C. Aru and E. de Geradon, *La Galerie Sabauda de Turin*, 1952

Crowe and Cavalcaselle, 1862–3 — J. A. Crowe and G. B. Cavalcaselle, *The Early Flemish Painters*, 1857. The edition for which an abbreviated reference is given is a French translation, *Les Anciens Peintres Flamands*, with additional matter by Alex. Pinchart and Ch. Ruelens, 1862–3. Editions other than these two were issued; one in German by Springer, 1875, gives documents conveniently

Destrée, 1930 — Jules Destrée, *Roger de la Pasture*, 1930; Vol. I, text; Vol. II, plates

Feder, 1966 — T. H. Feder, 'A Re-examination through Documents of the First Fifty Years of Roger van der Weyden's Life', in *The Art Bulletin*, vol. XLVIII, 1966, pp. 416 f.

Folie, 1963 — Jacqueline Folie, 'Les Oeuvres Authentifiées des Primitifs Flamands', in the *Bulletin de l'Institut Royal du Patrimoine Artistique*, Vol. VI, 1963, pp. 207 f.

Friedländer, 1967 — Max J. Friedländer, *Early Netherlandish Painting*, Vol. II, *Rogier van der Weyden and the Master of Flémalle*. This is a translation, with supplementary material and comments by Nicole Veronee-Verhaegen, of what Friedländer wrote in his *Die Altniederländische Malerei*, Vol. II, 1924 and Vol. XIV, 1937

Houtart, 1907 — Maurice Houtart, *Jacques Daret*, 1907

Hulin, 1938 — C. Hulin de Loo, entry for Rogier van der Weyden in the *Biographie Nationale (Belgique)*, Vol. XXVII, 1938, col. 222 f.

Panofsky, 1953 — E. Panofsky, *Early Netherlandish Painting, Its Origins and Character*, 1953

Pinchart, 1867 — A. Pinchart, '*Roger de le Pasture dit van der Weyden*', in the *Bulletin des Commissions Royales d'Art et d'Archéologie* (Brussels), VI Year, 1867

Renders, 1931 — Emile Renders, avec la collaboration de Jos. De Smet et Louis Beyaert-Carlier, *La Solution du Problème van der Weyden-Flémalle-Campin*, 2 vols., 1931

Rolland, 1949 — P. Rolland, 'Les Impératifs Historiques de la Biographie de Roger', in the *Revue Belge d'Archéologie et d'Histoire de l'Art*, Vol. XVIII, 1949, pp. 145 f.

Sonkes, 1969 — Micheline Sonkes, *Dessins du XVe Siècle: Groupe van der Weyden (Les Primitifs Flamands, III, Contributions à l'Etude des Primitifs Flamands)*, 1969

Tolnay, 1939 — C. de Tolnay, *Le Maître de Flémalle et les Frères van Eyck*, 1939

Tschudi, 1898 — H. von Tschudi, 'Der Meister von Flémalle' in the *Jahrbuch der Preussischen Kunstsammlungen*, Vol. XIX, 1898, pp. 14 f., 98 f.

Winkler, 1913 — Friedrich Winkler, *Der Meister von Flémalle und Rogier van der Weyden*, 1913

Winkler, 1942 — Friedrich Winkler. Entry for Rogier van der Weyden in Thieme-Becker, *Allgemeines Lexikon der Bildenden Künstler*, Vol. XXXV, 1942, pp. 468 f.

Winkler, 1950 — Friedrich Winkler. Entry for the Master of Flémalle in Thieme-Becker (as above), Vol. XXXVII, 1950, pp. 98 f.

BIOGRAPHICAL DATA AND RECORDS
OF WORKS: A SELECTION

Rogier van der Weyden

9 or 1400 Born at Tournai.

The date is deduced from documents of 1435 and 1442 (q.v.), in which he is stated to be 35 and 43 years old; see the comment by Pinchart, 1867, p. 444.

The place of birth is established *inter al.* from the record of a memorial service for him in 1464, with candles given by the Corporation de S. Luc at Tournai. Pinchart, 1867, pp. 442 f.; Renders, 1931, vol. I, p. 124.

His surname occurs also in French (de le Pasture) and Latin (de Pascuis). *Weyden* in Flemish means a meadow.

Some secondary sources give *Rogier of Bruges* and *Rogier of Louvain*; also *Rogier of Brussels*. It is safe to assume that no separate Rogier of distinction as a painter existed.

ca. 1426 His son Corneille born. Documents from which this is deduced in Pinchart, 1867, pp. 457 f. Comment on this and on Rogier's marriage by Feder, 1966, pp. 420 f.

1426 (7 November) 'Maistre Rogier de le Pasture' received a present of wine from the town of Tournai. This seems to be in disaccord with apprenticeship to Robert Campin in the following year (q.v.); attempts to accord it are unconvincing. It has therefore been suggested that Campin's apprentice in 1427 was not the great painter Rogier, a thesis very difficult to defend. Alternatively, and much preferably, the recipient of wine in 1426 was a different man; he is not described as a painter. Renders, 1931, vol. I, p. 123; Feder, 1966, p. 419.

1427-32 5 March, 1426 (o.s.), i.e. 1427. 'Rogelet de le Pasture, natif de tournay Commencha son apresure le cinqiesme Jour de mars lan mil CCCC, vingt six. Et fut son maistre Maistre Robert Campin, paintre Lequel Rogelet a parfait son apresure deuement avec sondit maistre.' Renders, 1931, vol. I, pp. 56 f., 136. Destrée, 1930, p. 39 (facsimile). Feder, 1966, pp. 422 f. It has been unreasonably doubted that this entry refers to the great and famous Rogier van der Weyden.

1 August 1432. 'Maistre Rogier de le pasture, natif De tournay, fut Receu a la francise Du mestier, des paintres Le premier Jour daoust lan dessusdit' (i.e. 1432). Renders, 1931, vol. I, pp. 57, 136. Destrée, 1930, p. 39 (facsimile). Unreasonable doubt, as for the preceding.

1430 (?) A most doubtful date of 1430 has been associated with Rogier, in an inscription (stated to be of the sixteenth century) that gives the sitter of a portrait as Philippe de Machefoing (who is re-corded from 1442, died 1453): see Jacques Dupont in *Annales du XXXe Congrès de la Fédération Archéologique et Historique de Belgique 1935*, 1936, pp. 30 f. The picture is reproduced by Dupont, and in the exhibition catalogue *Portraits Français*, at the Galerie Charpentier, Paris, 1945 (no. 116). It was in the Mme. Tudor Wilkinson sale, Paris, 3-4 July 1969 (lot 38). It is believed to be of the sixteenth century, and claimed to be a varied copy of a lost portrait by Rogier. The association with Rogier seems doubtful and the picture has no catalogue entry here. Winkler, 1942, p. 474, objects to the date 1430 for the presumed original.

1435 Money invested by Rogier in Tournai stock; Rogier stated to be aged 35, and living at Brussels. Pinchart, 1867, pp. 433 f.; Feder, 1966, pp. 426 f.; facsimile in Destrée, 1930, pp. 58 f.

1435 (September) At this date Jacques Daret had painted four existing pictures, which show stylistic connections with pictures assigned to Rogier and to Campin. See under Daret.

1436 Rogier already town-painter of Brussels; among economies proposed was that the post should be abolished after Rogier's death. Pinchart, 1867, pp. 446 f.; Feder, 1966, pp. 427 f.; facsimile of the relevant part of the document in Destrée, 1930, p. 60.

1436-7 Three mentions of work at Tournai by Master Rogier the painter, who has reasonably been claimed to be Rogier Wanebac, master at Tournai in 1427. For the documents and dispute of this, see Renders, 1931, pp. 121, 134, 171. See also Panofsky, 1953, p. 155. A Rogier Bonnevacq painter is recorded at Tournai in connection with Campin; see under Campin, 1422.

1437 There is some evidence for believing that *The Exhumation of St. Hubert* and its pendant (Plates 99-100), ascribed by some critics to Rogier, are not earlier than 1437. See the catalogue entry for Rogier: London 2.

1438 Date on a picture in the Prado showing Heinrich von Werl and St. John the Baptist; an associated picture shows St. Barbara (Plates 152-3). They are without much exception ascribed to Campin (q.v.). They are stylistically near to Rogier.

1439 Four pictures of Justice in the town hall at Brussels have been destroyed, apparently in 1695. One of the two for Trajan is recorded in the seventeenth century to have borne a signature or name inscribed, and a date of 1439. One of the two for

Herkinbald is similarly recorded to have had a signature or name inscribed; dating of these has been questioned. See the entry Rogier: Brussels, Town Hall (formerly). Rogier's most famous works, while they existed.

1439–40 Polychroming of a sculptured relief in the Franciscan church at Brussels; paid for by Philip the Good. Pinchart, 1867, pp. 413 f. Winkler, 1913, p. 181.

1441 Colouring by Rogier of a dragon used in a religious procession. Destrée, 1930, p. 64.

1442 (n.s.) More money invested by Rogier in Tournai stock. Rogier stated to be living at Brussels aged 43 (this may refer back to 1441). Pinchart, 1867, pp. 436 f.; Destrée, 1930, p. 66.

1443 Date on the Edelheer altarpiece at Louvain (cf. Figs. 16–17), which is mostly dependent on the *Deposition* now in the Prado (Plate 1); that is the first of bases for attribution to Rogier. See the entry for Rogier: Madrid 1.

1443 Rolin's Hospital at Beaune formally founded; the altarpiece of the chapel, representing *The Last Judgement* (Plates 34–48), is assigned to Rogier. The picture was probably completed not later than 1451 (dedication of the chapel), or else 1452 (change of patron saint of the Hospital). See the entry for Rogier: Beaune.

ca. 1444 The Bladelin altarpiece (Plates 26–33) assigned to Rogier was beyond reasonable doubt at Middelburg near Bruges, and may well be not earlier than ca. 1444; how much later not being established. See the entry for Rogier: Berlin 4.

1445 King John II of Castile gave a triptych to the Charterhouse of Miraflores near Burgos (see Fig. 4); for the specification then to Rogier and for the picture, see the entry Rogier: Granada. A weak argument for before 1438 is there recorded; it is based on the date 1438 for two pictures in the Prado (see 1438, above). The Granada triptych (Plates 13–15) is assigned to Rogier.

1446 Date recorded for a missing picture by 'a certain Rogerus', once in the Carmelite monastery at Brussels. In the record (by Sanderus) it is stated to have been damaged in 1581 and repaired in 1593; some description. Winkler, 1913, p. 188. See Rogier: Rotterdam, for a drawing of the Virgin and Child (Plate 115) that has been connected (Panofsky, 1953, p. 266).

1446 This or soon after is the date of a miniature, *Jean Wauquelin presents a book to Philip the Good* (Plate 74), which is sometimes ascribed to Rogier. See the entry Rogier: Brussels, Bibliothèque Royale.

1449 Picture by *Rogier of Brussels* (or, in the heading of the passage, *of Bruges*) shown by Lionello d'Este (d. 1450) at Ferrara to Ciriaco d'Ancona (d. 1457). A *Deposition* and the *Fall*; less unclearly recorded by Fazio (see 1456). The *Deposition* has unsatisfactorily been identified with a picture in the Uffizi (see Rogier: Florence).

ca. 1449 This date is deduced for a missing picture, once at Batalha, for which Rogier's authorship has been suggested. See the entry Rogier: Batalha.

1450 Fazio, writing in 1456, records that Rogier visited Rome in the Holy Year (1450); the duration of his visit to Italy is not known, nor is his route. Fazio says that Rogier admired frescoes (now missing) by Gentile da Fabriano in the Lateran. Consult especially Michael Baxandall in the *Journal of the Warburg and Courtauld Institutes*, vol. XXVII, 1964, pp. 90 f. (p. 101). Feder, 1966, p. 430. For other things recorded by Fazio, see the year 1456.

1450 Payment in 1450 to Rogier *via* Bruges for various pictures for Lionello d'Este (d. 1450), Ferrara. There is no evidence that Rogier did the work in Italy, and no precise identification of the work paid for: though there might be a connection with the picture shown to Ciriaco d'Ancona at Ferrara in 1449 (see under that date). See E. Kantorowicz in the *Journal of the Warburg and Courtauld Institutes*, vol. III, 1939–40, pp. 178 f.

1451 Nicolas Cusanus refers to Rogier as *maximus pictor* (see the *Repertorium für Kunstwissenschaft*, vol. XXXIX, 1916, p. 20). This is apropos of a self-portrait appearing in his lost murals in the town hall of Brussels; see under Rogier: Brussels, Town Hall, and Various Collections 6, in the catalogue.

1451 This date appears on an *Annunciation* somewhat in Rogier's style, in the Metropolitan Museum of Art, New York; Friedländer, 1967, no. 103, plate 115.

1451 (or preferably a little later) There is some evidence of this date for the triptych of the *Sacraments* (Plates 54–7), assigned to Rogier; see the entry for Rogier: Antwerp 2.

ca. 1452 An unidentified picture, subject not stated, of about this date was in S. Gudule at Brussels; reliably recorded, it seems, as Rogier's. See Plac. Lefèvre, O. Praem., in *Mélanges Hulin de Loo*, 1931, pp. 237 f.

1452 There is some evidence that the Braque triptych assigned to Rogier (Plates 49–53) is not much later than 1452; it could be just a little earlier. See the entry for Rogier: Paris 1.

1454 Foundation of the Charterhouse of Scheut near Brussels. *Christ on the Cross with the Virgin and St. John* in the Escorial (Plates 10–12) was once there; it is the second best documented picture for attribution to Rogier. See the entry.

1454 This may be the earliest date for a *Virgin and Child* assigned to Rogier or his studio (Plate 84); see Rogier: Houston.

1455–9 Missing altarpiece, commissioned of Rogier in 1455 by Jean Robert, Abbot of S. Aubert at Cambrai; delivered in 1459 at Cambrai, possibly or probably by Rogier himself. The text has fairly recently been established as meaning an altarpiece with two shutters, not two (or eleven) scenes; see Panofsky, 1953, p. 474. To be dismissed are a long enduring claim for identification with an inferior triptych in the Prado (Friedländer, 1967, no. 47, plates 66–7; mentioned under Rogier: Antwerp 2); and a claim for a diptych in the J. G. Johnson Collection at Philadelphia (see the entry).

1456 In this year, Fazio wrote comments on Rogier: these include Rogier's visit to Rome in 1450, which has been recorded under that year. Fazio refers to Rogier as a pupil of Jan van Eyck. The works by Rogier he specifies are:

1. a picture at Ferrara, clearly the same as one seen by Ciriaco d'Ancona in 1449 (see that year). Fazio specifies that it was a triptych, with the *Fall* on one wing, a donor on the other.

The central panel has been claimed to be identical with a picture in the Uffizi at Florence, which is highly doubtful (see Rogier: Florence).

2. at Genoa a woman in a bath and two youths observing. Not identified.

3. tapestries (?) of the Passion owned by King Alfonso of Naples (cf. 1524, Summonte). Not identified.

4. Work at Brussels in a church (unidentified).

For Fazio's evidence, consult especially Michael Baxandall in the *Journal of the Warburg and Courtauld Institutes*, vol. XXVII, 1964, pp. 90 f. (pp. 105 f.). Cf. Winkler, 1913, pp. 182, 189.

1458 (May) Alessandro Sforza of Pesaro returned from an eight-months journey to Burgundy and Flanders, including Bruges. A portrait of him and two other pictures, assigned to Rogier, are recorded at Pesaro in 1500; for details, see Rogier: Brussels 3.

1458–9 Payment to Rogier for colouring statues. Winkler, 1913, p. 183.

1460–3 1460, letter of introduction from Milan, wrongly (?) referring to Master Gulielmus; 1463, letter of thanks from Milan addressed to 'Mro Rugerio de Tornay pictori in Burseles'. The first is certainly associable with the second. They concern the painter Zanetto Bugatto, and his studying painting in Flanders, i.e. with in fact Rogier, during the period. The apparently wrong name in 1460 may suggest that Rogier, although already of repute in Italy, was not so famous in court circles at Milan as some might wish. See F. Malaguzzi Valeri, *Pittori Lombardi del Quattrocento*, 1902, pp. 126 f.; Destrée, 1930, p. 36 (facsimile of the second document). The Sforza triptych (Rogier: Brussels 3) has been associated with Bugatto; the association has been denied.

1461 There is evidence that the portrait of Philippe de Croy, assigned to Rogier, at Antwerp (Plate 94) is not later than 1461 (probably not much earlier). See the entry Rogier: San Marino.

1462 (May) Rogier advanced money to the Charterhouse of Scheut near Brussels. Pinchart, 1867, pp. 476 f. At an undefined date, this monastery received from Rogier (and his wife) money and unspecified pictures (Pinchart, 1867, p. 452); Pinchart thinks this was before 1460 (no record being found in the accounts for 1460–5, which he could consult). This house was founded in 1454 (see under that date).

1462 Picture of this date claimed to be a self-portrait of Rogier, recorded in the house of Zuan Ram at Venice; See under 1530–1 (Anonimo Morelliano).

1463 A picture at The Hague (Plate 119) is most probably not earlier than 1463; it is assigned to Rogier or his studio or a follower. See the entry.

1464 (June 18) Died at Brussels. The date has been given as June 16 and June 18; in favour of the latter date, see Plac. Lefèvre, O. Praem., in *Mélanges Hulin de Loo*, 1931, pp. 237 f. Memorial service at Tournai, with which the Corporation de S. Luc there associated itself; facsimile of the record in Destrée, 1930, p. 40. Pinchart, 1867, pp. 442 f.; Feder, 1966, p. 427.

ca. 1464 (or a little earlier) Mentioned by Filarete; Winkler, 1913, p. 190. But see also E. K. J. Reznicek in the *Miscellanea Jozef Duverger*, 1968, I, pp. 83 f.

1476 Battista de Agnelli is stated to have given an altarpiece, stated to be by Rogier, of the life of St. John the Baptist to the church of S. Jacques at Bruges. For the unsatisfactory state of knowledge concerning this, see the entry Rogier: Berlin 1. See also 1520–1 (Dürer).

ca. 1485–90 'Rugero' praised by Giovanni Santi, as 'discepol' of Johannes (van Eyck). Winkler, 1913, p. 190.

1500 Inventory of Giovanni Sforza of Pesaro including three pictures ascribed to Rogier (of Bruges). Two were most probably destroyed in 1514; the third has been claimed to be the Sforza triptych. See Rogier: Brussels 3 for details.

1516–24 In inventories of Margaret of Austria are recorded as by Rogier:

(a) a small Pietà, with wings painted by Hans. Not identified.

(b) a small Trinity. Not identified.

(c) a portrait of Charles the Bold. See the entry Rogier: Berlin 5 (though it is not the same picture).

(d) a small Crucifix and St. Gregory, apparently a diptych. Not identified.

For the texts and comment on them, see Winkler, 1913, pp. 184 f.

1520–1 Unspecified paintings by Rogier recorded by Dürer as seen by him in 1521 at Bruges, in S. Jacques and ('gemalt Capelln') in the Prinsenhof. For S. Jacques, compare the record under 1476 above; conceivably the diptych of Jean de Gros could also have been seen there by Dürer (see Rogier: Tournai). In Brussels in 1520 Dürer saw the Justice scenes in the town hall (see the year 1439); also a 'Sanct Lucas Tafel', no painter's name recorded by Dürer, sometimes claimed to be the *S. Luke* assigned to Rogier (see the entry Rogier: Boston). See also especially Panofsky, 1953, p. 253.

1524 Pietro Summonte in a letter of 1524 on art at Naples to Marcantonio Michiel refers to tapestries (?) of the Passion, which he knew at least by repute; they seem clearly identical with the work recorded by Fazio (see 1456). See F. Nicolini, *L'Arte Napoletana del Rinascimento*, 1925, pp. 162 f., 233 f.

1528 The painter Rogier van der Weyden the Younger, great-grandson of the subject of this book, was received Master at Antwerp. He died 1538–43; his paintings have not been identified. See Léon de Burbure, *Documents Biographiques . . . pour . . . Gossuin et Roger van der Weyden le Jeune*, 1865, pp. 9 f. The sure existence of this painter is possibly relevant to confusions concerning the great Rogier.

1530–1 The Anonimo Morelliano (Italian) records in the house of Zuan Ram at Venice a portrait of 1462 claimed as a self-portrait of Rogier. Text frequently quoted; Pinchart, 1867, pp. 449, 478 f.

Sometimes identified as a portrait of 1462 assigned to Bouts, in the National Gallery in London, no. 943; cf. the catalogue, *Early Netherlandish School*, 1968, pp. 17 f.

The Anonimo also records as by Rogier a small Virgin and Child in the Vendramin collection; sometimes claimed, but with little or no justification, to be that at Vienna (see Rogier: Vienna 1). Winkler, 1913, pp. 185 f.

1550 (and 1568) Rogier recorded by Vasari as a disciple of Jan van Eyck. Winkler, 1913, pp. 191 f.

Before 1563 Felipe de Guevara (c. 1500–63) records as by 'Rugier' a portrait of his father, Don Diego de Guevara, painted about 90 years before Felipe wrote. Don Diego died in 1520, *his* father in 1441; see Abdón M. Salázar in the *Archivo Español de Arte*, vol. XXVIII, 1955, pp. 129, 131. For the record of this lost or unidentified portrait, see Sánchez Cantón, *Fuentes Literarias*, etc., vol. I, 1923, pp. 172 f. Salázar, *loc. cit.*, p. 137, dates Felipe de Guevara's treatise c. 1560–2, which is more than 90 years after Rogier's death in 1464.

1565 Date on engraving by C. Cort of a composition closely corresponding in the figures with the picture now in the Prado (see Madrid 1). The engraving is inscribed *M. Rogerij Belgiae inuentum*.

ca. 1570 Molanus, the historian of Louvain, records as by Rogier 'civis et pictor Lovaniensis' the Edelheer altarpiece in S. Pierre (still there), the *Deposition* now in the Prado, and a copy of it by Coxcie (apparently the picture now in the Escorial). All these are recorded in the entry for Rogier: Madrid 1. Text in Pinchart, 1867, p. 417.

1574 Four pictures are recorded among gifts by Philip II to the Escorial, with attribution to Rogier (the form of the name varying slightly).

1. The *Deposition*, now in the Prado (Plate 1), is clearly recognizable; the entry for it provides the first item in any list now to be drawn up of pictures attributable to Rogier. See Madrid 1.

2. *Christ on the Cross between the Virgin and St. John*, still in the Escorial (Plate 10), is only a little behind as a basis for attribution. See the entry, under Escorial.

3. An upright *Pietà* showing four figures is reasonably identifiable with a composition known in several versions. The one recorded in 1574 should be an original; the one now on view in the Escorial is not. See Rogier: Various Collections 2.

4. A *St. Luke* is imprecisely recorded in 1574. The composition may have been that of *St. Luke drawing a Portrait of the Virgin*, known in several versions; the version now at Boston (Plate 76) seems to be an original (q.v.).

These four records, so far as they can be interpreted, are of serious, indeed vital, value for attribution to Rogier. No. 1 of most value; No. 2 almost on a par, for a picture the King of Spain could be vain of owning; No. 3 much less; No. 4 perhaps more than No. 3, but it is not clear what composition is referred to.

Late sixteenth century A copy (privately owned in Genoa), of the Merode *Annunciation* is stated to be probably of this date and to bear an old inscription *Rogier van der W* . . . See the entry for Campin: New York.

1604 Carel van Mander, in his history of painters, gives separate biographies of Rogier van Brugghe and Rogier van der Weyden schilder van Brussel. His statements summarized by Winkler, 1913, p. 193; van Mander mentions (as by Rogier of Brussels) the Justice scenes and the *Deposition* now in the Prado.

ca. 1623 Dubuisson-Aubenay makes a valuable record of Rogier's paintings of Justice (see under 1439 and the entry Rogier: Brussels, Town Hall). He also identifiably records, as ascribed to Rogier, a diptych of the Exhumation and the Consecration of St. Hubert in S. Gudule at Brussels; cf. the year 1437, and see the catalogue entry Rogier: London 2.

Robert Campin

1375–9 (?) Houtart in Fédération Archéologique et Historique de Belgique, *Annales, XXIIIᵉ Congrès, Gand 1913*, vol. III, 1914, p. 88, refers to documents of 1427 and 1428; he says they indicate a date of birth of 1378 or 1379, which he accepts. A document of 1422 recorded below indicates 1375 as the date of birth. The place of birth is not known; he was not a native of Tournai (see the record of 1410 below).

1406 Mention of work at Tournai by 'Maistre Robert Campin, pointre' for the late Jehanne Esquierqueline. Renders, vol. I, p. 157.

He settled at Tournai.

1406–7 Mural paintings in S. Brice at Tournai, of which it would seem that some ruined fragments of an *Annunciation* are known; apparently documented as by Campin, 1406–7. See P. Rolland, *La Peinture Murale à Tournai*, 1946, pp. 42 f., plates XXXV–XXXVIII. These do not seem to be connectable by stylistic criticism with the panel paintings assigned to the Master of Flémalle/Merode, whose identity with Robert Campin is here accepted. They have no catalogue entry in this book, being hardly fit for any art-historical study.

1408, 1413 1424–34 Mentions of work on various public or semi-public commissions at Tournai; Renders, vol. I, pp. 157 f. It is very doubt-

equently),
1441 ful if any of this work could properly be called work on
 pictures.

1410 'Maistre Robert Campin, pointre' acquired citizenship at Tour-
ember 29) nai. Pinchart, 1867, p. 489; Renders, vol. I, p. 168; Feder, 1966,
 p. 416.

ca. 1415 He received as a pupil Hannekin, son of the painter Gheeraert
 de Stoovere of Ghent; Hannekin remained with him until 1419.
 See Houtart in *Fédération Archéologique et Historique de
 Belgique, Annales, XXIIIe Congrès, Gand 1913*, vol. III, 1914,
 p. 90.

1418 The young Jacques Daret was a member of his household: see
 under Daret.

1422 Mention in a financial record that Campin was aged 47. Renders,
 vol. I, p. 168; Feder, 1966, p. 425.

1422 Mention in connection with a painter Rogier Bonnevacq.
(April 30) Renders, vol. I, pp. 171, 168. Is that Rogier distinct from Rogier
 Wanebac, who became Master at Tournai in 1427 (Renders,
 vol. I, p. 134) and has been associated with some work recorded
 at Tournai (see Rogier, 1436–7)?

1423 Election of Campin as Dean of the painters' corporation at
(June 9) Tournai. (The register of the corporation does not go back
 before 1423.) See Feder, 1966, p. 417, who comments on the
 social upheavals of the time.

1425 'Eswardeur' at Tournai, till 1427. Pinchart, 1867, p. 492; Feder,
ruary 19) 1966, p. 421, where a summary of other public offices held.

1426–8 Polychroming by Campin of a sculptured *Annunciation*, now in
 the church of the Madeleine at Tournai. See P. Rolland in the
 Revue Belge d'Archéologie et d'Histoire de l'Art, vol. II, 1932, pp.
 335 f.

1426 An apprentice to him, Haquin de Blandin.

1427 An apprentice to him, Willemet. Renders, vol. I, pp. 136–7.

27/8–1432 Had as apprentices Rogier (identical with the great Rogier van
 der Weyden for this book), and Daret; q.v.

1429 A pilgrimage to Saint-Gilles (in Provence) imposed as a punish-
 ment. Presumably, he went. Pinchart, 1867, p. 492; Renders,
 vol. I, p. 168; Feder, 1966, p. 425. Stylistic comment on this
 journey has been made by G. Troescher in the *Jahrbuch der*

Berliner Museen, 1967, pp. 100 f. See further, with corrections
to Troescher, Charles Sterling in *L'Œil*, October 1969, pp.
2 f.

This date has been claimed on wrong evidence for a large com- Before 1430
position, of which a fragment, *The Bad Thief* of Calvary (Plate
135), survives; see the entry (Campin: Frankfurt 1).

Condemnation for immoral life. 1432 (July 29)

Intervention in Campin's favour by Madame de Haynau (October 25)
(Marguerite de Bourgogne; or Jacqueline?). Renders, vol. I, p.
168. Cf. P. Rolland in the *Revue Belge d'Archéologie et d'Histoire
de l'Art*, vol. II, 1932, pp. 54 f.

At this date Jacques Daret had painted for Saint-Vaast at Arras 1435
four existing pictures (Plates 166–9), which show stylistic con- (September)
nections with pictures assigned to Campin and to Rogier; see
under Daret.

Date on one of two shutters showing Heinrich von Werl with 1438
St. John the Baptist, and St. Barbara (Plates 152–3): usually
assigned to Campin; see the entry for Campin: Madrid 2.

Cartoons of the life and passion of St. Peter (subjects having 1438
been supplied in writing), executed by Campin and to be used
for paintings by a master to be selected; Henri de Beaumetiel
was chosen, the work to be painting on 'draps de toille'. No-
thing known to exist. Renders, vol. I, pp. 159–60. P. Rolland in
the *Revue Belge d'Archéologie et d'Histoire de l'Art*, vol. II, 1932,
pp. 55 f.

The *Deposition* now in the Prado (Plate 1), first of bases for 1443
attribution to Rogier, is deducibly not later than 1443, i.e.
painted during Campin's lifetime. See Rogier: Madrid 1.

Campin died. Pinchart, 1867, pp. 492–3; Renders, vol. I, p. 168; 1444
Feder, 1966, pp. 425–6. (April 26)

A copy (privately owned at Genoa) of the Merode *Annunciation*, Late
claimed to be probably of this date, is stated to bear on it an old sixteenth
inscription *Rogier van der W . . .* See the entry for Campin: New century (?)
York. (A most obscure signature of Campin has been claimed
on the original picture, and on other pictures assigned to
Campin; see T. L. de Bruin in the *Gazette des Beaux-Arts*,
January 1966, pp. 5 f.)

Jacques Daret

1400–3 The year of his birth would be in this period according to
 Houtart in *Fédération Archéologique et Historique de Bel-
 gique, Annales, XXIIIe Congrès, Gand 1913*, vol. III, 1914, p.
 95; Houtart thinks 1401 the most likely year. He was born at
 Tournai, according to his apprenticeship records: Renders, vol.
 I, p. 136.

Recorded as a member of Robert Campin's household, 'ouvrant 1418
de son métier' in 1418; Houtart, 1907, p. 29 (various other facts (April)
given in the list here are recorded by Houtart, but he is not
specifically cited). There are some references to Daret from then
on, until 1426, in the accounts of money administered on his
behalf; not recorded here.

1426 Daret out of Tournai for a while because of the plague. Feder, 1966, p. 418.

1428
(April 2) Daret, who had been living (and presumably painting) in Campin's house for years, began his apprenticeship with Campin. There is an error in the date as given in the painters' register, but it seems clear that 1428 is correct. Renders, vol. I, pp. 136, 173.

1432
(October 18) Daret received as master into the Guild at Tournai; at once became provost. Comment on this peculiarity by Feder, 1966, p. 426.

1433
(January 8) His brother Danelet Daret became his apprentice at Tournai. Renders, vol. I, p. 138.

Jacques Daret in the succeeding years had several other apprentices at Tournai; not recorded here.

1435
(September) At this date Daret had painted four existing pictures (Plates 166–9) for the abbey of Saint-Vaast at Arras. The pictures, each size $22\frac{1}{2} \times 20\frac{1}{2}$ in. (0.57×0.52 m.) are *The Visitation* (with donor) and *The Adoration of the Kings* at Berlin (Dahlem), *The Presentation in the Temple* in the Petit Palais at Paris, and *The Nativity* in the Schloss Rohoncz collection (Baron Thyssen-Bornemisza) at Lugano. Friedländer, 1967, plates 104–5. The association with Daret was made by Hulin in *The Burlington Magazine*, vol. xv, 1909, pp. 202 f. and vol. xix, 1911, pp. 218 f. But see also Folie, 1963, pp. 213 f. The documentation is complicated, yet there is no reason at all to doubt that these pictures formed the wings of a retable in Saint-Vaast at Arras. According to Hulin they were in place by July 1435; Folie demonstrates that this was so by September 1435.

These are the only pictures established as by Daret. They are the only existing pictures touching closely on the subject of this book where the attribution is to be considered documented from contemporary record. For connections between these pictures and Rogier or Campin, see in the catalogues Rogier, Leipzig; Rogier, Turin; Campin, Dijon; Campin, Berlin 6.

1441 Recorded at Arras.

1444–58 Living at Arras. A painted altarpiece there of 1452, according to Hulin in *The Burlington Magazine*, vol. xv, 1909, p. 208; not known to exist.

1468 Prominent in supplying decorations for the marriage of Charles the Bold at Bruges.

CONCORDANCES

Index of the Numbers of Friedländer 1967

(*Early Netherlandish Painting*, Vol. II, *Rogier van der Weyden and the Master of Flémalle*)

Friedländer No.	Main Catalogue entries or references (if any) in the present volume	Friedländer No.	Main Catalogue entries or references (if any) in the present volume
1	Rogier: Granada	14	Rogier: Beaune
2	Rogier: Berlin 1	15	Rogier: Philadelphia
3	Rogier: Madrid 1	16	Rogier: Antwerp 2
4	Rogier: Berlin 2	17.	Rogier: Berlin 3
5	Rogier: Leipzig	18, 19	Rogier: London 2
6	Rogier: Turin	20	Rogier: London 3
7	Rogier: Vienna 1	21	Rogier: Frankfurt
8	Rogier: Lugano 1	22	Rogier: Florence
9	Rogier: Turin	23	Rogier: New York 1
10	Rogier: Antwerp 1	24	Rogier: Brussels 1
11	Rogier: Vienna 2	25	Rogier: Escorial
12	Rogier: London 1	26	Rogier: Paris 1
13	Rogier: New York, Rockefeller	27	Rogier: Chicago

Friedländer No.	Main Catalogue entries or references (if any) in the present volume	Friedländer No.	Main Catalogue entries or references (if any) in the present volume
28, 29	Rogier: Tournai	77	Campin: London 4
29A	Rogier: Washington	78–81	Daret: see his biographical data
30, 31	Rogier: Caen	82	Mentioned under Campin: Madrid 1
32	Rogier: Lugano 2	83	Mentioned under Rogier: London 2
33	Rogier: Indianapolis (formerly)	84	Rogier: Antwerp (Cathedral)
34	Rogier: London 4	85	Mentioned under Rogier: Munich 1
35	Rogier: Houston	86	—
36	Rogier: London 1	87	Mentioned under Rogier: Riggisberg
37	Rogier: Brussels 2	88	Mentioned under Campin: Frankfurt 1
38	Rogier: Berlin 4	89	—
39, 40	Rogier: San Marino (Cal.)	90	Mentioned under Rogier: Madrid 1, Vienna 2
40A	Rogier: New York 2		
41	Mentioned under Rogier: Granada	91	Mentioned under Rogier: Various Collections 1
42	Rogier: Berlin 5		
43	Rogier: Berlin 6	92	—
44	Mentioned under Rogier: Brussels 1	93	Rogier: Brussels 3
45	Rogier: Upton	94	Rogier: Various Collections 1
46	Rogier: The Hague	95	Rogier: Munich 2
47	Mentioned under Rogier: Antwerp 2 and in Rogier's biographical data (Cambrai, 1455–1459)	96	—
		97, 98	Rogier: Various Collections 2
		99	—
48	Rogier: New York 3	100, 101, 102	—
49	Rogier: Munich 1	103	Mentioned among Rogier's biographical data (1451)
50	Campin: Berlin 1		
51, 52	Campin: Madrid 1	104, 105	—
53	Campin: Dijon	106	Rogier: Boston
54	Campin: New York (The Cloisters)	107, 108, 109	Mentioned under Rogier: Boston
55	Campin: London 1	110	Rogier: Donaueschingen (formerly)
56	Campin: Philadelphia	111, 112, 113,	—
57	Campin: Washington (Dumbarton Oaks)	114, 115, 116,	—
58	Campin: London 2	117, 118, 119	—
59	Campin: Frankfurt 1	120	Rogier: Various Collections 3
60	Campin: Frankfurt 2	121	Rogier: Various Collections 4
61	Campin: Berlin 2	122	Mentioned under Rogier: Frankfurt
62	Campin: Berlin 3	123, 124	—
63	Campin: New York (Magnin)	125	Rogier: Various Collections 5
64, 65	Campin: Leningrad	126	Rogier: Paris 2
66	Campin: Aix	127	Rogier: Turin
67	Campin: Madrid 2	128	Rogier: Budapest
68	Campin: Berlin 4	129	Rogier: Petworth
69	Campin: Brussels 1	130	Rogier: Lugano 1
70	Campin: Various Collections	131	Rogier: Riggisberg
71	Campin: Louvain	132	Rogier: Madrid 2
72	Campin: Paris (Cabinet des Dessins)	133	Rogier: Detroit
73	Campin: Brussels 2	134	Rogier: Maidenhead
74	Campin: London 3	135	Rogier: New York 4
75	Campin: Berlin 5	136, 137	—
76	Campin: Berlin 6	138	Mentioned under Rogier: Boston

Friedländer No.	Main Catalogue entries or references (if any) in the present volume	Friedländer No.	Main Catalogue entries or references (if any) in the present volume
139	Rogier: Various Collections 1	148	Campin: London 5
140	Mentioned under Rogier: Various Collections 1	149	Campin: Cleveland
		150	Campin: Brussels 2
141	Mentioned under Rogier: Petworth	151	Campin: Brussels, Gendebien
142	—	152	Campin: Washington
143	Mentioned under Rogier: Brussels 3 and Detroit	153	Campin: Le Puy
		154	Mentioned under Campin: Berlin 2
144	Mentioned under Rogier: Various Collections 1	155	Mentioned under Campin: New York (The Cloisters)
145	Rogier: London 1	156	Mentioned under Campin: Leningrad
146	Rogier: Cologne	157	Campin: Lugano
146A	Rogier: Rotterdam	158, 159	—
147	Campin: London, Seilern	160	Mentioned under Rogier: Granada

Index of the Numbers of Sonkes 1969

(Dessins du XVᵉ Siècle: Groupe van der Weyden)

The present book is not about the drawings more or less closely associated with Rogier or Campin; drawings are recorded in it if they have some interest from the point of view of Rogier's paintings. The following list is for only some of the drawings mentioned, where the drawing is of particular importance for the composition.

Sonkes No.	Main Catalogue entries or main references in the present volume
A 1	Rogier: Various Collections 6
A 4	Rogier: Rotterdam
C 1, 2	Campin: Berlin 5
C 3	Campin: Berlin 6
C 7	Campin: Paris
C 9	Rogier: London 1
C 10	Rogier: Various Collections 4
C 11	Rogier: Batalha (formerly)
C 17, 23, 24	Rogier: Various Collections 1
E 12	Rogier: Brussels, Town Hall (formerly)

Sonkes accepts five drawings as originals by Rogier. Her A1 and A4 are recorded above. Her A2 is mentioned in the present volume under Rogier: Granada. Her A5 is mentioned under Rogier: Donaueschingen, and Tournai. Her A3, a beautiful drawing, is the *Portrait of a Lady* in the British Museum. Sonkes accepts no drawing as an original by Campin.

CATALOGUE OF WORKS
ASSOCIATED WITH
ROGIER VAN DER WEYDEN

The Annunciation

Antwerp, Koninklijk Museum voor Schone Kunsten

8 × 4¾ in. (0.20 × 0.12 m.).

The attribution of this minor little picture to Rogier has often been questioned. Accepted by Friedländer, 1967, p. 62, no. 10. Rejected by Panofsky, 1953, p. 482, who thinks of a miniaturist. I do not associate it closely with Rogier. A large version of 1489 assigned to the Swabian School is at Carlsruhe: Catalogue 1966, p. 276, no. 806a (reverse); plate volume, p. 78.

The Antwerp picture was in the collection of the Chevalier Florent van Ertborn, who bought it in Germany in 1833; bequeathed by him to Antwerp, 1841.

Friedländer, 1967, no. 10
Panofsky, 1953, index.

Triptych: **Altarpiece of the Sacraments**

Antwerp, Koninklijk Museum voor Schone Kunsten

Central panel, 78½ × 38¼ in. (2.00 × 0.97 m.); wings, 46¾ × 24¾ in. (1.19 × 0.63 m.). The wings appear to be fixed wings; according to the Antwerp catalogue, shutters originally could be reasonably supposed.

Rather damaged. In particular Panofsky, from notes by Robert A. Koch, lists among the small figures ten repainted heads and the addition of one figure; this might have been done at some time after 1475. See Panofsky, 'Two Roger Problems', in *The Art Bulletin*, 1951, p. 33, note 3, and Panofsky, 1953, p. 472. Reflectograms in J. R. J. van Asperen de Boer, *Infrared Reflectography*, 1970, plates XIX, XX.

The scene is the interior of a Gothic church. In the central panel (the nave) there are large figures of Christ on the Cross, the Virgin supported by St. John, and the three Marys. Behind, a priest at an altar raises a chalice: the central sacrament of the Eucharist. An angel with a scroll. Sculptures over the altar include the Virgin and Child.

The other six sacraments are shown on the side panels, in the aisles or chapels off the aisles of the church. Left, Baptism, Confirmation, Penance; right, Ordination, Marriage, Extreme Unction. Six angels, in the appropriate liturgical colours (Panofsky, 1953, p. 283) hold scrolls, on which are texts applicable to these six sacraments. The texts of these and of the scroll associated with the Eucharist are considerably adapted from the sources stated. Panofsky, 1953, pp. 472–3, gives texts and sources as follows:

The Eucharist. 'Hic panis, manu sancti spiritus formatus in virgine, Igne passionis est decoctus in cruce. Ambrosius in Sacramentis' (IV, 4, 14–17).

Baptism. 'Omnes in aqua et pneumate baptizati In morte Christi vere sunt renati. Ad Romanos VI capitulo' (Romans, VI, 3).

Confirmation. 'Per crisma, quo a praesule inunguntur, Vi passionis Christi in bono confirmantur. In quarto Sententiarum' (cf. Peter Lombard, IV, dist. VII).

Penance. 'Sanguis (Christi) nostras consciencias emundabit, Dum penitentiale debitum seipso mitigauit. Ad Hebraeos IX capitulo' (Hebrews, IX, 14).

Ordination. 'Dum summus pontifex Jesus in sancta intrauit, Tunc sacramentum ordinis vere instaurauit (?). Ad Hebraeos IX capitulo' (Hebrews, IX, 25).

Marriage. 'Matrimonium a Christo commendatur, Dum sponsa sanguinum in carne (con)copulatur. Exodi IIII capitulo' (Exodus, IV, 25).

Extreme Unction. 'Oleo sancto in anima et corpore infirmati Sanantur merito passionis Christi. Jacobi ultimo' (James, V, 14).

At the top of each panel, in the spandrels outside the arches that enclose the three views into the church, are coats of arms: left, Chevrot; right, Bishopric of Tournai.

These establish association with Jean Chevrot, one of the most powerful men at the Burgundian Court, born ca. 1400, Bishop of Tournai from 1436 until his death in 1460 (see the French Dictionary of National Biography). His portrait is indeed found in the picture, in the figure of the Bishop administering Confirmation (left wing). The identity appears certain from the presence of a cleric recognizably the same man in a miniature sometimes ascribed to Rogier (see under Brussels, Bibliothèque Royale); only Chevrot could be expected as the ecclesiastic there, in a representation of Duke Philip the Good's inner circle. See Panofsky, 'Two Roger Problems', in *The Art Bulletin*, 1951, pp. 33 ff.

Panofsky goes on to point out that the arrangement of the sacraments at the left is interrupted by the presence of another cleric, the insertion of whom must signify that he was a person of much importance (whether directly concerned with the commission of the picture or not). Panofsky convincingly finds the same person, older, in the mitred donor of a picture at The Hague (q.v.) and proposes on sound grounds that he is Pierre de Ranchicourt, who would be depicted in the Antwerp picture as a Protonotary Apostolic. He was Bishop of Arras from 1463 until his death in 1499.

Panofsky more doubtfully suggests that the Bishop on the right, in the scene of Ordination, is Jean Avantage, Bishop of Amiens in 1437 (died 1456).

It is not known what circumstances would have made Chevrot (if it was he who commissioned the picture) associate Ranchicourt and possibly Avantage.

The attribution of the picture to Rogier is usually accepted, some varying doubt expressed being perhaps due in part to the picture's state of preservation. Accepted by Friedländer, 1967, no. 16. Beenken, 1951, pp. 92 f., 99, thinks it is by an assistant, the design of the large figures in the central panel being Rogier's, the rest not Rogier's even in design; this view seems difficult to accept, the concept here being clearly of original distinction. Panofsky, 1953, p. 282, believes in studio execution.

Since Jean Chevrot was Bishop of Tournai from 1436 until his death in 1460, the picture should not be dated earlier than 1436, nor much later than 1460. From details of Ranchicourt's career, Panofsky can claim a date not earlier than 1451, probably 1453 or soon after: 'Two Roger Problems', *op. cit.*, pp. 37–8 and Panofsky, 1953, p. 284. The presence of Avantage, if correctly claimed, implies a date not much later than his death in 1456.

It has been suggested that the church is a (free) rendering

of S. Gudule at Brussels; R. Maere in *De Kunst der Nederlanden*, vol. 1, 1930, pp. 201 ff.

The pose of the seated female figure in the right wing has been compared with that of the Magdalen in the National Gallery (see under Rogier: London 1). A drawing freely after this figure is at Bâle (Sonkes, 1969, no. B18). The Mary nearest the Cross in the central panel partly recurs, as a gesticulating figure, in the Riggisberg Triptych (q.v.). The head of the Mary furthest to the right seems to be imitated in a picture at Cologne, assigned to the Master of St. Catherine (see under Rogier: Cologne). The greyhound is similar (inverted) to one in the Triptych of the *Adoration of the Kings* at Munich, and the other dog here recurs more or less there; see the entry for Munich 1, concerning these canine appearances.

The disposition here of the Sacraments may well have influenced the production of a picture in the Prado by a follower of Rogier (perhaps Vrancke van der Stockt; Friedländer, 1967, No. 47, Plate 67), which was long and erroneously identified with Rogier's altarpiece for Cambrai, 1455–9 (see the biographical data).

The coats of arms on the Antwerp picture have suggested that the origin of the picture was connected precisely with Tournai as well as with Chevrot, its Bishop; so, a locational attribution to the Cathedral of Tournai. Acquired in Dijon in 1826, from the heirs of the last premier président of the Parlement de Bourgogne, Pirard, by the Chevalier Florent van Ertborn, with whose collection bequeathed to the Antwerp Museum in 1841.

Friedländer, 1967, no. 16
Panofsky, 1953, index.

Portrait of John the Fearless

Antwerp, Koninklijk Museum voor Schonen Kunsten　　　ANTWERP
$8\frac{1}{4} \times 5\frac{1}{2}$ in. (0.21 × 0.14 m.).

Jean sans Peur: born 1371, Duke of Burgundy 1404, d. 1419.

Recorded in the Antwerp catalogue of 1958 (in French), p. 128, as Anon.

Some writers (e.g. Panofsky, 1953, p. 171) have suggested that this is a painting, modernized from an earlier one, by or else in the studio of Rogier. It appears on any hypothesis of little significance for the appreciation of Rogier, and is not further discussed here. Entry for it in the Exhibition Catalogue, *Flanders in the Fifteenth Century*, Detroit, 1960 (no. 3).

In the collection of the Chevalier Florent van Ertborn; bequeathed to Antwerp, 1841.

Panofsky, 1953, index and fig. 378.

Philippe de Croy, Antwerp, Koninklijk Museum voor Schone Kunsten; see Rogier, San Marino.

ANTWERP CATHEDRAL

The Marriage of the Virgin
Antwerp Cathedral
$51 \times 41\frac{1}{4}$ in. (1.30×1.05 m.).

There are two incidents depicted: (1) St. Joseph designated as the bridegroom tries to escape from the Temple. (2) The Marriage. These two incidents are similarly associated in a picture at Madrid (Campin: Madrid 1).
According to the catalogue of the *Exposition des Primitifs Flamands* at Bruges, 1902 (no. 29), over the altarpiece of the church are shown sculptures of Moses, and Moses obtaining the Tables of the Law; in the spandrels over the main arch, the Meeting at the Golden Gate and St. Joachim praying at the bed of St. Anne (?); on the tympanum of the side door, the Sacrifice of Abraham, Moses above. The morse of the priest at the marriage shows Adam and Eve.
Ascribed by Friedländer, 1967, no. 84 to a Follower of Rogier. The picture in the past has been associated stylistically with the Edelheer altarpiece at Louvain (unspecifiable Rogier follower of ca. 1443; see under Rogier: Madrid 1), the *Exhumation of St. Hubert* (probably Rogier studio rather than further away; see Rogier, London 2, with further details there), etc. The Antwerp picture may well not derive directly from Rogier himself. The associations are unconvincing to the present writer, except probably (for the executing hand) with the *Exhumation of St. Hubert*. Described by Wauters in the *Revue Universelle des Arts*, 1855, Vol. II, pp. 89 f.; *Exposition des Primitifs Flamands* at Bruges, 1902 (no. 29).

Friedländer, 1967, no. 84 and plate 106.
Panofsky, 1953, index ('Master of the History of St. Joseph').

BANBURY

Banbury, Lord Bearsted: see Upton.

BATALHA (formerly)

The Virgin and Child with Philip the Good, Isabella of Portugal and Charles the Bold Kneeling in Prayer
Portugal, Batalha Monastery (destroyed?)
The size is calculable roughly as 40×70 in. (1.00×1.80 m.).

This picture is known only from a sketchy drawing ($4\frac{1}{2} \times 7\frac{7}{8}$ in., 0.112×0.20 m.) in the National Museum at Lisbon; the drawing is identified as being by Domingos António de Sequeira (1768–1837), and done in 1808. A full account in Sonkes, 1969, pp. 109 f., no. C 11 and Plate XXIIIb.
On the drawing, the arms of Isabella have been identified. The two male donors, each wearing the collar of the Golden Fleece, would be Philip and Charles. A date ca. 1449 for the picture has been deduced. The picture was in 1808 in the monastery of Santa Maria de Victoria at Batalha; it has been thought that it was originally in the chapel of the founder of Batalha, Isabella's father, King John.
Philip the Good, Duke of Burgundy, 1396–1467. Isabella, daughter of King John I of Portugal, b. 1397, married Philip as his third wife in 1430, died 1471; cf. for instance E. Michel, Louvre Catalogue, *Peintures Flamandes du XV^e et du XVI^e Siècle*, 1953, pp. 105 f. Their son, Charles the Bold, 1433–77.
The attribution of the picture to Rogier is hypothetical, Sequeira's drawing concealing the style of the original; but some comparisons, especially of the design of the Virgin and Child with designs of pictures associated with Rogier, are given by Sonkes, 1969, p. 112. It is thought that the representation of Isabella might have been related to the Rockefeller picture (Rogier: New York, Rockefeller).
There appears to be no evidence available that the original, in whole or in part, now exists.

Triptych: **The Last Judgement**
Beaune, Hôtel-Dieu

BEAUNE
Plates 34–48
Figs. 2, 11

The triptych with the wings open shows a continuing scene in nine sections; seven in the main tier; two above, on each side of the upper part of the main central section, which is taller than the others of the main tier. On each side, the two outer sections of the main tier were constructed to fold back over the three middle sections, and the top of the central section was covered by the two sections above when these were folded back. Six painted compartments were visible when the triptych was closed. Originally wood throughout. Measurements by Mme Veronee kindly communicated by Mlle Sonkes (the interior in all cases): central section, with frame, ca. $86\frac{1}{2} \times 43$ in. (2.20×1.09 m.). Height of the six lateral sections, each with frame, ca. 54 in. (1.375 m.). Overall width of the interior, including frames, ca. 216 in. (5.49 m.); width of the three central sections, including frames, ca. $107\frac{1}{2}$ in. (2.73 m.); width of the inner sections of the wings, including

frames, each ca. 32½ in. (0.825 m.); width of the outer sections of the wings including frames, each ca. 21½ in. (0.545 m.). The two sections above, each (size of the support) ca. 29¼ × 18¼ in. (0.745 × 0.465 m.).

In a good many parts in rather poor condition. All the paintings of the backs have been separated. With the triptych considered open, the three lateral sections at the right and the innermost one at the left (of the main tier) have been transferred to canvas. Some photographs showing the preservation are in Fierens-Gevaert, *Les Primitifs Flamands*, vol. I, 1908, plates XXIV–XXVI; and (including ultraviolet photographs and X-radiographs) in the *Bulletin du Laboratoire du Musée du Louvre*, October 1957, pp. 22 f.

With the triptych open, Christ in Judgement is seen on the upper part of the central section. His right hand is raised in blessing; His left hand is stretched out, dismissing the damned. The appropriate quotations from Matthew, XXV, 34 and 41 are written. Clad in a mantle, Christ shows His Wounds; He is seated on a rainbow; His feet are on a globe. At His head, to the right, is a lily (cf. Isaiah, XXXV 1); to His left a sword (Revelation, XIX, 15).

Below Christ there stands on the ground St. Michael with peacock's wings, in alb and cope. He holds scales, in which (raised) is a human form with the word *virtutes*, (sunk) one with *peccata*. Four angels blow trumpets to bring up the dead; two of these, man and woman, naked, arise (hopefully, it seems) from the ground. No tombs are seen.

The innermost left section shows in the sky the Virgin praying (and the continuation of the rainbow). Behind her, two Apostles (these and elsewhere the remaining ten are not well characterized).

The next section on the left shows four more Apostles, four male saints and some further haloes. The four male saints are a Pope, a Bishop, a Sovereign and another; the orphrey of the Pope's cope is ornamented visibly with three figures of saints, one St. Andrew.

Below, in both these sections, are men and women resurrecting or resurrected, destined for Paradise.

The innermost right panel shows, opposite the Virgin, the other Intercessor, St. John Baptist. Behind him, two more Apostles.

The next section on the right shows the remaining four Apostles; three female saints (one crowned); and one further halo.

Below, in both these sections, men and women resurrecting or resurrected, more in number than on the other side, destined for Hell (a beginning of which is seen at the right). Two of the humans by their attitude suggest Adam and Eve being turned out of Eden.

The two small sections on the upper tier show angels with Instruments of the Passion: Cross, nails, reed, Crown of Thorns, sponge, lance, vessel of vinegar (?), birch and whip, column.

The outermost panel at the left on the main level shows the entrance to Paradise. An angel welcomes two men and one woman; the left leg of one of the men is seen on the already recorded adjoining panel. The fane of Paradise, apt for reception, is shown empty. The capitals of the building are ornamented with grapes.

The outermost panel at the right on the main level shows Hell (which begins, as has been noted, on the adjoining panel). Men and women are falling down into flames; devils are not seen.

The sky is of gold, with clouds added.

When the wings of the altarpiece were closed (before the separation of the backs), six compartments with figures in niches were seen. Left and right, the donors; centre, two saints represented in grisaille as statuary; above, the Annunciation in grisaille as statuary. The wings (on the main tier) are unusually divided each into two compartments.

The donors are identifiable from the coats of arms, associated with an angel behind each, as Nicolas Rolin and his second wife Guigone de Salins. The keys of the donor's arms and the turrets of the donatrix' arms are repeated on the coverings of the prie-dieu in front of each.

Nicolas Rolin died in 1461 (reputedly aged 86); Chancellor of Burgundy. Guigone married Rolin not later than 1411, and died in 1470. An earlier portrait of Rolin is in Jan van Eyck's picture in the Louvre.

The two saints seen between the donors are: on the left St. Sebastian, nearly naked, with arrows in his body; on the right St. Anthony, as a monk, with emblems of hog, tau stick, bell, beads.

The Annunciation seen above includes the Holy Ghost as a Dove.

The resurrecting humans are on a scale much smaller than the figures of Christ, the Virgin and the associated saints. This is in the taste of the time; graded sizes are even more marked in the nearly contemporary *Coronation of the Virgin* by Enguerrand Quarton at Villeneuve-lez-Avignon, commissioned in 1453.

For a difficulty that cropped up concerning the weighing of souls, whether up or down means good or bad, or else *vice versa*, see Panofsky, 1953, pp. 270 f. Here the painting shows virtue raised and sin sunk; the contrary is shown in

Memlinc's *Last Judgement* at Gdańsk (*Corpus, Pologne*, 1966, p. 64).

St. Sebastian may be present, for the hospital at Beaune, as a saint invoked against plague; no more precise reason seems to have been established.

Suggestions have been made (over some length of time) to identify certain of the principal saints as portraits of people prominent at the period. The claims seem unattractive; Friedländer, 1967, p. 63, inclines to accept two of the identifications.

The donor, Nicolas Rolin, formally founded in 1443 the hospital at Beaune, where the picture now is, and for which it was obviously commissioned. Constructing a hospital had been approved by Pope Eugenius IV in 1441, and Rolin was acquiring land for the purpose in 1442. The dedication of the hospital was to St. Anthony, who is shown on a shutter of the picture. On 30 December 1452, Pope Nicholas V (1447–55) changed the patron saint of the hospital to St. John the Baptist. Although a man of Rogier's taste might have found it awkward to repeat St. John the Baptist, who is necessarily prominent in the interior scene of the *Last Judgement*, as patron of the hospital—though admittedly Memlinc shows St. Michael twice in his *Last Judgement* at Gdańsk; yet in any case it would seem strange for St. Anthony to be included as he is included after 1452. Although some doubts about the dating of the picture have been expressed, it does seem clear that the picture is unlikely to have been commissioned before 1443; that it may have been being painted in the second half of the 1440s to be ready for the chapel of the hospital (where it was), which was consecrated on 31 December 1451; and that if (surprisingly) it was not complete at the end of 1452, it was at least then so far advanced that a change of the figure of St. Anthony was not undertaken. For the facts stated, see Abbé J.-B. Boudrot, *Petit Cartulaire de l'Hostel-Dieu de Beaune*, 1880.

This picture is generally accepted as by Rogier, though sometimes studio help is postulated; Friedländer, 1967, no. 14. The state of preservation is an impediment to judgement. Panofsky, 1953, p. 268, says that the Annunciation is the work of an indifferent assistant. For the present writer, studio execution is not obvious in the main picture, and is to be excluded for the portraits of Rolin and his wife; the rest of the outsides of the shutters may not have been executed by Rogier himself.

Some critics think there is Italian influence in the picture, and date its conception after Rogier's journey to Rome in 1450. There might have been just time for Rogier so to do

it by the end of 1451 or 1452 (see above for these dates); yet this large picture, even if hastily executed, would have needed more than a short time to produce.

For some figures, especially Christ and even more the Virgin, this picture shows a close connection with the Braque triptych in the Louvre (Paris 1); that is most probably datable, and with some precision, shortly after 1452. This carefully organized representation of the Last Judgement, although it is divided into sections, had some influence on display of the Event in the north. Memlinc's *Last Judgement* at Gdańsk, of a different mood, is clearly dependent on this picture, the most precise derivation being the figure of Christ; see *Corpus, Pologne*, 1966, no. 120, text and plates. A *Last Judgement* assigned to Colijn de Coter, of which four fragments are known to be preserved, is also in part dependent, in particular for the figure of St. Michael; see Friedländer, *Early Netherlandish Painting*, Vol. IV, *Hugo van der Goes*, 1969, no. 94, Plate 88.

A drawing in the Louvre, connected with the Christ here (and not with Memlinc's derivative), is dated 1469 (date sometimes doubted); it is often accepted as by Schongauer, though Dürer's authorship has also been proposed. Another drawing of this figure, dated 1493, is at Carlsruhe. A drawing after the Virgin here is at Budapest. See Sonkes, 1969, nos. B 15, 16, 17.

Drawings of Nicolas Rolin and Guigone de Salins are in the Recueil d'Arras, a collection of portrait drawings attributed to Jacques Leboucq (d. 1573). The heads correspond closely. Variation of the other parts may be due to the fancy of the draughtsman; or he may have depended on other portraits, connected with but distinct from the ones on this altarpiece.

Clearly from the beginning in the hospital at Beaune; first known to be recorded there in 1501, as the high altarpiece of the chapel.

Friedländer, 1967, no. 14
Panofsky, 1953, index
A volume on this picture in the *Corpus* series is expected to be published in 1972.

Portrait of a Man in Prayer

Berchem, Abbé de Lescluse (formerly ?)
12 × 8½ in. (0.30 × 0.22 m.).

Probably one half of a diptych (cf. Panofsky, 1953, p. 479). Stated to be in damaged condition.

Lent by the Abbé de Lescluse, Berchem near Antwerp, to

the Exhibition *Art Flamand Ancien* at Antwerp, 1930, no. 333 (Anonyme). Recorded by Winkler, 1942, p. 474, as probably an original Rogier. Beenken, 1951, p. 71 and plate 111, accepts. Panofsky, 1953, p. 479, from the reproduction thinks it possibly authentic.

Panofsky, 1953, index.

BERLIN I
Plates 58–60

Triptych: **Scenes from the Life of St. John the Baptist**
Berlin-Dahlem, Gemäldegalerie der Staatlichen Museen
Three panels, each 30¼ × 19 in. (0.77 × 0.48 m.). A triptych with fixed wings.

Each of the three principal scenes is shown under an arch. Left, the birth or naming of St. John. St. Elizabeth is in bed in the middleground. The female figure in the foreground at the left, who has brought the newborn infant to St. Zacharias (he is writing the name) has a halo, and can only be the Virgin Mary, present according to a tradition hardly ever represented. See Panofsky, 1953, pp. 281 f. and M. A. Lavin in *The Art Bulletin*, 1955, pp. 87 f.
Centre, the Baptism of Christ. God the Father in the heavens holds a scroll with inscription based on Matthew III, 17.
Right, the beheading of St. John. Salome in the foreground receives the head of St. John in a charger from the executioner; in the middle ground, the kneeling Salome offers the head to Herod and Herodias at table.
Panofsky, 1953, p. 280, gives a ground plan of the interiors seen.
At the sides of each of the three arches are shown sculptures, standing figures of the twelve Apostles. The following scenes (from left to right) are shown as small sculptures in the archivolts, for the most part clearly identifiable:
Birth scene: the Angel appearing to St. Zacharias, St. Zacharias rendered dumb leaving the temple, the marriage of the Virgin and St. Joseph, the Annunciation, the Visitation, the Nativity.
Baptism scene: St. Zacharias foretelling the future of St. John, St. John praying in the desert, St. John baptizing (the axe in the tree trunk is from Matthew III, 10 or Luke III, 9), three scenes of the Temptation.
Beheading scene: St. John questioned apparently by the priests and Levites (John I, 19), St. John pointing out Jesus as the Messiah, St. John before Herod (two figures only), St. John imprisoned, St. John visited by his disciples in prison, Dance of Salome before Herod. Further detail given by Birkmeyer in *The Art Bulletin*, 1961, pp. 16 ff.

This triptych is generally accepted as by Rogier; Friedländer, 1967, no. 2. Friedländer dates it early, at much the same time as the Granada–New York triptych (see under Granada), but this is not acceptable. Panofsky, 1953, pp. 279 ff., rightly claims that it is considerably later; he thinks it after Rogier's Italian journey of 1450, producing some arguments suggestive of Italian influence.
A version of reduced size, old but much inferior, is in the Staedelsches Kunstinstitut, Frankfurt; Panofsky, 1953, p. 471, thinks it was produced in Rogier's workshop. A drawing showing the head and arm of St. John and his legs and feet, copied after the Baptism scene, was in the Lehman Collection—now presumably Metropolitan Museum, New York; Sonkes, 1969, no. B 11.
The suggestion, e.g. by Valerian von Loga in the Prussian *Jahrbuch*, Vol. XXXI, 1910, p. 56, that the triptych may have come from Miraflores near Burgos is not supported by evidence. A retable showing the life of the Baptist, by Rogier, is stated to have been given to the church of St. Jacques at Bruges in 1476 by Battista del Agnelli, a merchant of Pisa; for all that is known about this, see Winkler, 1913, p. 183 and Folie, 1963, p. 212. In 1521 Dürer records unspecified work by Rogier in S. Jacques at Bruges (see the biographical data).
The triptych now at Berlin became separated. The *Birth* and the *Baptism* were in the collection of King William II of Holland; Nieuwenhuys, in his catalogue of 1843, p. 46, records them, saying that they had been taken from Spain to London in 1816. At the King of Holland's Sale in 1850, they were acquired for the Berlin Gallery.
The third panel was soon after acquired for Berlin from England (cf. the Berlin Catalogue, 1851, p. 171). The copy of the triptych at Frankfurt establishes that this panel does go with the other two.

Friedländer, 1967, no. 2
Panofsky, 1953, index.

Portrait of a Woman
Berlin-Dahlem, Gemäldegalerie der Staatlichen Museen
18½ × 12⅝ in. (0.47 × 0.32 m.).

BERLIN
Plate 106

X-radiographs in Alan Burroughs in *Metropolitan Museum Studies*, Vol. IV, Part 2, 1933, p. 135, and in C. Wolters, *Die Bedeutung der Gemäldedurchleuchtung mit Röntgenstrahlen für die Kunstgeschichte*, 1938, Plate 23.
Apparently not one leaf of a diptych. A scraped-out coat of arms in a wreath on the back seems clearly of later date.

Detail from *The Nativity*
(Plate 26).
Berlin-Dahlem,
Staatliche Museen
(Cat. Rogier, Berlin 4)

The sitter looks at the spectator, which has suggested that she may be the painter's wife; Jan van Eyck's wife looks at the spectator in her portrait by him in the Groeninge Museum at Bruges.

Published by Friedländer (*Amtliche Berichte aus der Königlichen Kunstsammlung*, 1908, col. 125 sqq.) as by Rogier, though with some reserve from its exceptional character; Friedländer, 1967, no. 4. It seems to me clearly acceptable as Rogier's, a masterpiece, and early. Comparison with a female portrait in London (Campin: London 1) does not lead me to associate the two.

A copy ascribed to the Genoese School was in the Bevilacqua—La Masa Sale, Palazzo Pesaro, Venice, 15–22 October 1900 (lot 378), reproduced in the catalogue; cf. Winkler, 1913, p. 160.

The Berlin picture was in the collection of Princess Soltikoff, St. Petersburg; acquired for the Berlin Gallery, 1908.

Friedländer, 1967, no. 4
Panofsky, 1953, index.

BERLIN 3
Plate 121

Right Wing of a Triptych: **SS. Margaret and Apollonia**
Berlin-Dahlem, Gemäldegalerie der Staatlichen Museen
$20\frac{1}{4} \times 11$ in. (0.515 × 0.275 m.).

In a private collection there is a copy of this picture, and a picture of the same size but with figures on a larger scale, showing SS. John the Baptist and Evangelist, which is supposed to be a copy of the left wing of the original triptych. Friedländer, 1967, plate 37 (Coll. B. Dierckz de Casterlé, Brussels). St. John the Baptist points, and has the inscription AGNUS DEI QVI TOLLIT PECCATA MVNDI. No identification has been made for the central part, presumably a picture; the Baptist and the inscription suggest the presence of Christ there. St. Margaret is shown here with a cross and a dragon, St. Apollonia with a tooth held by pincers.

The Berlin picture is accepted by Friedländer, 1967, p. 63, no. 17. Beenken, 1951, p. 99, calls it studio work. Panofsky, 1953, p. 465, says possibly executed by an assistant.

From Spain. Lent by L. Moreno, Paris, to the Golden Fleece Exhibition at Bruges, 1907 (no. 183). Acquired for the Berlin Gallery, 1909.

Friedländer, 1967, no. 17
Panofsky, 1953, index (Berlin).

Triptych: **The Altarpiece of Pierre Bladelin**
Berlin-Dahlem, Gemäldegalerie der Staatlichen Museen
Central Panel, $35\frac{3}{4} \times 35$ in. (0.91 × 0.89 m.); wings, $35\frac{3}{4} \times 15\frac{3}{4}$ in. (0.91 × 0.40 m.), each.

BERLIN 4
Plates 26–33

X-radiographs published by Alan Burroughs, *Art Criticism from a Laboratory*, 1938, figs. 104, 105.

Central compartment, the Nativity, with the donor in proximity (for donors placed by Rogier close to the crucified Christ, see the comment on Rogier: Vienna 2). In the background is the Announcement to the Shepherds.

Left wing, Augustus and the Sibyl. Augustus (the Imperial Eagle is on the glass of the window) was to be worshipped as a god; but the Tiburtine Sibyl showed him a vision of the Virgin and Child, the words *Haec est ara coeli* were uttered, and the church of S. Maria in Araceli is now on the spot in Rome. To point the story, which was very popular as significant for the spread of Christianity westwards, the painter shows the Virgin and Child, seen in the sky, upon an altar.

Right wing, the Star (in the form of a Child) appears to the Magi, who will go to Bethlehem. One of the Magi is negroid. In the background, they are shown again as very small figures, bathing; the bath of the Magi is mentioned in *The Golden Legend*—see, apropos of a derivative painting, T. Rousseau in the *Bulletin of the Metropolitan Museum of Art*, Vol. IX, June 1951, pp. 274–5.

Outsides of the wings, the Annunciation in grisaille, St. Gabriel's scroll being inscribed *Ave gratia*, etc. Panofsky, 1953, p. 504, comments on St. Gabriel's being shown on the right. The figures correspond closely with an engraving by Master FVB, as was pointed out by Graham Smith in *Oud Holland*, 1970, pp. 115 f.

There is no good reason to doubt the traditional identification of the donor as Pierre Bladelin, who had a distinguished career in the public service and died in 1472. He founded a town, Middelburg (near Bruges), in or about 1444.

Part of the view of a town in the central panel was indeed engraved as representing Bladelin's castle at Middelburg for the *Flandria Illustrata* of Sanderus (1586–1664). It may well be that Bladelin's castle no longer existed at all at that time; yet the choice of what is seen in the picture to illustrate Sanderus' historical book strongly suggests that the picture was then at Middelburg, and supports the identification of the donor. Admittedly, it is most improbable that the picture records what Bladelin's castle was like. Bladelin clearly had to build it himself, and would hardly have opted

for Romanesque windows; further, what can be called a free repetition of the view in this picture is in the triptych at Munich (see Munich 1), which (a) is not known to be associated with Bladelin, (b) does show, prominent among numerous differences of detail, Gothic windows to the castle.

In the Nativity here the Infant Christ, although not enveloped in rays, displays rays by the form of His halo; the Virgin is in a white dress; and St. Joseph holds a lighted candle. All this is clearly based on a vision of St. Bridget, who saw the material light of the candle annihilated by Christ's spiritual light (Panofsky, 1953, p. 126). Compare the *Nativity* at Dijon (Campin), which is rather more precisely connected. Panofsky also comments on the Romanesque architecture of the shed, signifying the Old Law about to be replaced (p. 136), and on the traditional favour given to the ox over the ass at this scene (p. 470). The main reason for the prominent column here, frequently to be seen in Early Netherlandish Nativities, is acceptably the text of the *Meditations* by Pseudo-Bonaventura, where it is recounted that the Virgin supported herself against a column that was there; see Panofsky, p. 277 for this and a different, additional suggestion. More than one explanation of the two holes in the foreground (one grated) has been made. G. von der Osten thinks that principally the reference is to the cave at Bethlehem in which, according to ancient tradition, the Birth took place; see his articles 'Der Blick in die Geburtshöhle' in *Kölner Domblatt*, 23/24, 1964, pp. 341 ff. (especially p. 345) and 26/27, 1967, pp. 111 ff.; further, Günter Bandmann in the *Festschrift für Gert von der Osten*, 1970, pp. 130 f.

Use of *The Golden Legend* for iconographical details is suggested, not only by inclusion of the already noted bath of the Magi, but by display of the Star as an Infant and of Augustus with a censer; see Panofsky, 1953, p. 277. Miss Rosalie Green pointed out that the Star shown as an Infant is somewhat rare. An example close to Rogier's treatment is in a fresco by Taddeo Gaddi in S. Croce at Florence; A. Venturi, *Storia dell'Arte Italiana*, vol. V, 1907, fig. 427.

Panofsky, 1953, p. 278, finds in two of the witnesses in the scene of Augustus and the Sibyl the features of Pierre de Bauffremont and Jean le Fèvre de St. Remy; see Rogier's 'The Medici Madonna' at Frankfurt, where also he finds portraits of these.

The triptych is generally acknowledged as Rogier's; Friedländer, 1967, No. 38, with the remark that the Annunciation is workshop production. The style of that indeed is somewhat apart from Rogier's; this receives comment from Panofsky, 1953, p. 469. Taddeo Gaddi's already mentioned fresco with the Star as an Infant seems not to provide strong evidence that Rogier's picture post-dates his Italian journey for the Jubilee of 1450.

Among copies and derivations may be mentioned first a copy on canvas of the three scenes of the front, with less at the top and more at the bottom, in the church at Middelburg. It might be of the eighteenth century. It was discovered in the presbytery by Canon J. O. Andries (*Messager des Sciences Historiques*, 1855, pp. 69 ff.); Canon Andries says that the engraving published by J. J. de Smet in the *Messager*, 1836, p. 348, was taken from this copy. For confusion at one time with the original, see A. Michiels in the *Gazette des Beaux-Arts*, 1866, Vol. II, p. 220–1. This copy, like the engraving in Sanderus, supports the claim that the original comes from Middelburg.

In an elaborate altarpiece, now mostly in the Metropolitan Museum (The Cloisters) at New York, the central part is fairly closely derived. See T. Rousseau in the *Bulletin of the Metropolitan Museum of Art*, Vol. IX, June 1951, p. 270 ff.; Friedländer, *Early Netherlandish Painting*, Vol. IV, *Hugo van der Goes*, 1969, No. 81, as Master of the Joseph Sequence (but corrected by him to Rogier Follower); Marguerite Baes-Dondeyne in the *Bulletin* of the Institut Royal du Patrimoine Artistique, Vol. XI, 1969, pp. 93 f.

A derivation from the *Augustus with the Sibyl* is in the Staatliche Museen, Bode-Museum, East Berlin (at one time on deposit at Bonn; Friedländer, 1967, no. 9a, Plate 133). The dog there is not seen in the original; it is found elsewhere (see under Munich 1). A painting on the other side of this panel is connected with an *Annunciate Virgin* at Petworth (q.v.).

The negroid king corresponds fairly well with a figure on the Abegg Triptych (see Riggisberg); cf. also the soldier spectator in Campin's fragment of the *Bad Thief* at Frankfurt (Campin: Frankfurt 1). The most prominent of the witnesses in the *Augustus and the Sibyl* recurs in the name-piece of the Master of the Legend of St. Catherine (Friedländer, Vol. IV, *Hugo van der Goes*, 1969, Pl. 50). The castle in the background of the central panel, recurring with variations at Munich, has already been mentioned.

Sonkes, 1969, mentions connected drawings B7 (Florence); B8 (Brunswick; eleven heads of women assigned to Rubens, of which one is the Tiburtine Sibyl here); B9 (Vienna).

It is not certain that this picture was commissioned in the first instance for Middelburg, which Bladelin founded in or about 1444. The church there is dedicated to St. Peter, who

is not shown in the picture; or else, according to J. J. de Smet in the *Messager des Sciences et des Arts*, 1836, p. 335, to SS. Peter and Paul, neither of whom appears. The church seems to have been dedicated in 1459, according to Karel de Flou, *Woordenboek der Toponymie van Westelijk Vlaanderen*, Vol. x, 1930, col. 541. Nevertheless, the tradition that it does come from Middelburg church receives support from the already mentioned engraving in Sanderus' *Flandria Illustrata* and the copy now in the church.

Acquired by the Berlin Gallery from Nieuwenhuys, 1834.

Friedländer, 1967, no. 38
Panofsky, 1953, index.

Portrait of Charles the Bold

BERLIN 5
Plate 123

Berlin-Dahlem, Gemäldegalerie der Staatlichen Museen
$19\frac{1}{4} \times 12\frac{5}{8}$ in. (0.49 × 0.32 m.).

An X-radiograph published by Alan Burroughs, *Art Criticism from a Laboratory*, 1938, fig. 131.

Charles the Bold (1433–77), Duke of Burgundy, son of Philip the Good (d. 1467); he is here identified with certainty on comparison with other portraits. He wears the jewel of the Order of the Golden Fleece on a chain; he was admitted into the Order in the year of his birth.

This is usually considered to pass as a painting by Rogier. It may well be related to one of Rogier's better documented works, a portrait of the sitter recorded in the inventories of his granddaughter, Margaret of Austria, 1516 and 1523–4 (see the biographical data for Rogier). Margaret's portrait may indeed have corresponded fairly closely with the portrait at Berlin, except that here there is the hilt of a sword or dagger in his left hand and there the sitter held a roll of paper in his right hand. This matter may have been made confused by some statements. Winkler, 1913, p. 184, says that there exist works by miniaturists showing the Duke similarly to the Berlin portrait, but with a roll of paper instead of a dagger, e.g. in the Bibliothèque Royale at Brussels; Hulin, 1938, col. 230, says that a portrait of the sitter, agreeing with the record of Margaret's and (except for the roll of paper, etc.) with the portrait at Berlin, is copied in a drawing at Brussels. These statements appear to be untrue. Nevertheless, the pose of this portrait recurs in various derivations. This indicates that the portrait at Berlin is, or is based on, a standard portrait of the sitter, and a standard portrait of this sitter might be presumed to be by Rogier. Friedländer, 1967, no. 42, as Rogier. Panofsky, 1953, p. 286, thinks it a workshop replica; I incline to agree.

The appearance of the sitter here (born in 1433) precludes a date much before 1460.

Acquired for Berlin with the Solly Collection, 1821.

Friedländer, 1967, no. 42
Panofsky, 1953, index.

The Virgin and Child at Half-length

BERLIN 6
Plate 116

Berlin-Dahlem, Gemäldegalerie der Staatlichen Museen
$16\frac{1}{2} \times 12\frac{1}{4}$ in. (0.42 × 0.31 m.).

An X-radiograph published by C. Wolters, *Die Bedeutung der Gemäldedurchleuchtung mit Röntgenstrahlen für die Kunstgeschichte*, 1938, plate 18.

Perhaps the left half of a diptych.

Like many other pictures, many not acceptable as by Rogier, the composition is related in part to the *St. Luke Drawing a Portrait of the Virgin* (see Boston). Rather closely related (inverted) to a *Virgin and Child* at Chicago (q.v.).

Doubtfully accepted by Friedländer, 1967, no. 43.
Beenken, 1951, p. 99, says executed by an assistant.

Acquired for Berlin in 1862.

Friedländer, 1967, no. 43
Panofsky, 1953, index.

St. John the Evangelist

BERLIN 7
Plate 117

Berlin-Dahlem, Gemäldegalerie der Staatlichen Museen
$8\frac{5}{8} \times 4$ in. (0.22 × 0.10 m.).

The saint holds a chalice, from which a dragon emerges. This little picture, acquired for the Prussian Collections in 1821 with the Solly Collection, was for some time on deposit at Münster. It was returned to Berlin and published as Rogier by Winkler in the Prussian *Jahrbuch*, Vol. LXIII, 1942, p. 105. Accepted by Beenken, 1951, pp. 30 f. The attribution may pass, or nearly. The purpose for which the little picture was painted is not clear; it has not been cut.

Acquired for Berlin with the Solly Collection, 1821.

Panofsky, 1953, index.

'The Miraflores Altarpiece': Berlin-Dahlem, Gemäldegalerie der Staatlichen Museen; see Rogier: Granada.

BERLIN

Pietà: Berlin-Dahlem, Gemäldegalerie der Staatlichen Museen; see Rogier: London 3.

St. Gabriel from an Annunciation: Berlin, Bode Museum; see Rogier: Petworth.

BERNE **Justice Scenes** (tapestries): Berne, Historisches Museum; see Rogier: Brussels, Town Hall (formerly).

BOSTON **St. Luke drawing a Portrait of the Virgin**
Plate 76 Boston, Museum of Fine Arts
$53\frac{1}{4} \times 42\frac{13}{16}$ in. (1.353 × 1.088 m.).

Infra-red and X-ray photographs are included in Corpus, *New England Museums*, 1961. X-ray photographs in Burroughs, *Art Criticism from a Laboratory*, 1938, figs. 125, 128. Very considerably damaged (*Corpus*, 1961, pp. 71 ff.).
Several versions exist. The one at Boston is now usually admitted to be the original; the existence of some pentimenti seems to favour this view. See *Corpus*, 1961, pp. 75 ff. The Virgin is shown suckling the Infant Christ. St. Luke, by ancient tradition a painter, and in particular a portraitist of the Virgin and Child, is shown drawing the Virgin's head (cf. Corpus, *Leningrad*, 1965, p. 40). He is seen with his emblem, the ox; his gown and cap here may refer to his being a physician (cf. SS. Cosmas and Damian, in Rogier: Frankfurt).
The arm-rest of the Virgin's throne shows the Fall. It has been suggested that the couple seen from the back in the middle distance are SS. Joachim and Anne (Panofsky, 1953, p. 253). The coat of arms in stained-glass has been thought suggestive of the arms of a painters' guild of St. Luke; see Corpus, *New England Museums*, 1961, p. 74. The normal arms of guilds of St. Luke, which are there reproduced in a drawing, appear in the panel showing Heinrich von Werl (see Campin: Madrid 2). Since St. Luke is here shown drawing, i.e. as a painter, several writers think that his features are more or less accurately those of Rogier van der Weyden. See *Corpus*, 1961, p. 73.
The association of this composition with Rogier van der Weyden is made on stylistic grounds, and is easily acceptable on those grounds.
Some support may be sought in an entry for a gift by Philip II to the Escorial, 1574: 'Una tabla en que está pintado sant Lucas, que tiene dos puertas escriptas; la una en griego y la otra en latín: es de mano de Masse Rugier, y tiene de alto tres pies y medio y de ancho tres sin puertas' (Folie, 1963, p. 210). This may refer to a painting of the present composition, and if so would be valuable evidence for associating it with Rogier; but the entry is too imprecise to be used definitely in this way. Nevertheless, some confirmation that it is the present composition has been claimed from the provenance of the Boston picture from Spain in the nineteenth century, and similarly the version

of it at Leningrad (in two parts; see Corpus, *Leningrad*, 1965, pp. 39 ff.). The wings with inscriptions are unlikely to have been of Rogier's time; cf. the commentary on Rogier, Various Collections 2.
A painting by Rogier of this subject might well have belonged to the painters' guild at Brussels (see Corpus, *New England Museums*, 1961, pp. 74 f.). Some confirmation has been sought in an entry in Dürer's diary, 1520, when he was at Brussels, '2 Stüber geben von Sanct Lucas Tafel aufzusperren'; but Panofsky, 1953, p. 253, strongly objects. Some confirmation of a provenance from Brussels may perhaps be found in a picture of the Virgin and Child with the Magdalen and a Donatrix at Liège, which seems clearly to reflect it; this is assigned to the Master of the View of S. Gudule, a painter who (to judge from other works assigned to him) was active at Brussels. See Friedländer, *Early Netherlandish Painting*, Vol. IV, *Hugo van der Goes*, 1969, Plate 67; Exhibition catalogue, *Flanders in the Fifteenth Century*, Detroit, 1960, no. 27.
The couple seen from the back in this composition, and a good many other things in the arrangement of the picture are clearly related to Jan van Eyck's Virgin and Child with Chancellor Rolin in the Louvre; it is presumed that Rogier's composition depends on van Eyck's, which Rogier would have seen in the original or in some copy. See further in Corpus, *New England Museums*, 1961, p. 85.
A picture of St. Luke painting the Virgin by Colijn de Coter at Vieure, not very like, is sometimes thought to reflect a composition by Campin, which might have influenced Rogier. Panofsky, 1953, p. 175, is doubtful. See Friedländer, *Early Netherlandish Painting*, Vol. IV, *Hugo van der Goes*, 1969, no. 100, Plate 92.
The version at Boston, occasionally referred to as an original in the nineteenth and early twentieth centuries, was published after cleaning as Rogier's original picture by Philip Hendy and Friedländer in *The Burlington Magazine*, Vol. LXIII, 1933, pp. 53 ff. See also Friedländer, 1967, no. 106. The claim for originality was agreed by Hulin, 1938, cols. 234–5. Panofsky, 1953, p. 252, is doubtful. See further in Corpus, *New England Museums*, 1961, pp. 71 ff.
A list of other versions and derivations is in Corpus, *New England Museums*, 1961, pp. 82 ff. A version at Munich long passed as the probable original; I do not accept it as such. There are other versions at Leningrad (two truncated parts separated and later rejoined; see Corpus, *Leningrad*, 1965, pp. 39 ff.), and in the Wilczek Collection once at Burg Kreuzenstein, then Vaduz (reproduced in Friedländer, 1967, Plate 119).

There is a derived tapestry in the Louvre.

Rogier and his followers may well be thought to have used the Virgin and Child of this composition as the normal source for designs of the Virgin and Child at half-length. For pictures that have entries in the present catalogue, see under Chicago, Tournai, Berlin 6, Donaueschingen (formerly). See also lists of many of the less imprecise derivations in Friedländer, 1967, nos. 107, 108, 109, 138 (more information about the last in the catalogue of the O'Byrne Sale, London, 30 March 1962, lot 78).

The Boston picture belonged before 1853 in Spain to the Infant Don Sebastian (1811–75). Said to have come from Toledo. Catalogued for auction in New York, property of the Duque de Dúrcal, 5–6 April 1889 (lot 67), bought privately by H. L. Higginson. Presented by Mr. and Mrs. H. L. Higginson to the Museum of Fine Arts, Boston, 1893. Further details in Corpus, *New England Museums*, 1961, pp. 80 f.; exhibition catalogue, *Flanders in the Fifteenth Century*, Detroit, 1960 (no. 7).

Corpus, *New England Museums*, 1961, no. 73
Corpus, *Leningrad*, 1965, no. 111
Friedländer, 1967, nos. 106; 107, 108, 109, 138
Panofsky, 1953, index.

BRAZIL, PANNWITZ **The Dream of Pope Sergius**: Brazil, von Pannwitz Collection; see Rogier: London 2.

BRUSSELS 1 **A Group of Men**
Brussels, Musées Royaux des Beaux-Arts de Belgique
19¾ × 13 in. (0.50 × 0.33 m.).

The group, which clearly does not form a complete composition (a true edge only at the right), was once wrongly claimed to be from an *Adoration of the Kings*. The subject is now thought to be *David Receiving the Cistern Water* (II Samuel, XXIII, 15–17); see Hulin, 1938, col. 239 and Panofsky, 1953, p. 278.

The features of the man in the centre are suggestive of those of St. Cosmas or St. Damian (the inner figure) in the *Virgin and Child with Four Saints* at Frankfurt (q.v.). The features of the man on the right correspond well with those of the *Portrait of a Man* in a large hat, with an arrow, at Antwerp (1958 *Catalogue* in French, p. 241, no. 539; van Ertborn bequest 1841; Friedländer, 1967, no. 44, Plate 65). The present writer thinks that the Antwerp portrait is improperly associated with Rogier. There is an article on it by

L. Wuyts in the *Jaarboek 1969*, Koninklijk Museum voor Schone Kunsten, Antwerpen, pp. 61 f.

Further, the head of the principal figure is strongly suggestive of that of the turbaned follower of the Magi, holding a hat, in the Columba Altarpiece (see Munich 1); the head and hat of the man on the right of the Brussels painting correspond fairly closely with those of the rearmost witness in the scene of *Augustus and the Sibyl*, left wing of the Bladelin Altarpiece (see Berlin 4). The columns resemble the prominent column in the central panel of that altarpiece.

The features of the principal figure have been identified as those of Pierre de Bauffremont; the Antwerp portrait has been claimed to be of Jean le Fèvre de St. Remy. See Stein in the Prussian *Jahrbuch*, 1926, pp. 18 f.; and under Frankfurt, both men being claimed to be seen there.

The Brussels painting is accepted as by Rogier or from his studio by Friedländer, 1967, no. 24. Beenken, 1951, p. 100, thinks probably not autograph. It is, for the present writer, unattractive.

According to the Adolphe Schloss sale catalogue, from the Marquis de Moustier Mérenville. Acquired by Schloss, Paris, ca. 1906 (*Gazette des Beaux-Arts*, 1907, Vol. II, p. 180); Sale, Paris, 1949 (lot 68). Bequeathed to the Brussels Museum by Fernand Houget, 1963.

Friedländer, 1967, nos. 24, 44; plate 44
Panofsky, 1953, index (Paris, Schloss; Antwerp).

A Knight of the Golden Fleece holding an Arrow **BRUSSELS 2 Plate 105**
Brussels, Musées Royaux des Beaux-Arts de Belgique
15¼ × 11¼ in. (0.39 × 0.285 m.).

The symbolism of the arrow is uncertain.

Seemingly, a portrait by itself. At one time the sitter was wrongly identified as Charles the Bold, Duke of Burgundy. An alternative suggestion was made of Antoine (le grand Bâtard) of Burgundy, 1422–1504, Golden Fleece 1456; he is excluded on comparison with what is accepted as an authentic portrait of him known in two versions (Dresden, Chantilly), which are classed by Friedländer, *Early Netherlandish Painting*, Vol. VI, Part I, 1971, no. 102, Plate 127, as copies of a missing Memlinc. More recently it has been suggested that he is John of Coïmbra (see G. Van Camp, 'Portraits de Chevaliers de la Toison d'Or', etc. in the *Bulletin des Musées Royaux des Beaux-Arts de Belgique*, Vol. II, 1953, pp. 87 f.). According to the catalogue of the *Toison d'Or* Exhibition at Bruges, 1962, Jean de Portugal

duc de Coïmbre prince titulaire d'Antioche, 1433–57, was admitted into the Order of the Golden Fleece in 1456.
Accepted as Rogier's by Friedländer, 1967, no. 37, and generally.
Bought from Nieuwenhuys (Brussels), 1861.

Friedländer, 1967, no. 37
Panofsky, 1953, index.

BRUSSELS 3 **The Sforza Triptych**
Brussels, Musées Royaux des Beaux-Arts de Belgique
Wood. Centre panel 21¼×18 in. (0.54×0.46); wings, each 21¼×7¾ in. (0.54×0.195 m.).

The centre panel shows Christ on the Cross between the Virgin and St. John, in a landscape; in the foreground are three figures of donors. Left wing, the Virgin adoring the Child at the Nativity; St. Francis and a saint who has been claimed to be Bavo or Julian are in the foreground below. Right wing, St. John the Baptist (*Ecce agnus* etc. written across the sky); and in the foreground below, SS. Catherine and Barbara. The landscapes continue that of the central panel. Reverses of the wings, St. Jerome and the Lion, St. George and the Dragon, in grisaille.

A donor right of centre in the main panel is in armour; he kneels in prayer, half facing the spectator. Further right, and prominently displayed, is a coat of arms with a crest. Left of centre is a girl or young woman kneeling in prayer, her face not averted from Christ. To the left of her is a boy, half kneeling, his hands not joined in prayer; the decoration of his doublet (or tabard) is acceptably of heraldic character.

The coat of arms and crest are those of the Sforza family. It has, not thoughtlessly, been claimed that the boy's tabard refers to the Varano family, whose arms according to Litta are vair, as is seen here.

The arrangement of the donors is curious. They are prominently placed in the scene of Calvary; this was becoming unusual for Netherlandish painting. The man in armour, whose importance is shown by the great coat of arms next him, is at the right of the Cross for the spectator. This position, to our right, is one of natural subordination if a donor is alone. But when there are several figures of donors, the principal one is expected to be on the left for us of the religious scene. One may wonder if the man in armour here is the principal donor. It is very odd that he faces away from the Cross; true, his face has been said to be scratched out and renewed, but its pose is unlikely to have been

changed. Were the man's features not available to the painter except in this pose? The massive display of heraldry beside him may best to attributed to bad taste on someone's part. The girl and boy may not seem very different in age; for this reason, and for being placed together away from the man, they are unlikely to be his wife and a son of that union. The boy's attitude could be thought pious, but would be unusual. One may suppose that some of these peculiarities are due to special circumstances in the commission.

It is claimed that the Sforza or Sforzas here cannot be of the Milanese branch of the family on the ground that when Francesco Sforza got the Duchy of Milan, not very long after the death of the last Visconti in 1447, he added the Visconti arms to his own.

It has been thought more promising to consider another of the branches of the Sforza family, associated with Pesaro; this branch did keep its arms. The man here has been claimed to be Alessandro Sforza (1409–73), who became Lord of Pesaro in 1445. Some support for this identification has been claimed from the facts that Alessandro is recorded to have returned to Pesaro in May 1458 from an eight-months' journey to Burgundy and Flanders (including specifically Bruges), and that in 1500 his grandson Giovanni (1466–1510) owned three pictures ascribed to Rogier, in all probability inherited from his grandfather; see G. Mulazzani in *The Burlington Magazine*, May 1971, pp. 252 f.

On the assumption that Alessandro Sforza of Pesaro is correctly identified, Catherine W. Pierce (*Art Studies*, vol. 6, 1928, pp. 39 ff.) argued that the woman is Alessandro's first wife Costanza, m. 1444, died 1447 aged about 19. The boy would be her brother Rodolfo Varano, younger than her by about five years; it has been mentioned already that the boy's tabard may indicate the Varano family. Catherine W. Pierce makes some further remarks in connection concerning the colours of the ribbons that are associated in the picture with the Sforza coat of arms and crest.

Still on the assumption that Alessandro is the man here, it has been claimed that the woman and boy are his children by Costanza; i.e. Battista (b. 1446, m. in 1460 Federigo the famous Duke of Urbino), and Costanzo (1447–83). Some support has been claimed from other records of the features. See Jacques Mesnil, *L'Art au Nord et au Sud des Alpes à l'Epoque de la Renaissance*, 1911, pp. 32 f., and Mulazzani, *loc. cit.*

Another suggestion was made by Josée Mambour in the *Bulletin* of the Musées Royaux des Beaux-Arts de Belgique,

1968, pp. 99 f., that the woman is Alessandro's second wife Sveva, b. 1434, m. 1448; she left her husband to enter into religion under the name of Serafina, dying in 1478, and now beatified. A pictorial record of her features, rather closely similar, is cited in support; it, or something like, might even have been the material used by the painter of the Brussels triptych. The boy would still be Costanzo.

The first suggestion implies a date for the picture ca. 1445 (before the birth of Battista and Costanzo); the second, not later than 1460 and (from the apparent ages of the woman and boy) not much earlier; the third would accord with a similarly late date. A still later date for the execution should not be excluded.

None of these suggestions is proved to be true. In particular, SS. Alessandro, Costanzo, Rodolfo have not been found on the picture.

The triptych shows numerous reminiscences of Rogierian style and *motifs*. There seems to be nothing precise except for the *St. Jerome*, which is related to a picture that has been ascribed to Rogier (see Rogier: Detroit). A *St. Jerome* much closer than that to the one here is at Bergamo; this was published in connection by Catherine W. Pierce, *loc. cit.*, who points out that it is a derivative, some landscape added for the *St. Jerome* of the Bergamo picture being based on part of the landscape in the central panel here. It is painted on soft wood, and is often ascribed to the Lombard School. The Brussels picture has been associated with Zanetto Bugatto, a Milanese (?) painter who was in Rogier's studio ca. 1460/3 (see the biographical data on Rogier). The association, which has been made without knowledge of Zanetto's style, has been denied; yet there is connection between the Brussels picture and Lombardy if the *St. Jerome* at Bergamo is Lombard.

The Brussels picture has also been associated with Memlinc, whose style was clearly much influenced by Rogier's, and who may have been working as a boy or young man in Rogier's studio at an undefined date during the later years of Rogier's life. There is indeed in the Brussels picture a good deal that is suggestive of Memlinc, but his participation or youthful authorship is hypothetical.

This triptych, prettily painted and minor to a marked degree (see the comment on it by Destrée, 1930, pp. 106 f.), has an entry here because of a claim that it is one of the three pictures ascribed to Rogier that were owned by Giovanni Sforza of Pesaro, grandson of Alessandro and son of Costanzo, in 1500; see Mulazzani, *loc. cit.*

The document serving as base for this is an inventory, mostly of books, dated 21 October 1500; it was published by A. Vernarecci in the *Archivio Storico per le Marche e per l'Umbria*, vol. III, 1886, pp. 501 ff. The three pictures in question are thus recorded (p. 522):

'La testa del Duca de Borgogna de man de Ruzieri da Burges in duy ochij' (i.e., not in profile);

'La testa del Ill. S. Alex. in duy ochij de man de Rugieri';

'La Tauoletta del christo in croce cum li paesi de man de Rugieri'.

The last, together with two pictures not ascribed to Rogier, is recorded then to have been taken to Urbino; the occasion of the inventory of 1500 was indeed political trouble. It is not known if these three or any of them were soon after brought back to Pesaro. If so, they would probably have been destroyed with other pictures by a fire in 1514, which did much damage and is recorded to have consumed many Sforza portraits (communication from Marchese Ciro Antaldi in the *Archivio Storico, cit.*, same volume, pp. 790 f.).

It has been noted already that Alessandro Sforza returned from an eight-months' journey to Burgundy and Flanders in 1458. If this was the occasion of the three Rogier pictures, the first would presumably have been a portrait of Philip the Good. Two differing portraits of that prince (see Rogier: Various Collections 5) are associated with Rogier; none of the numerous versions known to survive are accepted as originals. It might seem quaint if Alessandro Sforza obtained an original. For a portrait of Charles the Bold, Duke of Burgundy, see Rogier: Berlin 5. The second item, a portrait of Alessandro himself, could have been painted from the life in Flanders ca. 1458; or Rogier going to or from Rome ca. 1450 might have visited Pesaro. Nothing further is known; this one should have been the original. It is the third item that is claimed to be the triptych at Brussels. The inventory record can be said not to exclude identification. If the identification is correct, this ascription in 1500 at Pesaro to Rogier cannot supplant the Escorial inventory of 1574 (see especially Rogier: Escorial, and Madrid 1) as the basis for attribution to him; but it would be of interest as evidence that the Brussels picture was produced from Rogier's studio, and that Rogier allowed things undistinguished in concept to issue from his studio.

For Rogier of Bruges—stated in the inventory of 1500—see the record of 1449 or soon after by Ciriaco d'Ancona in the biographical data on Rogier, and comments in the *Essay* on the supposition of more than one great painter of this name in the fifteenth century.

The triptych belonged to Wolsey-Moreau, who lent it to

an Old Masters Exhibition at Bruges 1867 (no. 9; identifying description) and to Leeds 1868 (no. 529). According to the catalogue of the former exhibition (which is by Weale), it had belonged to a member of the Flemish family Discaert living at Modena, to whom it had been bequeathed by a bishop of Modena of the same family (not identified). Alfred Michiels, *Histoire de la Peinture Flamande*, 2nd edition, vol. V, 1868, p. 459, says that it came from Modena; had belonged to a bishop of Flemish origin named Discaert, who had died some 30–40 years previously; and was sold by a nephew of his of the same name to Wolsey-Moreau. There was a Chevalier d'I(scart) of Modena Sale, Paris, 10 January 1861; the picture has not been identified in the catalogue (some pictures in the sale are stated to be by Francesco Discart of Modena, with the name thus spelt). The picture has been claimed to come from the Zambeccari Collection at Bologna; this seems to be derived from Crowe and Cavalcaselle's *Early Flemish Painters*, 2nd edition, 1872, pp. 209 f. It was acquired by the Brussels Museum at the W. Middleton (of Brussels) Sale, London, 1872.

Friedländer, 1967, nos. 93, 143; 133; plate 109
Panofsky, 1953, index.

Pietà: Brussels, Musées Royaux des Beaux-Arts de Belgique; see Rogier: London 3.

Laurent Froimont (?): Brussels, Musées Royaux des Beaux-Arts de Belgique; see Rogier: Caen (Musée, Mancel Collection).

Illustration in a Manuscript: **Jean Wauquelin presents a book to Philip the Good**
Brussels, Bibliothèque Royale, MS 9242
Size of the page, 17¼ × 12¼ in. (0.44 × 0.31 m.).
Many of the faces are recorded to be damaged.
The miniature forms the frontispiece of Jean Wauquelin's translation for Philip the Good of a work by Jacques de Guise, *Annales illustrium principum Hannoniae*. This translation was begun in 1446; the frontispiece was painted then or very few years later.
It shows Wauquelin presenting his book to Duke Philip, near whom is seen a boy, his son the Comte de Charolais, who later succeeded as Duke Charles the Bold. Duke Philip is surrounded by people important at his court, several of them wearing the collar of the Golden Fleece. Two, on the left, have been identified. One is Nicolas

Rolin, on comparison with Rogier's altarpiece at Beaune (q.v.); the other Jean Chevrot, to be compared with a figure acceptably him in Rogier's *Altarpiece of the Sacraments* (Antwerp 2). Both these men deserve from their position at court the positions given in the miniature.
This exceptionally fine and influential miniature has often been ascribed to Rogier, although that is by no means always accepted. Panofsky, 1953, p. 268, says at least designed by Rogier. Friedländer, 1967, p. 25 and Plate 35A. Among numerous references:
Paul Durrieu, *La Miniature Flamande au temps de la cour de Bourgogne*, 1927, p. 64, Plate XXXVI;
C. Gaspar and F. Lyna, *Philippe le Bon et ses beaux livres*, 1944, pp. 10 f., Plate V;
Panofsky, 'Two Roger Problems' in *The Art Bulletin*, 1951, pp. 33 f.;
L. M. J. Delaissé in *Miscellanea Erwin Panofsky* (Bulletin des Musées Royaux, Brussels), 1955, pp. 21 f.;
Catalogue of the Exhibition *La Miniature Flamande, Le Mécénat de Philippe le Bon*, Brussels, 1959 (no. 42).
The value on various counts of this miniature is very high indeed; one of its least values is for introducing us to Rogier van der Weyden.

Friedländer, 1967, p 25
Panofsky, 1953, index.

SS. Margaret and Apollonia, SS. John the Baptist and Evangelist: Brussels, Dierckz de Casterlé Collection: see Rogier: Berlin 3.

Mural Paintings in the Town Hall at Brussels (Destroyed). These large paintings were probably the most famous of Rogier's works from the time of their execution. They do not survive, and were apparently destroyed in the siege of Brussels in 1695. They are recorded summarily here.
They showed the *Justice of Trajan* and the *Justice of Herkinbald*. Painted lessons of conduct, of this type, were esteemed for public places in Flanders in the fifteenth century; for instance, Bouts' pictures from Louvain now in the Brussels Gallery, Gerard David's pictures now in the Bruges Gallery. Panofsky, 1953, p. 264, says that Rogier's are the earliest examples of such scenes of which some pictorial record remains, though there is purely literary record of earlier comparable work (he does not class Campin; Berlin 5, *The Vengeance of Tomyris*, as a Justice scene of this type).
According to a written record of the 1620s, one of Rogier's

pictures of the *Justice of Trajan* was inscribed with his name and the date 1439; and one of his two pictures of the *Justice of Herkinbald* was inscribed with his name. Arguing without precise evidence, some critics suggest a date later than 1439 for the latter. Rogier was already town-painter of Brussels in 1436 (see the biographical data).

Record of an inspection in 1451 gives that Rogier's own portrait appeared in one of the scenes.

Distorted shadow of these pictures is found in a tapestry now in the Bernisches Historisches Museum at Berne (Friedländer, 1967, Plate 132). This is datable not later than 1461 (ca. 1450?). Much as Rogier's work may have been twisted in the tapestry, a connection more precise than merely the subjects is established from the inscriptions concerning these on the tapestry, which correspond with the inscriptions recorded to have been associated with Rogier's compositions. A drawing in the Bibliothèque Nationale at Paris (Sonkes, 1969, no. E12) has been claimed to be a more accurate record of part of Rogier's representation of the *Justice of Trajan* than the Berne tapestry. The drawing has been assigned to the Master of the Coburg Roundels, who is believed to have been active at the end of the fifteenth century; he has been credited with copy-drawings certainly connected with Rogier: London 1, 2 (q.v.).

It is a deprivation not to have these prime works for consideration of Rogier's capacity. The visual records known to survive, deemed to be partly true, are insufficient. Discussion, therefore, is not entered into here; even the subjects are left without explanations.

Among many commentaries one recent, stemming from the Berne tapestry, is in the exhibition catalogue *Die Burgunderbeute und Werke Burgundischer Hofkunst*, Berne, 1969 (no. 242). See also particularly Maquet-Tombu in *Phoebus*, Vol. II, 1949, pp. 178 f. For the drawing in Paris, J. G. van Gelder, *Enige Kanttekeningen bij de Gerechtigheids taferelen van Rogier van der Weyden* (Rogier van der Weyden en zijn Tijd, International Colloquium, 11–12 June 1964), 1966; this drawing, without reference to van Gelder's comment, is Sonkes, 1969, no. E12. For the portrait of Rogier (Various Collections 6), see Panofsky in *Late Classical and Medieval Studies in Honor of Albert Mathias Friend, jr.*, 1955, pp. 392 f.

Friedländer, 1967, p. 12; plate 142
Panofsky, 1953, index (Weyden, Works known through literary sources; separately, Berne).

Two Male Heads
Budapest, Museum of Fine Arts
Vellum, $4\frac{3}{8} \times 3\frac{3}{8}$ in. (0.11 × 0.085 m.), each.

Friedländer, 1967, p. 88, no. 128 and plate 128, thinks that these are copied from out of some composition by Rogier. They seem very strange.
Budapest Catalogue *A Régi Képtár Katalógusa*, 1954, as Weyden (?), nos. 5419, 5420; ditto in 1967 Catalogue in German.
From the collections at Budapest of Károly Pulszky and Lukacs Enyedi.
Presented by Countess A. Ladányi-Niczky, Budapest, 1919.

Friedländer, 1967, no. 128; plate 128.

Diptych: **The Virgin and Child,** CAEN
and Laurent Froimont (?) Plates 95–7
The Virgin and Child, Caen, Musée (Mancel Collection)
Portrait of Froimont (?), Brussels, Musées Royaux des Beaux-Arts de Belgique
The Virgin and Child, $19\frac{1}{2} \times 12\frac{1}{4}$ in. (0.495 × 0.31 m.);
Froimont (?), $19\frac{1}{8} \times 12\frac{3}{8}$ in. (0.485 × 0.315 m.).

X-radiograph of the portrait in Alan Burroughs, *Art Criticism from a Laboratory*, 1938, fig. 129.
The two pictures were associated as a diptych with some reason by Hulin in *The Burlington Magazine*, Vol. XLIV, 1924, pp. 179 f. The measurements do not appear to have been minutely established. It could perhaps be, though probably less well, that the *Virgin and Child* was originally with the *Portrait of Philippe de Croy* at Antwerp (see under Rogier: San Marino).
The *Virgin and Child* carries on the front the *Ave* message of St. Gabriel at the Annunciation. Whatever may have been painted on the reverse has gone (Hulin, *loc. cit.*, p. 180, note 3).
The portrait carries on the front the inscription *Raison lensaigne* (guided by reason). On the reverse is painted St. Lawrence with book and grid-iron, represented in grisaille as a statue in a niche. Also a shield now blank, stated by Hulin (*loc. cit.*) once to have borne arms. Also a scroll inscribed *froimont*.
The donor is identified as Laurent Froimont from the figure of St. Lawrence and the word inscribed on the scroll. Nothing is known of him; it is not certain if *froimont* was intended as a name.
The *Virgin and Child* appears to be the only Rogieresque

example of the Virgin at half-length supporting the Child with the Virgin praying. Like many others much more precisely, it may be claimed to depend on Rogier's *St. Luke* (see Boston).

Both are accepted by Friedländer, 1967, nos. 30, 31, and generally.

The *Virgin and Child* was in the collection of Cardinal Fesch; taken to Rome from France in 1815, according to the 1845 catalogue; 1841 catalogue, no. 1366, no attribution; 1845 Sale Catalogue, Parts 2/3, lot 260, as Hubert van Eyck. P.-B. Mancel (1798–1872) went to Rome at the time of this Sale; *Musée de Caen et Collection Mancel*, Catalogue, 1928, pp. 129 f. and pp. 148 f., no. 50.

The portrait was in the Manfrin Collection at Venice, which was formed at least in part by Conte Gerolamo Manfrin (d. 1801, apparently). Acquired in 1856 for the Accademia at Venice (Catalogue 1914, no. 191). Acquired by the Brussels Museum in 1921 from the Accademia at Venice, in exchange for a Veronese ceiling painting.

Friedländer, 1967, nos. 30, 31
Panofsky, 1953, index (Caen; Brussels).

CASTAGNOLA Castagnola, Thyssen-Bornemisza Collection: see Lugano.

CHICAGO **The Virgin and Child at Half-length**
Plate 83 Chicago, Art Institute, Mr. and Mrs. Martin A. Ryerson Collection
15 × 11 in. (0.385 × 0.283 m.).

Believed by Friedländer, 1967, p. 23, to have been painted to be by itself. The composition is with some variation derived (inverted) from the *St. Luke Drawing a Portrait of the Virgin* (see under Boston), which seems to have been used by Rogier himself, and much more by his followers as a main source for Rogierian pictures of the Virgin and Child at half-length. For a rather closely related *Virgin and Child* (inverted), see Berlin 6.

Accepted by Friedländer, 1967, p. 66, no. 27.

Lent by V. Steyaert to an exhibition of Old Masters at Bruges, 1867 (no. 18). Lent by M. Matthys, Brussels, to the *Exposition des Primitifs Flamands* at Bruges, 1902 (no. 28). Winkler, 1913, pp. 75, 175, under Paris, Steinmeyer. Mr. and Mrs. Martin A. Ryerson Collection; bequeathed to Chicago, 1933.

Friedländer, 1967, no. 27
Panofsky, 1953, index.

Jean de Gros: Chicago, Art Institute; see Rogier: Tournai.

The Deposition COLOGN
Cologne, Wallraf-Richartz Museum.

An example of this composition forms the central panel of a triptych at Cologne; size 50¾ × 37⅜ in. (1.29 × 0.95 m.). It is assigned to the Master of the Legend of St. Catherine (considered a special pilferer from Rogier). Friedländer thought the composition goes back to Rogier; Friedländer, 1967, no. 146 and Vol. IV, *Hugo van der Goes*, 1969, no. 51 and Plate 55, where another painted version is also reproduced. Panofsky, 1953, p. 465, reasonably doubts if the design should be attributed to Rogier himself. Entry for the Cologne picture in the catalogue *Deutsche und Niederländische Gemälde bis 1550*, 1969, pp. 81 f. and plates 83–5.

The head of the Mary furthest to the right in the Cologne picture seems to be imitated from that of the Mary furthest to the right in the *Triptych of the Sacraments* (Rogier: Antwerp 2).

The picture at Cologne is on deposit at the Museum from the Franziskanerkloster there.

Friedländer, 1967, no. 146
Panofsky, 1953, index.

St. Jerome DETROIT
Detroit, Institute of Arts
12½ × 10⅜ in. (0.316 × 0.283 m.). Cut at the top, apparently.

St. Jerome dressed as a cardinal is in a landscape, extracting a thorn from a lion's paw; he is shown again, in penitence, in the background at the left.

It is fairly similar to the outside of the left shutter of the Sforza Triptych (see Rogier: Brussels 3). A version of the St. Jerome there, attributed to a Lombard painter, is in the Accademia Carrara at Bergamo; Friedländer, 1967, no. 143 and plate 109.

The picture at Detroit is accepted as Rogier's by Friedländer, 1967, no. 133. Beenken, 1951, p. 99, thinks that the figure of the saint may be by Rogier, at least on his design. Panofsky, 1953, p. 458, doubts if the Detroit picture was even partially executed by Rogier; I sympathize with this view.

Entry for the picture in the exhibition catalogue, *Flanders in the Fifteenth Century*, Detroit, 1960 (no. 9).

To judge from the descriptions, the Detroit picture was

possibly in the Collection of José de Madrazo (d. 1859) at Madrid; *Catálogo*, 1856, no. 489, as Anon.: and then Marquis de Salamanca Sale, Paris, 3–6 June 1867 (lot 163), as School of Memlinc. It was in Parisian ownership; gift of Mr. and Mrs. Edgar B. Whitcomb to Detroit, 1946.

Friedländer, 1967, nos. 133, 93, 143; plate 138
Panofsky, 1953, pp. 249, 458 (not in index).

**DONAU-
SCHINGEN
(formerly)**

The Virgin and Child at Half-Length
Donaueschingen, Gallery (formerly)
$12\frac{5}{8} \times 10\frac{1}{4}$ in. (0.32 × 0.26 m.).

Friedländer, 1967, no. 110, rightly rejects a suggestion that it formed a diptych with the Portrait in the Thyssen-Bornemisza Collection (see Lugano 2); on p. 24 he points out that it seems to be a picture complete in itself.
Accepted by Friedländer, 1967, no. 110.
The composition bears some relationship to Rogier's *St. Luke* (see Boston). The head of the Virgin corresponds quite closely with that of the Renders Madonna (see Tournai); a quite closely corresponding drawing, perhaps by Rogier, is in the Louvre (Sonkes, 1969, no. A 5). A picture related in design to the Renders Madonna is at Boston, associated with Memlinc; Friedländer, 1967, no. 111; Corpus, *New England Museums*, 1961, pp. 62 f.
The Donaueschingen picture was acquired in Paris as by Hubert van Eyck by Prince Joseph von Lassberg; in his collection in Germany near Constance (Waagen in *Kunstblatt*, 1848, p. 254, as by Rogier the Elder). Acquired from the Lassberg Collection in 1853 by Prince Fürstenberg for the Donaueschingen Gallery; 1921 Catalogue, pp. 102 f. Apparently bought in 1938 by Dr. Springer, Berlin. *Ca.* 1950 in a South German Collection (note in Friedländer, 1967, no. 110).

Friedländer, 1967, no. 110; plate 122
Panofsky, 1953, index.

**ESCORIAL
Plates 10–12**

Christ on the Cross with the Virgin and St. John
Monastery of the Escorial, Nuevos Museos
(sight) $128 \times 75\frac{1}{2}$ in. (3.25 × 1.92 m.).
Severely damaged. See F. J. Sánchez Cantón, 'Un Gran Cuadro de Van der Weyden Resucitado' in *Miscellanea Leo van Puyvelde*, 1949, pp. 59 f., who in figs. 2 and 3 gives photographs showing damage; see also Beenken, 1951, figs. 105, 108.
This is one of the three basic pictures for attribution to

Rogier, the other two being Madrid 1 (with slightly superior authority) and the Miraflores altarpiece at Berlin (where the records are confusing; see under Granada).
It is recognizably mentioned as by Rogier in 1574, in an inventory of Philip II's gifts to the Escorial: 'Una tabla grande en que está pintado Christo Nuestro Señor en la cruz, con Nuestra Señora y sant Juan, de mano de Masse Rugier, que estaua en el Bosque de Segouia, que tiene treze pies de alto y ocho de ancho estaua en la Cartuja de Brussellas' (Folie, 1963, p. 210).
The Charterhouse of Scheut, from which the picture is thus recorded to come, was founded in 1454; E. de Moreau, *Histoire de l'Eglise en Belgique*, Vol. IV, 1949, p. 277. No known document proves that it was painted for Scheut, but this seems unreasonable to doubt; Rogier in life had connections with this house, giving to it pictures and money (Folie, 1963, p. 210), and the grey, near-white dresses of the Virgin and St. John here may seem designed to accord with Carthusian taste. The date 1454/64 is thus probable.
Generally accepted as by Rogier; Friedländer, 1967, no. 25. Compare the *Christ on the Cross* and *The Virgin Supported by St. John* (Rogier, Philadelphia), and the comment there about the presentation.
It is stated by Sigüenza, *Historia de la Orden di San Gerónimo*, 1605 (relevant part of the text dated 1602) that a copy was made by Navarrete (el Mudo); pp. 389, 414 of the extracts by F. J. Sánchez Cantón, *Fuentes Literarias*, Vol. I, 1923. Sigüenza's text suggests that it was sent to take the place of the original at the Bosque de Segovia when that had been transferred to the Escorial. The original was for some time confused with it. See Sánchez Cantón in *Miscellanea Leo van Puyvelde*, 1949, pp. 59 ff.; he thinks Mudo's copy is one on canvas in the Carmelite monastery at Guardalajara. Copies of the Virgin and St. John (by El Mudo?) are in the Church of the Escorial, on either side of the *Christ Crucified* by Benvenuto Cellini; Venturi, *Storia dell' Arte Italiana*, Vol. x, Part ii, 1936, fig. 399.

From Scheut, as already noted. Acquired at an unknown date for Spain. At one time in the Bosque de Segovia (Valsain); given by Philip II to the Escorial, 1574.

Friedländer, 1967, no. 25
Panofsky, 1953, index.

The Deposition from the Cross: Escorial; see Rogier: Madrid 1.

FLORENCE
Plates 77–82

The Lamentation for Christ at His Entombment

Florence, Galleria degli Uffizi

$43\frac{1}{4} \times 37\frac{3}{4}$ in. (1.10×0.96 m.).

The body of Christ is supported in front of the tomb; on the left is the Virgin, on the right St. John. Behind, probably St. Joseph of Arimathaea left (from his type; see the identification made for the *Deposition*, Madrid 1); St. Nicodemus right. The Magdalen kneels in front. Three crosses against the sky.

It is claimed that the stone above which the body of Christ is supported is not merely the door of the Sepulchre behind, but also the Stone of Unction; see Mary Ann Graeve, 'The Stone of Unction in Caravaggio's Painting for the Chiesa Nuova' in *The Art Bulletin*, 1958, pp. 223 f., esp. pp. 227, 231 f.

The exact subject of this picture, a Lamentation at the entrance to the Sepulchre, does not appear to have been in the repertoire of Northern painters; but it does sometimes occur in Italian painting, particularly at Florence. A panel

Fig. 12

by Fra Angelico (d. 1455), now at Munich, is close enough in the treatment of this subject for a direct influence from it to have been plausibly proposed. Consult Panofsky, 1953, pp. 273–4 and text illustration 57. Fra Angelico's picture is reasonably supposed to be from the predella of the high altarpiece of S. Marco at Florence. It is not dated but credibly of *c*. 1440; from Fra Angelico's circumstances, a picture with that origin would not be post 1450.

The Uffizi picture is generally accepted as by Rogier; Friedländer, 1967, no. 22.

The just mentioned claim of Italian influence in it (which does not obviously affect its style) makes a deduction 'painted in Italy' or soon after a visit there attractive. The only time Rogier is known to have been in Italy was in the jubilee year, 1450 (see biographical data on Rogier). It is most improbable that Rogier's journey then lasted for more than a few months. Fazio in his record refers only to Rogier's being in Rome; yet it is not unreasonable to suppose that his journey to or from Rome was via Florence, where (in 1450) he could have seen Fra Angelico's picture.

The figure of the Magdalen recurs in a *Virgin among Virgins* assigned to the Master of the Legend of St. Lucy, at Brussels; see the exhibition catalogue *Primitifs Flamands Anonymes* at Bruges, 1969, no. 15, where that picture is claimed to have been set up in Notre-Dame at Bruges in 1489.

The Uffizi picture has been claimed to have influenced Piero della Francesca and Michelangelo; less implausibly

for the latter (*The Entombment* in the National Gallery in London).

The picture is first surely recorded at Florence in 1666 (see below). Support for the idea that it was there earlier is provided by a *Lamentation* ascribed to 'Tommaso', once in the H. W. Jurgens Collection at Nijmegen; the background there does indeed seem to be derived from the background here. See E. K. J. Reznicek in the *Miscellanea Jozef Duverger*, 1968, vol. I, p. 85 and Berenson, *Italian Pictures of the Renaissance, Florentine School*, 1963, vol. II, plate 1182.

Attempts have been made to identify it with a *Deposition* seen at Ferrara in 1449 by Ciriaco d'Ancona, also recorded there by Fazio writing in 1456. See the biographical data on Rogier; texts in Winkler, 1913, pp. 181–2. This picture at Ferrara might be associated in part with payments to Rogier in 1450 for undescribed works for Lionello d'Este (see Kantorowicz in the *Journal of the Warburg and Courtauld Institutes*, III, 1940, p. 179 for the payments). None of this is at all likely to apply to the Uffizi picture.

The Uffizi picture has also been claimed to be identical with an undescribed picture ascribed to Memlinc, mentioned by Vasari; text in Winkler, 1913, p. 191.

This has been claimed to be the same as an unattributed picture in the inventory of Lorenzo de' Medici, il Magnifico, at Careggi, 1492: 'el sepolcro del nostro Signore schonfitto di crocie e cinque altre fighure' (Folie, 1963, p. 212).

This was put forward by Warburg; see his *Gesammelte Schriften*, 1932, Vol. I, pp. 211, 215 (cf. pp. 381 f.). The claim may be thought to have some plausibility, though the lack of detail in the evidence leaves the matter unproved.

The Uffizi picture entered the Grandducal Collection in Florence in 1666 from the estate of Cardinal Carlo de' Medici (see catalogues of the Uffizi Gallery).

Friedländer, 1967, no. 22
Panofsky, 1953, index.

The Virgin and Child with Four Saints ('The Medici Madonna')

FRANKFU
Plate 73

Frankfurt, Staedelsches Kunstinstitut

21×15 in. (0.53×0.38 m.); flattened rounded top.

X-radiograph in C. Wolters, *Die Bedeutung der Gemäldedurchleuchtung mit Röntgenstrahlen für die Kunstgeschichte*, 1938, Plate 100.

A markedly symmetrical composition. The Virgin stands holding the Child, Who is at her breast, before a tent held

partly open by two angels. Left, SS. John the Baptist and Peter; right, the two doctor saints, Cosmas and Damian. At the bottom three shields, the side ones blank. The central one shows a lily of dull lilac colour, on a ground gold with numerous white touches; this is assumed to be the arms of Florence, which are a red lily on a white ground. It is strange that only the central shield shows a coat of arms. It is often assumed that what are called the arms of Florence here indicate a connection with the Medici family, prominent citizens of Florence at the time. Medici portraits have been claimed in the saints here shown; difficulties with this emerge in an article by E. Müntz in the *Revue de l'Art Chrétien*, 1895, pp. 192 f. It has also been pointed out that SS. Cosmas and Damian were patrons of the Medici, and that Peter and John were the names of two sons of Cosimo de' Medici. Yet it seems difficult to believe that the Medici would have had the arms of Florence (assuming that they are so meant) and not their own put on to the picture: unless indeed, in spite of its small size, it was destined for some official or public place.

Perhaps in favour of an Italian connection is the composition, claimed to be Italianate; Panofsky, 1953, p. 275, expounds. The picture and a derivative to be mentioned were in Italy in the nineteenth century.

Generally accepted as by Rogier; Friedländer, 1967, no. 21. The only known visit by Rogier to Italy was in 1450.

Panofsky, 1953, pp. 274–5, says that SS. Cosmas and Damian have the features of two Burgundian courtiers, Jean le Fèvre de St. Remy and Pierre de Bauffremont. He finds these features again in the Bladelin Altarpiece (Berlin 4) and in a fragmentary picture (Brussels 1). See further Stein in the Prussian *Jahrbuch*, 1926, pp. 18 f.

A.-J. Wauters in *The Burlington Magazine*, Vol. XXII, 1912–1913, p. 230, thinking that the coat of arms indicates the Louvain family of Gheylensone, incredibly proposed that the picture was painted *c.* 1425, to mark the foundation of Louvain University.

A variant ascribed to Vrancke van der Stockt is in the Collection of Mr. and Mrs. Wetzlar, Amsterdam; Friedländer, 1967, no. 122 and Plate 126. This was purchased by Sir Charles Robinson at Rimini in 1860, and was long in the Cook Collection.

The Frankfurt picture was acquired from the Rosini Collection at Pisa in 1833 by Ernst Förster, who sold it in the same year to Frankfurt.

Friedländer, 1967, nos. 21, 122
Panofsky, 1953, index.

Triptych of the Virgin: (a) **The Holy Family**, (b) **Pietà**, (c) **Christ Appearing to His Mother after the Resurrection**

(a, b) Granada, Capilla Real; (c) New York, Metropolitan Museum of Art

A non-folding triptych, consisting originally of panels of equal size. (a) and (b) have been cut at the top; present size, each 19¾ × 14½ in. (0.50 × 0.37 m.); (c), 25 × 15 in. (0.635 × 0.38 m.). X-radiographs and infra-red photographs of (a) and (b) in Corpus, *Granada*, 1963 (no. 101); X-radiograph of (c) in Burroughs, *Metropolitan Museum Studies*, Vol. IV, Part 2, 1933, p. 134 and *Art Criticism from a Laboratory*, 1938, fig. 96.

(c) is accepted as the third panel, to be associated with the two at Granada, to form the original triptych. Friedländer, 1967, no. 1 (Rogier). A good, very exact old version of the whole triptych (Fig. 4), referred to in more detail presently, each panel intact, 28 × 17 in. (0.71 × 0.43 m.), is in the Gemäldegalerie der Staatlichen Museen, Berlin-Dahlem, and shows that the New York panel is of the correct composition for association. The Berlin triptych is often referred to as the Miraflores Altarpiece, from its reasonably assumed provenance.

The inscriptions, each on a scroll held by an angel in each compartment (supplied from the Berlin version for the Granada pictures, where the scrolls have been almost entirely cut away) make it clear that the Virgin Mary is the theme of the triptych. Thus transcribed by Panofsky, 1953, p. 461—For the Holy Family: Mulier hec fuit probatissima, munda ab omni labe; ideo accipiet coronam vitae. Ex Jac. I°. For the Pietà: Mulier hec fuit fedelissima in Christi dolore; ideo datur ei corona vitae. Ex Apoc. II° capitulo. For Christ Appearing to His Mother: Mulier hec perseveravit vincens omnia; ideo data est ei corona. Ex Apoc. VI° capitulo. The texts are altered for the purpose of the triptych from James I, 12, Revelation II, 10, Revelation VI, 2. Interpretation given by Panofsky, 1953, p. 461. Each angel does hold a crown.

The edge of the Virgin's robe in all three compartments is inscribed with words from the Magnificat.

Each scene is shown framed in an arch.

In the Holy Family the Virgin is in a white dress; cf. the inscription, munda ab omni labe.

The *Pietà* shows the body of Christ, the Virgin, St. John and (acceptably) St. Joseph of Arimathaea; cf. what is said about him and St. Nicodemus in the entry for the *Deposition* now at Madrid no. 1. The Cross is seen behind.

The compartment with Christ appearing to His Mother

shows in the background the Resurrection with the three Marys approaching the Tomb. The subject illustrates a long tradition, that Christ after the Resurrection appeared first to His Mother; see Breckenridge, 'Et prima vidit', in *The Art Bulletin*, 1957, pp. 9 f.

Details of the small sculptures shown are for the most part clear for identification. Capitals of pillars show sculptured scenes. For the Holy Family, the Sacrifice of Isaac and the Death of Absalom; for the Pietà, the Expulsion from Paradise; for Christ appearing to His Mother, David and Goliath, Samson and the Lion and at the Gates of Gaza. Further details, and comment by Birkmeyer in *The Art Bulletin*, 1961, pp. 2 f., for these scenes and the following. The framework in each case shows statues in grisaille.

At the springs of the arches, standing figures of the four Evangelists, and extreme left and right, St. Peter and St. Paul. The sculptured scenes in the archivolts show events, for the most part from the Gospels, that link as narratives with the three main subjects. The scenes cut away from the two panels at Granada are supplied from the version of the triptych at Berlin, and marked with an asterisk. From left to right: For the Holy Family: The Nativity; the Visitation*; the Annunciation*; the Presentation in the Temple*; the Adoration of the Kings*; the Adoration of the Shepherds. In the Adoration of the Shepherds, the Virgin is on a bed, supporting the Child (Corpus, *Granada*, Plate CLXV). For the Pietà: the Way to Calvary; the Virgin receiving the news of Christ's arrest*; Christ taking leave of His Mother before the Crucifixion*; the Entombment*; the Crucifixion*; the Erection of the Cross. For Christ appearing to His Mother after the Resurrection: Pentecost; the Ascension; the Holy Women (at the time of their visit to the tomb) with the Virgin; the Coronation; the Apostles assembled at the Dormition of the Virgin; the Announcement of the Virgin's Death.

The order of the scenes on the arches receives a comment by Panofsky, 1953, p. 261. Some further comments on iconography of the two pictures at Granada in Corpus, *Granada*, 1963, pp. 89 f.

A version of the composition, acceptably recognizable from the description and reasonably believed to be identical with the version now at Berlin (Fig. 4), is recorded by Ponz, *Viaje de España*, Vol. XII, 1788, pp. 57 f., in the Charterhouse of Miraflores near Burgos. Ponz quotes from the cartulary of the monastery: 'Anno 1445, donavit predictus rex (i.e. John II of Castile) pretiosissimum, et devotum oratorium, tres historias habens; Nativitatem, scilicet, Jesu-Christi, Descensionem ipsius de cruce, quod

alias Quinta Angustia nuncupatur, et Apparitionem ejusdem ad matrem post Resurrectionem. Hoc oratorium a Magistro Rogel, magno et famoso Flandresco fuit depictum.' (Folie, 1963, p. 211). Ponz, who applied this record to the picture he saw at Miraflores, adds as a tradition that, before belonging to King John II, it had belonged to Pope Martin V (died 1431).

Queen Isabella of Castile (d. 1504) owned beyond any reasonable doubt the *Holy Family* and the *Pietà* (now at Granada) and the *Christ Appearing to His Mother* (acceptably the panel now at New York). It has been suggested that she obtained the original triptych from Miraflores, letting that monastery have a copy in exchange; this *could* have happened, but no documentation has been found to show that it did.

Ponz, therefore, most probably did see at Miraflores near Burgos the identical triptych that was recorded in the cartulary of the monastery. The triptych now at Berlin is said to have passed from Miraflores during the Napoleonic wars to General d'Armagnac.

In the catalogue of the General Vicomte d'Armagnac Sale at Christie's, London, 2 July 1836 (lot 122), is an entry recognizably for this composition, picture stated to have been found in 1809 in the cathedral of Burgos by the Vicomte d'Armagnac; compare the record in Waagen, *Kunstwerke und Künstler in England*, 1837, Vol. II, pp. 233 f. The person in question would be Jean Darmagnac or d'Armagnac (1766–1855), General 1801, Baron 1810, Vicomte 1823; see the French Dictionary of National Biography, Vol. III, col. 667 and A. Révérend, *Armorial du Premier Empire*, Vol. II, 1895, p. 8.

The Berlin triptych was bought by Nieuwenhuys from a French wine merchant (*Kunst-Blatt*, 1843, p. 245); he sold it to the King of Holland (not in 1837 Catalogue, *Prince d'Orange*; 1843 Catalogue, no. 15, with some statements by Nieuwenhuys concerning the provenance). The Berlin picture had (already in the Armagnac Sale Catalogue) acquired the title of Travelling Altarpiece of the Emperor Charles V (an appellation applied perhaps less wildly to a triptych by Memlinc in the Prado). At the King of Holland's Sale in 1850, the picture was bought for Berlin.

The details stated give substantial support to the claim that the Berlin triptych is the one once at Miraflores; indeed, it seems rather unlikely that the Miraflores picture (claimed to be a good one) would have disappeared and not many years later a different picture (also claimed to be a good one) would have been discovered.

The provenance of the Berlin triptych has been recorded at

some length, because of the importance of what Ponz records about the Miraflores triptych. What is there said does indeed appear acceptably recognizable as a record of this composition; yet the acceptability could be put in doubt if there were serious doubt that the Miraflores and Berlin pictures are identical.

Ponz notes, as we have seen, from a document obviously old though not necessarily contemporary, that what is henceforward here referred to as the Berlin picture was painted by Rogier, and that it was given to Miraflores in 1445 by King John II of Castile (who indeed had founded the monastery in 1442). Ponz also gives as a tradition that the picture had belonged to Pope Martin V (d. 1431).

The attribution accorded provides one of the bases for any attribution to Rogier. It might be the first of all, if the Berlin picture on stylistic grounds were acceptable as an original by Rogier. The already mentioned hypothesis that Queen Isabella early on effected a substitution should not retain us, in the absence of documentary support for it. The best we can say at present is that King John II appears not to have obtained Rogier's original, but that the record of his gift to Miraflores provides us with a good clue to what Rogier's style of painting was like. As for modern critics' views on the autograph quality of the Berlin picture, it is normally excluded; Friedländer, 1967, no. 1, as faithful replica. J. Taubert in *Pantheon*, 1960, pp. 67 f., unconvincingly claimed that the *Christ Appearing to His Mother* at Berlin (not the other two panels) is an original.

Ponz also provides a date, 1445, by which the Berlin picture (or at least, one may think, a version of it) existed. The tradition Ponz records that it is not later than 1431 (death of Pope Martin V), is usually, and rightly, neglected by critics. Nevertheless, Friedländer, 1967, p. 45 (text of 1924), seems to favour before 1427, which I find not credible; A.-J. Wauters in *The Burlington Magazine*, Vol. XXII, 1912, pp. 75 f., put forward that it was a gift from the town of Louvain to Pope Martin V.

An argument for dating before 1438 has been put forward from the gesture of Christ's right hand in the *Christ Appearing to His Mother*. It is claimed that this was borrowed—and improperly for the subject—in the gesture of St. John the Baptist, protecting saint of Heinrich von Werl, in a picture dated 1438 at Madrid (see Campin; Madrid 2). This argument is not very strong, whatever attribution is favoured for the picture at Madrid. Granted that in the present composition Christ's gesture is proper for displaying the 'print of the Nails' and may have been invented by Rogier (cf. Panofsky, 1953, p. 264); yet, if the unproper gesture in the picture at Madrid is a misunderstood imitation, it was not necessarily imitated from this composition—there may have been something earlier of the subject that is not known to have survived.

A drawing of fine quality, somewhat suggestive of St. Joseph in The Holy Family, is at Oxford; Sonkes, 1969, no. A 2.

For a variant design of the Pietà (London, Brussels, etc.) see under London 3.

A picture of *Christ Appearing to His Mother* at Washington, size 64×36⅝ in. (1.63×0.93 m.) is loosely related to the composition of the subject in this triptych. I do not accept it as Rogier's; Friedländer doubtfully does (1967, p. 68, no. 41 and Plate 64). Beenken, 1951, p. 100, rejects it; he records a proposal by Winkler that its pendant is a Rogier schoolpiece (Vrancke van der Stockt?) of the same size, showing *The Annunciation*, at Dijon (Friedländer, 1967, no. 160, Plate 143). The association is very probable. The Washington picture was in the Marquis de Salamanca Sale, Paris, 3–6 June 1867 (lot 155), as van der Goes; previously in the collection of José de Madrazo (d. 1859), at Madrid (Cátalogo, 1856, no. 519). Cf. the Catalogue of the Exhibition of Flemish Art at the Royal Academy, London, 1927 (No. 30). An *Annunciation*, described as a companion, was in the Madrazo Collection, no. 518; the description of it in the Salamanca Catalogue (lot 154) corresponds well with the Dijon picture. That picture was given to the Dijon Museum by Jules Maciet in 1898.

The Washington picture is related in composition to a picture no. 1086 in the National Gallery, London (Corpus, Vol. II, no. 59) and to one assigned to the Master of the S. Ursula Legend in the Metropolitan Museum in New York (Friedländer, Vol. VI (Part I), *Hans Memlinc and Gerard David*, 1971, no. 117; Wehle and Salinger's *Catalogue* 1947, pp. 76 f.).

Three pictures forming a triptych now at Granada and (it is reasonably believed) at New York are recognizably recorded as having been bequeathed by Queen Isabella of Castile (d. 1504) to Granada (Capilla Real; Corpus, *Granada*, 1963, pp. 99, 108).

The *Holy Family* and the *Pietà* are still there, with the tops cut off; this was perhaps done when the pictures were fitted into altarpiece shutters of *c.* 1630–3.

The *Christ Appearing to His Mother* left the Capilla Real of Granada at an unknown date. It is acceptably identified as the picture once owned by the Duke of Osuna at Madrid, and acquired from Duveen by Michael Dreicer, 1917, who

bequeathed it in 1921 to the Metropolitan Museum, New York (Wehle and Salinger's *Catalogue*, 1947, p. 34).

Corpus, *Granada*, 1963, no. 101
Friedländer, 1967, no. 1
Panofsky, 1953, index (Granada; New York).

THE HAGUE **The Lamentation after Christ's Deposition from the**
Plate 119 **Cross**
The Hague, Mauritshuis
31¾×51¼ in. (0.807×1.303 m.). The picture would not appear to have been the central panel of a triptych (cf. Panofsky in *The Art Bulletin*, 1951, p. 34, note 10).
Reflectograms in J. R. J. van Asperen de Boer, *Infrared Reflectography*, 1970, Plates V, IX, X.

Present, the Virgin, St. John, the Magdalen, two other Marys. According to a tradition, the male figure supporting Christ should be St. Joseph of Arimathaea, the figure standing towards the right being St. Nicodemus; cf. the comment to the *Deposition* (Madrid 1). To the right, the kneeling Donor dressed as a Bishop; SS. Peter and Paul stand behind.
On the Donor's crozier, the Annunciation; on his morse, God or Christ and two Angels; on the orphrey of his cope, SS. Peter, Paul, John the Evangelist, Bartholomew and others.
In 'Two Rogier Problems' (*The Art Bulletin*, 1951, pp. 33 f.), Panofsky points out that the mitred donor here is indeed also to be seen in the Altarpiece of the Sacraments (Antwerp 2); but against a previous, incorrect claim identifies him with an ecclesiastic accompanying a Bishop in that picture (who is acceptably Jean Chevrot) in the scene of Confirmation. He ingeniously, indeed convincingly, proposes that the important ecclesiastic in the Antwerp picture is Pierre de Ranchicourt, who became Bishop of Arras (his first bishopric, so far as is known) in 1463 and died in 1499. With regard to his appearance in the present picture, St. Peter is Pierre de Ranchicourt's patron saint. The provenance of this picture from the Collège d'Arras at Louvain (founded 1508) had previously misled Weale into taking up a claim that the donor is Nicolas Le Ruistre, bishop of Arras 1501, died 1509, with implication for the picture's date properly objected to by Hofstede de Groot; see the *Revue de l'Art Chrétien*, 1901, pp. 124 f. and *Oud-Holland*, 1901, pp. 141 f.
Panofsky's identification of the donor (Bishop, 1463) does not leave much time for doing the picture to Rogier (died

1464). The attribution of this distinguished work to his hand has indeed often been questioned, and I find it very difficult to accept, though Rogier may have been concerned with it. Accepted by Friedländer, 1967, no. 46. Beenken, 1951, p. 99, calls it a school-piece, not excluding participation by the young Memlinc (cf. the reference to difficulties about the young Memlinc under Munich 1).
The figure of the Mary in the foreground at the left recurs in the *Miracle of the Loaves and Fishes* assigned to the Master of the Legend of St. Catherine in a triptych at Melbourne (Friedländer, *Early Netherlandish Painting*, Vol. IV, *Hugo van der Goes*, 1969, no. 49); also (inverted) in a *Deposition*, mostly based on Rogier's *Deposition* (Madrid 1), by the Master of S. Bartholomew in the Louvre (entry for it in the exhibition catalogue *Des Maîtres de Cologne à Albert Dürer*, Paris, 1950, no. 54). A copy drawing of the Marys is at Vienna (Sonkes, 1969, B 14). Other derivatives, and more information generally about this picture, in the Hague catalogue, *Schilderijen en Beeldhouwwerken 15e en 16e eeuw*, 1968, pp. 54 f.
A claim for a provenance from Middelburg near Bruges is to be neglected. In the Collège d'Arras at Louvain (founded 1508); sold in 1805 to P. J. Geedts(?). Owned by Baron van Keverberg van Kessel; recorded by him in *Ursula, Princesse Britannique*, etc., 1818, pp. 163 f. Acquired from him in 1827 by the King of the Netherlands.

Friedländer, 1967, no. 46
Panofsky, 1953, index.

The Virgin and Child at Half-Length HOUSTON
Houston, Museum of Fine Arts (Edith A. and Percy S. Plate 84
Straus Collection)
12⅜×8⅞ in. (0.315×0.225 m.).

Friedländer, 1967, p. 24, thinks that it was painted to be alone.
Following on and correcting P. Rolland, 'La Madone Italo-Byzantine de Frasnes-lez-Buissenal', in the *Revue Belge d'Archéologie et d'Histoire de l'Art*, Vol. XVII, 1948, pp. 97 f., Panofsky (1953, pp. 296 f.; see figs. 59, 60 in the text volume) convincingly showed that the unusual design is freely based on that of an Italo-Byzantine Madonna. This in 1440 was brought from Rome by a canon of Cambrai; he bequeathed it in 1450 to the cathedral there. It is in the present cathedral there.
In 1454 fifteen copies of it were ordered for distribution; three from Petrus Christus and twelve from Hayne of

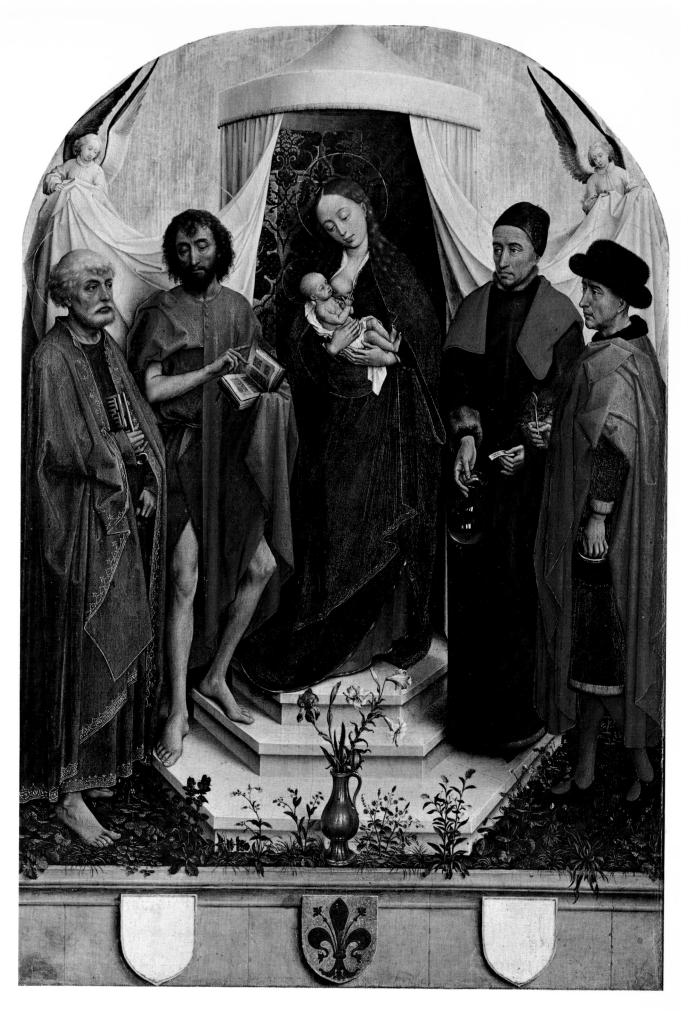

The Virgin and Child with four Saints. Frankfurt, Städelsches Kunstinstitut (Cat. Rogier, Frankfurt)

Brussels (one of which is put forward as surviving at Kansas City). See further on this composition Catherine Perier-d'Ieteren in the *Bulletin*, Musées Royaux des Beaux-Arts de Belgique, 1968, nos. 3/4, pp. 111 f.

It is believed that Rogier went to Cambrai in 1459, to deliver in person an altarpiece; this is not actually stated in the text of the documents known (see the biographical data), but may be true. In any case, Rogier might have seen copies.

The Houston picture is accepted by Friedländer, 1967, No. 35. Beenken, 1951, p. 99, inclines to separate it altogether from Rogier. Panofsky, 1953, p. 296, calls it 'replica'.

The facts expounded by Panofsky make it improbable that the date is earlier than 1454.

The picture came from Hungary; Cassirer, Amsterdam, 1924; Hess Collection, Berlin. New York, Edith A. and Percy S. Straus Collection; bequeathed to Houston, 1944. In the Exhibition *Flanders in the Fifteenth Century*, Detroit, 1960 (No. 8).

Friedländer, 1967, no. 35
Panofsky, 1953, index.

Portrait of a Man

INDIANA-
PLIS
(formerly)

Formerly Indianapolis, The Clowes Fund
$14\frac{1}{2} \times 10\frac{1}{2}$ in. (0.37×0.265 m.).

Apparently much damaged (cf. Friedländer, 1967, no. 33). The measurements correspond closely with those of the *Portrait of a Lady* in the National Gallery (London 4), but it should not be thought that the two formed a pair; they are reproduced side by side in Friedländer, 1967, plate 56, which makes clear the unacceptably great difference of scale in the two figures. They were claimed to be a pair in *Connaissance des Arts*, December 1968, p. 37 (the present portrait then Galerie Robert Finck, Brussels).

Accepted by Friedländer, 1967, no. 33. Rejected by Winkler, 1913, p. 162 (Studio?); by Beenken, 1951, p. 99. Panofsky, 1953, p. 478, says very doubtful. Probably never of much significance.

Collection Charles-Léon Cardon; lent to Bruges, *Exposition des Primitifs Flamands*, 1902 (no. 27). Later Mortimer Schiff, New York; in the Clowes Fund, Indianapolis; Anon. Sale, Christie's, 24 November 1967 (lot 35).

Friedländer, 1967, no. 33; plate 56
Panofsky, 1953, index (Brussels, Cardon).

The Visitation

LEIPZIG
Plate 70

Leipzig, Museum der Bildenden Künste
$22\frac{1}{2} \times 14\frac{1}{4}$ in. (0.57×0.36 m.).

Not usually claimed to be one wing of an altarpiece. It is related in composition to the altarpiece wing of this subject at Turin (q.v.).

The small figure at the entrance to St. Elizabeth's dwelling is presumably St. Zacharias.

Generally accepted as by Rogier; Friedländer, 1967, no. 5. A derivative forms part of an elaborate altarpiece in the Metropolitan Museum of Art at New York (The Cloisters); Friedländer, *Early Netherlandish Painting*, Vol. IV, *Hugo van der Goes*, 1969, no. 81, as Master of the Joseph Sequence (but corrected to Rogier follower). The central part of the altarpiece at New York is derived from the Bladelin Altarpiece (Berlin 4); on stylistic grounds, the Leipzig *Visitation* is put considerably earlier than the Bladelin Altarpiece.

There is considerable similarity between the Leipzig *Visitation* and the variant at Turin on the one hand, and the *Visitation* painted by Daret and finished not later than September 1435, now in the Gemäldegalerie der Staatlichen Museen, Berlin-Dahlem (Friedländer, 1967, Plate 104). There seems to be an inspiration in common; precise copying is not involved. Daret was from 1428 until 1432 a co-apprentice with Rogier in Campin's studio. Possibly Campin painted a picture of the subject, influential on both Rogier and Daret; or Daret based himself on Rogier. Daret's humdrum character, deducible from his four surviving paintings, makes unattractive the hypothesis that Rogier based himself on Daret.

Plate 166

The Leipzig picture was in the Speck von Sternburg Collection at Lützschena; presumably no. 37 of the 1827 Catalogue, as Memling (no description; size given as 24×15 Zoll). Now in the Museum at Leipzig.

Friedländer, 1967, no. 5
Panofsky, 1953, index (Lützschena).

Christ Carrying the Cross: Leipzig, Becker Collection (formerly); see Rogier: Various Collections 1.

LEIPZIG,
BECKER

St. Luke Drawing a Portrait of the Virgin: Leningrad; see Rogier: Boston.

LENINGRAD

Heads of St. Joseph and St. Catherine (?): Lisbon, Calouste Gulbenkian Foundation; see Rogier: London 1.

LISBON,
GULBENKIAN

Fragments of an Altarpiece: **The Magdalen reading,
Heads of St. Joseph and St. Catherine** (?)

The Magdalen, London, National Gallery
The two heads, Lisbon, Calouste Gulbenkian Foundation
The Magdalen, $24\frac{1}{4} \times 21\frac{1}{2}$ in. (0.615 × 0.545 m.); each head,
$8\frac{1}{2} \times 7$ in. (0.21 × 0.18 m.). The heads are on oak; the
Magdalen has been transferred to mahogany. X-radio-
graphs of the Magdalen in Corpus, *London*, Vol. II, Plates
CCCXCVII–CCCIC.
Until 1955 the background of the Magdalen was over-
painted with almost uniform paint.

This fragment now shows the Magdalen (identified by her
pot) seated on the ground, reading, turned towards the
left. Behind her stands a headless figure holding beads and
supporting himself on a stick. To the left is red drapery
from a missing figure with bare feet; the corner of a bench
above it. The Magdalen is in the right-hand corner of a
room; a cupboard and wall to the right; landscape and a
little architecture are seen through a fragment of window
to the left of the standing figure.
The head of this standing figure is identifiable with cer-
tainty as the male head at Lisbon; folds of drapery and the
architecture correspond precisely.
The female head at Lisbon has been with the other head
since the first known record of them in 1907. It was estab-
lished as being from the same altarpiece by John L. Ward
in *The Art Bulletin*, 1971, pp. 32 and 281 (see his text).
Water in the landscape there carries on satisfactorily from
water in the landscape of the Magdalen. The wall coming
forward at the left there indicates a position on the left; the
figure may well have been shown kneeling. Mojmír S.
Frinta, *The Genius of Robert Campin*, 1966, p. 78, rejects the
association of this head.
Information about the central part of the picture is ob-
tained from a drawing at Stockholm, seemingly of the late
fifteenth century, assigned to the Master of the Coburg
Roundels; Friedländer, 1967, no. 145, plate 21; Sonkes,
1969, no. C9, rejecting that attribution. The drawing shows
at the right a kneeling figure before a bench; correspon-
dence with the portion of drapery seen in the picture at
London, the feet, and the corner of a bench is so precise
that the identity of the picture in part copied in the drawing
is indubitable. The drawing shows, centre and right, a main
group of the Virgin seated in an interior on a bench,
holding the Child. Left is a standing figure, clearly St. John
the Baptist. Right, the kneeling figure is identifiable as St.
John the Evangelist (Rogier does elsewhere show this

saint of this type, in red, with bare feet); he kneels holding
a book and an inkwell for the Child, who is writing in the
book.
The seven figures (four on the drawing, the Magdalen, and
the two whose heads are at Lisbon) may have formed the
complete composition.
The male saint (head in Lisbon, body in London) is
probably St. Joseph. Type and costume are suitable; he is
shown with prayer-beads in some pictures, e.g. in a Petrus
Christus at Kansas City. The female saint in Lisbon is not
precisely identifiable; her rich costume suggests that she
may be St. Catherine, a Virgin of Royal Blood. At one
time, wrongly called the Virgin Mary.
The picture would have been large for the Early Nether-
landish School. Sonkes, 1969, no. C9, suggests approxi-
mately 0.85 × 1.40 or 1.50 m.; about 35 × 55 inches. The
right-hand side of the *Magdalen* is clearly approximately
the original edge; it is not likely that the left-hand side
of the *Head of St. Catherine* has been much cut.
The drawing shows on the left a standing figure, Bishop or
Abbot; not the St. Catherine (?) postulated in the original
picture. It seems most unlikely that the drawing records
the position of this figure relatively to the group of the
Virgin and Child with the two SS. John; indeed, a wavy
line on the drawing (the edge of S. Catherine's (?) dress?)
seems to separate him. If (as is probable) this figure is
copied from a painting, it might have been on a shutter of
this altarpiece. John L. Ward in *The Art Bulletin*, March
1971, pp. 27 f., seeks to introduce him on the main panel to
the left of the S. Catherine (?), but there are several doubt-
ful points in his reconstruction.
A drawing of drapery at Berlin, also assigned to the Master
of the Coburg Roundels, was associated with the *Head of
St. Catherine* (?) by A. J. Klant-Vlielander Hein, 'Rogiers
"Lezende Magdalena" geconfronteerd met de Heilige
Catharina', in *Miscellanea I. Q. van Regteren-Altena*, 1969,
pp. 20 f.; but it does not sufficiently fit.
The motif of the Virgin with the writing Child (but not as
seen here) has been written on by Parkhurst in *The Art
Bulletin*, 1941, pp. 292 ff. and Squilbeck in the *Revue Belge
d'Archéologie et d'Histoire de l'Art*, 1950, pp. 127 f. Here it
would seem as if the Infant Christ were writing the Gospel
of St. John, considered particularly inspired. It is rather
unusual to see a grown-up St. John the Evangelist in close
association with the Infant Christ; but it should be noted
that a now well-known motif of the two children with the
Virgin, apparently of Florentine origin, would not have
spread to the Netherlands at the time of this picture, in-

deed may not have started at Florence itself until ca. 1460. The *Magdalen* and the two SS. John are each associated with a book; this may suggest a commission from some learned source.

The fragments of this picture are discussed more fully by the present writer in the *Miscellanea Prof. Dr. D. Roggen*, 1957, pp. 77 f.

The *Magdalen* was not associated in art literature with the two *Heads* until very shortly before the removal of overpaint covering the background in 1955. Tschudi, 1898, p. 34, thought it on the borderline between Rogier and Campin; but mostly it has been accepted as Rogier's, e.g. by Winkler, 1913, pp. 100 f., by Friedländer, 1967, no. 12, by Hulin, 1938, col. 239. The two *Heads* were accepted by Friedländer, 1967, no. 36. Further references to opinions given before the association was made are hardly useful. In the opinion of the present writer, it would be wrong to separate the fragments from Rogier. Indeed, the complete picture would have been one of his chief works; from the loose design, probably rather early.

There is some similarity of pose, type and setting between the *Magdalen* and the *St. Barbara* (Campin: Madrid 2), usually assigned to Campin, the shutter pendant to which is dated 1438. This figure has also been compared with one in the *Triptych of the Sacraments* (Rogier: Antwerp 2).

The *Magdalen* is said to come from the collection of the Demoiselles Hoofman at Haarlem; acquired as part of the Edmond Beaucousin Collection, Paris, by the National Gallery in 1860. The two *Heads* were lent by Leo Nardus to the *Toison d'Or* exhibition at Bruges, 1907 (no. 184 of the picture section); Onnes (Château de Nÿenrode) Sale, Amsterdam, 1923 (lot 23); now Fundaçâo Calouste Gulbenkian, Lisbon.

Corpus, *London*, Vol. II, no. 57
Friedländer, 1967, nos. 12, 36, 145
Panofsky, 1953, index (London; New York, Gulbenkian).

LONDON 2
Plates 99–100

The Consecration of St. Hubert (The Dream of Pope Sergius);

The Exhumation of St. Hubert

The Consecration, Brazil and New York, von Pannwitz Collection; *The Exhumation*, London, National Gallery

The Consecration, 34½ × 31½ in. (0.88 × 0.80 m.); *The Exhumation*, 34⅝ × 31¾ in. (0.88 × 0.805 m.).

The Exhumation was cleaned in 1953–4; in particular, a painted-out hand was then revealed. Reproduction after cleaning: Friedländer, 1967, plate 38.

The two pictures are associated by their subjects, and the sizes closely correspond. It should not be doubted that they formed a diptych; what are clearly these pictures are so recorded in the earliest known reference to them (1623 or soon after), with *The Exhumation* on the left. The centralized perspective of each would hardly accord with their being the wings of a triptych.

St. Hubert, Bishop of Maestricht, later first Bishop of Liège; patron of hunting; d. 727.

For the subject of *The Consecration*, see Chanoine Joseph Coenen in *Fédération Archéologique et Historique de Belgique*, XXIXᵉ Session, *Congrès de Liège*, 1932, pp. 210 f. St. Hubert went on a pilgrimage to Rome. An angel appeared to Pope Sergius asleep; revealed to him the assassination (ca. 708) of St. Lambert, Bishop of Maestricht; presented St. Lambert's crozier to the Pope; and instructed him to consecrate St. Hubert, whom he would soon meet. St. Hubert reached Rome the same day, and was consecrated Bishop of Maestricht. The Pope's dream is the principal subject of the picture. In the middle-ground the Pope and two cardinals go out, meeting two petitioners. Further back, a cardinal rides across the Ponte Sant'Angelo; still further back, the Pope blesses the pilgrim St. Hubert (?)—unclear in the photographs available—at the entrance to old St. Peter's.

As for the National Gallery picture, the body of St. Hubert was twice exhumed; it is clear that the second occasion (in the year 825) is the subject. The body was then translated from the church of S. Pierre at Liège (the church in the picture is deducibly dedicated to St. Peter) to the abbey of Andagium or Andainum, which soon became famous under the name of Saint-Hubert-des-Ardennes. Identifiable figures in the picture as on the left, Walcandus or Walcaudus, Bishop of Liège, who presided at the ceremony, and Louis le Débonnaire, King of France and Emperor. On the right probably Adelbald, Archbishop of Cologne, who was also present. Further information on the circumstances in the National Gallery catalogue, *Early Netherlandish School*, 1968, p. 173.

The Consecration shows a view of part of Rome, a little more trustworthy than might at first seem. The bridge of Sant'Angelo is seen leading to the castle of Sant'Angelo (statue of St. Michael visible on top). Behind is old St. Peter's; a variant of this representation of it is found in the *Presentation of the Virgin* by a follower of Rogier in the Escorial (Friedländer, 1967, no. 83 and plate 106). By the side of the church is an obelisk, certainly the one moved from that position in 1586 to St. Peter's Square, where it now is.

At the time of the picture this obelisk had a bronze ball at the top; see Paul Molajoni 'Come avvenne l'innalzamento dell'obelisco in Piazza di S. Pietro nel 1586' in *L'Illustrazione Vaticana*, 16–29 February 1936, pp. 167 f. For comments on the obelisk, and illustrations of it still at the side of St. Peter's (but with the church partly reconstructed in its present form), see for instance Cesare d'Onofrio, *Gli Obelischi di Roma*, 1965, or F. Ehrle and H. Egger, *Piante e Vedute di Roma e del Vaticano*, 1956. See also C. Galassi Paluzzi, *San Pietro in Vaticano*, vol. I, 1963, figs. 15, 29 (drawings made to show old St. Peter's, including the obelisk). Among other details checkable from photographs, Christ as God is represented on the gable of the papal bedroom; Christ and St. Peter (?) lower down.

The Exhumation in the *pendant* is represented as taking place in the choir of a Gothic church, of a style of architecture not much earlier than the time of the picture. A reliquary on the altar shows the figure of St. Hubert with his hunting horn. Behind this there is represented a painted retable with figures of St. Catherine (?), St. Peter, Christ on the Cross between the Virgin and St. John, St. Matthew (?) and St. Gudula. St. Catherine (?) has sword and crown, St. Catherine's specific emblem of a wheel not being seen. St. Matthew (?) has a pike. St. Gudula (Patroness of Brussels, d. 712) is shown with a lantern and a small figure of the devil trying to extinguish it; this used to occur as St. Gudula went to church. Above the retable is a statue of St. Peter. He, St. Paul and the Virgin and Child are seen in the stained-glass of the church. Statues of apostles are above the capitals, SS. Peter and Paul being prominent; also seen, SS. Andrew, John and Bartholomew (?). On the cope of the Bishop at the left, figures of SS. John and Bartholomew (?); a figure of God (?) on the morse of the prelate standing at the right. Further comment in Corpus, *London*, vol. II, 1954, no. 58.

The figure of St. Hubert on the reliquary is no doubt meant as a reference to his having been buried in the church where he is shown as now being exhumed. That church was S. Pierre at Liège, whence the prominence of St. Peter in the above decorations. The picture (with its pendant) is recognizably recorded in St. Gudule in Brussels ca. 1623 or soon after.

Friedländer, 1967, nos. 18, 19, classes both pictures as by Rogier. They were dubitatively assigned to him in the first known record of them, ca. 1623 or soon after. Beenken, 1951, p. 99, says that the National Gallery picture is by a pupil and records the opinion of W. Houben that the pendant is by another hand. Panofsky, 1953, p. 482, thinks

workshop, not certainly to be associated with any other existing works. One may ascribe *The Exhumation* to an independent follower; or it may rather be a studio production, possibly with intervention by Rogier himself in the principal group in the centre. It has been classed as by the Master of the Exhumation of St. Hubert (or the Edelheer Master), and grouped with other paintings: the Edelheer altarpiece (see under Rogier: Madrid 1), a woman's head in a Parisian Rothschild Collection (see under Rogier: Turin) and the *Marriage of the Virgin* in Antwerp cathedral (q.v.). The last might be by the same hand, for whatever in *The Exhumation* is not thought to have been executed by Rogier himself.

The chapel where the two pictures were ca. 1623 or soon after had been founded in 1437 (see Corpus, *London*, vol. II, 1954, p 188). The illustrations of Rome in the *Consecration* should not lead to the deduction that the picture is no earlier than 1450, the year in which Rogier is known to have visited Rome; drawings or pictures of monuments so famous as St. Peter's, etc. may well have been available in painters' studios in the Netherlands.

The angel in *The Consecration* recurs somewhat varied and inverted in a triptych of the *Last Supper* in the Seminary at Bruges, assigned to the Master of the Legend of St. Catherine; Friedländer, *Early Netherlandish Painting*, vol. IV, *Hugo van der Goes*, 1969, no. 48. Arrangement and details in this picture seem to have been used for pictures of the life of SS. Ulrich and Afra at Augsburg; A. Stange, *Deutsche Malerei der Gotik*, vol. VIII, 1957, figs. 77, 78. A drawing at Rotterdam, seemingly of the fifteenth century, after the *Exhumation* has been assigned to the Master of the Coburg Roundels; Sonkes, 1969, no. B 20, not very convincingly rejects the attribution of the drawing. A drawing of two figures from the picture, in the Louvre, may well be more recent; Sonkes, 1969, no. B 21.

The two pictures are mentioned together, with error but recognizably, by Dubuisson-Aubenay ca. 1623 or soon after, in a chapel (of St. Hubert, which had been founded in 1437) in S. Gudule at Brussels; for details, see Corpus, *London*, vol. II, 1954, no. 58, p. 188. They are later mentioned separately in the collection of the Earls of Bessborough.

The Consecration is presumed to have been ('John Van Eyck, A vision of a pope') in an Anon. Sale at Christie's, 7 May 1796 (lot 34); Messrs. Christie's kindly gave the information that this was Bessborough property. Recognizably in the Bessborough sale, 11 July 1850 (lot 186); then Labouchere (Lord Taunton); cf. Waagen, *Treasures of Art*, vol.

II, 1854, p. 421. Later Mortimer L. Schiff, New York; Schiff sale, Christie's, 24 June 1938 (lot 84). Pannwitz collection, at one time in Holland (de Hartekamp); Friedländer, 1967, no. 19, as in Brazil and at New York.

The Exhumation was in the Earl of Bessborough Collection by 1781, probably (see Corpus, *London*, vol. II, 1954, pp. 190 f.); this Earl died in 1793; Bessborough sale, 1801. Beckford, Fonthill (sold 1823); Harman sale, 1847; Eastlake in that year (see the National Gallery Catalogue, *Early Netherlandish School*, 1968, p. 175). Acquired by the National Gallery from the Eastlake Collection, 1868.

Corpus, *London*, vol. II, 1954, no. 58
Friedländer, 1967, nos. 18, 19
Panofsky, 1953, index (under Master of the Exhumation of St. Hubert; London: Haartekamp).

LONDON 3 Pietà
Plate 72

London, National Gallery
$14 \times 17\frac{3}{4}$ in. $(0.355 \times 0.45$ m.$)$.
Infra-red and X-ray photographs in Corpus, *London*, Vol. III, 1970, Plates XCVI–XCIX.

On the left, St. Jerome and a Donor; right, a Dominican (St. Dominic?)

The composition is presumed to be developed from that of the panel showing this subject in the 'Miraflores' composition (see Rogier: Granada). It may be thought a stock design, since two variants are known; for these, see Friedländer, 1967, under no. 20 and plate 41. One is at Brussels, the two figures besides Christ and the Virgin there being St. John and the Magdalen; no donor. Reflectograms in J. R. J. van Asperen de Boer, *Infrared Reflectography*, 1970, Plates XI, XIII. The other is known in two versions, at Berlin-Dahlem and Madrid; an upright composition, showing the Virgin, Christ and St. John with a donor on the right. It has been suggested that he was connected with ancestors of the Broers family, from a painting of his head and bust alone; see O. le Maire in the *Bulletin de la Société Royale d'Archéologie de Bruxelles*, July 1935, pp. 107 f.

Only the stem of the Cross is visible in the National Gallery picture; this is shown as if the arms of the Cross were conceived of as seen obliquely, as they are in the variant composition at Berlin and Madrid, and are not in the 'Miraflores' composition. But this is not certain, since a copy of the National Gallery picture shows the arms of the Cross (which were never included in the original) parallel to the picture surface; see G. Carandente, *Collections d'Italie*, I,

Sicile (Les Primitifs Flamands, Répertoire series), 1968, no. 24, plate XVIII (Palermo, coll. Nicola Leotta).

The National Gallery picture is accepted by Friedländer, 1967, no. 20. Beenken, 1951, p. 99, as not original; Panofsky, 1953, p. 462, not having seen it, reserved judgement. I have no doubt that it is autograph. The pictures at Brussels, Berlin, Madrid, meritorious as they indeed are, seem to be progressively less easily acceptable. It is to be noted that the picture at Madrid has a shaped top, of a type very popular for some decades at the beginning of the sixteenth century, the first dated example of it being apparently of 1496; this was stressed by Winkler in the *Zeitschrift für Kunstgeschichte*, vol. IX, 1940, pp. 66 f., but Dr. Xavier de Salas examined the picture and kindly told the present writer that he considers it to have been cut to its present shape at some time subsequent to the painting of it. The Brussels picture was acquired in 1899 from the Pallavicini-Grimaldi Collection, Genoa; the Berlin picture was acquired in Florence in 1901; the Madrid picture was acquired in 1925, having been in the mid-nineteenth century owned by D. Fermín Lasala, Duque de Mandas.

The National Gallery picture was in the collection of the Earl of Powis by 1895; acquired by the National Gallery in 1956 through Messrs. Agnew under the terms of the Finance Act of 1956.

Corpus, *London*, Vol. III, no. 130
Friedländer, 1967, no. 20
Panofsky, 1953, index (London, Powis; Brussels; Berlin; Madrid).

Portrait of a Lady
LONDON 4
Reverse: Christ Crowned with Thorns
Plates 108–9

London, National Gallery

Obverse $14\frac{1}{4} \times 10\frac{1}{2}$ in. $(0.365 \times 0.27$ m.$)$. The painting on the reverse is of approximately the same size.

Before the picture was cleaned in 1967, the sitter's left sleeve from the shoulder downwards was seen widened. A good deal of paint is missing from the reverse.

Probably not part of a diptych or triptych; the figure is acceptable as a simple portrait, and the frontality of presentation of the Christ on the reverse would not be in disaccord with this. It has been suggested that a male portrait is a pendant portrait to it; but that seems to lack connection except in the measurements (see Rogier: Indianapolis, formerly).

Dark areas in the background at the left and at the top are

probably to suggest shadows from the original frame; this was rather often done in the sixteenth century.

José Cortez in *Belas Artes*, Lisbon, 1955, no. 8, pp. 13 f., unconvincingly suggested that the sitter is Beatrice, of the Portuguese Royal Family; m. 1452 Adolphe of Cleves, Lord of Ravenstein; died young in 1461.

Assigned to Rogier by Friedländer in *Werk über die Renaissance-Ausstellung*, 1898, p. 7; Friedländer, 1967, no. 34. Some restrictions on the attribution to Rogier himself have been made, partly on comparison with a superficially similar portrait at Washington (q.v.); Beenken, 1951, pp. 74, 99, denies that it is autograph. But it is usually accepted.

Mme Bl(anc) sale, Paris, 3 May 1876 (lot 15), bought by the Baron de Beurnonville; in whose sale at Paris, 14–16 May 1881 (lot 363). Bequeathed to the National Gallery in 1895 by Mrs. Lyne Stephens (Yolande-Marie-Louise, known as Pauline Duvernay).

Corpus, *London*, vol. II, 1954, no. 60
Friedländer, 1967, no. 34
Panofsky, 1953, index.

LONDON 5
Plate 75

S. Ivo (?)

London, National Gallery

$17\frac{3}{4} \times 13\frac{3}{4}$ in. (0.45 × 0.35 m.).

In excellent condition, except for damage along a vertical joint somewhat left of centre.

The figure holds a paper, on which are marks that do not form words.

The picture in 1970 still showed a false halo and a false inscription top right, .S.IVO/ADVOCATVS/PAVPERVM. S. Ivo (1253–1303), a Breton saint, dedicated himself to protecting poor persons; Patron of lawyers. He may be represented in a furred gown, or sometimes in ecclesiastical costume. The costume here may seem suggestive of ordinary civil costume, yet not entirely; an out-of-date appearance suggests rather that it is a professional dress, perhaps legal. There seems little or no reason to doubt that S. Ivo is shown, seated, studying a petition.

The false inscription was in lettering similar to that of an inscription (considered false) on a picture in the Rockefeller Collection, New York: q.v. The inscription there records as subject the Persian Sibyl. That picture is often claimed to be a portrait. Any association of the Persian Sibyl and S. Ivo is unexplained.

The picture here is from its presentation not acceptable as a portrait, although the features may record those of someone who made himself available to be used.

It has not been cut. It might be one panel of a group, but this on the whole is unlikely. There need be no original association with the Rockefeller picture.

It is a recent discovery. Attribution away from Rogier seems unimaginable: one of his great efforts. Probably mature work.

An article on it by the present writer was published in *The Burlington Magazine*, April 1971, pp. 177 f.

From the collection of Lady Baird, widow of Sir James Hozier Gardiner Baird, 9th Bart. Acquired through Christie's by the National Gallery in 1971.

'The Edelheer Altarpiece': Louvain, S. Pierre; see under Rogier: Madrid 1.

LOUVAIN,
S. PIERRE

Diptych (?): The Virgin and Child; St. George and the Dragon

LUGANO
Plates 85–

The Virgin and Child; Lugano, Thyssen-Bornemisza Collection (Schloss Rohoncz Foundation).

St. George; Washington, National Gallery of Art

The Virgin and Child, $5\frac{1}{2} \times 4\frac{1}{8}$ in. (0.14 × 0.105 m.)

St. George, $5\frac{5}{8} \times 4\frac{1}{8}$ in. (0.143 × 0.105 m.).

In the *Virgin and Child*, the crowned Virgin is seated in what may be called a shrine; Christ is in a red robe. The six statues at the side of the shrine include David, and are claimed to be prophets; Birkmeyer in *The Art Bulletin*, 1962, p. 329 makes some suggestions for identifications. The scenes in relief are the Annunciation, Visitation, Nativity, Coronation, Adoration of the Kings, Resurrection and Pentecost. Iconographical comment by Panofsky, 1953, p. 146.

Beenken, 1951, p. 29, points out that the *St. George* is of the same size as the *Virgin and Child*, and suggests that they may have formed a diptych. Confirmation of this may be found in some published references to seals on the back, which for the *Virgin and Child* has caused ownership by Frederick the Great of Prussia to be claimed; if the seals are found to be identical, original association would be strongly supported.

The style of the two pictures, also, may sufficiently accord. In the view of the present writer these pictures, with which a diptych (Vienna 1) can be stylistically grouped, may be immature originals by Rogier. Admittedly there is a gap between them and masterpieces (believed to be early works of Rogier) such as the *Deposition* in the Prado (Madrid 1) and the *Portrait of a Woman* (Berlin 2). Yet great skill is manifest in the two pictures under discussion; maybe

Rogier's skill developed early, his own fire breaking out a little later—and this might accord with an attribution of strong talent to his master Campin. But too little is known for any certainty; and I do not think it excluded that these two pictures are by a painter (or two?) separate from Rogier and from Campin.

The attribution has indeed been questioned, though usually the *Virgin and Child* is accepted as Rogier's. Friedländer, 1967, nos. 8, 130, accepts both (with different dating). Panofsky, 1953, pp. 425–6, does not accept that the *St. George* is by either Campin or by Rogier. (It has been presented on occasions as by Hubert van Eyck.)

The *Virgin and Child* is from a seal on the back claimed to have been owned by Frederick the Great of Prussia (Passavant, *Kunstreise durch England und Belgien*, 1833, pp. 94–5). Coll. Karl Aders, a German merchant living in London; Passavant says that he acquired it in Paris. Samuel Rogers; Thomas Baring; Earl of Northbrook.

The *St. George* has on the back, in XVI (?) century writing, *A°(?)7./Videatur et pondere-/tur ab arte reperitis*. General de Plaoutine, St. Petersburg, some years before 1902 (see *The Fortnightly Review*, October 1902, p. 598). He married a cousin of Lady Evelyn Mason, mother of Mrs. L. A. Impey, in whose sale at Sotheby's, 16 March 1966 (lot 1); see the entry.

Friedländer, 1967, nos. 8, 130
Panofsky, 1953, index (Lugano; London, Lady Evelyn Mason, under Master of Flémalle).

Portrait of a Man

LUGANO 2
Plate 113

Lugano, Thyssen-Bornemisza Collection (Schloss Rohoncz Foundation)
12½ × 10¼ in. (0.32 × 0.26 m.).

Friedländer, 1967, under no. 110, rightly rejects a suggestion that it formed a diptych with the *Virgin and Child* formerly at Donaueschingen (q.v.).

The sitter has been identified as Pierre de Bauffremont, Comte de Charny, died *c.* 1472, on comparison with a drawing where the name is inscribed (presumably on good grounds) in the Recueil d'Arras. This is a collection of portrait drawings, many after earlier pictures etc., attributed to Jacques Leboucq, died 1573 (cf. the exhibition catalogue *Le Siècle de Bourgogne*, Brussels, 1951, no. 52); the drawing in question is reproduced in the Prussian *Jahrbuch*, 1926, p. 18, and by Winkler, 1913, fig. 27. Pierre de Bauffremont was admitted into the Order of the Golden

Fleece in 1430, and is not shown wearing the Collar of that Order; the identification is therefore excluded. Some critics have found him in other pictures (see for instance Rogier: Frankfurt).

The attribution is accepted by Friedländer, 1967, no. 32, and generally. Not very early work.

Coll. Richard von Kaufmann, Berlin; exhibited at Berlin, 1898 (no. 44); Catalogue of the Collection, 1901 (no. 1); Sale, Berlin, 4 sqq. December 1917 (lot 67). Dr. Wendland, Basle. Entry in the exhibition catalogue *Collectie Thyssen-Bornemisza (Schloss Rohoncz)*, Rotterdam, 1959–60 (no. 77).

Friedländer, 1967, no. 32
Panofsky, 1953, index.

The Deposition from the Cross

MADRID 1
Plates 1–9
Fig. 18

Museo del Prado, Madrid (on deposit from the Escorial)
86½ × 103 in. (2.20 × 2.62 m.).

The pose of the fainting Virgin echoes that of Christ; for an interpretation of this, see Otto G. von Simson 'Compassio and Co-Redemptio in Rogier van der Weyden's Descent from the Cross' in *The Art Bulletin*, 1953, pp. 9 f. She is assisted by St. John; two of the Marys behind. St. Mary Magdalene is on the extreme right (IHESVS MARIA on her belt). The two standing men are SS. Joseph of Arimathaea and Nicodemus. St. Joseph of Arimathaea is to be identified as the man on the left, superior for supporting Christ's body; concerning some traditional distinctions between the two, see for instance L. Réau, *Iconographie de l'Art Chrétien*, vol. II, part II, 1957, pp. 957, 515 and vol. III, part II, pp. 760 f., p. 975. For a comment on the man standing close to the Magdalen and the servant on the ladder, see Otto G. von Simson in *The Art Bulletin*, 1953, p. 10. The man holds a pot, possibly the Magdalen's pot, her hands being clasped in grief. This pot may well be not merely her normal emblem, but a pot of ointment for embalming Christ's body. (The Magdalen is shown anointing one of Christ's feet in a *Deposition* assigned to G. David in the National Gallery; see Corpus, *London*, vol. I, 1953, no. 41, p. 89 and plates CC, CCVIII.) The servant holds two Nails. On the ground is a skull, by tradition that of Adam, for Golgotha. Apart from this natural ground, the scene is set in a gilt niche.

The raised central part of the picture would not be in disaccord with the belief that this picture originally had shutters; cf. out of many examples of varied arrangement, Rogier's altarpiece at Beaune (q.v.; Friedländer, 1967, plate Fig. 11

23). In an inventory of the Escorial of 1574, two shutters are indeed recorded, the paintings on the insides of which are assigned to Rogier like the *Deposition* itself; the subjects are noted as the four Evangelists with appropriate texts and the Resurrection, the presentation being unclear. No such shutters are now known to exist.

This picture, clearly identifiable, is mentioned as by Rogier in the Escorial inventory of 1574, which is quoted later, under the provenance; it is thereby the best authenticated picture by Rogier, main basis of attribution of any picture to him. Some further support for the attribution is provided in an engraving by Cornelis Cort, 1565, where the design of the figures with little variation is set in a landscape; the print bears the inscription *M. Rogerij Belgiae inuentum* (J. C. J. Bierens de Haan, *L'Oeuvre Gravé de Cornelis Cort*, 1948, no. 90). Yet further support is given by Molanus, the historian of Louvain, writing about 1570; see the provenance, and among copies and derivations the Edelheer triptych in S. Pierre at Louvain, where the central panel is a fairly accurate copy. Molanus mentions both pictures as by Rogier of Louvain, a local confusion (one should believe) for Rogier van der Weyden.

Writers on Rogier in the past have sometimes been uncertain on one point, whether the version now in the Prado (from the Escorial) is the original; but the provenance of this version, famous from fairly early times in literary references and from copies and derivations, leaves no room for doubt about this. In our present state of knowledge, neither the attribution of the composition to Rogier, nor the attribution of this version to his hand, ought to be questioned. Friedländer, 1967, no. 3. It is noted that Mojmír S. Frinta, *The Genius of Robert Campin*, 1966, pp. 82 f., attempts to introduce an association with Campin. Friedländer, when he inclined to amalgamate Rogier and Campin, particularly compared this picture with the *Thief* at Frankfurt; see an adverse comment in the entry for that picture (Campin: Frankfurt 1).

The date is to be considered earlier than 1443, which is the date on the already mentioned Edelheer triptych in S. Pierre at Louvain.

The composition shows connections with another of related subject, often believed also to be Rogier's; see under Various Collections 1 (drawing in the Louvre, sculpture at Detroit). There has been speculation (with little precise to go on) whether the picture at Madrid is Rogier's first attempt, or at least first major attempt at depicting the theme.

Campin's *Deposition*, as known from a copy at Liverpool

(Plate 133), may be thought connected, though not precisely; for it, see Campin: Frankfurt 1.

There are old records that, when Mary of Hungary obtained the original (see the provenance), a copy by Michael Coxcie (1499–1592) was substituted in the church at Louvain from which the original came; since this links up with the identification of the original, the difficult subject of Coxcie copies is confronted first. Coxcie may have painted more than one copy.

A copy, no painter's name given, is reported to have taken the place of the original at Louvain on Mary of Hungary's orders by 1548; see S. Sulzberger, 'La descente de croix de Rogier van der Weyden' in *Oud-Holland*, 1963, p. 150. It should not be doubted that the original referred to is Rogier's original *Deposition* on this design; and it is reasonable to believe that the copy referred to is identical with a Coxcie substitute copy later recorded by Molanus and van Mander. Molanus, the historian of Louvain, writing about 1570, says that Mary of Hungary gave a copy by Coxcie in place of Rogier's original for the altar at Louvain (Sulzberger, *loc. cit.*; Folie, 1963, p. 209). Carel van Mander, *Het Schilder-Boeck*, 1604, records a Coxcie copy received at Louvain in place of the original (Folie, 1963, p. 209).

Coxcie's copy at Louvain seems later to have gone, like the original, to Spain; but the circumstances are obscure.

A copy by Coxcie of a picture assumed to be Rogier's *Deposition* (though the text does not mention Rogier's name, subject mentioned) is referred to as ready to be sent to Philip II in a letter from Cardinal Granvella to Gonzalo Pérez, 28 December 1563; Narciso Sentenach y Cabañas, *La Pintura in Madrid*, 1907, pp. 23–4.

In 1564, an inventory of the Palace of El Pardo at Madrid records a picture that seems likely to have been the original (see the provenance); *Archivo Español de Arte y Arqueología*, 1934, p. 69. But this has been assumed to be a copy by Coxcie. It is indeed clear that by 1582 a copy of the original (which was then in the Escorial) was in El Pardo; see Argote de Molina, *Libro de la Montería*, etc., 1582, as quoted by Roblot-Delondre in the *Revue Archéologique*, vol. for July–December 1910, p. 56. The transfer of the original from El Pardo to the Escorial had taken place shortly (?) before 1566 or 1576; see the provenance.

In 1567, Antonio Pupiler was sent by Philip II for nine months to Flanders, to copy an altarpiece at Louvain of undescribed subject; the altarpiece in question might have been Coxcie's copy, substituting the original at Louvain. See *Archivo Español de Arte y Arqueología*, 1932, pp. 278–9.

A (or the ?) copy by Coxcie is claimed to have been paid

for, on instructions from Philip II to the Duke of Alba, 18 November 1569; see the Prado Catalogue, 1963, p. 781, or more at length 1933, pp. 397-8.

This payment is applied to a copy belonging to the Prado, the provenance of which is claimed or established in Madrazo's Prado Catalogues, e.g. that (in French), 1913, p. 379 or better 1920, p. 370.

The picture belonging to the Prado, identified as a copy by Coxcie, was sent to the Escorial (now Nuevos Museos there) in exchange for the deposit of the original from the Escorial in 1939. It is well executed, recognizably in a style later than Rogier's.

Next after this account of copying by or associated with Coxcie, the Edelheer triptych in S. Pierre at Louvain is recorded. This is mentioned together with the original as by Rogier of Louvain by Molanus, the historian of Louvain writing about 1570 (Folie, 1963, p. 209). The central panel follows the original quite closely on a reduced scale; it is not acceptable as by Rogier, but is important for the date of 1443 on it. Cf. E. van Even in the *Messager des Sciences Historiques*, 1866, pp. 43 f. On the outside of a shutter is a representation of *The Trinity* (Fig. 16), related in composition to a picture in the Louvain Museum (see Campin: Louvain); see also *The Trinity* at Frankfurt (Campin: Frankfurt 2) and Leningrad (q.v., Campin). The Edelheer triptych has been grouped stylistically with some existing pictures; see *The Exhumation of St. Hubert* (Rogier: London 2).

An engraving of the figures in a different setting (Plate 134) is assigned to the Master of the Banderoles, supposed to have been active ca. 1450-70. Confusingly and confusedly the two Thieves are added, still on their crosses; these are connected with a composition assigned to Campin, from which one Thief—but not included in the material used by the engraver—survives in the original at Frankfurt (Campin: Frankfurt 1). The engraving by Cornelis Cort, 1565, has been mentioned already, in connection with attribution. These two prints are reproduced in Friedländer, 1967, plate 10.

Among painted copies of Rogier's picture, one at Berlin-Dahlem is recorded to bear the date 1488; the authenticity of this date is doubted in the Berlin Catalogue, 1931. Besides the above-mentioned copy assigned to Coxcie (now deposited in the Escorial), the Prado at Madrid owns another copy, no. 1894 of the catalogue. Other painted copies are listed by Friedländer, 1967, under his no. 3.

The Magdalen was frequently copied; e.g. a painted example at Dresden introduced into a Crucifixion otherwise dependent on the triptych at Vienna (Vienna 2); a drawing at Coburg (Sonkes, 1969, B 13). The figure is closely related to another in a composition already referred to, occurring in a drawing in the Louvre and in sculpture (see Various Collections 1).

Two small wooden sculpture groups at Baltimore are taken from figures in this composition; see Robert A. Koch in the *Journal of the Walters Art Gallery*, vol. XI, 1948, pp. 39 f.

A picture clearly dependent loosely on this design is the centre panel of the Oultremont Triptych assigned to Mostaert, at Brussels; Friedländer, *Die Altniederländische Malerei*, vol. X, 1932, plate 1.

A derivative variant, mostly based on this picture but with one figure from the *Lamentation* at The Hague (q.v.), is acceptably by the Master of St. Bartholomew, in the Louvre (Fig. 5); entry for it in the exhibition catalogue *Des Maîtres de Cologne à Albert Dürer*, Paris, 1950, no. 54. A picture at Niederwaroldern, dated 1519, has reminiscences of this picture, as well as of the *Thief* at Frankfurt and the Riggisberg Triptych (Campin: Frankfurt 1 and Rogier: Riggisberg); see Medding in the *Zeitschrift für Kunstgeschichte*, 1938, pp. 119 f.

This picture, according to various old records noted in their place, was the property of the Crossbowmen's Guild in their Chapel in Notre Dame hors ville at Louvain; hanging from the tracery of the niche in the main corners right and left top are very small crossbows.

The earliest known reference to it, clearly acceptable although no painter's name is given (but subject mentioned), is in an account of the journey of Prince Philip (i.e. King Philip II of Spain) to the Low Countries in 1548, by Vicente Alvarez; the reference is given and discussed by S. Sulzberger in *Oud-Holland*, 1963, pp. 150-1. The picture was then in the chapel of Mary of Hungary's castle at Binche, and is recorded to have come from Louvain. Mary of Hungary, Regent of the Netherlands, died in 1558. The original, as having been at Louvain, is recorded by Molanus, the historian of Louvain, about 1570: 'Magister Rogerius, civis et pictor Lovaniensis, depinxit Lovanii . . . in capella beatae Mariae summum altare, quod opus Maria regina Sagitariis impetravit, et in Hispanias vehi curavit . . .' (Folie, 1963, p. 209). Molanus goes on to report that the picture perished at sea en route, but this is denied by Carel van Mander, *Het Schilder-Boeck*, 1604 (Folie, 1963, p. 209), who adds identifying detail; a still later reference to the picture is made by Opmeer, quoted for instance by Piot in the *Revue d'Histoire et d'Archéologie*, vol. III, 1862, pp. 198-9.

The original had been sent to Spain not very long after the mention of it at Binche in 1548. It was sent by Mary of Hungary (died 1558) to her nephew, meaning King Philip II of Spain, according to Argote de Molina, *Libro de la Montería*, etc. 1582, as quoted by Roblot-Delondre in the *Revue Archéologique*, vol. for July–December 1910, p. 56.

The original was for a time in the Palace of El Pardo at Madrid. It is probably recorded there in an inventory of 1564 (subject stated; *Archivo Español*, 1934, p. 69), though this entry has been assumed to refer to a copy by Coxcie (which was in El Pardo by 1582; see the commentary above). That the original (subject stated) was in El Pardo for a time is shown from a memorandum from Philip II to his secretary Hoyo of 4 July 1566 (?)—date also given as 1576; see Narciso Sentenach y Cabañas, *La Pintura in Madrid*, 1907, pp. 41–2, repeated in Zarco Cuevas, *Pintores Españoles en San Lorenzo el Real de El Escorial*, 1931, pp. 29–30. The memorandum refers to the recent (?) transfer of the original from El Pardo to the Escorial; the picture was in need of attention, and was to await repair (strictly limited) by the painter Navarrete (El Mudo).

The original was given by Philip II to the Escorial in 1574, and the gift is thus recorded: 'Una tabla grande en que está pintado el Descendimiento de la cruz, con Nuestra Señora y otras ocho figuras, que tiene dos puertas, pintado en ellas por la parte de dentro los quatro Euangelistas con los dichos de cada vno con la Resurreción, de mano de Maestre Rogier, que solía ser de la Reyna María, pintadas por de fuera las puertas de mano de Juan Fernández Mudo, de negro y blanco, que tiene de alto la tabla de en medio, por lo que toca a la cruz que en ella está pintada, siete pies y de ancho diez pies escasos' (Folie, 1963, p. 208).

This entry of 1574, of prime importance for attribution to Rogier, is the first known record of shutters to the picture; no such shutters are now known to exist, but the picture's shape (raised at the centre) is not in disaccord with the belief that these were intended originally. The paintings on the insides of the shutters, the arrangement of which is unclear, are assigned to Rogier in the entry, Mudo's work being the grisailles on the outsides.

The original is twice recognizably recorded in the Escorial by José de Sigüenza writing in 1602 (*Historia de la Orden de San Gerónimo*, 1605). See F. J. Sánchez Cantón, *Fuentes Literarias para la Historia del Arte Español*, vol. I, 1923, p. 389 (where Mudo's paintings on the outsides of the shutters are noted as representing Prophets), and a passage omitted from the extracts in that volume, to be found in the 1907–8 edition of Sigüenza, vol. II, p. 635. Cf. also Carl

Justi in the *Zeitschrift für bildende Kunst*, 1886, pp. 97 f. Rogier's name is not mentioned by Sigüenza in either place.

The original remained in the Escorial until, after the exhibition of Spanish pictures at Geneva in 1939 owing to the civil war, on return to Spain in that year, it was deposited by order of the government in the Prado at Madrid.

A copy belonging to the Prado has been sent to the Escorial in exchange, as has been noted above.

Friedländer, 1967, no. 3
Panofsky, 1953, index.

The Virgin and Child in a Niche

MADRID
Plate 71

Madrid, Museo del Prado
$39\frac{1}{4} \times 20\frac{1}{2}$ in. (1.00 × 0.52 m.).

Seated in a niche, the Virgin holds the clothed Child, Who is toying with a book; an angel holds a crown above her head. It is not known if this picture always stood by itself. In the Prado Catálogo of 1963 it is recorded that an X-radiograph does not reveal landscape or architecture under the black part of the background within the niche.

Accepted by Friedländer, 1967, no. 132, and generally.

The design of the Virgin and Child is known in derivatives. Friedländer associates these mostly with the Master of the Embroidered Foliage; see Friedländer, 1967, nos. 132 a–d, and his Vol. IV, *Hugo van der Goes*, 1969, nos. 85, 85a, b. Some have Spanish connections; see the Prado Catalogue, 1963, entry for the original on pp. 780–1, no. 2722, and especially Robert A. Koch in the *Record of the Art Museum, Princeton University*, Vol. XXVI, no. 2, 1967, pp. 46 f. The angel here may be compared with the angels in the Triptych of the Virgin (see under Granada), though here there is no scroll.

It has been suggested that the picture is identical with one in the inventory after the death of the first Marqués de Leganés (D. Diego Felipe de Guzman), 1655, as by Maestro Rugier. This must refer to a square picture, each dimension a little less than a vara (83.6 cm.), which is finally excluded because the Virgin holding the Child is recorded to be crowned by *two* Angels. See the publication of the Leganés inventory by José López Navio in *Analecta Calasanctiana, Suplemento científico-literario de Revista Calasancia*, Año IV, 1962, p. 286 (p. 28 of the offprint), no. 378.

The Prado picture was acquired by Pedro Fernández-Durán at the Palacio de Boadilla, Madrid, in 1899 and bequeathed to the Prado in 1930.

Friedländer, 1967, no. 132
Panofsky, 1953, index.

Pietà: Madrid; see Rogier: London 3.

Portrait of a Man holding an Open Book
Maidenhead Thicket, Collection of the late Sir Thomas Merton
Picture surface of the front, 13⅜ × 9½ in. (0.34 × 0.24 m.).

In the original frame; on the reverse is painted a branch of holly. Presumably a portrait by itself.
On the frame, back and front, is the inscription *Je he ce que mord*. This has been variously translated; the suggestion by Panofsky (1953, pp. 477–8, note 5), *I hate that which I sting*, may be grammatically acceptable and is welcome as making sense.
It has been claimed that the sitter is Guillaume Fillastre, apparently a bastard, who had a distinguished ecclesiastical career and died in 1473. Thought to have been born ca. 1400, he was received into the Order of S. Benedict in childhood, and was made Prior of Sermaize in 1426. Doctor at Louvain University, 1436. He held various benefices, also secular posts; Abbot of S. Bertin; Bishop of Tournai. Panofsky, 1953, p. 477, on comparison with a miniature, notes that the head-dress in the picture is a doctor's hood. The identification has been made on comparison with a drawing apparently of a much older man in the Recueil d'Arras, f. 265; this is a collection of drawings, many after various original pictures, etc., attributed to Jacques Leboucq, died 1573 (see the exhibition catalogue, *Le Siècle de Bourgogne*, Brussels, 1951, no. 52). This identification of the sitter does not convince me. There does not appear to be evidence that Fillastre used the emblem or the motto shown in the picture.
Acceptable as rather early work by Rogier; Friedländer, 1967, no. 134; Alfred Scharf, *A Catalogue of Pictures and Drawings from the Collection of Sir Thomas Merton, F.R.S.*, 1950, no. XXXI.
From a dignitary of the church residing in the Evêché of Laval near Angers; Colnaghi; acquired by Sir Thomas Merton. Put on exhibition at the National Gallery in 1969, on loan from Lady Merton.

Friedländer, 1967, no. 134
Panofsky, 1953, index.

Triptych: **The Adoration of the Kings, The Annunciation, The Presentation** ('The Columba Altarpiece')
Munich, Alte Pinakothek

Central panel 54¼ × 60¼ in. (1.38 × 1.53 m.); wings, each 54¼ × 27½ in. (1.38 × 0.70 m.).

In the Munich catalogue of 1936, it is recorded that there is marbled paint on the back. Panofsky, 1953, p. 475 (note 1 to p. 287) records that the man in the right middle distance of the central panel, who wears a turban and holds a hat, was at first shown bare-headed.
In the central compartment, a crucifix (flesh-coloured Christ) is shown fixed to the shed. On the outside of the building in the right middle distance are statues of Moses, David and another figure. The hollow in the foreground has been interpreted as a reference to the cave at Bethlehem, where according to ancient tradition the Birth took place; see G. von der Osten, 'Der Blick in die Geburtshöhle' in *Kölner Domblatt*, 23–4, 1964, pp. 341 f. (esp. p. 344) and 26–7, 1967, pp. 111 f.
The inscription in the Annunciation is AVE GRATIA, etc.; in the Presentation, NUNC DIMITTIS, etc. The Fall is seen on the Virgin's prie-dieu in the Annunciation. The interior architecture of the Presentation is Romanesque (only slightly tending to Gothic forms); the exterior is Gothic overlay—this is best seen in the already mentioned building visible on the right of the central panel.
The attribution to Rogier is generally accepted; Friedländer, 1967, no. 49. The origin is not established. The unidentified donor with a rosary is seen at the extreme left of the central panel. The picture was in a chapel in S. Columba's at Cologne and may have been there for a long time; but it may not have been commissioned for it—in particular, the (imprecise) dating of the chapel's foundation provides a difficulty (see the provenance further on). It appears considerably to have influenced several German painters, some of them of Cologne; so far as its date is concerned, the earliest sure, dated derivation may be in a picture by Herlin, 1462 (?), at Nördlingen (A. Stange, *Deutsche Malerei der Gotik*, vol. VIII, 1957, p. 89 and figs. 183–4). It should be noted in this connection that Herlin's *Annunciation* in an altarpiece of 1459 divided between the National Museum at Munich and the Städtisches Museum at Nördlingen, which shows influence from Rogier's style, need not depend precisely on the *Annunciation* here. (Reproduced in the Munich *Jahrbuch*, 1923, p. 3.)
In the central panel, Rogier shows an Adoration of the Kings with the Virgin central (or nearly). He may for this

have been influenced by the prominent example of the Cologne Dombild by Stefan Lochner (d. 1451). Panofsky, 1953, p. 286, thinks that the King on the right is modelled on Charles the Bold (for a portrait of him, see Berlin 5). The view of a town in the left background of the central panel corresponds fairly closely (though with numerous variations of detail) with what is seen in the Bladelin altarpiece at Berlin (Berlin 4: q.v.). The two dogs seen in the central and right panels recur several times, in particular in the *Seven Sacraments* at Antwerp (Antwerp 2); the greyhound also in a derivative from the left wing of the Bladelin altarpiece in East Berlin (Friedländer, 1967, plate 133; mentioned under Rogier: Berlin 4). One or both these dogs recur in pictures assigned to the Master of the Legend of St. Catherine at Bruges, Geneva (private collection) and Melbourne; Friedländer, *Early Netherlandish Painting*, vol. IV, *Hugo van der Goes*, 1969, nos. 47, 48, 49, with reproductions. The considerable influence of this picture on German painting has been mentioned; it is outside the scope of this entry to make a list. Particular effect on Memlinc here receives some comment. Two triptychs with *The Adoration of the Kings* in the central panel, accepted as characteristic Memlincs, in the Hospital at Bruges and in the Prado at Madrid (Fig 8), seem clearly to show extensive influence from this picture; Friedländer, vol. VI (Part I), *Hans Memlinc and Gerard David*, 1971, nos. 1, 2. It may in particular be mentioned that the peculiarity in Rogier's picture of a man wearing a turban and holding a hat (not always so; see the comment near the beginning of this entry) seems to have been taken over by Memlinc in his Prado picture, in a figure at the extreme left of his central panel. Three other pictures also showing such influence have been associated together and with the youthful Memlinc. One of them, *The Presentation*, passed from the Czernin Collection at Vienna to the National Gallery of Art, Washington; Friedländer, 1967, no. 85 and plate 106. For more about these, see Hulin in *The Burlington Magazine*, vol. LII, 1928, pp. 160 f. and Friedländer, vol. VI *cit.*, no. 99. It is to be remarked that attribution to the young Memlinc needs reconsideration since the fairly recent proof that the Donne triptych now in the National Gallery, London, assigned to him, need not be a very early work; see National Gallery Catalogues, *Early Netherlandish School*, 3rd edition, 1968, pp. 125 f.

The *Presentation* was also imitated in a picture in the Bargello at Florence, in which also there is an imitation of *The Annunciation* at New York (New York 3); Friedländer, *Early Netherlandish Painting*, vol. IV, *Hugo van der Goes*, 1969,

No. 52, with reproduction, as Master of the Legend of St. Catherine. Sonkes, 1969, records a drawing after the Annunciation here at Stockholm (Sonkes B 1), one after the angel here at Berlin assigned to the Master of the Coburg Roundels (B 2), and one believed to be freely after the Virgin on this wing, which has been attributed to the same hand (B 3); also a drawing at Stockholm derived from the Presentation, assigned to Burgkmair (B 10).

The triptych at Munich was in a chapel in S. Columba's, Cologne, though it may not have been painted for it. From the view of a town in the central panel, already mentioned as related to part of the background of the Bladelin altarpiece (Berlin 4), the unlikely claim has been made that it was commissioned by Pierre Bladelin. The chapel is stated to have been founded by Goedert von der Wasservass; E. Firmenich-Richartz, *Die Brüder Boisserée*, vol. I, *Sulpiz und Melchior Boisserée als Kunstsammler*, 1916, p. 456, gives dates of 1489 or 1493 for the foundation, but O. H. Förster, *Kölner Kunstsammler*, 1931, p. 11, prefers earlier.

Its presence in Cologne fairly soon after its painting may reasonably be deduced from some stained-glass in Cologne cathedral, where there are recognizably derivations, reproduced in Friedländer, 1967, plate 70; this glass is dated 1508 (see H. Oidtmann, *Die Rheinischen Glasmalereien*, vol. II, 1929, pp. 360 f.).

Obtained by the Boisserée brothers from S. Columba's in 1808 (Firmenich-Richartz, *loc. cit.*). Acquired with the Boisserée Collection in 1827 for the Munich Gallery.

Friedländer, 1967, nos. 49; 85
Panofsky, 1953, index.

The Deposition
Munich, Alte Pinakothek

MUNICH
Plate 118

There is a painted example of this design in a small picture at Munich (Friedländer, 1967, no. 95, plate 111; $22\frac{1}{2} \times 20\frac{1}{2}$ in., 0.57×0.52 m.). See also a drawing at Nuremberg; Sonkes, 1969, no. C 22.

Friedländer, 1967, no. 95, thinks the Munich picture a good workshop product. Panofsky, 1953, p. 465, reasonably doubts if the design was invented by Rogier himself.

The composition or some of its elements, nevertheless, appear to have been well known. See the long discussion by Winkler, 1913, pp. 89 f., with references to motifs more or less closely recurring elsewhere, especially in German painting. To be added, that the figure of the Mary at the extreme left corresponds fairly closely with the figure of the

Virgin in the triptych of *The Crucifixion* at Riggisberg (q.v.). The Munich picture was obtained in 1803 from Freising.

Friedländer, 1967, no. 95
Panofsky, 1953, index.

St. Luke Drawing a Portrait of the Virgin: Munich, Alte Pinakothek; see Rogier: Boston.

YORK I **Francesco d'Este**
S III–12 New York, The Metropolitan Museum of Art
11¾×8 in. (0.30×0.205 m.).

Presumably a portrait by itself.
The sitter, who used wrongly to be called Lionello or Meliaduse d'Este, is identified from the arms and inscriptions painted on the back of the picture. The arms are those adopted by Este since 1432. The crest seems to be a blindfold lynx, which is associated with Lionello d'Este. The inscriptions are *m e* (Marchio Estensis), twice; *voir (?) tout* and (apparently later) *non plus courcelles*, neither explained; and *francisque*, prominently.
The last permitted E. Kantorowicz in the *Journal of the Warburg and Courtauld Institutes*, vol. III, 1940, pp. 165 f., to identify the sitter with certainty. Francesco d'Este was an illegitimate son of Lionello d'Este. He was sent in 1444, perhaps aged 14 or 15, to be educated at the court of Brussels. He lived mostly in Flanders, and was still alive in 1475.
The attribution is accepted by Friedländer, 1967, no. 23. Beenken, 1951, pp. 72 f., finding some things strange for Rogier, inclines to follow a suggestion previously made and postulate intervention by Zanetto Bugatto, a Milanese (?) who was working under Rogier ca. 1460–3 (see the biographical data). But there seems to the present writer no good reason for dissociating the picture from Rogier or for associating it with Italy. In particular, the sitter's life in Flanders leaves as pure hypothesis a claim that has been made, that it was painted at Ferrara.
The sitter holds a ring; also a hammer, perhaps associated with him for some governing status (see Kantorowicz in the *Warburg Journal*, 1940, pp. 176–7). It has been remarked that, unusually, the background is light; cf. the portrait supposed to be of Robert de Masmines (Campin: Berlin 2.) In the collection of Sir Audley Neeld; sold 1909. Sir Edgar Speyer; exhibited at the Grafton Galleries, London, 1911 (no. 90). Passed from England to Michael Friedsam, New York; bequeathed to the Metropolitan Museum, 1931.

Friedländer, 1967, no. 23
Panofsky, 1953, index.

The Holy Family, and a Donor introduced by St. Paul NEW YORK 2
New York, The Metropolitan Museum of Art
22½×19 in. (0.57×0.48 m.).

In a very bad state of preservation.
The Holy Family is here grouped in a landscape as if for a Rest on the Flight into Egypt. The motif of the Infant Christ's holding a Cross, which an angel helps him to support, is of clear meaning; it occurs in other works, perhaps in imitation of this picture, e.g. Friedländer, 1967, plate 64 (no. 40A, b). The attitude of the Christ somewhat resembles that in the drawing at Stockholm recording the central part of the altarpiece from which the *Magdalen Reading* is the principal surviving fragment (see Rogier: London 1).
Despite its condition, Friedländer, 1967, no. 40A, was clear for Rogier. Very often rejected, e.g. by Panofsky, 1953, p. 482. In the 1947 Catalogue of the Metropolitan Museum as by a Follower.
Stated to be from the Guicciardi Collection, Milan. Collection Cristoforo Benigno Crespi, Milan; Sale, Paris, 4 June 1914 (lot 96). Apparently on the market until acquired by Michael Friedsam, 1927; bequeathed by him to the Museum, 1931.

Friedländer, 1967, no. 40A; plate 64
Panofsky, 1953, index.

The Annunciation NEW YORK 3
New York, The Metropolitan Museum of Art
73¼×45¼ in. (1.86×1.15 m.).

Left wing from an altarpiece (?).
Seen through the window is the *Hortus Conclusus*.
The arms, which appear in the window and (vulgarly) on the carpet on which the Virgin kneels, are those of the Clugny family of Autun. The prominent Ferry de Clugny, b. 1410, had ecclesiastical positions at Autun; in 1472 he was made chancellor of the Order of the Golden Fleece and Bishop of Tournai; Cardinal, 1480; d. 1483. Alternatively, his brother Guillaume might have commissioned the picture; he also had a Burgundian career, also ecclesiastical; made Bishop of Poitiers in 1479, he died in 1480. See the French Dictionary of National Biography.
Accepted by Friedländer, 1967, p. 69, no. 48, but rather

often ascribed to the studio. Panofsky, 1953, p. 482, thinks ca. 1470, possibly Memlinc; this suggestion deserves further study, especially now that the Donne triptych assigned to Memlinc is no longer fixed in date as not later than 1469. A drawing after the Virgin is at Weimar (Sonkes, No. B 4). A loose derivation occurs in a picture in the Bargello, Florence, where also there is a derivative from the *Presentation* in Rogier's Columba altarpiece (Munich 1). See Friedländer, *Early Netherlandish Painting*, vol. IV, *Hugo van der Goes*, 1969, no. 52, repr., as Master of the Legend of St. Catherine.

Earl of Ashburnham Collection, where Weale says he saw it in 1878 (*The Burlington Magazine*, vol. VII, 1905, p. 141). Rodolphe Kann, Paris. J. Pierpont Morgan, New York, who presented it to The Metropolitan Museum in 1917.

Friedländer, 1967, no. 48; plate 69
Panofsky, 1953, index.

<div style="margin-left:2em">NEW YORK 4
Plate 120</div>

Portrait of a Man in a Turban, with a Pink
New York, The Metropolitan Museum of Art (Bache Collection)
11 × 8 in. (0.28 × 0.20 m.).

Accepted by Friedländer, 1967, no. 135. Rejected by Beenken, 1951, p. 99; Panofsky, 1953, p. 478, says not acceptable. The attribution seems very doubtful.

J. Bruyn finds the same sitter in a miniature; and unconvincingly identifies him as the chronicler Enguerrand de Monstrelet (ca. 1390–1453), on comparison with a drawing in the Recueil d'Arras, a collection of portrait drawings attributed to Jacques Leboucq (d. 1573); see the *Miscellanea Jozef Duverger*, 1968, vol. I, pp. 92 f.

Apparently not recorded until 1929; *A Catalogue of Paintings in the Collection of Jules S. Bache*, 1929. From a collection in Holland; acquired from Duveen by Jules S. Bache; then to the Metropolitan Museum with the Bache Collection in 1949.

Friedländer, 1967, no. 135
Panofsky, 1953, index.

Christ Appearing to His Mother after the Resurrection:
New York, The Metropolitan Museum of Art; see Rogier: Granada.

NEW YORK, PANNWITZ **The Dream of Pope Sergius**: New York, von Pannwitz Collection; see Rogier: London 2.

A Lady
New York, Estate of the late Mrs. John D. Rockefeller, Jr.
18½ × 15 in. (0.47 × 0.38 m.).

Inscribed in the top left-hand corner PERSICA/SIBYLLA/.IA. It is often claimed that this inscription is not contemporary with the picture; the picture has not been examined by the present writer. The lettering of this inscription is at least very similar to that of a false inscription until recently on S. Ivo (?) (Rogier: London 5); it is not necessary to deduce that the two pictures were associated originally.

Many writers think that the picture does not represent the Persic Sibyl, but is a portrait. For the sibyls, listed with the Persic Sibyl first, see for instance J. J. M. Timmers, *Symboliek en Iconographie der Christelijke Kunst*, 1947, pp. 205 f. Various suggestions for a sitter have been made; see Panofsky, 1953, pp. 293–4. Isabella of Portugal is favoured. She, daughter of King John I of Portugal, was born in 1397; in 1430 she married as his third wife Philip the Good, Duke of Burgundy; she died in 1471. See for instance E. Michel, Louvre Catalogue, *Peintures Flamandes du XVᵉ et du XVIᵉ Siècle*, 1953, pp. 105 f.

The identification has been thought to receive support from a picture once at Batalha (q.v.), known only from a summary drawing of 1808, where Isabella has been identified and the presentation seems to be rather similar. See Sonkes, 1969, no. C 11.

The Rockefeller picture is accepted by Friedländer, 1967, no. 13.

What seems to be a copy of this picture appears in the central panel (The Multiplication of the Loaves and Fishes) of a triptych at Melbourne, assigned to the Master of the Legend of St. Catherine and other hands. Some figures in a wing of this triptych are recognizably based on known portraits. See the exhibition catalogue, *Primitifs Flamands Anonymes*, Bruges, 1969 (no. 45), and *The National Gallery of Victoria, Melbourne* (Corpus series), 1971, no. 131.

According to Reinach, *Répertoire*, vol. IV, p. 243, it was in the collection of Licio (*sic*) Odescalchi; this may be a confusion with lot 6 of the Nieuwenhuys sale of 1883 ('Ysenbrandt', no. 2585 of the National Gallery, London). The Rockefeller picture was lot 4 of that sale, C. J. Nieuwenhuys, at Brussels, 4 May 1883, as Jan van Eyck. Rothschild Collections at Paris; mentioned as belonging to Adolphe de Rothschild by Friedländer, in *Werk über die Renaissance-Ausstellung* (Berlin 1898), 1899, p. 7. New York, Mrs. John D. Rockefeller Jr.; in the exhibitions of Flemish Art at the

Royal Academy, London, 1927 (no. 29) and of *Flemish Primitives* at Knoedler's, New York, 1942, p. 26 of the catalogue.

Friedländer, 1967, no. 13
Panofsky, 1953, index.

Portrait of a Man
New York, Wildenstein (formerly ?)
13 × 8½ in. (0.33 × 0.215 m.).
There is on the back a coat of arms with the initials E.S; this may be difficult to interpret, but would seem deserving of research. Accepted by Beenken, 1951, p. 106 and plate 114, as an early Rogier.
This striking picture may be acceptable as an early work by Rogier and may be associable stylistically with Sir Thomas Merton's portrait (see Rogier: Maidenhead). They can be seen as rather immature, pointing towards Rogier's developed style. If so, I do not think that a work such as the *Thief* (Campin: Frankfurt 1) can be Rogier's creation, whatever guesses at dates may be made. See also the comment on the small pictures at Vienna, Lugano and Washington (Rogier: Vienna 1 and Lugano 1).
5th Earl of Malmesbury (Hurn Court) Sale at Christies,' 3 November 1950 (lot 14).

Panofsky, 1953, index (whereabouts unknown).

Triptych: **Christ, The Virgin and Saints at Half-Length**
Paris, Musée du Louvre
Front: central panel, 13¼ × 24½ in. (0.335 × 0.62 m.); wings, each, 13¼ × 10⅝ in. (0.335 × 0.27 m.); including the original framing, central panel, 16¼ × 26¾ in. (0.41 × 0.68 m.); wings, each, 16¼ × 13⅝ in. (0.41 × 0.345 m.).
X-radiographs given by M. Hours in the *Bulletin du Laboratoire du Musée du Louvre*, October 1957, figs. 12 and 14 and pp. 31, 32, and Mojmír S. Frinta, *The Genius of Robert Campin*, 1966, fig. 51.

The central panel shows Christ between the Virgin and St. John the Evangelist. Left wing, St. John the Baptist, with the Baptism of Christ in the background. R. wing, the Magdalen. The main figures are associated with inscriptions from the Bible: John VI, 51, for Christ; Luke I, 46–7, for the Virgin; John I, 14, for St. John the Evangelist; John I, 29, for the Baptist; John XII, 3, for the Magdalen. The reverses of the wings are painted, and provide information concerning the origin of the picture. Elaborate

accounts of this picture are given by Paul Leprieur in the *Gazette des Beaux-Arts*, 1913, vol. II, pp. 257 f., and in the Louvre catalogue by E. Michel, *Peintures Flamandes du XVe et du XVIe Siècle*, 1953, pp. 275 f.
On the reverse of the left wing are a skull on a partly broken brick; arms of Braque. On the reverse of the right wing, a cross; arms (female shield) of Braque and Brabant. Cf. comment by Leprieur, pp. 263–4.
On the reverse of the left wing is also an inscription:
MIREZ-VOUS SI ORGUEILLEUX ET AVERS*
MON CORPS FU BEAUX ORE EST VIANDE À (VERS).
 *(AVERS = AVARES).
On the reverse of the right wing is inscribed a quotation from Ecclesiasticus, XLI, 1–2; but giving . . . homini injusto et pacem habenti . . .; for the addition of the words *injusto et*, see Leprieur, pp. 262–3, note 3, or Michel. There are only small remains of an inscription *Bracque et Brabant*, given by Waagen, *Treasures of Art*, 1854, vol. II, p. 162.
What has been recorded clearly associates the commissioning of the picture with Jehan Braque of Tournai (d. 25 June 1452) and the wife he married in 1451 or just before, Catherine de Brabant; these seem the only possible identifications. Catherine de Brabant survived her husband for many years, and in her will of 1497 mentions what must be this picture, as is confirmed from subsequent provenance. There is thus evidence for dating the picture with some precision. It may indeed be wrong to associate the commission with Jehan Braque himself, and therefore date it 1451–2. It may rather be a memorial picture ordered by his widow; the skull and funereal inscription, indeed the absence of portraits, suggest this. If so, it is unlikely that the commission—or possibly completion of the picture with modifications if Jehan Braque had ordered it during his lifetime—would indicate a date much after 1452.
Generally accepted as by Rogier; Friedländer, 1967, no. 26. The Virgin, to a less extent Christ and (for the types) the two SS. John show similarity to those figures in the *Last Judgement* at Beaune (q.v.); that picture is datable almost certainly not earlier than 1443, and most probably not later than 1451.
Some derived drawings are known. Two of the Magdalen are in the British Museum (Sonkes, 1969, B 23, 24). Friedländer, 1967, pp. 48 f. and plate 48, reasonably thinks that the better one, in his view possibly by Rogier, was done from the painting. St. John the Evangelist with a different head at Coburg (Sonkes, 1969, C 31): the Baptist at Munich (Sonkes, 1969, B 22). A drawing of *Christ Blessing* at Florence, accepted as by Schongauer, shows some relationship; it has

been thought to have been copied from the Christ here, or from a picture ex-Hoschek now at Greenville (Friedländer, 1967, no. 124a, plate 126), or from some related Rogieresque design (Sonkes, 1969, C 30).

The picture is recorded with descendants of the Braque family, last some time after 1586; for details, see Michel's Louvre catalogue. Claimed to have been imported from Flanders, acquired at a sale by a priest, from whom (in the north of England) acquired by Evans, London, who owned it in 1845. See *Le Beffroi*, vol. I, 1863, p. 64. He sold it to the Marquis of Westminster; passed to Lady Theodora Guest, a daughter, and sister of the 1st Duke of Westminster. Acquired from Kleinberger by the Louvre in 1913.

Friedländer, 1967, no. 26
Panofsky, 1953, index.

PARIS 2 **Portrait of Jean Duke of Cleves** (?)
Paris, Musée du Louvre
$19\frac{1}{2} \times 12\frac{3}{4}$ in. (0.495 × 0.325 m.).

From its presentation, presumably the right wing of a diptych.

Traditionally John I, Duke of Cleves and Count de la Marck (b. 1419, much in Flanders, d. 1481). The sitter wears the collar of the Golden Fleece, which this Duke of Cleves obtained in 1451.

Published by Conway in *The Burlington Magazine*, vol. XL, 1922, pp. 213 f. as a copy after a lost Rogier; he compared it with Philippe de Croy at Antwerp (see Rogier: San Marino). Friedländer, 1967, no. 126, agrees with this. See also E. Michel, Louvre Catalogue, *Peintures Flamandes du XV^e et du XVI^e Siècle*, 1953, pp. 281 f., and the catalogue of the Bruges *Toison d'Or* exhibition, 1962 (no. 27).

Probably bequeathed by Joseph Van Praet (1754–1837) to the Bibliothèque Nationale at Paris; on loan thence to the Louvre since 1943.

Friedländer, 1967, no. 126; plate 128
Panofsky, 1953, index.

The Annunciation: Paris, Musée du Louvre; see Rogier: Turin.

The Deposition (drawing): Paris, Musée du Louvre; see Rogier: Various Collections 1.

PARIS, **Bust of a Woman**: Paris, Rothschild Collection; see
ROTHSCHILD Rogier: Turin.

Two Fragments: **The Annunciate Virgin; A Donor with** PETWORTH
St. James
Petworth (Sussex)
The Virgin, $26 \times 10\frac{1}{4}$ in. (0.66 × 0.26 m.); the Donor with St. James, $26 \times 15\frac{3}{4}$ in. (0.66 × 0.40 m.).

It is not clear how the two fragments were arranged; correspondence in the flooring does link them.

But it is clear that the Virgin is from an *Annunciation*. The design of the St. Gabriel seems to be preserved in a panel in the Staatliche Museen (Bode-Museum), East Berlin; this was acquired with the Solly Collection in 1821 (see various early Berlin catalogues, no. 555), and was for a time on deposit at Bonn (Bonn catalogue, 1927, no. 319). On the other side of this derivative at Berlin is painted a derivation from *Augustus and the Sibyl* in the Bladelin altarpiece (see Rogier: Berlin 4). A variation of the St. Gabriel is in the Germanisches Nationalmuseum at Nuremberg (Friedländer, 1967, no. 141). These two paintings are reproduced in Friedländer, 1967, plate 133. The pose of St. Gabriel corresponds very closely with that in the *Annunciation* in the Louvre (see under Rogier: Turin).

The two fragments at Petworth were ascribed to Rogier by Friedländer, 1967, no. 129. The style seems slight for Rogier himself. It may be against originality that the figure of St. Gabriel seems to have been a derivation from the *Annunciation* in the Louvre, itself a disputed attribution (see under Rogier: Turin). The Petworth fragments were rejected by Panofsky, 1953, p. 482.

The two fragments are recorded at Petworth as School of van Eyck, by Waagen, *Treasures*, vol. III, 1854, p. 39. The name of the former owners is Wyndham; titles Egremont and Leconfield are associated. Among the pictures at Petworth accepted by the Treasury in lieu of death duties; on loan there from the Treasury to the National Trust since 1957.

Friedländer, 1967, nos. 129, 141; plate 133
Panofsky, 1953, index (Petworth).

Two Panels: **Christ on the Cross, The Virgin Supported** PHILA-
by St. John DELPHIA
Philadelphia, John G. Johnson Collection Plates 89–
Each $70 \times 36\frac{1}{4}$ in. (1.78 × 0.92 m.).

The two panels go together, a corner of the Virgin's mantle being seen in the panel with *Christ on the Cross*.
Friedländer, 1967, no. 15, suggests that the two panels are

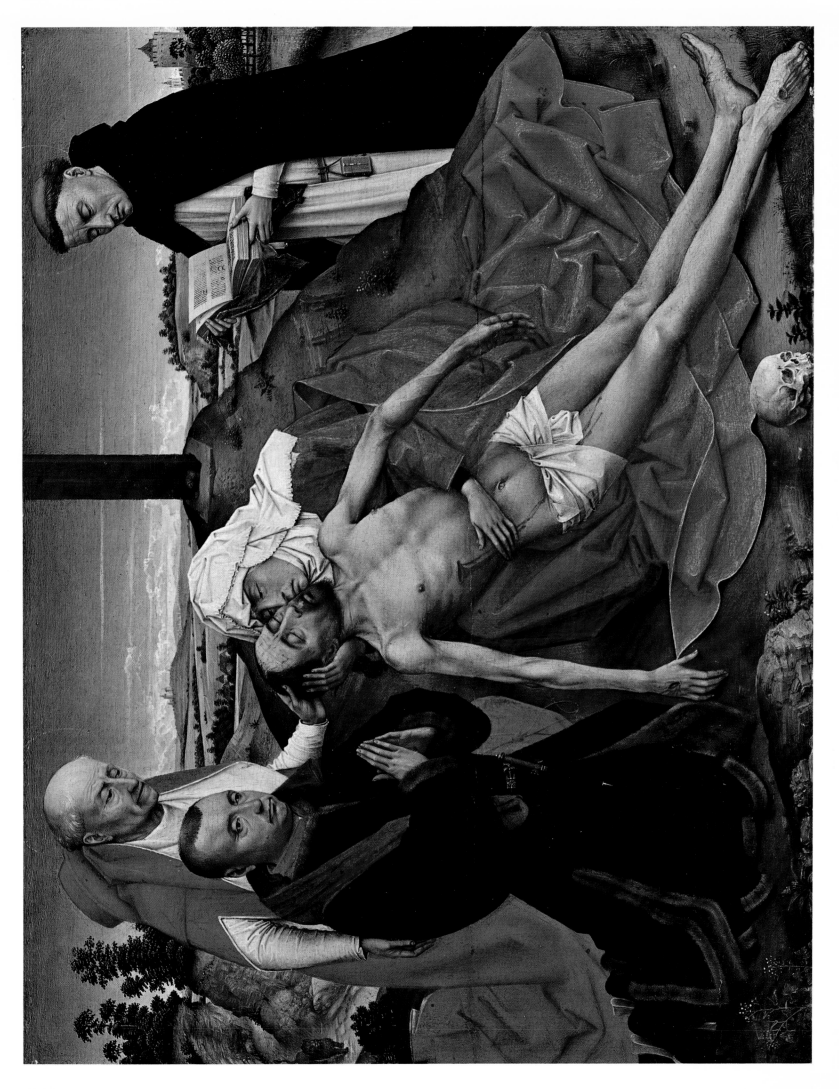

Pietà. London, National Gallery (Cat. Rogier, London 3)

the outsides of shutters of a triptych. They are painted mostly in grisaille except for the hangings, which are of a strong red; since cleaning, the gold backgrounds are seen. Panofsky, 1953, pp. 285 and 474, does not believe that they could have been outsides, or two parts of a triptych.

The presentation may reflect what could be seen in churches. Compare a miniature showing the interior of a chapel, where above the altar and against the back wall, and set off by a hanging, what are clearly statues of the Virgin and St. John stand on each side of a sculptured Christ on the Cross; this is a miniature in a Pontifical in the Teyler Foundation at Haarlem, assigned to Simon Marmion ca. 1455 by A. W. Byvanck, 'Les Principaux Manuscrits à Peintures conservés dans les Collections Publiques du Royaume des Pays-Bas' in the *Bulletin de la Société Française de Reproduction de Manuscrits à Peintures*, Year 15, 1931, pp. 25 f. and plate VIII.

Nevertheless, the reduction of the scene here to three figures is characteristic of Rogier's taste for abstracting to get at the essential; characteristic also, the retention of soil and rock (cf. Rogier: Madrid 1). The skull (and bone) here refer to Golgotha; it had become a tradition that the skull there was the skull of Adam.

Usually accepted; Friedländer, 1967, no. 15. Beenken, 1951, p. 100, says hardly autograph; on plates 106, 107, he contrasts the heads of Christ here and in the *Christ on the Cross* at the Escorial in support of his view.

E. P. Richardson in *The Art Quarterly*, 1939, pp. 57 f., wrongly suggested that these two pictures might have formed Rogier's Cambrai altarpiece (for which see the biographical data, 1455–9).

These two pictures are recognizably described in the catalogue of the Marquis de Salamanca Sale, Paris, 3–6 June 1867 (lots 165, 166), as from the Madrazo Collection; i.e. José de Madrazo (d. 1859), Madrid (*Catálogo*, 1856, nos. 659, 660); in both cases as Rogier (supposedly the younger painter of that name). Cf. Passavant, *Die Christliche Kunst in Spanien*, 1853, p. 133. They were acquired in 1906 (see John G. Johnson Collection, *Catalogue of Italian Paintings*, 1966, p. xii). Aline B. Saarinen, *The Proud Possessors*, 1959, p. 104, says that they were at Kleinberger's, Paris; the *Virgin with St. John* was bought by Johnson, *Christ on the Cross* by Widener, who ceded it a few months later to Johnson.

Friedländer, 1967, no. 15
Panofsky, 1953, index.

Triptych: **The Crucifixion, with a Donor**

Riggisberg, near Berne, Abegg-Stiftung

Central panel, $40 \times 27\frac{3}{4}$ in. (1.02×0.705 m.); wings, $40\frac{1}{2} \times 12\frac{1}{4}$ in. (1.03×0.31 m.) each.

On the central panel, Christ on the Cross, the Virgin, St. John, three Marys; the sun and moon prominent. On the right wing, SS. Joseph of Arimathaea and Nicodemus, and a man carrying a ladder for use in the Deposition. St. Joseph is to be identified as the figure to the left, from his type; see the figure identified as St. Joseph with commentary in the *Deposition* (Rogier: Madrid 1). On the left wing, the donor kneels in a portico, over the arch of which are small statues of the Annunciation. He wears a collar with a jewel that has been claimed to be that of the Order of the Porcupine; but Panofsky, 1953, p. 483, disputes this.

On stained glass behind him is a coat of arms under a crest. In 1880 the arms were identified as those of the Conti Pensa di Marsaglia; but the current identification as de Villa is satisfactory. Dr. Stettler kindly confirmed the colours; the arms do correspond with de Villa as given in Rietstap's *Armorial Général*, except that at Riggisberg the coat shows bends sinister. They may be compared with the arms (not bends sinister) seen in a triptych (?) mostly of the story of Job, assigned to the Masters of St. Catherine and of St. Barbara, at Cologne (Friedländer, *Early Netherlandish Painting*, vol. IV, *Hugo van der Goes*, 1969, no. 69, as ca. 1485–90; Bruges, Exhibition Catalogue, *Primitifs Flamands Anonymes*, 1969, no. 46; Cologne Catalogue, *Deutsche und Niederländische Gemälde bis 1550*, 1969, pp. 82 f.); there is some evidence other than the arms for associating this Cologne picture with the de Villa family. One should also cite the arms on the donor's panel of two wings of a triptych at Turin (q.v.); these are seen only in an X-radiograph, so the colours are unknown—they would show bends sinister if they are painted on the reverse.

The de Villa family of Piedmont had various connections with the Netherlands; Panofsky, 1953, p. 483, note 1, gives some references. The Riggisberg Triptych has been supposed to have been commissioned by Oberto de Villa, born ca. 1420–5 (?).

Tolnay is recorded to have suggested that the outsides of the wings are two grisailles of *Christ shown to the People*. They are in the Bob Jones University at Greenville; see the Catalogue, vol. II, 1962, nos. 109, 110; also the entry for them in the exhibition catalogue *Flanders in the Fifteenth Century*, Detroit, 1960, no. 11. The sizes are given as $36\frac{3}{4} \times 10\frac{3}{4}/11$ in. ($0.935 \times 0.275/28$ m.), which seems unsatisfactory.

These Greenville pictures correspond closely with two at Fiesole, ascribed to Vrancke van der Stockt; see Friedländer, 1967, no. 87 and plate 107 for reproductions of all four. The triptych now at Riggisberg, already ascribed to Rogier by Louis Gonse in the *Gazette des Beaux-Arts*, 1880, vol. II, p. 86, was published by Friedländer in *Pantheon*, 1933, pp. 7 f. and was included in his supplementary volume of 1937 (Friedländer, 1967, no. 131). Friedländer, 1967, p. 56, stressed Campinesque and Rogieresque reflections in this picture as an argument for amalgamating Campin and Rogier. It is true that the faces of St. Nicodemus and the man with a ladder in the triptych somewhat resemble those of the two spectators in Campin's fragment of *The Bad Thief* at Frankfurt (Campin: Frankfurt 1); the latter face corresponds, perhaps more, with the face of the negroid King in Rogier's Bladelin altarpiece (Berlin 4). The Christ in the Triptych corresponds closely with that in Rogier's *Crucifixion* (see Vienna 2). The upturned head of the Mary with raised arms in the triptych corresponds fairly well with that of one of Rogier's *Seven Sacraments* (Antwerp 2) except that in one the figure is violent, in the other calm. The type of St. Joseph of Arimathaea in the Triptych has already been compared, for identification of the person, with that of the figure in Rogier's *Deposition* (Madrid 1); the head of the figure in his picture at Florence (q.v.) may also be compared. The whole figure of St. John corresponds fairly well with the St. John in the *Deposition* at Madrid. The Virgin corresponds fairly closely with the Mary at the extreme left of a derivative *Deposition* at Munich (no. 2; q.v.). Use of such comparisons for the amalgamation of Campin and Rogier is weak for various critics who do not accept the Riggisberg Triptych as by Rogier's hand. In any case, repetition of motifs or details in pictures of the Early Netherlandish School does not prove identity of hand; it must have been a practice of the studios. Rogier himself appears clearly to have taken from Jan van Eyck (see under Boston).

The numerous correspondences listed above, and the nature of some of them may indeed suggest that the Riggisberg triptych, although diligently executed, is derivative work by an imitator. Beenken, 1951, pp. 34, 53, 100, who had not seen the original, is strongly inclined to reject; he unconvincingly associates the style with part of the triptych of which *The Annunciation* in the Louvre is the centre (see under Rogier: Turin). Panofsky, 1953, pp. 298 f., rejects, rightly specifying some of the things in it unsuitable for Rogier; he, more doubtfully, associates it with the hand of a *Crucifixion* at Berlin (Campin: Berlin 4).

Friedländer in *Pantheon*, 1933, p. 10, reproduces a partial derivation in the Novak Collection at Prague. The Mary furthest to the right in the Riggisberg Triptych recurs in a *Deposition* at Niederwaroldern; see Medding in the *Zeitschrift für Kunstgeschichte*, 1938, pp. 119 f. That picture also contains derivations from Rogier (Madrid 1) and Campin (Frankfurt 1); since its date is late (1519), this is to be passed over re the claim to amalgamate Campin and Rogier—cf. for instance the varied thefts in the name-piece of the Master of the Bruges Passion Scenes (soon after 1500 (?); see the Bruges exhibition catalogue, *Primitifs Flamands Anonymes*, 1969, no. 26).

The Riggisberg Triptych was exhibited at Turin, *IVᵃ Esposizione Nazionale di Belle Arti*, 1880, plates LXXXII–LXXXIII of the Album, lent by the Costa family (Conti della Trinità, Carrù, Polonghera ed Arignano). Stated to have been still in de Villa ownership at Turin in 1920; see the useful entry in the exhibition catalogue at Berne, *Die Burgunderbeute*, 1969, no. 220. Abegg Collection in different places in Switzerland; now fixed at Riggisberg near Berne.

Friedländer, 1967, no. 131; plates 134/5
Panofsky, 1953, index (Zug, Abegg).

The Virgin and Child

Rotterdam, Boymans-van Beuningen Museum

ROTTERDAM
Plate 115

A squared drawing (8½ × 5¼ in., 0.216 × 0.133 m.) is at Rotterdam: Sonkes, 1969, no. A 4 and p. 292. It shows the Virgin at full length, seated, holding the Child, Who blesses. The drawing is thought to be by Rogier or at least to record a design by him. Several painted versions with variations and additions, none near to Rogier in execution, exist. One of these at Leipzig suggested to Panofsky, 1953, p. 266, Sanderus' description of a missing Madonna of the Carmelites of 1446, 'cuius super caput utrimque Angelus coronam stellis insignitam sustinet' (see Winkler, 1913, p. 188 for the whole text of this seventeenth-century record). See Sonkes, 1969, no. A 4, with long bibliography. The drawing comes from the Koenigs Collection.

Friedländer, 1969, no. 146A
Panofsky, 1953, index.

Diptych (?): **The Virgin and Child; Philippe de Croy, Seigneur de Sempy**

The Virgin and Child, San Marino (Cal.), The Henry E. Huntington Library and Art Gallery

SAN MARINO
Plates 93–4

Philippe de Croy, Antwerp, Koninklijk Museum voor Schone Kunsten

The Virgin and Child, transferred from panel, 19¼ × 12¼ in. (0.49 × 0.31 m.). *Philippe de Croy*, wood, 19¼ × 11⅞ in. (0.49 × 0.30 m.); a strip all the way down the right-hand side, ca. 8 cm. wide, is a replacement. An X-radiograph of this picture in Alan Burroughs, *Art Criticism from a Laboratory*, 1938, fig. 133.

The portrait is acceptably one leaf of a diptych.

It seems not established that it could not have been associated with Rogier's *Virgin and Child* at Caen (q.v.). Nevertheless, it may well be better associated with the *Virgin and Child* at San Marino. That association was made, with reasons not more than quite good, by Hulin in *The Burlington Magazine*, vol. XLIII, 1927, pp. 53 f. Friedländer, 1967, pp. 67-68, has reserves, pointing out that the gold background in the *Virgin and Child* is not continued in the portrait.

The portrait shows on the front, top left, S P (perhaps; meaning doubtful). On the reverse is a coat of arms; inscriptions (top), (Phil)ippe de Croy, (bottom), (Seig)neur de Sempy. These identify the sitter as Philippe de Croy, of a family already important, himself in the inner circle of the Burgundian Court. Date of birth not established, ca. 1431 being suggested; educated with the Comte de Charolais (later Duke Charles the Bold), he participated in a joust in 1451. In 1457 he was Chamberlain of Philip the Good. From ca. 1463, he and his father left their Burgundian positions for activities on behalf of France. Died 1511.

He was using the title Seigneur de Sempy in 1459; in 1460-1 he changed to Seigneur de Quiévrain.

See especially *Les Chefs-d'Oeuvre d'Art Ancien à l'Exposition de la Toison d'Or à Bruges en 1907*, 1908, pp. 17 f.; Catalogue of the *Toison d'Or* exhibition, Bruges, 1962, p. 128; the French Dictionary of National Biography.

Both pictures are acceptable as by Rogier; Friedländer, 1967, nos. 39, 40. There is good reason, as noted, for dating the portrait not later than 1460-1.

The *Virgin and Child* was lent by Henry Willett of Brighton (still on panel) to the Burlington Fine Arts Club, London, 1892 (no. 18). Rodolphe Kann, Paris. Acquired in 1907 by Mrs. C. P. Huntington (cf. *The Burlington Magazine*, vol. XII, January 1908, p. 205).

The Portrait was acquired in the region of Namur by the Chevalier Florent van Ertborn, who bequeathed it to Antwerp in 1841.

Both pictures were in the Exhibition of Flemish Art at the Royal Academy, London, 1927 (nos. 40, 41).

Friedländer, 1967, nos. 39, 40
Panofsky, 1953, index (San Marino; Antwerp).

The Virgin and Child with Saints (drawing): Stockholm, Nationalmuseum; see Rogier: London 1. STOCKHOLM

Diptych: **The Virgin and Child;** TOURNAI
Jean de Gros Plates 91–2
The Virgin and Child, Tournai, Musée des Beaux-Arts
Jean de Gros, Chicago, Art Institute, Mr. and Mrs. Martin A. Ryerson Collection
Each, 15¼ × 11¼ in. (0.385 × 0.285 m.).
The Tournai picture is a good deal damaged.

The two pictures are associated together with certainty, because of what is painted on their backs (Friedländer, 1967, plates 50, 51). On the reverse of the *Virgin and Child* is a pulley suspended, and the inscription *Graces A Dieu*. On the reverse of the portrait is a coat of arms suspended from a similar pulley, and a scroll inscribed GRACES A DIEV. The ropes at each side there seemingly form the letters J and G.

The arms are stated to be those of the Gros family. The sitter is reasonably claimed to be Jean de Gros, a financier apparently grasping; date of birth apparently not even approximately established; prominently recorded from 1469; died 1484. See Hulin in *The Burlington Magazine*, vol. XLIV, 1924, pp. 185 f. An approximation to the arms, of the seventeenth century, presumably the same Gros family, is seen in J. Gailliard, *Inscriptions Funéraires et Monumentales de la Flandre Occidentale*, *Arrondissement de Bruges*, vol. I, Part II, 1866, pp. 224–5.

Accepted as Rogier's by Friedländer, 1967, nos. 28, 29. Some doubts about the autograph quality of both parts of the diptych have been expressed, probably wrongly.

The composition of the *Virgin and Child* is rather closely related to that in the *St. Luke drawing a Portrait of the Virgin* (see Rogier: Boston), a frequently used source for Rogierian Madonnas at half length. The head of the Virgin here corresponds closely with that in the *Virgin and Child* formerly at Donaueschingen (q.v.). A drawing corresponding fairly closely with the head of the Virgin here, perhaps by Rogier, is in the Louvre; see Friedländer, 1967, p. 48 and plate 129A, and Sonkes, 1969, no. A 5.

Jean de Gros was a patron of the church of S. Jacques at Bruges; Dürer in 1521 saw there unspecified work by Rogier (see the biographical data, 1520/1).

The *Virgin and Child* was in the van Caloen Collection at

Bruges; acquired thence in 1888 by Alfred Moulant, from whom acquired by Emile Renders at Bruges; now Tournai Museum (1971 Catalogue, no. 481). The portrait was in the collection of Dr. August de Meyer at Bruges; useful entry for it in the Bruges exhibition catalogue, 1867 (no. 19). Later, Rodolphe Kann, Paris; Mr. and Mrs. Martin A. Ryerson, bequeathed to Chicago, 1933.

Friedländer, 1967, nos. 28, 29
Panofsky, 1953, index (Bruges, Renders; Chicago).

TURIN
Plates 19–21

Triptych: **The Annunciation,**
with The Visitation (r.) **and a Donor** (l.) on the wings
Central panel, Paris, Musée du Louvre
Wings, Turin, Galleria Sabauda
Central panel 33¾ × 36¼ in. (0.86 × 0.92 m.). The wings, each 34¼ × 14½ in. (0.87 × 0.365 m.).

It is clear from the provenance that the association of the three pictures is correct, though it is not established that they were painted at the same time to form a triptych from the beginning.

The figure of the donor is largely false; the head and bust totally so, being on an insert in the original panel. It is often claimed, with doubtful justice, that the original figure here (where the wood has been cut out) survives in the head and bust of a woman in a Rothschild Collection at Paris (formerly J. P. Heseltine, London). Friedländer, no. 127, plate 13. Among difficulties of this association, including style, is that this figure of a presumed donatrix would not be looking towards the central panel; the effect of inserting it is seen in a composite plate in Beenken, 1951, plate 130. The size of the *Woman* is variously given. According to Corpus, *Turin*, 1952, p. 22, it is 6⅞ × 4½ in. (0.174 × 0.115 m.); according to the Heseltine Catalogue, *Ten More Little Pictures*, 1909, no. 5, it is 6¼ × 4¾ in. (0.16 × 0.12 m.); according to the catalogue of the Bruges Exhibition of 1902, it is 5 × 3½ in. (0.125 × 0.09 m.).
The Donor (originally donatrix?), in a landscape, is at the entrance to an interior (in the central panel), as is seen from the portico; cf. the arrangement in the Merode Triptych (Campin: New York). Beenken, 1951, pp. 31 f., thinks that the three panels do not go neatly together. Panofsky, 1953, pp. 300 f., suggests that the *Annunciation* was painted first, the wings being added later.
An X-radiograph (see Corpus, *Turin*, 1952, plates LIII, LIV) reveals on the donor's wing a coat of arms plausibly (though no colours are shown) identified as Villa, a Pied-

montese family associated with the Netherlands and with Netherlandish pictures. If these arms are painted on the reverse of the panel, which is here covered up (Corpus, *Turin*, 1952, plate LV), they would show bends sinister, as on the coat of the Triptych at Riggisberg (q.v.).
In *The Annunciation*, the Lions on the bench may be the Lions of the throne of Solomon (I Kings, x, 19), referring to the Virgin as the Sedes Sapientiae. God the Father is seen on the medallion hanging on the bed.
In *The Visitation*, St. Zacharias (apparently) is seen as a small figure, seated at the entrance to St. Elizabeth's dwelling.
In the donor's panel, the capital of the portico shows the spies sent by Moses to bring back grapes from the land of Canaan (Numbers, XIII, 17 sqq.) and David and Goliath; Corpus, *Turin*, 1952, plate LI. On a doorway to the left, in the middle-ground of this panel, are some letters obviously not contemporary, read as Smalagus (Corpus, *Turin*, 1952, p. 23 and plate L).
The two panels at Turin are accepted as Rogier's by Friedländer, 1967, p. 61, no. 6, though this has several times been questioned, e.g. by Panofsky, 1953, pp. 300 f. Beenken, 1951, pp. 34, 100, thinks that the background of the donor's panel at Turin and the Rothschild *Bust of a Woman* (the association of which he accepts) are assistant's work, thinking there is stylistic connection with the Riggisberg triptych (q.v., Rogier). *The Annunciation* is dubiously accepted, as by Rogier under the influence of Campin, by Friedländer, 1967, p. 62, no. 9 (text of 1924); accepted by Beenken, 1951, p. 31.
The Rothschild *Bust of a Woman* is ascribed by Friedländer, 1967, no. 127, possibly to the painter of the *Marriage of the Virgin* in Antwerp cathedral (q.v., Rogier); for other paintings that have been grouped with this, see under *The Exhumation of St. Hubert* (Rogier: London 2).
Some critics have thought *The Annunciation* to be connected at least with Campin. But Panofsky, 1953, pp. 254 f., contrasts the style of apparently similar details here and in the *St. Barbara* at Madrid, generally accepted as Campin's; in particular, a pitcher in each.
The pose of the angel of *The Annunciation* seems to have recurred closely in another picture, of which the figure of the Annunciate Virgin at Petworth (q.v.) is sometimes claimed to be a fragment of Rogier's original.
The Annunciation seems clearly to have been imitated in the Soest Altarpiece assigned to the Master of Schöppingen, where in other compartments other Rogieresque and Campinesque influences have been claimed. In the Schöppingen altarpiece itself, the *Annunciation* is not connected

with the present one, but depends on the version of the Merode *Annunciation* at Brussels and the *St. Barbara* at Madrid, both associated with Campin. These pictures classed as by the Master of Schöppingen may be of the 1450s. See the exhibition catalogue, *Westfälische Maler der Spätgotik 1440–90*, Münster, Landesmuseum, 1952, nos. 29 sqq. and 24 sqq., with reproductions.

The Visitation corresponds fairly closely with a picture at Leipzig (q.v.). See there for comment on relation of that picture (and the Turin one, equally) to Daret's picture of the subject (not later than 1435) at Berlin-Dahlem. A derivative of *The Visitation* at Turin is in a triptych (?) at Cologne mostly of the story of Job, assigned to the Masters of St. Catherine and St. Barbara; these pictures also are associated with the Villa family. See Friedländer, *Early Netherlandish Painting*, vol. IV, *Hugo van der Goes*, 1969, no. 69; Bruges exhibition catalogue, *Primitifs Flamands Anonymes*, 1969, no. 46; Cologne catalogue, *Deutsche und Niederländische Gemälde bis 1550*, 1969, pp. 82 f.

The building in the background of *The Visitation* is freely copied in a picture of *Scenes of the Life of St. Ulrich* in the church of SS. Ulrich and Afra at Augsburg; see A. Stange, *Deutsche Malerei der Gotik*, vol. VIII, 1957, fig. 78.

From the coat of arms recorded above, apparently associated in origin or at least very soon with the de Villa family of Piedmont. The first known record of the pictures in the Louvre and at Turin, with recognizable description and the donor already falsified apparently as now, is of 1635, in the collection of the Duke of Savoy (Corpus, *Turin*, 1952, pp. 24–5). The wings have stayed at Turin. The *Annunciation* is recorded to have been brought from Turin to Paris in 1799 (E. Michel, Catalogue, *Peintures Flamandes du XVe et du XVIe Siècle* of the Louvre, 1953, p. 273).

The head and bust of a woman now in a Rothschild Collection at Paris had been lent by J. P. Heseltine to the Exhibition *Primitifs Flamands* at Bruges, 1902 (no. 96).

Corpus, *Turin*, 1952, no. 19
Friedländer, 1967, nos. 6, 9, 127
Panofsky, 1953, index (Paris; Turin; Paris, Rothschild).

UPTON
Plate 110

Portrait of a Man

Upton House (The National Trust, The Bearsted Collection)

7½ × 5¾ in. (0.19 × 0.145 m.).

Possibly the right wing of a diptych.
Accepted by Friedländer, 1967, no. 45.

According to the Upton catalogue, from the Butler Collection. The picture was at one time in Canada, and was brought to England at some time before 1914; see Sir Martin Conway, *The Van Eycks and their Followers*, 1921, p. 148, and Hulin in *The Burlington Magazine*, vol. XLIII, 1923, p. 54 (references to Dreicer ownership are wrong, or else Dreicer did not keep the picture). Acquired by the Hon. Walter Samuel, who in 1927 succeeded as 2nd Viscount Bearsted and died in 1948; Royal Academy, *Exhibition of Flemish Art*, 1927 (no. 46). Just before he died, Lord Bearsted gave Upton House and its contents to the National Trust.

Friedländer, 1967, no. 45
Panofsky, 1953, index (London, Bearsted).

Christ's Body Carried to the Tomb, with Mourners

VARIOUS
COLLEC-
TIONS I

This composition is known from a drawing in the Louvre (Friedländer, 1967, no. 94, plate 110; Sonkes, 1969, no. C 23); from a carving in wood (Detroit; Friedländer, 1967, no. 139, plate 110); and from a good number of painted derivatives, some showing variations (one assigned to the Master of Frankfurt at Watervliet is Friedländer, 1967, no. 140; see further in the *Bulletin* of the Institut Royal du Patrimoine Artistique, Vol. IX, 1966, pp. 9 f.). For a discussion of the sculpture at Detroit with a list of versions, see Nicole Verhaegen, 'The Arenberg "Lamentation" in the Detroit Institute of Arts', in *The Art Quarterly*, 1962, pp. 294f. Another drawing connected is Sonkes, 1969, no. C 24.

The iconography is not discussed in this catalogue.

The design is often believed to have been invented by Rogier; though one may not exclude that it could be constructed out of various elements partly his. Its popularity, deduced from the number of versions surviving, may be considered in connection with this.

Speculation about its origin has been made. From the form of the drawing in the Louvre, which might imply a destination under a window, Friedländer wondered if it should be associated with Rogier's painted chapel noted by Dürer (see the biographical data, 1520/1). It has also been unsatisfactorily associated with Rogier's work at Ferrara (see the biographical data, 1449, 1450). The design has also been claimed to have been made for sculpture.

The drawing in the Louvre seems to reach back farthest. Reasonably attached to that is a drawing of what would seem to have been a wing; Friedländer, 1967, no. 144, plate 142; Sonkes, 1969, no. C 17. This shows *Christ Carrying the Cross*, and was once in the Becker Collection at Leipzig.

The composition clearly includes points of contact with Rogier's *Deposition*, now in the Prado (Madrid 1). These are general, except for the notably popular figure of the Magdalen with clasped hands; but she is here kneeling, not just with knees bent. The figure of the Magdalen as here is introduced into a painted *Crucifixion* in the Prado; Friedländer, 1967, no. 91, plate 108.

Comments on the priority of this composition or of the *Deposition* now in the Prado have been made. Panofsky, 1953, p. 465, says that the composition under discussion is later. From a detail of costume, Sonkes supports the claim that it is earlier; the argument would not stand if this composition is mixedly (if freely) derived from different sources. Since no example of this composition is known close to Rogier in quality and convincingly dependent on him as inventor cum executant, the catalogue entry has been limited.

Friedländer, 1967, nos. 94, 139, 140, 144, 91; plate 110
Panofsky, 1953, index (Paris; Leipzig, Becker).

VARIOUS COLLECTIONS 2

The Descent from the Cross (upright composition: figures not at full-length)

Two variants of the composition are known. One shows Christ, the Virgin, St. John and St. Joseph of Arimathaea; the other is without St. John. The figure supporting the body of Christ would be St. Joseph, not St. Nicodemus, according to a tradition; see the reference to Réau given under Rogier: Madrid 1.

Each composition is known in many versions, none of which at the time of writing is generally accepted as executed by Rogier, nor are all of them in fifteenth-century style; but Rogier is credited with the invention of one or both compositions. This indeed seems more likely, at least for one of the two, than attribution to a follower assembling elements from Rogier.

For examples of these compositions, see Friedländer, 1967, nos. 97, 98 and plates 111, 112; S. Reinach in *The Burlington Magazine*, vol. XLIII, 1923, pp. 214 f.; E. Salin in the *Gazette des Beaux-Arts*, 1935, vol. I, pp. 15 f.; Georges Marlier, *Pierre Coeck d'Alost*, 1966, pp. 198 f.

An example of the variant including St. John (Friedländer, 1967, no. 97) may indeed have been an original by Rogier. It is recorded among pictures given by Philip II to the Escorial in 1574: 'Otra tabla de pintura de la Quinta angustia, con nuestra Señora y sant Juan y Nicodemus, de Maestre Rogier, con dos puertas escriptas, que fué de la Reyna María: que tiene dos pies de alto y pie y medio de ancho, sin las puertas: es redonda por lo alto' (Zarco Cuevas, *Inventario de las alhajas*, etc., *donados por Felipe II al Monasterio de El Escorial*, 1930, p. 143, no. 1029). *Quinta angustia* in Spanish means Deposition or Pietà: see for instance the cartulary of Miraflores cited under Rogier: Granada, or Rogier's *Deposition* (Madrid 1) in the record of it by José de Sigüenza, 1602 (1605), in F. J. Sánchez Cantón, *Fuentes Literarias*, vol. I, 1923, p. 389. The size of known versions of the composition varies, but the measurements stated for the picture given to the Escorial would do. An example of the variant without St. John, and not acceptably of the fifteenth century, but with rounded top, and having wings with inscriptions, is reproduced in *The Burlington Magazine*, vol. XLIII, 1923, pp. 214 f., plate II L.

This record of the Escorial picture is insufficient to serve as a basis for attribution to Rogier, although that is the case for the *Deposition* and the *Crucifixion* recorded in the same document (see Rogier: Madrid 1 and Escorial): where the pictures are clearly identifiable now, also such that getting possession of them would have been an event. Winkler, 1913, p. 186, records an example of the composition with four figures in the Apartments of Philip II at the Escorial: but a copy. Still there in 1970; poor quality. No wings, or marks of hinges. It would be most difficult to believe that this is the picture given to the Escorial by Philip II; if it were, the reliability of the inventory would be greatly lessened.

As for the wings with inscriptions in the record of 1574, there is no need to believe these contemporary with the picture. Such wings are frequently met with, mostly of the sixteenth century, mostly with pictures of Spanish provenance; I do not know of any example reasonably datable within Rogier's lifetime.

Several versions of the variant with St. John (Friedländer, 1967, no. 97) are in Bruges; it has been suggested that the original of this variant was commissioned for Bruges.

Winkler (*Das Werk des Hugo van der Goes*, 1964, p. 133, with references to two articles by him) unconvincingly claimed that Rogier painted the figures at full-length, and that the numerous versions of both designs not at full-length show a subsequent reduction of the field. He bases this claim on four versions, apparently all only partially connected and showing full-length figures. One (a miniature) is reproduced by him in the *Amtliche Berichte*, 1913-14, p. 17. One in the Prado is reproduced by Post, *History of Spanish Painting*, vol. IV, Part I, 1933, fig. 35; one at Aachen is reproduced

in *Aachener Kunstblätter*, Heft 28, Ernst Günther Grimme, *Das Suermondt-Museum*, 1963, no. 101. The fourth (Baegaert at Greifswald) is not known to the present writer otherwise than in Winkler's record.

Friedländer, 1967, nos. 97, 98; plates 111–12
Panofsky, 1953, index (Nancy: Madrid, Lázaro, under Massys).

The Virgin with a Flower

This composition is often thought to have been invented by Rogier van der Weyden. It is known from a print assigned to the Master of the Banderoles, who is believed to have been active ca. 1450–70; Friedländer, 1967, plate 120. There exist rather numerous connected pictures, varying somewhat from each other, often showing the Virgin at half-length; it seems that all of these are later, some being associated with the Master of the Magdalen Legend. It is sufficient here to give the following references, where further details and bibliography may be found:
for a version at Ghent, see the catalogue of the exhibition *Primitifs Flamands Anonymes*, Bruges, 1969, no. 69, pp. 141 and 269 f.;
for a version belonging to the Louvre (on loan at Strasbourg), see Edouard Michel, *Catalogue Raisonné des Peintures*, etc., *Peintures Flamandes du XVᵉ et du XVIᵉ Siècle* (Louvre catalogue), 1953, pp. 282 f.;
Friedländer, *Die Altniederländische Malerei*, vol. XII, *Pieter Coeck, Jan van Scorel*, 1935, pp. 17, 165 f. Also vol. VIII, *Jan Gossart, B. van Orley*, 1930, no. 94, variants associated with van Orley in the Colonna Collection, Rome, and elsewhere; the Colonna picture is reproduced by Friedländer in the Prussian *Jahrbuch*, vol. XXX, 1909, p. 17, where there is also a list of miscellaneous versions with some reproductions. The composition bears a not very close relationship to one known also in several variants, which are supposed to be connected with a picture assigned to Campin at Aix-en-Provence (q.v. for more). These, with some reference to the present composition, were discussed by Jeanne Tombu in *The Burlington Magazine*, vol. LVII, 1930, pp. 122 f. Cf. also a drawing in the Louvre; Sonkes, 1969, no. C 7. Another design, showing some relationship with these but rather far from the present composition, is a *Madonna of Humility* (see Campin: Brussels, Gendebien).

Friedländer, 1967, no. 120; plate 124
Panofsky, 1953, index (Paris).

The Virgin holding the Standing Child

The composition occurs both at half length and at whole length, with variations, very many times. It is often thought that there was an original painting by Rogier; Campin has also been suggested.
For several examples, see Friedländer, 1967, no. 121 and plate 125. An elaborated derivative, there reproduced, is datable soon after 1461; it was in the Berlin Gallery, and has been destroyed. For it, see the Berlin catalogue, 1931, p. 332, no. 590A, 'Niederländisch um 1465'. Many of the half-length derivations are assignable to the sixteenth century and the School of Bruges.
A connected drawing at Dresden receives a long commentary from Sonkes, 1969, no. C 10. Details on the tiles, etc. are not gone into in the present volume, the drawing's closeness to a presumed original not being clearly definable.

Friedländer, 1967, no. 121; plate 125
Panofsky, 1953, index (Dresden).

Bust Portrait of Philip the Good, Duke of Burgundy

Philip the Good (1396–1467); founded the Order of the Golden Fleece in 1430.
Two main types are known; in one with the Duke wearing a hat, in the other bare-headed. Several versions of each are known. Rogier is reasonably presumed to have painted one or more versions of each type, but no picture known is accepted as having been executed by him. The specimen nearest to Rogier may be the one in the Royal Palace at Madrid (Friedländer, 1967, plate 127). Details are excluded from the present volume. A portrait that may have been on one of these designs was owned by Giovanni Sforza at Pesaro in 1500; probably destroyed in 1514; for details see Rogier: Brussels 3.
See a long entry in the Corpus volume for the Musée Groeninge at Bruges, 2nd edition in French, 1959, pp. 107 f. Also Friedländer, 1967, no. 125; E. Michel, Louvre catalogue, *Peintures Flamandes du XVᵉ et du XVIᵉ Siècle*, 1953, pp. 278 f.; Micheline Sonkes in the *Bulletin* of the Institut Royal du Patrimoine Artistique, Vol. XI, 1969, pp. 142 f.
A claim is sometimes made that the original of the type without a hat must be post-1460, because the sitter appears to be wearing a wig on a shaved head. This claim is incorrect; see the exhibition catalogue, *Le Siècle de Bourgogne*, Brussels, 1951, no. 14.

Corpus, *Bruges*, 1959, no. 13
Friedländer, 1967, no. 125; plate 127
Panofsky, 1953, index (Bruges; Antwerp).

VARIOUS **Portraits of, or claimed to be of Rogier**, by or attributed
COLLEC- to him.
TIONS 6 Four are mentioned here:
(1) A face in his destroyed mural paintings in Brussels
Town Hall (q.v.);
(2) A drawing in the Recueil d'Arras (see ill. on p. 38 above)
and an engraving by Cock;
(3) In the picture of St. Luke drawing a Portrait of the
Virgin (see Boston);
(4) A drawing at Berlin.
The lost murals in Brussels Town Hall did include a por-
trait of Rogier by Rogier, if one accepts the evidence of
Nicolas Cusanus, of 1451. The identity of the face, from
probably much altered reflections of the paintings in tapes-
tries at Berne, has been convincingly discussed by Panof-
sky in *Late Classical and Medieval Studies in Honor of Albert
Mathias Friend, Jr.*, 1955, pp. 392 f. Doubt about a particu-
lar claim by Panofsky, that in the seventeenth century
Dubuisson-Aubenay wrongly located the portrait in his
description of the paintings, seems to be justified by J. G.
van Gelder's article, referred to in the entry for them. The
tapestry at Berne is of little use for the style, and not much
for the features of the figure identified.
The drawings in the Recueil d'Arras are attributed to
Jacques Leboucq, died 1573; see the exhibition catalogue,
Le Siècle de Bourgogne, Brussels, 1951, no. 52. The print is
from a series published by H. Cock in 1572. The two are
clearly related. It is uncertain if there was a painted
original. Friedländer, 1967, plate 144 for both.
The identification of Rogier's features, idealized or not, in
the picture of *St. Luke* is uncertain; see under Boston.
The drawing at Berlin may be by Rogier; but the identifi-
cation of him as the subject is most doubtful. See Sonkes,
1969, no. A 1.

Friedländer, 1967, plates 144, 118, 129 C
Panofsky, 1953, index (Berne; Arras; Boston; Berlin).

VIENNA 1 **The Virgin standing in a Niche, holding the Child:**
Plates 87–8 **St. Catherine in a Landscape, standing**
Vienna, Kunsthistorisches Museum
Each 7¼ × 4¾ in. (0.185 × 0.12 m.).

X-radiograph of the Virgin and Child published by Alan

Burroughs, *Art Criticism from a Laboratory*, 1938, fig.
98.
Clearly associated together, as a diptych, or conceivably in
origin as two parts of a triptych.
The crowned Virgin stands suckling the Child, before a
throne, on the arms of which are the Lions of Solomon (I
Kings, x, 19); i.e. the *Sedes Sapientiae*, referring to the wis-
dom of the Virgin. For this and for further iconographical
commentary, see Birkmeyer in *The Art Bulletin*, 1962, pp.
330 f. On the upper part of the niche in which the Virgin
stands are shown in grisaille, as sculptures, God the Father
and the Dove; left and right, similarly, the Fall, with
serpent and menacing angel. St. Catherine has her emblems
of wheel, sword and crown.
Accepted by Friedländer, 1967, no. 7; on p. 18 he compares
with Jan van Eyck. There has been some tendency
(wrongly?) to class the *St. Catherine* as lower; Panofsky,
1953, p. 251, says shop work, or rather work of a fellow
apprentice. See comment on the *Virgin and Child* in the
Schloss Rohoncz Collection and the *St. George* at Washing-
ton (Rogier: Lugano 1). All these pictures may be by
Rogier; excellent in execution; though without the fire
one might expect even in immature works.
A claim that the *Virgin and Child* may be identical with a
small picture of these figures 'in un tempio Ponentino', re-
corded as by Rogier in the collection of Gabriel Ven-
dramin, 1530, by Marc'Antonio Michiel (the Anonimo
Morelliano), is rightly rejected by Panofsky, 1953, pp. 458–
9. The two pictures are recorded in the Austrian Imperial
Collection in 1772.

Friedländer, 1967, no. 7
Panofsky, 1953, index.

Triptych: **Christ on the Cross; the Virgin, St. John, the** VIENNA 2
Magdalen, St. Veronica; Two Donors Plates 22–5
Vienna, Kunsthistorisches Museum
37¾ × 27¼, 10⅝ in. (0.96 × 0.69, 0.27 m.). 39¾ × 27½, 13¾ in.
(1.01 × 0.70, 0.35 m.), including the partly original sur-
rounds, which are not raised above the panels. These sur-
rounds on the outside compartments are gilt and shadowed
and with a slope represented on the lower side, in imita-
tion of gilt frames; essentially original. For the central
compartment only a very little of the original gilding is
still to be found, at its sides. The imitation framing is
wider on the left of the right compartment and on the
right of the left compartment; perhaps there extending so
as to share originally with the imitation framing of the

central compartment—but the other sides of the imitation framing of these side panels may have been cut. The imitation frames (assuming similarity for the central compartment) would curiously have shown the scene as through three windows. The label with INRI on the Cross is cut along its top; its awkwardness now need not imply a material cut, or damage. The band of gold above is not original; Rogier's imitation framing there might have made the hiding of part of the inscription convincing, even brilliant.

The triptych in general is in remarkably fresh condition. Some losses; the most important for any important part is on Christ's left heel. The lower half of St. Veronica's dress is a good deal damaged.

The side panels may have been folding wings, since the sizes would suit; but from the comments above this seems improbable. The backs of the side compartments have been planed.

X-radiographs published by Alan Burroughs, *Art Criticism from a Laboratory*, 1938, fig. 102 (the Virgin and St. John) and by C. Wolters, *Die Bedeutung der Gemäldedurchleuchtung mit Röntgenstrahlen für die Kunstgeschichte*, 1938, plate 36 (Christ).

In the central panel the Virgin embraces the foot of the Cross; St. John is behind her and supporting her; a male and a female donor, unidentified, kneel on the right. Left wing, the Magdalen stands holding a pot; right wing, St. Veronica stands holding a cloth on which the image of Christ's face has been impressed. The town in the background is to suggest Jerusalem. The skull of Golgotha is not shown.

Panofsky, 1953, pp. 266 f., points out several matters iconographically or stylistically interesting. This may be the earliest surviving triptych showing a biblical scene, where the side panels (with saints) are linked to the central panel by a continuous landscape; some strengthening of this unity is given by angels in the sky, two in the central panel, one in each wing. Nevertheless, compare the design of a triptych recorded under Campin: London, Seilern. Here, the Virgin embraces the foot of the Cross; normally, it is the Magdalen. The motif here did not become popular; it occurs in a few pictures that are perhaps derivative of this one—see in particular Campin: Berlin 4. Christ's loincloth here has its ends fluttering in the breeze; this did become popular, for decades, and may be here seen for the first time. Here, the donors kneel at the foot of the Cross, separated from it only by a break in the soil; the normal placing

of donors in Netherlandish painting soon after the time of this triptych was with increased respect on the wings, usually protected by their saints.

Accepted by Friedländer, 1967, no. 11, and generally (as it should be).

The Christ here recurs fairly exactly in the Abegg triptych (Rogier: Riggisberg). Among partial derivatives are here mentioned Friedländer, 1967, no. 90 (Dresden), and a picture at Madrid assigned to the Master of the Legend of St. Catherine (Friedländer, *Early Netherlandish Painting*, vol. IV, *Hugo van der Goes*, 1969, no. 50; see further in the exhibition catalogue, *Primitifs Flamands Anonymes*, Bruges, 1969, no. 44). The first incorporates the figure of the Magdalen from the *Deposition* now in the Prado (Rogier: Madrid 1). The *Crucifixion* at Berlin ascribed to Campin has been already referred to. A drawing that seems clearly derived from the St. John here is at Budapest; Sonkes, 1969, No. B 12, plate XIIa.

The picture at Vienna is recognizably listed in the collection of Archduke Leopold Wilhelm, 1659 (as Anon.); presumed to have remained constantly in the collection of Austria.

Friedländer, 1967, no. 11
Panofsky, 1953, index.

Portrait of a Lady

Washington, National Gallery of Art
$14\frac{1}{2} \times 10\frac{3}{4}$ in. (0.37 × 0.27 m.).

WASHING-
TON
Plate 107

Apparently a portrait by itself.

Accepted by Friedländer, 1967, no. 29A, and generally. Sir Charles Holmes was able to compare it in the original with the *Portrait of a Lady* in the National Gallery, London (London 4), which it superficially resembles; see *The Burlington Magazine*, vol. XLIII, 1926, pp. 122 f.

In the collection of the Duke of Anhalt at Wörlitz, Gotisches Haus; later at Dessau, Schloss. Mentioned by Friedländer in *Werk über die Renaissance-Ausstellung* (Berlin 1898), 1899, p. 9. Exhibited at Bruges, *Exposition des Primitifs Flamands*, 1902 (no. 108).

Passed through Duveen to the collection of Andrew Mellon; to Washington, 1937.

Friedländer, 1967, no. 29A
Panofsky, 1953, index.

St. George and the Dragon: Washington, National Gallery of Art; see Rogier: Lugano 1.

CATALOGUE OF WORKS
ASSOCIATED WITH
ROBERT CAMPIN

AIX
Plate 154 **The Virgin and Child, SS. Peter and Augustine, and a Donor**

Aix-en-Provence, Musée Granet
19 × 12½ in. (0.48 × 0.316 m.), including (?) the original (?) frame; the measurements were checked for Panofsky, 1953, p. 424.

The Virgin on a throne in the sky is shown partly as the Woman in Revelation, XII, 1, as if clothed with the sun, and with the moon at her feet. Small figures of Church and Synagogue decorate the front corners of the throne, left and right; cf. Campin: Leningrad. St. Peter wears a papal tiara and holds keys. St. Augustine has as his specific emblem a heart; 'sagittaveras tu cor nostrum caritate tua' occurs in his *Confessions*, Book IX, ii, 3. The donor is an Augustinian abbot, apparently. Arms on a shield on the lower part of the frame, seen in Plate 94 of Friedländer, 1967, have apparently not been identified.
Witting in the *Zeitschrift für bildende Kunst*, New Series, Vol. XI, 1899–1900, p. 89, published the picture as by Campin. Accepted by Friedländer, 1967, no. 66; but in his text of 1937 this is one of the pictures he specifies as attributable to Rogier (Friedländer, 1967, p. 55). Panofsky, 1953, p. 169 f., accepts it as Campin, but stresses close connection with Rogier's style.
The design of the Virgin and Child has been considered related to that of a Virgin and Child known in several variants, the one in the Douai Museum being recorded by Friedländer, 1967, no. 66a. This and variants at Cologne and Huesca, with reference also to a drawing in the Louvre (see Campin: Paris; Friedländer, 1967, no. 72a; Sonkes, 1969, no. C 7) are reproduced and discussed by Jeanne Tombu in *The Burlington Magazine*, Vol. LVII, 1930, pp. 122 f. For the picture at Cologne, see further the Cologne Museum catalogue, *Deutsche und Niederländische Gemälde bis 1550*, 1969, pp. 34 f. (as After Campin). Jeanne Tombu

points out that in the picture at Cologne the Virgin's head-dress corresponds closely with that seen in some versions of a Virgin and Child, usually a tondo (see Campin: Various Collections); this headdress occurs in other pictures also, for instance in one at Bilbao assigned to Benson (see the exhibition catalogue, *L'Art Flamand dans les Collections Espagnoles*, Bruges, 1958, no. 60). Some connections for the design of the Virgin and Child may also be observed in a *Madonna of Humility* that has been ascribed to Campin (see Brussels: Gendebien), and in a *Virgin and Child* known in several variants that are thought to reflect a design by Rogier (see Rogier: Various Collections 3).
The Aix catalogue of 1900, no. 300, records an inscription on the back attributing the picture's origin to the mid-fourteenth century. Bequeathed by Jean-Baptiste-Marie de Bourgignon de Fabregoules to the Aix Museum in 1863.

Friedländer, 1967, no. 66
Panofsky, 1953, index.

The Virgin and Child in a Flowery Setting BERLIN I
Plate 159

Berlin-Dahlem, Gemäldegalerie der Staatlichen Museen
14⅝ × 10 in. (0.37 × 0.255 m.).

The current title in German is 'Madonna an der Rasen-bank'. In the 1968 Berlin catalogue in English, it is entitled 'The Madonna of Humility'. This it seems indeed clearly to be; see reference to that motif in the entry for the National Gallery picture (Campin: London 2), which is more remote from the traditional form.
The haloed Virgin holds an almost naked Child, apparently unhaloed; she is seated on flowery ground before a low wall forming a recess, the top side of which also is covered with flowering plants. There is a hanging behind; in front of its corners rays descend obliquely towards the figures.
The attribution to Campin has been questioned. Friedländer,

1967, no. 50, thinks it possibly an early work of his. Panofsky, 1953, p. 160, inclines to accept, at least as shopwork. At present classed at Berlin as an original; I incline to accept it, as early work.

Published by Friedländer in *Art Flamand et Hollandais*, Vol. VI, 1906, p. 29; Richard von Kaufmann Collection, Berlin; Sale, 4 sqq. December 1917 (lot 68), as Netherlandish of *c.* 1440. Presented to the Berlin Gallery by Frau von Kaufmann, 1917.

Friedländer, 1967, no. 50
Panofsky, 1953, index.

BERLIN 2
Plate 162

Bust Portrait of a Fat Man
Berlin-Dahlem, Gemäldegalerie der Staatlichen Museen
$11\frac{1}{4} \times 7$ in. (0.285 × 0.177). X-radiographs are given by Alan Burroughs in *Metropolitan Museum Studies*, Vol. IV, Part 2, 1933, p. 136 and in *Art Criticism from a Laboratory*, 1938, fig. 100.

Apparently a portrait by itself.

It has been noticed as somewhat unusual that the background is light; but cf. the Portrait of Francesco d'Este (Rogier: New York 1).

An unacceptable suggestion has been made that the sitter is Niccolò Strozzi, on comparison with the bust of him by Mino da Fiesole (for which, see John Pope-Hennessy, *Italian Renaissance Sculpture*, 1958, Plate 70). The sitter is now usually thought to be Robert de Masmines, on comparison with a drawing inscribed with his name in the Recueil d'Arras, a collection of portrait drawings ascribed to Jacques Leboucq, d. 1573 (cf. the exhibition catalogue *Le Siècle de Bourgogne*, Brussels, 1951, no. 52). Masmines was in the service of Duke John the Fearless, and died in 1430; in that year he was made a Knight of the Golden Fleece (the collar of that Order is not seen in the portrait). This identification was made by Hulin in his contribution to the *Trésor de l'Art Flamand* (Memorial Volume on the Antwerp Exhibition of 1930), 1932, pp. 31 f. It was concurred in by Renders and Lyna in the *Gazette des Beaux-Arts*, 1933, I, pp. 129 f., who reproduce the Arras drawing and the picture at Berlin. I do not find the identification convincing. There have been wild attempts to find the features of the sitter here in other pictures up to well into the sixteenth century.

The attribution to Campin was accepted by Friedländer (text of 1924), 1967, no. 61, but with doubt about separating it from Rogier (pp. 41 f.). Specified in his text of 1937

among pictures that could be ascribed to Rogier (Friedländer, 1967, p. 55). Not very sensitive comparison with the head of St. Nicodemus in the *Deposition* from the Escorial, deposited at the Prado (Rogier: Madrid 1), has been made in attempts to amalgamate Campin and Rogier. Panofsky, 1953, p. 426, thinks the picture at Berlin a copy. Much doubt has been expressed; perhaps there was a better version.

A good and close version is in the Schloss Rohoncz Collection (Baron Thyssen-Bornemisza) at Lugano. Size, $13\frac{3}{4} \times 9\frac{1}{2}$ in. (0.35 × 0.24 m.), including the frame, which is in one piece with the panel. X-radiograph in Mojmír S. Frinta, *The Genius of Robert Campin*, 1966, fig. 39. Published by Winkler as autograph (the picture at Berlin also autograph) in *Berliner Museen*, 1957, pp. 37 f.; it was then at the Château de Ponthoz (van der Straten family). In the *Toison d'Or* Exhibition at Bruges, 1962 (no. 17).

The picture at Berlin, enlarged to 16 × 12 inches, as by Jan van Eyck, was in an Anon. Sale (Sir Henry Hope Edwards *et al.*), London, 27 April 1901 (lot 87), acquired for Berlin (Kaiser-Friedrich-Museum-Verein); for the identity, see the Prussian *Jahrbuch*, Vol. XXIII, 1902, p. 17.

Friedländer, 1967, nos. 61, 154
Panofsky, 1953, index (Berlin picture).

Portrait of a Man BERLIN 3
Berlin-Dahlem, Gemäldegalerie der Staatlichen Museen Plate 161
$14\frac{5}{8} \times 11\frac{7}{8}$ in. (0.37 × 0.30 m.).
An X-radiograph was published by Alan Burroughs, *Art Criticism from a Laboratory*, 1938, fig. 94.

Accepted as almost certainly by Campin (unless a copy) by Friedländer, 1967, no. 62, and p. 42. Panofsky, 1953, p. 426, as a schoolpiece. I incline to accept this unalluring picture as by Campin, painted before his known contact with Rogier (1427–32).
Presented by Baron von Werther in 1836 to Berlin.

Friedländer, 1967, no. 62
Panofsky, 1953, index.

The Crucifixion BERLIN 4
Berlin-Dahlem, Gemäldegalerie der Staatlichen Museen
$30\frac{1}{4} \times 18\frac{1}{2}$ in. (0.77 × 0.47 m.).

Under the present sky and back part of the landscape is a gold ground. Friedländer, 1967, no. 68, thinks that the

landscape, the sky and the angels in the sky are additions made soon after the original painting, but by a different painter. Beenken, 1951, p. 103 (note 35), cites the opinion of a former restorer at Berlin, that the main figures and the landscape are contemporary in paint. Publication of a scientific examination of the picture would be useful.

The picture shows Christ on the Cross, the Virgin, St. John, three Marys; angels in the sky. The Virgin kneels embracing the Cross, a motif perhaps derived from the Triptych at Vienna (Rogier: Vienna 2). From her mouth, the inscription: O *Fili dignare me attrahere et crucis in pedem manus figere. Bernhardus.* For comment on this phrase, see Panofsky, 1953, pp. 465–6, note 3.

Unhappily admitted as Campin's by Friedländer, 1967, no. 68 and p. 43. Among pictures specified by him in 1937 as amalgamable into Rogier's oeuvre (Friedländer, 1967, p. 55). Panofsky, 1953, pp. 298 f., rejects on sound grounds; but unconvincingly associates it with the Riggisberg Triptych (Rogier: Riggisberg).

There are suggestions of Rogier as well as of Campin in the main figures. The landscape is in treatment unlike the work either of Campin or of Rogier. It seems somewhat comparable to that in the name-piece of the Master of the Bruges Passion Scenes (or Bruges Master of 1500), a *Crucifixion* in S. Sauveur at Bruges, which was painted (perhaps soon) after 1500 with figures derived from Campin and others (see under Campin: Frankfurt 1). This loose comparison is not applied to the main figures in the Berlin picture, although the painting of these may not seem clearly distinct from that of the landscape. The angels do not seem characteristic of the early or middle fifteenth century, and can hardly be supposed intended to be like those of Campin or Rogier; it is nevertheless hard to separate them stylistically from Christ's loin cloth here. Probably the whole picture is an imitation, good, old, but not contemporary with Campin or Rogier.

Presumably (cf. Tschudi, 1898, pp. 94–5) this is the picture recorded by Passavant, *Die christliche Kunst in Spanien*, 1853, p. 137, as belonging to the engraver Professor Peleguer at Madrid (who thought it by Jan van Eyck). The owner would seem to be Vicente Peleguer, died 1865. Old Masters of the Peleguer Collection, presumably the same, were exhibited for sale in Paris from 22 April 1867 (Soullié no. 4308), and were in an auction sale at Paris on 9–10 December 1867 (Lugt no. 30067). The Berlin picture was in the collection of Anatole-Auguste Hulot (1811–91) at Paris; Sale, Paris, as Massys, 1892, lot 27, bought for Berlin.

Friedländer, 1967, no. 68; plate 95
Panofsky, 1953, index.

The Vengeance of Tomyris BERLIN 5
Formerly Berlin, Kaiser Friedrich Museum; destroyed
Canvas, 69¼ × 69¼ in. (1.76 × 1.76 m.).

The picture formerly at Berlin, although of poor execution, was considered the best record of a composition ascribed with some stylistic probability to Campin.

The subject is known from Herodotus. According to him, the best version of the story (not exactly followed in the picture) is briefly this. Queen Tomyris lost her son in battle against Cyrus the Great, King of Persia; she won another battle against Cyrus, who was captured and killed, and she plunged his head into skin full of blood.

The subject might have been found suitable for a secular administrative building, as a Justice Scene, according to the taste of the fifteenth and sixteenth centuries in Flanders; see the entry for Rogier's murals once in Brussels Town Hall. This may find some support in the existence of a late version (recorded below) in the Palais de Justice at Bruges. There was also a prominent painting of this subject, apparently not accompanied by others of comparable subjects, in a building for some time used as the Bishop's Palace at Ghent, which had been the court of St. Bavo; recorded there in inventories of 1587, 1621 and 1662. See Hulin in the *Bulletin de la Société d'Histoire et d'Archéologie de Gand*, vol. IX, 1901, pp. 222 f. and Carl van de Velde in *Gentse Bijdragen*, vol. XX, 1967, pp. 198, 204 f.

It has also, and not necessarily in contradiction, been pointed out that the subject is one of three prefigurations of the Virgin trampling upon the devil in the *Speculum Humanae Salvationis* (Chapter XXX), a work very popular in Flanders in the fifteenth century. The other two prefigurations are Judith and Holofernes, and Jael killing Sisera. One of the versions of the Berlin picture to be recorded has the subject turned into Judith and Holofernes. (There would seem little to be said in favour of thinking Judith the original subject, which would then have been turned into Tomyris.) A drawing of *Jael and Sisera* at Brunswick, on the grounds of its subject, has been brought into discussion; Sonkes, 1969, no. C 2.

Although the subject of the Berlin picture is secular, the capitals seen in it showed scenes from the Old Testament; according to Tschudi, 1898, p. 104, there were identifiable Adam and Eve being driven out of the Garden of Eden, and the Grapes of Canaan (Numbers XIII, 17 sqq.).

A version, apparently less true than the one formerly at Berlin, is in the Academy in Vienna; a varied picture, with the subject become Judith and Holofernes, is at Greenville; see Friedländer, 1967, no. 75 and plate 102. A version signed *P¹ Pieters* and dated 1610, is in the Palais de Justice at Bruges; see S. Sulzberger in *Oud-Holland*, 1966, p. 187. A drawing of the composition is at Berlin; Sonkes, 1969, no. C 1.

The Berlin picture came from Spain and was presented by Sir J. Charles Robinson, 1893; destroyed in the 1939–45 war.

Friedländer, 1967, no. 75; plate 102
Panofsky, 1953, index.

BERLIN 6 **The Adoration of the Kings**
Berlin-Dahlem, Gemäldegalerie der Staatlichen Museen
19¼ × 16¼ in. (0.49 × 0.41 m.).

Inscriptions on the hems are from Luke I and II.
Classed as after Campin by Tschudi, 1898, pp. 105 f.; Winkler, 1913, p. 13, at that time thought rather after Daret; Friedländer, 1967, no. 76, agrees with Tschudi. Although precise copying is not involved, the picture shows a good deal of connection with Daret's picture of the same subject, finished by Sept. 1435, now also in the Plate 169 Gallery at Berlin-Dahlem (Friedländer, 1967, plate 105). Daret was from 1428 until 1432 a co-apprentice with Rogier in Campin's studio. Although the execution here is poor, one may with some confidence claim that a missing original of Berlin 6 was by Campin, distinct both in details of style (e.g. the type of the Child) and in power from any work to be associated with Daret. It would further be difficult to credit that the postulated original was derived from (instead of inspiring) Daret's merely competent picture. Other copies or derivations are known; see Friedländer, 1967, no. 76. One, from the René de la Faille de Waerloos Collection 1903, is in the Fitzwilliam Museum at Cambridge; *Catalogue*, vol. 1, 1960, pp. 32 f.; reproduced by Constable, *Catalogue of the Marlay Collection* (Fitzwilliam Museum), 1927, Plate XVIII. Another at Verona is reproduced by Dülberg, *Frühholländer in Italien*, plate XXXXII and in the *Revue de l'Art Ancien et Moderne*, vol. LVI, 1929, p. 135. Another much varied is at Utrecht; reproduced by Hoogewerff, *De Noord-Nederlandse Schilderkunst*, vol. III, 1939, fig. 34. A drawing is at Berlin; Sonkes (1969, no. C 3) thinks this the nearest record known to the postulated original.

The Berlin picture was acquired with the Solly Collection in 1821.

Friedländer, 1967, no. 76; plate 102
Panofsky, 1953, index.

Portraits of Barthélemy Alatruye and his Wife Marie BRUSSELS
de Pacy (A Pair?)
Brussels, Musées Royaux des Beaux-Arts de Belgique
Each 17½ × 12½ in. (0.445 × 0.315 m.), without the frames.
These pictures are summarily dealt with here; they may have been executed in the sixteenth century. Coats of arms are stated to identify the sitters; Alatruye (d. 1446) lived at Lille, Marie de Pacy died 1452. They are painted over different coats of arms.
Friedländer, 1967, no. 69, as possibly old copies. They, or one or other of them, may be copied from work by Campin; they are presented as a pair, but the marked difference of scale may suggest that the postulated originals did not form a pair.
Discussed at length by E. Renders and F. Lyna in the *Gazette des Beaux-Arts*, November 1931, pp. 289 f.
They have been in the Brussels Museum for a long time; 1845 Catalogue, nos. 406, 407. On deposit at the Musée at Tournai (nos. 432, 433 of the 1971 Catalogue).

Friedländer, 1967, no. 69; plate 98
Panofsky, 1953, index.

The Mass of Pope Gregory BRUSSELS
Brussels, Musées Royaux des Beaux-Arts de Belgique
33½ × 28¾ in. (0.85 × 0.73 m.).

One of two (?) closely corresponding versions.
Pope Gregory I, accompanied by a Cardinal and an acolyte, kneels before an altar on which Christ stands displaying His Wounds. On the wall behind are Instruments of the Passion in a form that with many variations was popular, especially in Flanders in the fifteenth century; sometimes referred to as the *Arma Christi*. See for instance Corpus, *Granada*, 1963, pp. 112 f. Here, no description of the details of the main subject, or of subsidiary iconography. Friedländer, 1967, no. 73, mentions two versions, one from the Moreira Collection being probably the picture now in Brussels (Friedländer, no. 150); he considers that they record a lost painting by Campin. The other version mentioned, from the Weber Sale of 1912 and later Schwarz, New York, seems to be dated 1510 or 1514, which Fried-

länder objects to as in disaccord with the style; entry for it in the exhibition catalogue *Flanders in the Fifteenth Century*, Detroit, 1960, no. 10. The Brussels and Weber pictures are reproduced in Friedländer, 1967, plate 100; references to articles by Valentiner and Musper in Friedländer, 1967, notes 132 and 169. The version at Brussels has been claimed to be an original, which I do not accept; I am not at present convinced that Campin should be associated with the composition.

A suggestion has sometimes been made that an example of this composition, as one half of a diptych by Rogier, was in the collection of Margaret of Austria in the early sixteenth century; this may be neglected for imprecision and improbability. Consult, for instance, Winkler, 1913, pp. 184–5.

A derivative by the Westphalian Master of 1473 forms part of an altarpiece dated 1473 in the church of Maria zur Wiese at Soest; see *Westfälische Maler der Spätgotik 1440–1490*, catalogue of an exhibition at Münster, 1952, no. 234, reproduced.

The picture at Brussels seems to be identical with one in the Moreira Collection at Lisbon in 1898; see J. Moreira Freire, *Un Problème d'Art, L'Ecole Portugaise Créatrice des Grandes Ecoles*, 1898, repr. opp. p. 174, as Memling. Acquired by Brussels, 1932.

Friedländer, 1967, nos. 73, 150; plate 100
Panofsky, 1953, index (New York, Schwarz).

The Annunciation: Brussels, Musées Royaux des Beaux-Arts; see Campin: New York.

The Madonna of Humility
Brussels, Collection of the late Baronne Gendebien
18½ × 14¼ in. (0.47 × 0.36 m.).

The Virgin holding the Child is seated on the ground in a garden, in front of a low wall, the upper side of which is also covered with plants. The presentation is similar to that of a *Virgin and Child*, Campin: Berlin 1 (q.v.). A pot of lilies is shown. A crescent moon at the Virgin's feet refers to the Woman of the Apocalypse (Revelation, XII, 1; see Panofsky, 1953, p. 128).

The picture, as said to be monogrammed v.w., and associated with Rogier, was exhibited by G. Muller at Brussels in 1935. It was ascribed to Campin by C. de Tolnay, *Le Maître de Flémalle et les Frères van Eyck*, 1939, p. 16 (G. Muller, Brussels). Panofsky, 1953, records on p. 426 his informa-

tion that Tolnay had abandoned the ascription to Campin himself. Panofsky, 1953, p. 143, as a faithful copy of Campin. It seems remote, at least in execution, from Campin; it is recorded summarily here.

Nevertheless, some compositional similarity can be found to a *Virgin and Child* known in several versions, which are supposed related in some way to a picture at Aix (Campin; q.v.); also to the *Virgin with a Flower*, believed to be based on a design by Rogier (see Rogier: Various Collections 3). Lent by G. Muller to the exhibition *Cinq Siècles d'Art*, Brussels, 1935, no. 13 of the picture section.

Friedländer, 1967, no. 151; plate 142
Panofsky, 1953, index (Brussels, Müller).

The Annunciation: Cassel, Staatliche Kunstsammlungen; see Campin: New York.

St. John the Baptist (Fragment)
Cleveland, Museum of Art
6¾ × 5 in. (0.173 × 0.125 m.).

Cut at bottom. The complete panel may have originated with others, but speculation is unsure.

Ascribed to Campin by P. Pieper, following an opinion of Winkler, in *Pantheon*, vol. XXIV, 1966, pp. 278 f. The attribution is uncertain; if correct, the work would be early. Van Gelder in *Oud-Holland*, 1967, p. 2 f., thinks it earlier than Count Seilern's triptych (see Campin: London, Seilern).

In Christie's sale catalogue an inscription on the back is recorded, apparently the name of Albert Dürer. According to Pieper, *cit.*, p. 282, the picture was owned in Burgundy since the eighteenth century; believed at first in the Clermont-Tonnerre family, then Nettencourt-Vanbecourt and Le Molt.

Anon. sale at Christie's, 26 June 1964 (lot 44), as Cologne School. Acquired by Cleveland, 1966.

Friedländer, 1967, no. 149.

The Nativity
Dijon, Musée des Beaux-Arts
34¼ × 28¾ in. (0.87 × 0.73 m.).

At the entrance to a half-ruined shed in the country, the Virgin with hands raised apart and dressed in white kneels before the Infant naked on the ground, from Whose body

rays spring forth. Just behind, St. Joseph half kneels, holding a lighted candle. To the right are the two midwives of the Virgin, one traditionally best known as Zelomi or Zebel; the other (behind) as Salome—her hand withered because of her unbelief. Within the shed, ox and ass; three shepherds lean over a half-door into it, the foremost one half kneeling on the low wall that forms the base of the shed. In the air, three angels to the left, one towards the right. The landscape is mostly under the beams of the sun, certainly conceived as rising rather than setting (the shadows on the main figures are independent). A winter scene, but with no snow on the hills.

Inscriptions on scrolls refer. Round the head of the unbelieving midwife, *Salome* and *Credam qum probauero*; the scroll of the angel just above her, *Ta(nge . . .?) puerum et sanaberis*. The scroll of the believing midwife, *Virgo peperit filium*, and the name seemingly *Azel* (this name has not been found for her; perhaps it is or was meant for Zebel?). The scroll of the three angels at the left, *Gloria in excelsis*, etc.

Panofsky, 1953, pp. 125 f., refers to the iconography in connection with the Revelations of St. Bridget, which give the Virgin in a plain white dress, and St. Joseph's candle, of which the material light was annihilated by the radiance from the Infant Christ nude on the ground. Compare Rogier's Bladelin altarpiece (Berlin 4), where much of this is also shown. For the midwives of the Virgin, see E. Mâle, *L'Art Religieux de la Fin du Moyen-Age en France*, 2nd edition, 1922, pp. 54–5. Further iconographical comment by Tolnay, *Le Maître de Flémalle et les Frères van Eyck*, 1939, pp. 14 f. The edge of the Virgin's mantle bears words from a prayer to the Virgin, closely corresponding with one fragmentarily preserved in a woodcut believed to be from Nuremberg, ca. 1475; see W. L. Schreiber, *Handbuch der Holz- und Metallschnitte*, vol. II, 1926, no. 1039a.

Generally accepted as by Campin; Friedländer, 1967, no. 53. In his text of 1937, specified as a picture amalgamable into Rogier's oeuvre; Friedländer, 1967, p. 55.

One may claim a loose compositional connection with the earlier style *Nativity* in the *Très Riches Heures* at Chantilly: see Panofsky, 1953, p. 159 and fig. 81.

G. Van Camp in the *Revue Belge d'Archéologie et d'Histoire de l'Art*, 1951, pp. 295 f., suggested that the landscape in the picture is a view of Huy; this rather attractive suggestion was denied in detail by Génicot in the *Bulletin de la Commission des Monuments et des Sites*, 1960, pp. 175 f.

The composition shows a fairly close relationship, for the angels one may say amounting to copying, with Daret's

Nativity (finished by September 1435) in the Schloss Rohoncz Collection at Lugano. Daret was an apprentice of Campin until 1432; his uninspired character, deducible from his surviving paintings, makes it likely that Daret was the borrower.

The figure of Zebel recurs adapted in *The Birth of the Virgin*, wing of an altarpiece by the Master of Frankfurt in the Historical Museum at Frankfurt; Friedländer, *Early Netherlandish Painting*, vol. VII, *Quentin Massys*, 1971, no. 129 and plate 100. A reminiscence of the *Virgin and Child* at Leningrad (q.v., Campin) is also found in that picture. A drawing that seems freely copied from the Virgin here is at Carlsruhe; Sonkes, 1969, B 6.

The picture was bought for Dijon in 1828 (previous provenance speculative); then (or not much later) bearing an attribution to Memlinc. See P. Quarré in the *Bulletin de la Société des Amis du Musée de Dijon*, 1944/5, p. 33.

Friedländer, 1967, no. 53
Panofsky, 1953, index.

Fragment from the Right Wing of a Triptych: **The Bad Thief of Calvary on his Cross, with two Spectators seen at Half-Length**
Frankfurt, Staedelsches Kunstinstitut
$52\frac{1}{4} \times 36\frac{1}{2}$ in. (1.33 × 0.925 m.).

The front of the original picture is presumed to be faithfully reflected to the best of the copyist's ability in a copy at Liverpool, referred to at more length presently: except notably for the donor there and possibly a figure associated with him, and blue sky instead of a gold background. The Liverpool picture (Plate 133) is a triptych, showing in the central panel Christ being taken down from the Cross. The right wing includes what is seen in the original at Frankfurt, the two spectators being shown entire. The other Thief (whose face is turned upwards, and blindfolded) is on the left wing.

The Frankfurt fragment is indeed part of a shutter, since there is retained on the back the upper part of a male saint, under a baldacchino, in a niche, painted in grisaille (Plate 139); this was almost entirely concealed by overpainting until 1970. It is seriously damaged.

A suggestion has been made (e.g. by Beenken, 1951, pp. 24, 48) that the central panel of the original showed, not the Deposition, but the Crucifixion. This is based less on the derivative use of some figures in certain Crucifixions (see below) than on the attitude of the two spectators, which it

Plate 167

FRANKF
1
Plates 13

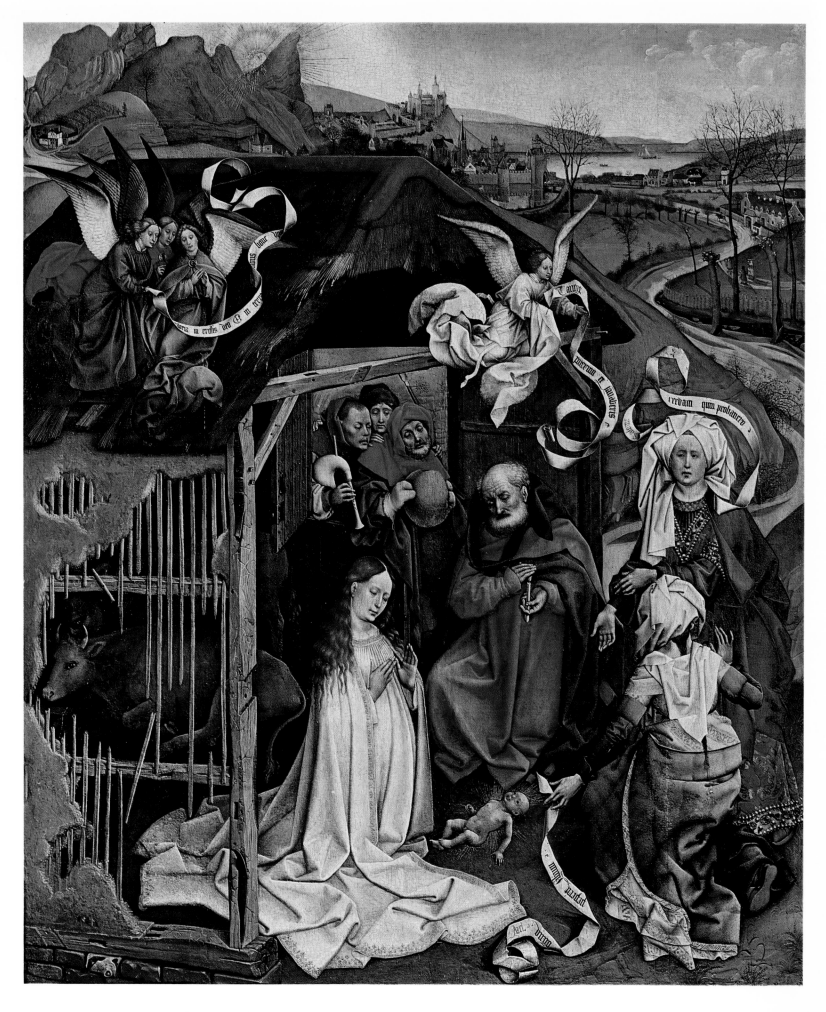

The Nativity. Dijon, Musée des Beaux-Arts (Cat. Campin, Dijon)

is claimed would accord better with Christ on the Cross in the missing central panel. But there does not seem to be good reason for supposing the Liverpool Triptych in the main to be other than faithful to the original; indeed, if the spectators are not suitably placed for a Deposition, why should the inferior painter of the Liverpool picture have been allowed to introduce them into one?

The Thief here, from his position to the left (our right) of the missing central group with Christ, and turning away from Christ, is certainly the Bad Thief; see Panofsky, 1953, p. 168. Attempts have been made to show that he is the Good Thief. This is partly because he does not look as bad as a secondary painter would in simplicity display the Bad Thief; more because of a print by the Master of the Banderoles, the confusion of which is recorded presently. In favour of this claim, see for instance J. Held in *The Art Bulletin*, 1955, pp. 213–14. It may be mentioned that both Thieves are blindfolded in the *Crucifixion* ascribed to Hubert van Eyck at New York (Friedländer, *Early Netherlandish Painting*, vol. I, 1967, Plate 36); a few comparable examples of both Thieves blindfolded are known. In the two versions of *The Mass of Pope Gregory* (Campin: Brussels 2) the central panel of the retable on the altar shows the Crucifixion; only one of the Thieves is visible, to Christ's right, and he is blindfolded. From further slight enquiry I find (if I see correctly in the reproductions available to me) several German examples of one Thief blindfolded, the other not. A Thief clearly characterized as bad, and correctly placed at Christ's left, is the one shown blindfolded in A. Stange, *Deutsche Malerei der Gotik*, vol. VI, 1954, Plate 166. Stange, vol. XI, 1961, Plate 227, shows the two Thieves characterized, and correctly placed with regard to Christ; it seems clear that here the good Thief is blindfolded, and it is reasonable to suppose that the bad one is not. Often the Thieves are not characterized except by their position. Examples of the Thief on Christ's right being the one who is blindfolded: Stange, vol. VI, Plate 103; Stange, vol. X, 1960, Plate 131; an altarpiece from Haverbeck associated with Hermen Rode, at Hanover (reproduced in the catalogue, vol. I, *Gemälde*, etc., 1930, p. 87, no. 138; not reproduced by Stange). It seems clear that there was no rigid tradition for painters in this matter; Campin may have represented the bad Thief at Frankfurt not blindfolded from some casual influence, or else rather from psychological interest.

The two spectators, both Jewish in appearance, are looking upwards. The civilian appears to be looking at the Thief, the soldier rather towards Christ on the missing central panel (in the Liverpool copy, both are looking at the scene in the central panel). Panofsky, 1953, p. 168, considers that this soldier is the centurion who believed; indeed his gesture seems to indicate faith.

The cloth round the thief's loins is a shirt. In Geertgen's *Deposition* at Vienna, the thieves wear shirts or tunics.

The grisaille on the back would be an early example of this taste, but probably less early than the two saints on grisaille on the back of *The Marriage of the Virgin* in the Prado at Madrid (no. 1; q.v.).

The size of the original was very large for the Early Netherlandish School. Panofsky, 1953, p. 167, says that the triptych with shutters open would have measured about $7\frac{1}{2} \times 12$ feet (about 2.30×3.70 m.).

The original triptych (as deduced from the Liverpool Triptych) was well known from early on, as is shown by the number of derivations from it; one example of these has wrongly been used to date it before 1430, in particular by Hulin. The reference is to a book of miniatures, known as the d'Arenberg Book of Hours or the Book of Hours of Catherine of Cleves, now in the Pierpont Morgan library in New York. The *Descent from the Cross* is partially reflected, with much variation, in one miniature; the two Thieves in another, where the main subject is *The Crucifixion* (believed to be based on a work by Campin; see under Lugano). Panofsky, 1953, figs. 129, 130. These miniatures are not dated, or reasonably datable 1430, and are considered most probably to be of ca. 1440; see for instance, Paul Pieper, 'Das Stundenbuch der Katharina van Lochorst und der Meister der Katharina van Kleve' in *Westfalen*, 1966, pp. 97 f., and John Plummer, *The Miniatures in the Book of Hours of Catherine of Cleves*, 1966.

Friedländer, 1967, pp. 53 f. (text of 1937) made the Frankfurt *Thief* the key picture for amalgamating most of Campin's oeuvre with Rogier's; but see Panofsky, 1953, pp. 168–9, for radical disagreement. I side with Panofsky, calling it Campin.

The rough landscape might be assigned to Campin's studio; but the distant landscape in the Dijon *Nativity* (q.v.) is also rather roughly executed.

Many derivatives are known from the original (as deduced from the triptych at Liverpool). Some appear combined with derivations from other sources. A selection is recorded here, some of which (and some others) are listed by Panofsky, 1953, p. 423 (note 1 to p. 167).

The Liverpool Triptych (Plate 133), already several times referred to, is on a much reduced scale; $23\frac{1}{2} \times 23\frac{3}{4}$, $10\frac{3}{8}$ in. (0.595×0.60, 0.265 m.). See the Liverpool catalogue, 1963,

pp. 39 f. It may be of ca. 1475. As has been noted, the two spectators of the Frankfurt fragment are shown entire; the sky is blue. On the left wing, besides the Good Thief on his Cross, is a standing female (?) saint (?) with a pot, and a kneeling male donor; presumably at least the second was not so in the original. The outsides of the shutters show SS. Julian and John the Baptist; presumably neither of them copied. On the right wing is a shield partly cut away, usually admitted to show the arms of Bruges; this is doubted in the Liverpool catalogue. The picture comes, according to tradition, from the hospital of S. Julian at Bruges; first recorded in the Roscoe Collection, 1816.

An engraving assigned to the Master of the Banderoles (Plate 134), supposed to have been active ca. 1450–70, is based mostly on Rogier's *Deposition* now in the Prado (Madrid 1); but the two Thieves on their Crosses have been added. One of these is the Good Thief seen in the Liverpool picture; but he and his position have been inverted in the making of the print—he is transferred there to Christ's left and is labelled there as the Bad Thief. It is chiefly from this that the wrong deduction has been made that the other Thief in the Liverpool picture, who is the same as the one at Frankfurt, cannot be the Bad Thief, but is the Good Thief. On the print, the figure that is labelled as the Good Thief does not correspond with the figure at Frankfurt, but appears to have been invented for the print in derivation from the other Thief, with a change of viewpoint rather than of pose.

For works with derivations from the composition under discussion that have entries in this catalogue, see the Riggisberg Triptych (q.v. Rogier; connection with the two spectators at Frankfurt); a less precise connection with one is in the Bladelin Triptych (Rogier: Berlin 4); and a *Crucifixion* claimed to derive from Campin (see under Lugano; the reference here is to one of the already mentioned miniatures in the d'Arenberg Book of Hours, compositionally distinct except for the addition of the two Thieves).

The Master of the Banderoles appears not to have been the only engraver to use the composition. Master IAM of Zwolle (ca. 1440–1504) appears in his smaller *Crucifixion* to have used the two Thieves, especially the Good one of the Liverpool painting. Hollstein, *Dutch and Flemish Etchings, Engravings and Woodcuts*, vol. XII, pp. 258–9, with reproduction.

Derivations in various pictures need not always depend on such prints. The Bad Thief at Frankfurt may have been the basis for the Good Thief of a Crucifixion in a Diptych at Chantilly; possibly the two spectators there (much varied) are also derived. Friedländer, 1967, no. 88, plate 107, as Follower of Rogier. The Good Thief (as at Liverpool) seems to have been used for the Good Thief of the Crucifixion in a triptych assigned to Joos van Gent (Wassenhove) in the cathedral of Ghent; Friedländer, vol. III, *Dieric Bouts and Joos van Gent*, 1968, plate 103. Several of the figures recur in a triptych in S. Sauveur at Bruges, the name-piece of the Master of the Bruges Passion Scenes (also called Bruges Master of 1500), probably painted soon after 1500 and presumably since its origin in S. Sauveur; this picture also includes derivations from Memlinc and Dürer. See the exhibition catalogue, *Primitifs Flamands Anonymes*, Bruges, 1969, no. 26. Several figures recur also in a *Deposition* presumed of the early sixteenth century, doubtfully ascribed to Joos van Cleve, at Dresden; see the Dresden catalogue, *Niederländische Malerei 15. und 16. Jahrhundert*, 1966, p. 17, plate 15. There are some reminiscences in a *Deposition* at Niederwaroldern, dated 1519, where also there are reminiscences of the *Deposition* at Madrid and the Riggisberg Triptych (Rogier: Madrid 1 and Riggisberg); see Medding in the *Zeitschrift für Kunstgeschichte*, 1938, pp. 119 f. In a triptych in Segovia cathedral, assigned to the Bruges painter Benson, there are several reminiscences of the Descent from the Cross and of the two spectators at Frankfurt; see G. Marlier, *Ambrosius Benson*, 1957, pp. 153 f., and J. Held in *Les Arts Plastiques*, 1949, pp. 197 f.

A drawing of the Good Thief as at Liverpool, best considered a copy, is in the Fogg Museum of Art, Cambridge, Mass.; Sonkes, 1969, pp. 127 f., no. C 20. A drawing of figures in the missing central panel (known from the copy at Liverpool) is in the Fitzwilliam Museum at Cambridge; Sonkes, 1969, no. C 21. This central composition may be compared, though not precisely, with the *Deposition* in the Prado (Rogier: Madrid 1).

As has been noted, a painted copy at Liverpool presumed to be in the main faithfully after the whole composition, and another picture in S. Sauveur at Bruges that includes several figures from it, are believed to have been painted for Bruges; a varied derivation at Segovia is, further, assigned to Benson, who was active at Bruges. It may be, therefore, that the original was commissioned for Bruges. No part of the original except the fragment at Frankfurt is known to survive. That is most probably recorded at Aschaffenburg, as style of van Eyck, in a letter from Cornelius to Boisserée, 13 May 1811; see *Monatshefte für Kunstwissenschaft*, 1913, pp. 377–8. Bought for Frankfurt from Pfeilschifter, 1840.

Friedländer, 1967, no. 59
Panofsky, 1953, index (Frankfurt; Liverpool).

Three Panels: **The Virgin standing, holding the Child; St. Veronica standing; The Trinity** (in grisaille)
Frankfurt, Staedelsches Kunstinstitut
The Virgin and Child, 63 × 26¾ in. (1.60 × 0.68 m.)
St. Veronica, 59½ × 24 in. (1.515 × 0.61 m.)
The Trinity, 58¾ × 24 in. (1.49 × 0.61 m.). A good deal damaged.

From their common provenance, and approximate correspondence in size, the three pictures are well considered to go together. There is no reason to doubt the statement that the *Trinity* once formed the back of the *St. Veronica*. On the back of the *Virgin and Child* is a *Mater Dolorosa*, as now seen in a later style; Mojmír S. Frinta, *The Genius of Robert Campin*, 1966, pp. 47 f. and Fig. 34, thinks it an overpainted original. The pictures might have been shutters to a triptych, of which the central panel (presumably a picture) is missing.

X-radiographs of various parts in Kurt Wehlte, 'Röntgenologische Gemäldeuntersuchungen im Städelschen Kunstinstitut', *Städel-Jahrbuch*, vols. VII–VIII, 1932, pp. 225, 227; Alan Burroughs in *Metropolitan Museum Studies*, vol. IV, Part 2, 1933, pp. 144–5 and *Art Criticism from a Laboratory*, 1938, fig. 111; C. Wolters, *Die Bedeutung der Gemäldedurchleuchtung mit Röntgenstrahlen für die Kunstgeschichte*, 1938, plate 17; Mojmír S. Frinta, *The Genius of Robert Campin*, 1966, figs. 30, 31.

The Child the Virgin suckles is clothed. The Trinity carries an inscription, SANCTI TRI(N)ITAS VNVS DEVS. It is an early example of a grisaille painting on the outside of a shutter; see the comment to *The Marriage of the Virgin* in the Prado (Campin: Madrid 1). For a special comment on the iconography of the Trinity, here and at Leningrad (q.v.), see Panofsky, 1953, pp. 124–5.

These pictures, reputedly from the Abbey of Flémalle, are the name-pieces of the Master of Flémalle, who is also written of as the Master of Merode, and here is referred to as Robert Campin. Like others they have from time to time been ascribed to Rogier. In 1924 Friedländer opted for Campin, while stressing connections with Rogier (Friedländer, 1967, pp. 71–2, no. 60 and p. 40); in 1937 these are among the pictures specified as amalgamable with Rogier by Friedländer (1967, p. 55). Some comment on the attribution, especially *The Trinity*, is made in the Essay here.

The top part of the design of the Virgin and Child is related to one frequently occurring, usually as a small tondo; see Campin: Various Collections. A painting after the top part of the Virgin and Child at Frankfurt is in the Museo Lázaro-Galdiano at Madrid; Friedländer, 1967, plate 89.
For a list of representations of the Trinity more or less related to the one here, see Corpus, *Louvre*, vol. 1, 1960, pp. 80 f.; in particular, a picture at Louvain (q.v., with further comment); also the outside of a shutter of the Edelheer altarpiece in St. Peter's at Louvain (Fig. 16), recorded under copies and derivations in Rogier: Madrid 1. Also a picture at Leningrad (q.v.) for which see Corpus, *Leningrad*, 1965, no. 108.
A good drawing after the *St. Veronica* is in the Fitzwilliam Museum, Cambridge; Sonkes, 1969, no. B 25.
Passavant saw these pictures (already separated to be three) in the possession of Ignaz van Houthem, and records their provenance from the abbey of Flémalle near Liège (apparently there was never any such abbey); see *Messager des Sciences de Belgique*, 1842, p. 229 or *Kunst-Blatt*, 1843, p. 262. E. Firmenich-Richartz, *Sulpiz und Melchior Boisserée als Kunstsammler*, 1916, p. 523, gives a note of 1848 that the three pictures were from Falin and bought by van Houthem from a priest in Liège; this matter better in the *Monatshefte für Kunstwissenschaft*, 1913, p. 377. S. Reinach claims neither from Flémalle nor from Falin, and suggests Elant; see the *Revue Archéologique*, July–December 1930, pp. 223 f. Bought for Frankfurt from Ignaz van Houthem, Aachen, 1849.

Friedländer, 1967, no. 60
Panofsky, 1953, index.

Judith and Holofernes: Greenville, Bob Jones University; see Campin: Berlin 5.

Diptych: The Virgin with the Child by a Fireplace; The Trinity
Leningrad, The Hermitage
Each, original painted surface, 11¼ × 7¼ in. (0.285 × 0.185 m.); each panel, 13⅝ × 9½ in. (0.345 × 0.24 m.). A diptych, originally hinged; marbled paint on the backs. The fronts show painted borders, not contemporary, replacing framework. The place of the Trinity is on the left.

An elaborate entry in Corpus, *Leningrad*, 1965, pp. 5 f., with reproductions of infra-red, ultra-violet and X-ray photographs.

For comment on the iconography of *The Trinity*, here and in the Campin at Frankfurt (q.v.), see Panofsky, 1953, p. 124 f. For a somewhat similar Trinity, see Campin: Louvain and particularly Corpus, *Louvre*, 1962, no. 87 (Colÿn de Coter). Among other more or less similar representations, there is the outside of a wing of the Edelheer altarpiece in S. Pierre at Louvain, referred to under Rogier: Madrid 1. *The Trinity* includes on the throne sculptures of Church and Synagogue; cf. Campin: Aix. Also the Pelican in her Piety (symbol of Redemption), and a lioness bringing her cubs to life (symbol of the Resurrection; lionesses were reputed to bear cubs dead and roar at them after three days to bring them to life).

Fig. 16

The Virgin on two cushions on the floor is to be classed as a Madonna of Humility (cf. the comment under Campin: London 2). The basic meaning of her gesture may be protecting the Child from the fire's too strong heat after His bath; there have been other attempted explanations.

Accepted by Friedländer, 1967, nos. 64, 65. Panofsky, 1953, p. 172, inclines to think that *The Trinity* may be only a replica. See further the remarks by J. Bruyn in *Oud Holland*, 1970, pp. 135 f.

A derivative of the panel showing the Virgin, formerly in the Cook collection, is at Greenville; Friedländer, 1967, no. 156; Greenville catalogue, vol. II, 1962, no. 130, reproduced. See further the name-piece of the Master of Frankfurt in the Historical Museum at Frankfurt (Friedländer, *Early Netherlandish Painting*, vol. VII, *Quentin Massys*, 1971, no. 129, plate 100); also in that picture is a figure taken from *The Nativity* (Campin: Dijon). The poses of the Virgin and the Child recur elsewhere, e.g. in a tondo at Berlin (No. 608), ascribed to Patenier.

The original pictures were bequeathed to the Hermitage by Dimitri Tatistcheff, 1845.

Corpus, *Leningrad*, 1965, no. 108
Friedländer, 1967, nos. 64, 65
Panofsky, 1953, index.

LE PUY **The Holy Family**
Le Puy, Cathedral
Canvas, 82 × 71 in. (2.085 × 1.805 m.).

See V. Bloch in *The Burlington Magazine*, vol. CV, 1963, p. 72, as a copy of a Campin composition; and (together with a copy in the Chapelle de la Mission Diocésaine at Clermont-Ferrand) J. Dupont in *Les Monuments Historiques de la France*, 1966, pp. 150 f. This picture is indeed suggestive of Campin, although considered to be of later date. It may reflect fairly accurately a lost work of his, or even be an original by a follower of his; but cf. C. Eisler in *The Burlington Magazine*, vol. CV, 1963, p. 371, and objections to Eisler's claims by Charles Sterling in *The Art Bulletin*, March 1971, p. 5, note 24. Details are not gone into here.

Friedländer, 1967, no. 153; plate 143.

The Deposition: Liverpool, Walker Art Gallery; see LIVERPOO Campin: Frankfurt 1.

A Man: A Woman LONDON
London, National Gallery Plates 163
Each 16 × 11 in. (0.407 × 0.279 m.).

The *Man* is rather damaged. X-radiographs of the *Woman* given by Alan Burroughs in *Metropolitan Museum Studies*, vol. IV, Part 2, 1933, p. 146, and of the *Man* in *Art Criticism from a Laboratory*, 1938, fig. 113; remains of plain painting on the backs, probably original, disturb the X-ray images. These pictures, which were together when first known to be recorded in 1832, seem obviously pendants, portraits of man and wife. Mojmír S. Frinta, *The Genius of Robert Campin*, 1966, pp. 57 f., expresses some restriction on this. Although it is difficult not to consider them a pair, it is noteworthy that the light comes from different directions; see the comment by Panofsky, 1953, p. 172, on portraits with heads averted from the light.

An attribution equivalent to attribution to Campin was doubtfully made by Bode in the *Gazette des Beaux-Arts*, 1887, vol. I, pp. 218 f. Attribution accepted by Winkler, 1913, pp. 52 f. Accepted by Friedländer, 1967, no. 55; in his text of 1937 (1967, p. 55) he specifies them in his list amalgamating most pictures assigned to Campin into Rogier's oeuvre. Accepted by Panofsky, 1953, p. 425. Frinta, *The Genius of Robert Campin*, 1966, pp. 57 f., rejects the attribution to Campin of the *Man*, which he sees as in the Eyckian tradition, or perhaps an early sixteenth-century copy.

The present writer in the catalogue of the *Early Netherlandish School* at the National Gallery, 1945, 1955 and 1968, classed the two pictures as Ascribed to Campin; it now seems to him wrong to separate them at all from the key-pieces for attribution to Campin.

The *Woman* shows apparent similarity to a female portrait at Berlin (Rogier: Berlin 2), which the present writer accepts as by Rogier. The similarity may well be much less than the difference.

The two portraits were by 1832 in the Campe Collection at Nuremberg; E. Firmenich-Richartz, *Die Brüder Boisserée*, vol. I, *Sulpiz und Melchior Boisserée als Kunstsammler*, 1916, p. 514. Dr. Frederick Campe sale, London, 18 May 1849 (lots 37, 38). Acquired as part of the Edmond Beaucousin Collection, Paris, by the National Gallery in 1860.

Corpus, *London*, vol. I, 1953, no. 33
Friedländer, 1967, no. 55
Panofsky, 1953, index.

LONDON 2 **The Virgin and Child before a Fire-Screen**
Plate 160 London, National Gallery
25 × 19¼ in. (0.635 × 0.49 m.). The original picture has been clearly cut at the top and the right-hand side, and thereafter extended. The present size of the painted surface is probably fairly well what the artist wished. About 1¼ in. (3 cm.) of this at the top and about 3¾ in. (9.5 cm.) at the right are of modern fabrication; so, cupboard and chalice are modern. It is not known what the reconstructionist had to go on; but a derivative picture, believed of the later fifteenth century, gives a probably reliable indication for the original field of the picture, also some possible indications for details now missing from the original (see Joseph Destrée in *The Connoisseur*, April 1926, p. 209). This had been lent by Mme Reboux of Roubaix to the exhibition 'Les Arts Anciens du Hainaut' at Charleroi, 1911 (no. 4); size 18 × 15 in. (0.46 × 0.38 m.). See also the comment by Panofsky, 1953, p. 164.
X-radiographs show various *pentimenti*, which include alterations in the Child. They are not very clear, except for the Child's eyes having at first been turned the other way. Mojmír S. Frinta, *The Genius of Robert Campin*, 1966, pp. 41 f.; Corpus, *London*, vol. I, plate CXLVIII.

The Virgin is apparently seated on a footrest in front of the bench, not on the bench itself. The picture has therefore been classed as a Madonna of Humility, i.e. of an iconographical class where the Virgin is shown seated on the ground or on a cushion on the ground; naturalistic detail throughout the picture brings it rather far from a Madonna of Humility precisely considered. See Millard Meiss, *Painting in Florence and Siena*, 1951, pp. 143, 156.
The lions on the bench are probably for the Lions of the Throne of Solomon (I Kings X, 19), symbol of the Virgin as Sedes Sapientiae.
Naturalistic treatment is striking in the depiction of the firescreen, which is clearly meant to suggest also a halo. A

firescreen of this type, but not used to suggest a halo, is seen in the de Limbourg miniature for January in the 'Très Riches Heures du Duc de Berry' at Chantilly; frequently reproduced, e.g. by Panofsky, 1953, fig. 88.
This is usually recognized as an important work in the group classed as Campin (Master of Flémalle).
Apparently from Enrico Carlo Lodovico di Borbone, Conte di Bardi, Parma (1851–1905), brother of Robert, last reigning Duke of Parma. Acquired by L. Somzée of Brussels, 1875 (?). Acquired from the Somzée collection by Agnew, 1902; G. Salting, 1903; bequeathed to the Gallery, 1910.

Corpus, *London*, vol. I, 1953, no. 36
Friedländer, 1967, no. 58
Panofsky, 1953, index.

The Virgin and Child with Two Angels (The Virgin in **LONDON 3**
the Apse)
London, National Gallery
22⅛ × 17⅜ in. (0.56 × 0.44 m.).

This specimen may not be the best of numerous versions, the composition sometimes being much varied. The design is usually attributed to Campin, but no version known to exist is normally accepted as executed by him. Friedländer, 1967, no. 74, wrote that, of such versions that preserve reflection of an early style, those where treatment of the perspective seems to flatten the apse come closest to the presumed original.
The composition has sometimes been misleadingly entitled *The Virgin of Salamanca*, from an incorrect claim that the apse shown is that of the Old Cathedral of Salamanca: see Sir J. C. Robinson in *The Burlington Magazine*, vol. VII, 1905, pp. 238 and 387, and Corpus, *London*, Vol. I, p. 61.
Some of the versions comparable in style with this one are: formerly at Minneapolis, Metropolitan Museum at New York, Private Collection at Loppem; Friedländer, 1967, plate 101 for all three. There are many other versions or variants in a later style, e.g. the styles of Gerard David and Bernaert van Orley. For much record, see Germain Bazin in *L'Amour de l'Art*, December 1931, pp. 495 f.; Corpus, *London*, vol. I, pp. 62 f.; Friedländer, 1967, pp. 74–5; National Gallery catalogue, *Early Netherlandish School*, 1968, p. 29; Friedländer, *Early Netherlandish Painting*, vol. IV, *Hugo van der Goes*, 1969, plates 40, 78, and vol. VI, *Hans Memlinc and Gerard David*, Part II, 1971, plate 222.
It is sufficient here to note that the specimen in the National Gallery was bequeathed by George Salting, 1910.

Corpus, *London*, vol. I, 1953, no. 35
Friedländer, 1967, no. 74; plate 101
Panofsky, 1953, index (New York).

LONDON 4 **The Death of the Virgin**
London, National Gallery
15 × 13¾ in. (0.38×0.35 m.) (approx.); top corners cut.
Considerable changes, acceptably by the original painter,
especially the removal of a tester to the bed and the intro-
duction of a view through a window; see National Gallery
Catalogues, *Early Netherlandish School*, 3rd ed., 1968, p. 29,
for details. X-radiograph and infra-red photograph in Cor-
pus, *London*, vol. I, plates CXXXIII/IV.

The version in the National Gallery is painted with skill; it
clearly reflects the style of Campin, though its execution
seems much later (early sixteenth century?). Two versions
fairly closely corresponding, at Berlin and Prague, do not
suggest Campin's style and do suggest the style of van der
Goes; often classed as copies after him. There are other
pictures possibly connected in composition, but loosely.
The existing pictures do not justify a long discussion here.
It may be that the composition was derived from ideas of
van der Goes (though hardly precisely from an invention
of his, whether painted or merely drawn), and that a late
pasticheur of Campin used it for the National Gallery pic-
ture. Although I think this picture much the best of those
known, it seems not relevant to Campin except in so far as
a later painter seems to have imitated Campin's style.
For the three pictures in London, Berlin and Prague, see
Friedländer, *Early Netherlandish Painting*, vol. IV, *Hugo van
der Goes*, 1969, no. 25 and plate 38. Another picture is there
mentioned, but not reproduced. See also Friedländer, *Die
Altniederländische Malerei*, vol. X, *Lucas van Leyden*, 1932, no.
148.
The National Gallery picture was in the Cᵗᵉ R Collection
(this is presumably the origin for a reputed provenance
from Charles I), then Sir Thomas Lawrence sale 1830,
Zachary sale 1838, King William of Holland sale, 1850;
acquired for the National Gallery with the rest of the
Edmond Beaucousin Collection, Paris, in 1860.

Corpus, *London*, vol. I, 1953, no. 34
Friedländer, 1967, no. 77; plate 103
Panofsky, 1953, index.

LONDON 5 **Portrait of a Man**
Plate 165 London, National Gallery

7⅞ × 4⅝ in. (0.187×0.117 m.). Including the original
frame, which is in one piece with the picture, 9×6 in.
(0.227×0.152 m.).
Infra-red and X-radiographs in Corpus, *London*, vol. III,
plates II–III. A pentimento to be mentioned, visible in an
X-radiograph: the sitter seems at first to have been holding
not a scroll, but a book.

It seems clearly to be a portrait by itself; no trace of marks
of hinges for attaching it to another picture.
The sitter may be of a religious order (a Benedictine?).
The picture was unknown in art literature until 1966.
Published as by Campin by the present writer in *The Burling-
ton Magazine*, December 1966, p. 622; National Gallery,
Early Netherlandish School, 3rd ed. of the catalogue, 1968,
p. 27.
From the collection of W. H. Nicholson. Acquired from
Messrs. Agnew in 1966 by the National Gallery (Grant-in-
Aid and Colnaghi Fund).

Corpus, *London*, vol. III, 1970, no. 124
Friedländer, 1967, no. 148.

Triptych: **The Entombment; The Thieves on their** LONDON,
Crosses with a Donor; The Resurrection SEILERN
London, Count Antoine Seilern Plates 144-
Centre, 23¾ × 19¼ in. (0.60×0.489 m.); wings, 23¾ × 8⅞ in.
(0.60×0.225 m.); excluding the original frames. The top
of the centre panel is formed of two round arches, side by
side, the wings are with rounded top. J. G. van Gelder 'An
Early Work by Robert Campin' in *Oud Holland*, 1967, p. 17,
notes on information from S. Rees Jones that on the backs
of the wings are remains of gesso bearing a design in grey
paint. Van Gelder in his article gives X-radiographs of the
wings. He notes that the writing on the donor's scroll has
been worn away.

The centre panel shows the body of Christ supported
above the Tomb; the Virgin, SS. John, Joseph of Ari-
mathaea, Nicodemus, three Marys. Panofsky, 1953, p. 160,
considers it a combination of *Entombment* and *Lamentation*.
Van Gelder, *cit*. pp. 13–14, says that the female figure
holding a cloth cannot be St. Veronica, who should not be
present; he thinks she is Mary Cleophas. On page 14 he
identifies St. Joseph of Arimathaea as the figure at Christ's
head. Angels at each side and in the sky hold Instruments
of the Passion. The background is gilt, with a design of
grapes (symbol of Christ's suffering and death on the

Cross). For more detail, see van Gelder in *Oud Holland*, 1967, pp. 1 f.

Generally accepted as by Campin, of a very early date: as indeed is suggested by the raised gold background and some awkwardnesses of drawing. Panofsky, 1953, p. 160. It seems indeed to be the major existing example of his early style.

Van Gelder, *cit.* records names written on the back, which suggest a provenance from Italy. Col. R. F. W. Hill of Bickleigh, Devon; Sale at Christie's, 14 August 1942 (lot 13), as Ysenbrandt. Collection of Count Seilern; Catalogue, *Flemish Paintings and Drawings at 56 Princes Gate, London*, 1955, no. 1. See further his volume *Corrigenda and Addenda*, 1971, pp. 15 f.; this is a substantial guide to recent comment, and in particular records a correction to van Gelder's identification of St. Joseph of Arimathaea (cf. Stechow in the Heydenreich *Festschrift*, 1964, p. 290; the correction probably does not apply to the identification of St. Joseph several times made elsewhere in my book).

Friedländer, 1967, no. 147
Panofsky, 1953, index.

LOUVAIN **The Trinity**
Louvain, Museum Van der Kelen-Mertens
49½ × 35½ in. (1.26 × 0.90 m.).

The Dove, which was on Christ's shoulder, is now almost entirely missing owing to damage in that area; see plates 1 and 2 (infra-red and ordinary light) given by J. Taubert in the *Bulletin de l'Institut Royal du Patrimoine Artistique*, vol. 2, 1959, pp. 20 f. The two uppermost of the four angels hold Instruments of the Passion: Cross, Spear, Nails. Iconographical comment on the composition in Corpus, *Louvre*, 1962, no. 87, pp. 74 f.

The well painted picture at Louvain seems to record a picture by Campin. A closely similar picture is part of an altarpiece signed by Colijn de Coter; it is larger—65¼ × 46 in. (1.66 × 1.165 m.). See for it Corpus, *Louvre*, 1962, no. 87; Friedländer, *Early Netherlandish Painting*, Vol. IV, *Hugo van der Goes*, 1969, no. 90. The relationship between the two has, with the use of infra-red photographs, been closely studied by J. Taubert in the *Bulletin de l'Institut Royal du Patrimoine Artistique*, vol. 2, 1959, pp. 20 f. A picture fairly closely corresponding to these two is at Brussels; Friedländer, *Die Altniederländische Malerei*, vol. IX, 1931, no. 201, as by the Master of the Holy Blood; Corpus, *Louvre*, 1962, plate XCI.

The general presentation, often much varied, occurs frequently and not only in paintings; lists in Corpus, *Louvre*, 1962, pp. 80 f. and Corpus, *Leningrad*, 1965, pp. 14 f. Early pictures separately recorded in the present book are one half of a diptych (Campin: Leningrad) and part of the altarpiece reputedly from Flémalle (Campin: Frankfurt 2); see also the outside of a wing of the Edelheer altarpiece dated 1443 in S. Pierre, Louvain (Fig. 16), recorded under Rogier: Madrid 1. Two engravings of the subject assigned to the Master of the Banderoles, supposed to have been active ca. 1450–70, are reproduced by Hollstein, *Dutch and Flemish Etchings, Engravings and Woodcuts*, vol. XII, on pp. 60, 61. A drawing (Sonkes, 1969, no. C 38) and two embroideries are reproduced in Friedländer, 1967, plate 99. Friedländer, 1967, no. 71a, does not admit the picture at Louvain as an original Campin. Panofsky, 1953, p. 175, says that the composition is possibly a workshop redaction rather than an original invention.

The widespread use of this presentation may suggest that Rogier picked it up (even perhaps helped to develop it) in Campin's studio, though it is not certain that Rogier's celebrity was necessary for the distributing. It has been put forward as an argument for the amalgamation of Campin and Rogier.

The picture at Louvain may have been publicly owned there for a long time. Recorded as Anon in the *Catalogue des Tableaux, Sculptures*, etc. *qui se trouvent à l'Hôtel de Ville de Louvain*, 1879, no. 35, no provenance stated.

Corpus, *Louvre*, 1962, no. 86 (Colijn de Coter's picture)
Friedländer, 1967, no. 71; plate 99
Panofsky, 1953, index.

The Crucifixion LUGANO

Two pictorial records are believed to reflect a lost painting by Campin. One is a painting assigned to Gerard David (0.88 × 0.56 m.) in the Schloss Rohoncz Collection (Baron Thyssen-Bornemisza) at Lugano; the other is a miniature in the d'Arenberg Book of Hours, or Book of Hours of Catherine of Cleves, now in the Pierpont Morgan Library at New York.

The two Thieves are seen only in the miniature; they correspond with, and are perhaps introduced there from the Thieves of a Triptych of the *Deposition from the Cross*, of which what seems to be mostly an accurate copy is at Liverpool, and of which part of the right wing showing the Bad Thief on his cross is preserved in the original (see Campin: Frankfurt 1).

The date of the miniature is probably ca. 1440. See for instance Paul Pieper, 'Das Stundenbuch der Katharina van Lochorst und der Meister der Katharina van Kleve', in *Westfalen*, 1966, pp. 97 f.; John Plummer, *The Miniatures in the Book of Hours of Catharine of Cleves*, 1966.

The claims are discussed by Panofsky, 1953, p. 176 f. (figs. 129 and 229). See also for the picture assigned to David, the exhibition catalogue *Collectie Thyssen-Bornemisza (Schloss Rohoncz)*, Rotterdam, 1959–60 (no. 65).

Friedländer, 1967, no. 157
Panofsky, 1953, index (David); fig. 229.

Bust Portrait of a Fat Man: Lugano, Thyssen-Bornemisza Collection; see Campin: Berlin 2.

The Marriage of the Virgin: The Annunciation
Madrid, Museo del Prado
On the reverse of *The Marriage of the Virgin*, grisaille figures of SS. James and Clare.
The Marriage of the Virgin, $30\frac{1}{8} \times 34\frac{1}{2}$ in. (0.765 × 0.88 m.);
The Annunciation, $30\frac{1}{8} \times 27\frac{1}{2}$ in. (0.765 × 0.70 m.).
X-radiographs of the *Marriage* in Mojmír S. Frinta, *The Genius of Robert Campin*, 1966, figs. 62–3.

These two pictures show considerable difference of style and of quality (*The Annunciation* being inferior), and they may have a difference of provenance (see further on); yet they may come from the same ensemble. Each is on three horizontal planks; *The Marriage* has not been cut, *The Annunciation* has been cut at the right. The reverse of the latter has been planed. See Friedländer, 1967, p. 100, note 48. Friedländer, no. 52, thinks that the two may have formed a diptych. Panofsky, 1953, p. 161, separating the two, thinks *The Marriage of the Virgin* is the wing of a folding triptych, where the subjects formed a cycle; this is said partly in connection with a derivative picture at Hoogstraten to be recorded later, where other scenes of St. Joseph are included.

The Marriage of the Virgin consists of two scenes: on the left St. Joseph, by his flowering rod already designated as the bridegroom, struggles to escape from the Temple and from his fate; on the right, the Marriage (the Virgin wears a gold crown with lily ornamentation). The Temple of Jerusalem is in a style of architecture that may be called Romanesque, which was used to suggest Oriental, also the Old Law. The New Law is indicated by the Gothic style of the portal before which the Marriage is taking place; the

unfinished Gothic building is shown as replacing the ancient Temple. Some reference to this is made in the Essay; more on this and on details of the iconography by Panofsky, 1953, pp. 134 f., also Birkmeyer in *The Art Bulletin*, 1961, pp. 10 f. Here noted: the glass of the Temple shows events from the Creation of Eve to the slaying of Abel, the capitals and reliefs other Old Testament scenes (Abraham, etc.); the tympanum of the Gothic portal shows statues of God and Moses, the scenes in the archivolts include Samson and the Lion, David and Goliath, the death of Absalom.

The Annunciation also shows references to the Old Testament; the sculpture includes statues of God, Moses, David. The stained glass includes Moses receiving the Tables of the Law, and the Sacrifice of Isaac. From the group of God and three angels seven rays descend towards the Virgin's head, as in the Merode Triptych (Campin: New York); but there the figure of the Child is included. In this picture the church is entirely Gothic except for the core of a tower, which is Romanesque.

The figures on the reverse of *The Marriage of the Virgin* are shown as unpainted statues in niches. St. James has a pilgrim's staff and a wallet marked with a cockle; St. Clare holds a pyx, frequent emblem for her, based on an incident of her life. Panofsky, 1953, p. 161, thinks these the earliest examples known to survive of figures painted as statues on the outside of a shutter in Netherlandish painting: a taste popular for many decades. Early, certainly; some grisailles on outsides, but probably not quite so early (though we have no precise dates) are here recorded for Campin: Frankfurt 1, 2. Panofsky, p. 162, refers to numerous records of statues in churches as being coloured, and suggests that the grisaille representations on pictures may show what the painters saw in their studios when these statues were sent to them to be coloured; this does not fully cover the frequent representations of uncoloured statues, set up in churches, that the painters depicted.

The Marriage of the Virgin is usually accepted as by Campin, *The Annunciation* less usually. Friedländer, 1967, nos. 51–2, accepts both; in his text of 1937 (1967, p. 55), he specifies both as pictures that might be fitted into Rogier's oeuvre. Panofsky, 1953, pp. 175 f., calls *The Annunciation* a pastiche; the presentation in a church would make it a pastiche of something in a rather old tradition. Lilli Fischel separates both from Campin, thinking them later; *Musées Royaux des Beaux-Arts, Bulletin*, vol. VII, 1958, pp. 3 f. But it seems to me unnecessary to hesitate about *The Marriage of the Virgin*.

The pose of the Virgin in *The Annunciation* is closely similar to that in the Merode Triptych at New York (q.v.). The Gothic portal in *The Marriage of the Virgin* has unconvincingly been claimed to be based on that of Notre-Dame du Sablon at Brussels. That portal is convincingly identified in later paintings assigned to the Master of the View of S. Gudule; it is true that two of these, showing *The Marriage of the Virgin*, are thought with some reason to have been influenced by Campin's composition (see the Bruges exhibition catalogue, *Primitifs Flamands Anonymes*, 1969, nos. 55–6; Friedländer, *Early Netherlandish Painting*, vol. IV, *Hugo van der Goes*, 1969, plate 69).

Plate 168 Probable influence of *The Marriage of the Virgin* is to be found in various details of Daret's *Presentation*, finished by September 1435, in the Petit Palais at Paris (Friedländer, 1967, plate 105): Daret was an apprentice of Campin until 1432. A certain, although varied, derivative is in a poor picture in the church at Hoogstraten, where there are also other scenes of St. Joseph; Friedländer, 1967, no. 82, plate 103.

According to the Prado catalogue of 1963, *The Marriage of the Virgin* entered the Escorial in 1584; two wings with inscriptions were presumably of later date (cf. the commentary to Rogier: Various Collections 2). According to the same source, *The Annunciation*, which had been acquired from Jacopo da Trezzo, entered the Escorial in 1577, but the date of entry for this picture is acceptably 1584; see the records of gifts by Philip II to that monastery, nos. 1399 and 1401 of Zarco Cuevas, *Inventario de las Alhajas*, etc., 1930 (no attribution for either picture). Old Prado catalogues gave the provenance of *The Marriage of the Virgin* as the Marqués de Leganés (D. Diego Felipe de Guzman), 1655; in this inventory as published by José López Navio in *Analecta Calasanctiana, Suplemento científico-literario de Revista Calasancia*, Año IV, 1962, p. 282 (p. 24 of the offprint), no. 298 there is 'una nrª señora a la puerta del templo, de mano del *mro. rugier* de una bara de alto y 3 quartas de ancho'. The size, indeed, seems to fit the Prado picture better than that given in the Escorial document, if *vara* is used (as it should be) to mean 83.6 cm. But the description is unsatisfactory; and if the picture entered the Escorial in 1584, how did it get out to Leganés in the following century? And how did it return there?

Both pictures passed in 1839 from the Escorial to the Prado at Madrid.

Friedländer, 1967, nos. 51, 52, 82
Panofsky, 1953, index (separate entries).

Two Shutters: St. John the Baptist introducing Heinrich von Werl; St. Barbara

Madrid, Museo del Prado
Each, 39¾ × 18½ in. (1.01 × 0.47 m.).

The painting showing St. John is rather damaged.

Faint traces of painting on the back of the *St. Barbara*, showing perhaps the haloes of a standing Virgin and Child, are recorded, e.g. in the Prado catalogue, 1963, p. 213. This was taken into account by Paul Pieper in developing an ingenious but unacceptable view concerning the original arrangement; *Wallraf-Richartz Jahrbuch*, vol. XVI, 1954, pp. 87 f.

The missing central panel, presumed to have been a painting, probably showed an interior; maybe there was a post of some kind in the right-hand bottom corner, the shadow of which would be what is seen in the left-hand bottom corner of the *St. Barbara*. The *St. John* would have been the folding left shutter, the *St. Barbara* the folding right shutter.

The donor is identified by an inscription at the foot of his panel, which also gives the date 1438. With abbreviations expanded, it runs: Ano milleno c quater x ter et octo hic fecit effigiem [] [dep?] ingi minister henricus werlis magister coloniensis. Cf. Tschudi, 1898, pp. 20–1; also pp. 113–114 for a suggested emendation and the claim that the inscription formed three hexameters. The inscription is indeed partly damaged, but it would be wrong to doubt the date of 1438.

Tschudi, 1898, p. 22, describes four coats of arms shown in the windows, but does not identify them. One of these corresponds with the conventional arms of Northern Guilds of St. Luke (see in Corpus, *New England Museums*, 1961, p. 74, with drawing).

Heinrich von Werl took his master's degree at Cologne in 1430. He was a great preacher, and Provincial of the Minorites (Conventual Franciscans); from 1432 he was a participant at the Council of Bâle; he died in 1461 at Osnabrück. See, for instance, E. Firmenich-Richartz in the *Zeitschrift für bildende Kunst*, 1898–9, pp. 2 f. An unnamed Provincial, reasonably believed to be Werl, is recorded to have been in Tournai in 1435; see Pieper, *cit.*, p. 96, with further references.

The donor's panel includes a mirror, in which the Baptist is reflected; also reflected are two figures (Franciscans, apparently; one a youth?) approaching from in front of the picture surface, indeed from out of doors. This seems clearly an imitation of the mirror and reflections in Jan van Eyck's *Arnolfini* in London, dated 1434. Fig. 20

On the back wall is a sculpture of the Virgin and Child, in Gothic style (Plate 150).

St. Barbara is identified from the building of her tower, seen through a window. Over the fireplace is a sculpture of the Trinity (Plate 151); this shows Christ fixed on the Cross, and so is not similar to a design known with variations in a good many examples (see Campin: Frankfurt 2 and Louvain, with comment). Curious reflections of light from the fire were noted by Winkler in the *Zeitschrift für Kunstgeschichte*, vol. IX, 1940, p. 67.

Jan van Eyck has been mentioned; his influence is claimed not only for the mirror but in the treatment of light in these pictures. Double shadows, frequently depicted by Campin, are noticeable here, e.g. on the wall above St. Barbara. Panofsky, 1953, pp. 254 f., contrasts the style of painting of some apparently similar objects in the present pictures and in *The Annunciation* in the Louvre (see under Rogier: Turin), which he accepts as Rogier's.

An attribution to Campin with some influence from Jan van Eyck is indeed usually agreed by the critics who do not amalgamate Campin and Rogier. It is thought that Werl might have given the commission at Tournai in 1435. Friedländer, 1967, no. 67 (text of 1924); in 1937 (1967, p. 55) these are among the Campin pictures he specifies as attributable to Rogier. Beenken, 1951, p. 26, accepting Campin's authorship, wonders nevertheless if the landscapes seen through the windows are not by Rogier.

No known characteristic Campin need be as late as 1438; Campin's late style is thus a peculiar speculation. It seems to the present writer most difficult to believe that Campin, six years after his formal association with Rogier had ended, three years at least after Rogier had moved from Tournai to Brussels, would have painted in the style of the present pictures: which clearly are in many ways strongly suggestive of Rogier, and of a Rogier presumed to have developed a good deal from the Rogier of Campin's studio. The suggestion of collaboration between Rogier and Campin in or towards 1438 is even harder to credit.

The painter was imitating van Eyck; but other imitation, either by Campin of Rogier or *vice versa*, is clearly to be presumed. The question is whether Campin would have imitated his ex-apprentice, and probably that ex-apprentice's style in a form more mature than when the two were together; or whether Rogier was here making some imitation of Campin.

The gesture as of withdrawal that St. John makes with his right hand, improper for a saint protecting a donor, has often been compared with the gesture of Christ in the *Christ Appearing to the Virgin* of the Granada Triptych (Rogier: Granada), where it is proper and may even have been invented for the scene there. It has been claimed that Campin here took over this gesture from Rogier without understanding it; it has therefrom been deduced that Rogier's Granada Triptych is earlier than the present pictures (1438). Friedländer, 1967, no. 67 and p. 13, at one time accepted this as a valid argument, but later (p. 55, text of 1937) rightly rejected it. The Granada Triptych may have been painted before 1438, though the two gestures do not prove this; the attribution of the present pictures seems unaffected by the matter.

The pose of the St. Barbara has often been compared with that of the *Magdalen Reading* (Rogier: London 1); relationship between the two figures appears closer with the reappearance from recent cleaning of a cupboard in the London picture. Parts of the setting in St. Barbara's panel appear to have served for an *Annunciation* probably of soon after 1453 in the Church at Schöppingen; most of that picture is related to the Merode *Annunciation* (Campin: New York), or rather to a variant at Brussels. See the exhibition catalogue, *Westfälische Maler der Spätgotik 1440–90*, Münster, Landesmuseum, 1952, no. 27, plate 8.

The two shutters were acquired by Charles IV (b. 1748, King of Spain 1788, died 1819). They passed in 1827 from Aranjuez to the Prado.

Friedländer, 1967, no. 67
Panofsky, 1953, index.

The Merode Triptych: **The Annunciation, St. Joseph and Two Donors**

New York, The Metropolitan Museum of Art (The Cloisters)

Central panel, 25⅛ × 24¾ in. (0.64 × 0.63 m.); wings, 25⅛ × 10¾ in. (0.64 × 0.27 m.).

The features and right hand of the male donor are damaged. Reproductions of the central panel and part of the donor's panel unrestored are given by Suhr in the *Bulletin* of the Metropolitan Museum of Art, December 1957, pp. 141–2. Changes in the donor's panel include the addition of the donatrix and the small figure in the background. Behind the windows of the central panel there was once gold. See Suhr, *cit.*, p. 144. It has been suggested that the donor married (or was betrothed) while the picture was being worked on. It has also been suggested, from this and some other incoherencies, that the donor's wing is by a hand

different from the painter of the other two parts; Mojmír S. Frinta, *The Genius of Robert Campin*, 1966, pp. 13 f., or in *The Art Quarterly*, 1968, pp. 247 f. X-radiographs and infra-red photographs are given by Frinta.

The central panel shows the Annunciation in an interior, with the Virgin humbly on the floor. A very small figure of the Infant Christ holding the Cross descends towards her down seven rays. In the right wing, St. Joseph is at work in his carpenter's shop. In the left wing, the donor and donatrix kneel in a garden, before a door that (badly fitting) opens into the Virgin's chamber in the central panel.

Two coats of arms on the windows of the central panel have been identified as Ingelbrechts of Malines and Calcum (?): see T. Rousseau in the *Bulletin* of the Metropolitan Museum of Art, December 1957, p. 125, also Tolnay in the *Gazette des Beaux-Arts*, March 1960, pp. 177 f. An Ingelbrechts is recorded as having investments at Tournai in 1427; Rousseau, *loc. cit.* Raymond Ingelbrechts is recorded at Tournai in 1434, according to Destrée in the *Revue de l'Art Ancien et Moderne*, vol. LVI, 1929, p. 129.

The iconography of this picture, especially of the Annunciation, has been the subject of much comment; it will not be gone into fully here. Recent articles are by W. S. Heckscher in the *Miscellanea Jozef Duverger*, 1968, vol. I, pp. 37 f., by C. I. Minott in *The Art Bulletin*, 1969, pp. 267 f., and by Carla Gottlieb in *Oud Holland*, 1970, pp. 65 f. Besides Panofsky, students may particularly attend to the issue of the *Bulletin* of the Metropolitan Museum of Art for December 1957, which includes articles already referred to by Rousseau (on general problems) and Suhr (on the preservation), a note by Rorimer and an iconographical article by Margaret B. Freeman (pp. 130 f.); also articles by Tolnay in the *Gazette des Beaux-Arts*, February 1959, pp. 65 f. and March 1960, pp. 177 f. Some other references will be given here as needed.

Panofsky, 1953, pp. 142 f., calls for good sense in finding symbols in this picture. He approves symbolism in the laver and basin, in the candlestick, and in the Lions on the bench (as Lions of Solomon, I Kings, x, 19); see his remarks, or a passage by Sonkes, 1969, p. 45.

Tolnay, in both his articles, notes that the season is spring for the left and central panels, winter for the right panel.

The object on St. Joseph's work-bench, another on the shutter outside the window and the board in which he is making holes have all been associated with mouse-traps, with theological symbolism. See originally Schapiro in *The Art Bulletin*, 1945, pp. 182 f.; some controversy in *The*

Burlington Magazine, 1966, pp. 126 f. (Zupnick), 373 f. (Jacob), 577 (Nickel). The board on which St. Joseph is boring holes has been associated with a piece of wood, later (?) than this furnished with nails, which is sometimes shown impeding Christ on his Way to Calvary; see, for instance, a picture at Greenville assigned to the Master of the Holy Blood (Bruges exhibition, *Primitifs Flamands Anonymes*, 1969, no. 32), and Sonkes, 1969, no. C 17, each with comment and references. See also Schapiro in *The Art Bulletin*, 1959, pp. 327 f.

As for the small figure by the gate in the donor's panel, Nickel (recording previous suggestions) claims that the small shield he wears identifies him as a messenger of Malines; *Bulletin* of the Metropolitan Museum of Art, 1966, pp. 237 f.

This picture is a key-piece for attribution to Campin. The basic group labelled Master of Flémalle (i.e. Campin) has been objected to by some critics as forming a less satisfactory basis for grouping than this picture; hence a name often used is Master of Merode. Friedländer, 1967, no. 54. In 1937, Friedländer specified this picture as one attributable to Rogier (1967, p. 55). A copy of the *Annunciation* in a private collection at Genoa (Friedländer, 1967, no. 155) was published by Valentin Denis in *Annales de la Fédération Historique et Archéologique de Belgique* (35e Congrès—Courtrai, 1953), 1955, pp. 541 f.; he considers it of the late sixteenth century, and records on it an old inscription *Rogier van der W . . .* As has been noted, Frinta thinks the donor's wing to be by a hand different from the painter of the other two parts.

The design of the *Annunciation* would appear to have attracted attention. Copies at Cassel and (already commented on) in a private collection at Genoa; Friedländer, 1967, plate 77. The picture at Cassel, from the arms there shown in the window, could be associated with Jean IV de Sainte-Aldegonde and his wife Marie de Rubempré, and dated not later than 1511; see Mme. C. van den Bergen-Pantens in the *Bulletin Trimestriel de la Société Académique des Antiquaires de la Morinie*, 1967, pp. 559 f. A drawing, quite close, considered to be a copy, at Erlangen; Sonkes, 1969, B 5. X-radiograph of the Cassel picture in Alan Burroughs, *Art Criticism from a Laboratory*, 1938, fig. 107. A variant picture is in the Musées Royaux des Beaux-Arts at Brussels, variously judged. Friedländer, 1967, no. 54b (plate 80), thought it probably executed in the Master's studio. Beenken, 1951, p. 102, note 25, thought it a copy, not of this picture but of a different and earlier version by Campin; this is agreed by Mojmír S. Frinta, *The Genius of*

Robert Campin, 1966, p. 75. Carla Gottlieb in *The Art Bulletin*, 1957, pp. 53 f., thought it a copy by J. Daret. X-radiograph in Alan Burroughs, *Art Criticism from a Laboratory*, 1938, fig. 92.

A rather large *Annunciation* in the church at Schöppingen, probably of soon after 1453, is mostly connected with the last (rather than with the original at New York); also partly with the *St. Barbara* of 1438 (Campin: Madrid 2). See the exhibition catalogue, *Westfälische Maler der Spätgotik*, Münster, Landesmuseum, 1952, no. 27, plate 8.

Part of a copy of the Brussels picture is preserved in a fragmentary painting, coll. Freiherr von Twickel Havixbeck; see P. Pieper 'Der Meister der bemalten Nimben' in *Mouseion*, Studien . . . für Otto H. Förster, 1960, pp. 229 f. and plate 243.

A loose derivative of the Brussels type is in the Gallery at Prague; reproduced by Tolnay in the *Gazette des Beaux-Arts*, February 1959, p. 67.

Derivatives also occur as reliefs. See, for instance, Sonkes, 1969, p. 46.

The pose of the Virgin corresponds closely in an *Annunciation* in the Prado (Campin: Madrid 1), often considered to be by a Follower rather than by Campin himself.

According to Rorimer (Metropolitan Museum of Art, *Bulletin*, December 1957, inside of cover), the triptych now at New York was acquired in Bruges in 1820 by the Prince d'Aremberg, and passed by inheritance to the Merode family. Recorded in the collection of the Comtesse de Merode in the *Gazette des Beaux-Arts*, 1887, vol. I, p. 218. Golden Fleece exhibition at Bruges, 1907; Flemish exhibition at Paris, 1923, no. 9 of the memorial volume. Acquired by 1957 for the Cloisters at New York, John D. Rockefeller Jr. Fund.

Friedländer, 1967, nos. 54, 155
Panofsky, 1953, index (Westerloo as location).

The Virgin in the Apse: New York, The Metropolitan Museum of Art; see Campin: London 3.

NEW YORK, **Portrait of a Man** (a Musician?)
MAGNIN New York, Mrs. John E. Magnin
$13\frac{3}{8} \times 9\frac{1}{2}$ in. (0.34×0.24 m.). On soft wood, according to Friedländer in *Werk über die Renaissance-Ausstellung* (Berlin 1898), 1899, p. 10. Apparently not recorded if it has been cut. Friedländer, 1967, no. 63, says it has been slightly over-cleaned; the state of preservation may be relevant to attribution.

The headdress is ornamented with music, apparently not interpreted.

Accepted by Friedländer, 1967, no. 63, but with doubt (p. 42) about separating it from Rogier; this was written at a time when he was not explicitly seeking to amalgamate Campin and Rogier. Panofsky, 1953, p. 425, accepts or inclines to accept. To judge from reproductions, the attribution seems doubtful.

Acquired in Vienna in 1895 by W. Gumprecht, Berlin; mentioned by Friedländer in *Werk über die Renaissance-Ausstellung* (Berlin 1898), 1899, p. 10; Gumprecht Sale, Berlin, 1918 (lot 11). Chillingworth sale, Lucerne, 1922 (lot 6). Exhibited at Kleinberger's, New York, *Flemish Primitives*, 1929 (no. 5).

Friedländer, 1967, no. 63; plate 91
Panofsky, 1953, index.

The Virgin and Child with Saints and Donors in an PARIS
Interior (Drawing) Plate 158
Paris, Musée du Louvre, Cabinet des Dessins
Pen and wash on paper, $7 \times 9\frac{1}{4}$ in. (0.178×0.235 m.).

The female patron saint is St. Catherine; the male saint has been identified as St. James.

This drawing seems to be a record of a picture or project for a picture by Campin; seemingly fairly accurate in style, also presumably in design.

Listed by Friedländer, 1967, no. 72; long entry for it by Sonkes, 1969, no. C 7.

Some compositional relationship in the Virgin and Child here has been noted with a design of the Virgin and Child believed to be related to the picture at Aix assigned to Campin; see Campin: Aix for further comment. Some resemblance has been found between the donatrix here and a picture at Dumbarton Oaks; see Sonkes, 1969, no. C 7, p. 100, and the entry for Campin: Washington (Dumbarton Oaks).

A drawing apparently merely a copy of this one is in the Ecole des Beaux-Arts at Paris; Sonkes, 1969, no. C 8.

In the Louvre by 1860.

Friedländer, 1967, no. 72
Panofsky, 1953, index.

Christ blessing, with the Virgin in Prayer at His Left PHILA-
Philadelphia, John G. Johnson Collection. DELPHIA
$11\frac{1}{4} \times 17\frac{3}{4}$ in. (0.285×0.45 m.). For an X-radiograph of the Plate 156
Virgin's head, see Alan Burroughs in *Metropolitan Museum Studies*, vol. IV, Part 2, 1933, p. 147.

The figures can be recorded as being shown at short bust length, most of the hands (which are deducibly raised at the elbows) being visible. Panofsky, 1953, p. 174, refers to it as representing the intercession of Our Lady with Christ. Friedländer, 1967, no. 56, accepts, but says that the head of Christ is much overpainted.

Friedländer, 1967, no. 56
Panofsky, 1953, index.

TOURNAI **Barthélemy Alatruye and Marie de Pacy**; Tournai, Musée des Beaux-Arts: see Campin: Brussels 1.

VARIOUS COLLEC- TIONS
Small Tondo: **The Virgin and Child**
Repeated with variations, including variations of style, in many versions. A few are not tondi.
The composition is related to the upper part of the Virgin and Child at Frankfurt (see Campin: Frankfurt 2); but it is usually thought that the small pictures are derived from a distinct, small picture by Campin.
Friedländer, 1967, no. 70, records two versions; see also Friedländer, vol. VI, Part I, *Hans Memlinc and Gerard David*, 1971, nos. 51, 52, Plate 99. Long list in Corpus, *Pologne*, 1966, pp. 38 f. An example acquired by the Prado in 1969 is reproduced in the *Gazette des Beaux-Arts*, *La Chronique des Arts*, February 1971, p. 50. A good example in its original frame was lent anonymously to Detroit, *Flanders in the Fifteenth Century*, 1960, no. 6A on supplementary page of the catalogue; the diameter of that is 8¼ in. (0.21 m.), with frame 11¼ in. (0.285 m.).
It has been suggested that such small tondi were for suspension, above a bed or similarly (see the Detroit exhibition catalogue).
Jeanne Tombu in *The Burlington Magazine*, vol. LVII, 1930, p. 127, remarks that the Virgin's headdress in a version she reproduces (also in others) corresponds with that in a Virgin and Child at Cologne, considered to be related to a picture at Aix-en-Provence assigned to Campin (q.v. for further comment).

Corpus, *Pologne*, 1966, no. 118
Friedländer, 1967, no. 70; plate 98.

WASHING- TON
The Virgin and Child with Four Saints
Washington, National Gallery of Art (Samuel H. Kress Collection)
47 × 58¼ in. (1.194 × 1.48 m.) without the frame; 54½ × 65¾ in. (1.385 × 1.67 m.) with the frame.

The saints are SS. John the Baptist, Anthony, Catherine, Barbara. A prayer is written along the bottom of the frame; given in the catalogue, *Paintings and Sculpture from the Kress Collection*, 1951, p. 168, no. 74. The prayer is followed by a monogram, believed to be possibly of the painter or donor; monogram reproduced by Passavant, *Kunstreise durch England und Belgien*, 1833, pp. 348 f.
This picture is strongly suggestive of Campin, but is considered not of a quality to have been executed by him. It is here not treated in detail.
According to Passavant (*cit.*) from a church in Bruges; recorded by him in the Imbert Collection, Bruges. For subsequent ownership, see the Kress catalogue, *cit.*

Friedländer, 1967, no. 152; plate 142
Panofsky, 1953, index (New York, Kress).

Female Portrait (?); traditionally a Sibyl
Washington, Dumbarton Oaks Collection
19½ × 14 in. (0.495 × 0.355 m.).

WASHING- TON (DUM- BARTON OAKS)

The reproduction of this picture in the catalogue of the Cernuschi sale, 1900, shows two inscriptions SIBYLLA/ AGRIPA and ALOISIA/SABAUDA. Neither looks authentic; most of the first survives. Objection has been made to considering the picture to represent a Sibyl. A. L. Mayer in *The Burlington Magazine*, vol. XLVIII, 1926, p. 41, said that a copy of it at Verona also bears the inscription *Aloisia Sabauda*, so it is a portrait of a member of the House of Savoy. Hulin in a contribution to the *Trésor de l'Art Flamand*, Memorial volume of the Antwerp exhibition of 1930, 1932, pp. 32 f., followed this up; on shaky grounds, he suggested that the sitter is Mary of Savoy, who in 1427 married Filippo Maria Visconti, Duke of Milan (d. 1447), and made her will in 1458. This is recorded also in the exhibition catalogue, *Flemish Painting*, Worcester (Mass.), 1939, no. 3.
Often accepted as by Campin; Friedländer, 1967, no. 57. Originality rejected by Panofsky, 1953, p. 175.
The figure bears some resemblance to the donatrix in a drawing in the Louvre (Campin, Paris; Sonkes, 1969, C 7). Cernuschi sale, Paris, 1900 (lot 143). Lent by Mrs. Bliss to the Flemish exhibition at Antwerp, 1930 (no. 138). Robert Woods Bliss Estate; given in 1940 to Harvard University; at Dumbarton Oaks.

Friedländer, 1967, no. 57; plate 84
Panofsky, 1953, index.

INDEX OF PERSONS

263

ICONOGRAPHICAL INDEX

PORTRAITS

MISCELLANEOUS

INDEX OF LOCATIONS

Grateful acknowledgements is made to all museum authorities and private owners who have kindly provided photographs and given permission for reproduction. The colour plates of the pictures in Dijon, Madrid and Paris have been reproduced from ektachromes provided by Photographie Giraudon, Paris.